Microanalysis in Music Therapy

also by Tony Wigram

Receptive Methods in Music Therapy
Techniques and Clinical Applications for Music Therapy Clinicians,
Educators and Students
Denise Grocke and Tony Wigram
Foreword by Cheryl Dileo
ISBN 978 1 84310 413 1

Songwriting
Methods, Techniques and Clinical Applications for Music Therapy Clinicians,
Educators and Students
Edited by Felicity Baker and Tony Wigram
Foreword by Even Ruud
ISBN 978 1 84310 356 1

Improvisation
Methods and Techniques for Music Therapy Clinicians,
Educators, and Students
Tony Wigram
ISBN 978 1 84310 048 5

A Comprehensive Guide to Music Therapy
Theory, Clinical Practice, Research and Training
Tony Wigram, Inge Nygaard Pedersen and Lars Ole Bonde
ISBN 978 1 84310 083 6

Clinical Applications of Music Therapy in Developmental Disability,
Paediatrics and Neurology
Edited by Tony Wigram and Jos De Backer
Foreword by Colwyn Trevarthen
ISBN 978 1 85302 734 5

Clinical Applications of Music Therapy in Psychiatry
Edited by Tony Wigram and Jos De Backer
Foreword by Jan Peuskens
ISBN 978 1 85302 733 8

Music Therapy in Health and Education
Edited by Margaret Heal and Tony Wigram
Foreword by Anthony Storr
ISBN 978 1 85302 175 6

of related interest

Music Therapy Methods in Neurorehabilitation
A Clinician's Manual
Felicity Baker and Jeanette Tamplin
Foreword by Barbara Wheeler
With a contribution from Jeanette Kennelly
ISBN 978 1 84310 412 4

Contents

List of Figures

List of Tables

List of Boxes

List of Web-based Resources

Audio examples

Video example

Foreword

Most of us experience music as a whole. It is likely that we were first drawn to music because we experienced the Gestalt of the music rather than the small things that go into it. Only later – for many of us, when we studied music – did we start to break the music down into its components of rhythm, melody, harmony, timbre, and so forth, so that we could understand it better. This increased understanding often leads to more appreciation or enjoyment of music. Similarly, when we learn a piece of music, we probably begin with a sense of the entire piece, often playing or singing it as a whole, although without the accuracy or depth of interpretation that will develop later. As we practice, we are likely to break the music down – determining the best fingerings to use, where changes of tempo or of volume should occur, which lines to emphasize. As we work on these smaller elements, we prepare to combine them into the larger piece, this time at a higher level.

A similar sequence has occurred in the development of music therapy. Most early reports of music therapy focused on the totality of what occurred in the music therapy session. We often read descriptions of the therapy process or case studies of music therapy that encompass the entire process; we can learn much through this kind of report. Only later, as music therapists begin to analyze what has occurred in the therapy, do they start to break it apart, studying specific responses and experiences and precise musical and behavioral responses and interactions. These analyses help to understand what is occurring in the music therapy and often lead to better therapy.

Microanalysis in Music Therapy will be valuable for music therapists' study of these smaller responses. The chapters in the book help us look carefully at the many components that make up the large picture and ultimately help us to understand more about what is occurring in the music therapy process. Each chapter presents a model or technique for studying one or more of these components. Most of these models have come from the authors' research and are grounded in their clinical work, lending credibility to the contents.

The 20 models represent a range of interests and are used with diverse populations and to meet different needs. They include a number that were developed for children with problems including autism, developmental disabilities, and social/behavioral disorders; others that were developed for work with adults with various psychiatric difficulties; as well as some for other groups and needs. Many of these can be applied beyond the clientele for whom they were originally developed. In addition, a number of the models were developed

with no particular population in mind. The authors and editors provide information and adaptations to help in the application of the models to clinical work. With such variety of intended and unintended populations, the contents of this volume will have broad applicability.

As one who tries to maintain an awareness of the broad picture of music and music therapy but is also fascinated by the small components that make up this work, this book holds lots of interest for me. I am pleased to have so many of these models together and in English. Some were developed especially for this publication, and all were adapted to provide methods that can be used by clinicians. Some were available but never in the same place, making it difficult to find one when it was needed or, of course, to even know about it. Others have been only doctoral theses and/or in another language, again, being either difficult or impossible to access in English. So it is helpful to have them gathered together in the same place, and their expansions and adaptations make them practical to use. It is always a privilege when literature that has been published only in another language (and the ideas that are contained in the literature) becomes accessible to people who do not know that language and that literature. This occurs in this volume due to the diverse backgrounds of the authors and editors.

I am pleased to write the Foreword to this important contribution to music therapy and honored to have been asked. I look forward to having these models become more and more a part of our music therapy methods and to the insights and growth that they will provide for the development of music therapy and our clients.

Barbara L. Wheeler
Professor and Director of Music Therapy, University of Louisville

Chapter 1

Microanalysis in Music Therapy: Introduction and Theoretical Basis

Thomas Wosch and Tony Wigram

Introduction

The development of music therapy as a profession placed within the areas of health, education and the social system, as well as in some more specialized areas, such as care of the terminally ill and prisons, is documented in the literature by many theoretical books, case studies, and research reports (American Music Therapy Association [AMTA] 2000; Bruscia 1987, 1991; Bruscia and Grocke 2002; Decker-Voigt 2001; Schwabe and Stein 2000; Wigram and De Backer 1999a, 1999b; Wigram, Nygaard Pedersen and Bonde 2002). The method and technique employed in the practice of music therapy has received less attention, as the majority of clinical applications are taught to music therapists through varied lectures and experiences in practicums, as well as through supervision. Beside some early texts on method (Nordoff and Robbins 1977; Schwabe 1974, 1978; Unkefer 1990) more recently texts have begun to emerge that give detailed explanations of the application of music therapy techniques, allowing a greater degree of consistency in the terminology used, and in treatment interventions (Baker and Wigram 2005; Grocke and Wigram 2006; Wigram 2004).

Methods of analyzing and documenting music therapy interventions have also received less than necessary attention, for two probable reasons. First, the main focus has over the period of development since 1945 been mainly on empirical clinical experience. Second, there has been almost a reluctance to address the more difficult process of analyzing and documenting clinical work systematically, and especially through standardized tools to which everyone would subscribe and in the application of which everyone would be trained. Exceptions exist, for example in the training given by Nordoff-Robbins courses since their inception in the method of analyzing and reporting the tapes of sessions, and also in the systematic record keeping of behavioral changes in the more behaviorally oriented approaches in the US, which often use nonmusical tools for an analysis or research studies (AMTA 2000; Gregory 2000).

However, especially in the last five years, a large number of research studies have involved the development of detailed analysis tools, or the use of existing ones – musical, textual, video, and even physiological. With the exception of physiological tools, this book is going to try and meet the challenge of converting these into "user-friendly" clinical tools. The focus of the book is restricted to tools that involve microanalysis – the detailed analysis of a small but relevant amount of data drawn from a single experience with a client, or a single session. In the majority of chapters the microanalyses are of active music making, where the therapist and client(s) are engaged in shared musical experiences. The analysis of musical activity, interpersonal behavior, clients' expressions, communication, emotions, and many other parameters has long since been the foundation of the arguments regarding the benefits and validity of music as a therapeutic intervention. However, research studies and case study reports frequently offer only limited explanation of how musical or verbal material has been systematically analyzed. The few studies that do usually describe a complex and lengthy process of analysis, sometimes with multiple dimensions, that is inaccessible for clinical practitioners as a relevant tool. This book seeks to document a selection of analysis methods that fall within the category of microanalysis, most of them grounded in research studies, all of which can be adapted and applied for use in training music therapists and for everyday clinical practice. In addition to musical activity, verbal interaction and other nonmusical behavior in music therapy are also analyzed.

The concept of microanalysis

Even though microanalysis can play an important role in day-to-day music therapy practice when the therapist has to make spontaneous decisions during a session, it is only sparsely found in music therapy literature (Holck 2002; Plahl 2000; Wosch 2002, 2004). The term "microanalysis" has a much longer history and is used systematically in related disciplines such as psychotherapy (Schindler 1996; Stuhr 1997), pedagogic disciplines like special education (Greving 2000), and in the academic field of music psychology (Scherer and Zentner 2001; Trevarthen and Malloch 2000). The specific "objects" in focus for a microanalysis should be understood and defined as *minimal changes in relationships or interactions between people or minimal changes in the music and in dynamic forces*. For clinical practice it is very important that one has the ability to consciously perceive and critically analyze therapy process, and with those skills to react appropriately to very small changes in social, musical, and emotional behavior and experiences within a therapeutic context. This book offers a wide range of instruments, analysis tools, and aids for systematically supporting these perceptions through a multitude of microanalysis methods in music therapy – as if it were put under a microscope – for different problems in clinical practice, different client populations, and different approaches of music therapy. The emphasis is on methods and techniques, and the editors have formulated a model for each chapter to ensure that clearly defined procedures for applying the methods of microanalysis are articulated. The structure and content of each chapter are explained below.

Benefits for clinicians, students, and researchers

Three categories of reader will profit from this book. The first group is *clinicians*. For them the different kinds of microanalysis provide possibilities for answering specific questions from their clinical work. In particular, these are questions which cannot always be perceived consciously during a music therapy session, and which need additional reflection outside of the session. For example, during an improvisation many changes in the interaction and communication between client and therapist can occur, and a therapist might only remember some of these moments of change because in individual therapy we are fully involved in playing, with the consequence that we are not always able to step back, observe, and modify our response or initiatives. Some of the methods presented here offer a system for analysis that can help to make these changes, and what they mean in terms of interaction and communication, visible. This can be very helpful for various therapy sessions which, as music therapists, we would like to reflect upon. The background questions to many of the examples of microanalysis presented here are as follows:

- What did actually happen?
- In what way can one perceive the problem that is the focus of this therapy?
- When and how did it start?
- Did the client really behave in the way that I believed they behaved?
- What was I doing, and why?

Sometimes, with briefer periods of therapy, we may just need a short but detailed assessment during the first therapy sessions. Another specific area that microanalysis of musical material in music therapy can be invaluable is when working with clients who can only reflect minimally or not at all. For understanding and clarifying therapy process with these clients, the analyses described in this book may offer reflections of their behavior, their development, and their potentials. The results of these microanalyses can provide the concrete example or evidence that is frequently implied but not explicit when reading about music therapy process and outcomes in work with many different populations.

For *students* two goals can be achieved with the methods provided here. One goal is the systematic sensitization of a future professional therapist to all the important small details that are occurring in a music therapy session. There are 20 different analysis methods documented here, and some will be more appropriate than others in clinical and research work, depending on the population in question, or the focus of the research study. For student therapists (and practicing clinicians and researchers), all of the analysis methods can potentially be used; however, the relevance of applying them needs to be taught carefully to students when expecting them to reflect in detail on clinical material. It will be important that students, qualified practitioners, and researchers make informed choices, and realize that often the application of any one of these methods requires an additional period of learning to become experienced, practiced, and competent. Through this process, competencies in perceiving the smallest details of musical or nonmusical behavior and its changes can be developed. Perhaps this will act as a "reality check" in order to help to reduce expectations of

possible "miracles" through music therapy. The ability to reflect upon the possibilities of processes induced by music therapy and to understand them for each individual case can be developed. In addition, professional flexibility in the use of music therapy interventions and ways of planning them can, to a certain extent, be gained.

The second goal for students could be the use of these methods in project work during their training, for analysis of clinical source material collected during their practicum experiences, and for their masters thesis where a research element or evidence of competencies in making a detailed analysis are required. A rich resource is offered here for using parts of or whole microanalyses for researching a case study. Many of the methods presented here were developed or used in this way.

For the *researcher*, an equally rich and complex range of microanalyses which goes beyond a masters thesis and which was developed in doctoral studies is offered, with staged or stepped procedures for application. None the less, most of the doctoral-level micro-analyses are also presented in the chapters as shorter versions for clinical practice and for masters studies. If a doctoral or post-doctoral researcher wants to analyze minimal details or changes within a music therapy session, compare them throughout a complete music therapy treatment, or even compare these details or changes across cases or client-populations, he or she will find a comprehensive overview and description of the individual microanalyses. If several cases or client-populations are compared, the opportunity to undertake a case series study or multiple case studies study is supported here through offering systematic and consistent models of analysis.

How to use this book

The book is structured as follows. In this Introduction the theory of microanalysis in the humanistic sciences in general and in music therapy in particular are briefly outlined, a definition of microanalysis based on this book is given, and the 20 chapters describing methods of microanalysis are theoretically systematized. Finally, in the last chapter of this book, systematization for clinical practice is offered, considering when methods might be applied, with whom, and to what extent. This means that in practice specific questions can be answered with specific microanalyses, and that individual microanalyses might be especially suitable for certain client-populations. The flexibility to which a microanalysis may be applied and the degree of detail and intensiveness with which it is undertaken will also be addressed, in consideration of the potential readership and their functional use of the methods described in this book. Several tables will give guidelines for the use of different microanalysis methods and finally a decision tree will give an orientation subsuming the different dimensions. This last chapter can also be of first interest for those readers who want to decide quickly which of the 20 microanalyses they can and want to use.

Chapter format

In each chapter, the individual method of microanalysis is described according to a standardized structure. This ensures the reader access to comparable information in all chapters:

Introduction section: In a short introduction a clinical problem, a theory-question, and/or an individual case is mentioned for each method, which led to the development or the use of the method of microanalysis.

Theoretical frame: A short section explaining the underpinning theoretical framework for the method in each chapter is presented. Here the microanalysis method is contextualized within the philosophical perspective of the contributor, and any literature supporting its application provided. The relationship to clinical application may also be addressed here from the theoretical perspective.

Methodology: The basic thoughts or initial ways of defining the method are outlined. The main part of each chapter is this detailed explanation of method. Here the individual microanalysis method is described, giving directions for use in such a way that the long and/or short version could be used by any clinician, student, or researcher. In most chapters a step-by-step procedure is outlined, sometimes within certain stages, and the "instructions" regarding what a clinician, researcher, or student needs to do are presented. The method section may also contain references to technical resources or additional information in the web-based resources.

Case example: The practical relevance of the individual microanalysis is then illustrated in a short case example. Here questions from practice or theory which are also mentioned in the introduction or the theory section can be given a first brief answer, or further thoughts and consequences for the theory and practice of music therapy can be added.

Summary: In a final summary a brief overview of the microanalysis is given, and further perspectives of clinical practice, teaching, and research are briefly discussed.

Web-based resources: In order to include a larger number of contributions to reflect the diverse forms of microanalysis, significant limits of space were imposed, and the text in the book is intended to directly explicate the method. Consequently the web-based resources were developed to contain much of the additional data, technical resources, and include (in some chapters) more comprehensive illustrations of the case examples. Many figures, videos, audio-files, questionnaires, etc. from the different microanalyses can be read on the web-based resources. For a number of chapters we suggest you work with the book and the web-based resources simultaneously, so that the figures corresponding to the text can be followed at the same time, video or audio examples can be watched or listened to and, sometimes, questionnaires or other material can be printed out for personal use. It is important to realize that the best way in some cases to understand the method in practice, following the contributors' procedure, is to look carefully at the case example.

Finally, there is an overview giving brief information about the contributors, including contact information in some cases. These authors can be contacted if the presented microanalyses are used – they would be happy to receive feedback, so that information flows both ways. Moreover, we would like this to be more than just a book: to be the catalyst for developing a unique collection of the results of microanalyses. There is potential for many case examples or case vignettes that are analyzed through microanalysis to be collected,

categorized (perhaps into population samples or applications samples) and used in meta-analysis research into music therapy. While not suggesting here that a process of standardizing and externally validating a particular microanalysis method would be realistic or even possible, it may be possible to establish a body of knowledge from microanalyses that further adds to the evidence for music therapy. This could enrich international music therapy, and may lead to important conclusions about the practice and theory of music therapy. So this book with its web-based resources and the above-mentioned project can become more than "just" a book.

Theoretical foundations of microanalysis in music therapy

Important sources for obtaining an overview in a specific area or subject nowadays are databases and internet search engines. If one feeds "music therapy" and "microanalysis" into PsycINFO, only three results appear (November 2006). On the other hand, there are 53 reports of microanalysis using the key words "psychotherapy" and "microanalysis," and a total of 181 for "microanalysis" alone. It becomes clear that psychotherapy already has a larger and longer history with microanalysis, albeit still quite a modest one. This means that when looking at the theory of microanalysis within human sciences we must take psychotherapy research into consideration as well as music therapy research.

Therapy process studies and research paradigms in music therapy and psychotherapy

For a long time the above-mentioned case studies were classified under the qualitative research paradigm within psychotherapy and music therapy research (Wheeler 1995). This is the paradigm of constructivism (Bruscia 1995, p.66). In short, constructivism states that there is no basic recognizability, or that there is not just one truth. Therefore music therapy often turns towards case studies in this research paradigm to allow for fully mirroring and studying the client's subjectivity. In addition the therapist as researcher can be fully involved in the study to be able to offer subjective views and a comprehensiveness of the research to be considered (Wheeler 2005, p.13). This form of research is also intimately linked with the study of therapeutic *processes* (Wheeler 1995). The counterpart to this qualitative process research is the quantitative research studies, especially those with an emphasis on outcome. Its paradigm is positivism (Wheeler 1995) and with that the absolute recognizability of the world at the same time as partly disregarding subjective differences. These types of study involve documenting the outcome of therapies supported by rigorous statistical analysis. There has, therefore, in the past been a clear distinction between the research topics of therapy process and case studies for qualitative analysis and outcome-based and large quantitative analyses, typically present in the literature and research milieus until the middle of the 1990s.

At precisely this time demands were made within psychotherapy which essentially questioned these seemingly inevitable polarities of research and analysis areas (Wosch 2002, pp.48–58). This was noticeable especially in the writing of Elliott (1991), Hilliard (1993), and Stuhr (1997). Elliott started out with process research itself. He called for multidimensionality, which would deal with the high complexity of process factors (1991,

p.101). This included, among other things, the possible separation of researcher and therapist, a necessary focus on the therapist or the client, and a focus on individual process variables. Basically this is one of the first examples of mixing qualitative and quantitative methods, and offers the possibility of having an external researcher as in quantitative research. Furthermore a focus on individual process variables as in the positivistic paradigm is incorporated.[1] Another mixing of methods becomes evident in Hilliard's work. Besides the classical qualitative case studies, he includes a quantitative and a single-case experiment case study design in his single-case methodology (Hilliard 1993, p.377). For process research and, through that, for the research of "how" things change in therapy, laboratory situations and naturalistic treatment settings are used in the quantitative paradigm next to classical case studies. A generalization of case studies in the positivistic sense is called for in case-by-case studies (Hilliard 1993, p.376). The mixing of the formerly separated principles and goals is continued by Stuhr who, referring to Bastine, Fiedler and Kommer (1989), draws the conclusion that quantitative outcome research needs to be extended through the analysis of microprocesses (Stuhr 1997, p.45). Stuhr calls this "prozessuale Erfolgsforschung" [process-outcome study] (1997, p.47). With that, process research is seen as outcome research: the two are mixed and, as it were, put on the same level. The special quality is that compared to the former separation it is possible to stay much closer to practice now. The call for explorative versus theory-driven research (Schindler 1996, p.272) affects quantitative analysis designs here. Besides what is already proposed by Hilliard, this can be done in single-case quantitative analysis, which can study psychotherapy directly in an unaffected, naturalistic, clinical setting.

This change can also be seen in music therapy. The second edition of the seminal book *Music Therapy Research* edited by Wheeler abandons the subtitle *Quantitative and Qualitative Perspectives* (Wheeler 1995, 2005). While in the first edition of the book naturalistic clinical settings and process research are classified mainly under qualitative analysis (Wheeler 1995, p.12; Bruscia 1995, p.71), in the second edition mixed methods designs are presented (Wheeler 2005, p.14). They can be found especially in publications through the years 1997–2004. Here belongs – referring to Robson (2002) – even the combination of qualitative *and* quantitative methods (see also Kenny 2004, p.32, triangulation of methods). Therefore, in close relation to practice, the path is paved for the analysis of microprocesses by combining qualitative and quantitative methods. In addition, in the new edition of *Music Therapy Research* there is a chapter on Quantitative Single-Case Design (Smeijsters 2005) in the section on Quantitative Research. In this chapter, four different methods from the years 1998–2002 are presented. Here, the case study becomes a means for both qualitative and quantitative research in music therapy, allowing the core values of process research, even in a much smaller number of cases. This phenomenon can be seen in music therapy as well as in general psychotherapy research during this period.

1 Elliott seems to keep close to practice as a researcher and appears not to be afraid of combining medical and nursing research (Elliott 2006).

The meaning and possibilities of microlevels in process analysis

In psychotherapy, process analyses are differentiated into different time levels. According to Schindler (1996, pp.278–89) they are divided into six different lengths of time:

Level 1: the whole process

Level 2: phase

Level 3: session

Level 4: episode

Level 5: phrase

Level 6: individual cognitive process.

It is as if the degree of magnification of a microscope is gradually increased. At Level 1, the process of the course of all therapy sessions with a client is analyzed. At Level 2, there are individual phases within the whole course. Here a number of individual sessions, not all the sessions, are studied. At Level 3, one looks at the process of one single session. The whole process of one therapy session can be further divided into individual episodes, so that at Level 4 the process of just one part of the session can be analyzed. This can be narrowed down further to just one phrase, as at Level 5, which is "eine Äußerung oder ein Teil einer Äußerung...welche eine Person an eine andere richtet" [an expression or part of an expression...which one person directs towards another] (Schindler 1996, p.285). Here we are at the level of a process of seconds or minutes which is studied. The last level (Level 6) finally refers to minimal internal processes of processing or changes in the client which can be based on inquiry, or which nowadays are more and more analyzed and made visible through neurology. Utilizing this, not only is the client's way, for example, of speaking or acting included in the study process, but also his internal experience separated from expression, and his "Wahrnehmung, Bewertung und Entscheidung" [perception, judgment, and decision] (Schindler 1996, p.288). These microprocesses are equally concerned with therapist and client and can be studied for either with their own research questions. Here the smallest micropsychological level – the "moment" – is reached. One could call this level a process-entity or process-cell, as it represents a basic element that cannot be divided anymore. According to the frame of the process, this entity – for example when looking at relationships – is called "Moment-zu-Moment Interaktion" [moment-to-moment interaction] (Schindler 1996, p.288).

For the microanalysis described in this book the above-mentioned Levels 3 to 6 are relevant. As described in the definition below, the timeframe of one session for the purposes of a single microanalysis is the largest possible range for a microanalysis. Several points led to this restriction and its possibilities for researching processes and changes in music therapy.

Within the theoretical framework of micro-perception in general psychology, perception of music and perception of time are frequently given as examples (Dorsch 1994, p.481; Frith 1969). Two dimensions become clear here. On the one hand the distinction of pitch is given as the leading example for the perception of minimal differences, while on the other hand there is the perception of time in general and of music. Among the arts, music is explic-

itly linked to time. This may lead to a special need and possibility for microanalysis on many levels both for music itself in the limited, auditory sense, and for music as art of time and process.[2] Minimal moments can be registered within the music experience. This is true for the principles of music therapy next to therapy analysis as aspired to and striven for in this book. An example of that is German Regulative Music Therapy (Röhrborn 2004; Schwabe 2004, 2007; Schwabe and Röhrborn 1996). Its basic principle is self-perception. During the course of Regulative Music Therapy, the client keeps perceiving more and more. Stepwise he or she is guided towards a micro-perception of minimal moments, which make it possible for the client to consciously perceive unconscious processes of experiencing. Selective perception is gradually loosened, so that during the course of therapy the client may speak for ten minutes about perceptions that may have occurred only for two to five seconds. Compared to his or her "normal" everyday perceptions, new perceptions become possible through this micro-perception which enables changes in the therapy process for the client. The general goal of individual microanalysis in this book can be understood in this way. The different methods of microanalysis presented here offer possibilities for the discovery of new observations which apply to the client and/or the therapist within a therapy session or its parts. New information and important changes of perspective for the therapist are obtained systematically, understandably, communicably, and recognizably through the slow and detailed analysis described by the many methods here, and through aiming at moments as described above. Here, ultimately, a first level of process and outcome analysis is reached. This can be obtained through a multitude of microanalyses using one method or a combination of methods and selected process variables.

All the presented microanalysis methods may be able to be used in practice with the full range of music therapy clients, depending on what is in focus. But the use of these methods has special significance on the one hand for clients who can work mainly or only nonverbally, and on the other hand for work in hospitals with increasingly shorter lengths of stay. For clients with severe developmental disorders, or severe and multiple handicaps, or for clients in rehabilitation who lost part or all of their ability to speak, it is very important that their nonverbal communication is understood. For that, these methods of microanalysis offer very good tools for exploration (Greving 2000) and testing. The therapy goals, too, are sometimes found in the area of micro-perception. This is also true for shorter lengths of stay in hospitals. Complete, clearly visible changes resulting from therapeutic intervention cannot be reached any longer through in-patient therapy that lasts for months. However, smaller but equally significant partial goals can be obtained which need micro-perception and which can (and sometimes have to be) reached within one therapy session.

To finish this theory section, let us return to the above-mentioned six levels of process analysis in psychotherapy. We see that four of them are relevant for microanalysis in music

2 Music as analogue communication has its special kind of process compared to digital
 language (see Schwabe 1983).

therapy, and they are partially renamed as follows according to their special qualities and differences to verbal psychotherapy:

Level 1: session

Level 2: episode (for example improvisation, verbal part, a music listening period)

Level 3: therapy event (for example a short verbal, musical, or other nonverbal phrase)

Level 4: moment-by-moment experienced change (for example moment-by-moment interaction, moment-by-moment emotion).

The *whole therapy session* itself – similar to psychotherapy – as the maximum timeframe is not renamed. And *episode* as the next level does not need to be changed as a term. In music therapy we need to add that we have episodes defined by music as, for example, an improvisation or a music listening period. Along these lines a session can be divided into several episodes, similar to verbal psychotherapy sessions. Within music therapy sessions, however, several episodes may be clearly visible without prior content exploration due to separate and complete musical actions. The third level of microanalysis in music therapy was renamed as a *therapy event* (formerly *phrase*). As this focuses only on the "spoken word" in music therapy in contrast to verbal psychotherapy, it is neither possible nor useful to speak of a therapy event here. This can also be a verbal phrase. But it may also be another event such as a part of an improvisation, a song, or a music listening phrase. The last level (Level 4) is the individual cognitive process which resides at the minimal individual level of experience. Here we deal with minimal inner process of experience in the client or the therapist which could not be subdivided any further. The timeframe is only a few seconds, during which a change at this very smallest level can be observed. Compared with the abovementioned term of cognition during speaking and judgment in verbal psychotherapy by Schindler, it is renamed here relating to comprehensive experiences (including cognition) in music therapy (Vink 2001; Wosch 2002).

Working definition of microanalysis

With this frame of microanalysis in music therapy the following definition is the basis of all methods of microanalysis in this book:

Microanalysis is a detailed method investigating microprocesses. Microprocesses are processes and changes/progressions within one session of music therapy. The amount of time can be one minute (moment) or five minutes (therapy event) of one session, one clinical improvisation (episode), or one complete session. To analyze process over time, several microanalyses can be undertaken to look at several events.

Systematization of methods of microanalysis

In Table 1.1 all methods of this book are shown differentiated in their level (Levels 1–4) of microanalysis in music therapy, in the form of analyzed material (musical activities, verbal interaction or nonmusical behavior), in data source of the microanalysis (audio files, video

Table 1.1: Differentiation of methods of microanalysis in music therapy in this book

Author	Basic approach		Data source			Form of analyzed material			Level of microanalysis			
	Quantitative	Qualitative	Video file	Audio file	Interview	Musical activity	Verbal interaction	Non-musical behavior	1 Session	2 Episode	3 Therapy event	4 Moment
Abrams	X		X	X		X				X	X	
Baker	X			X		X					X	X
Bonde												X
De Backer and Wigram		X	X			X				X	X	
Erkkilä	X			X		X				X		
Grocke	X			X		X				X	X	
Holck		X (ethnographic)	X			X		X		X	X	
Inselmann	X		X	X		X			X	X		
McFerran and Grocke		X (phenomeno-logical)			X		X		X			
Ortlieb et al.	X	X (grounded theory)		X			X		X			

Continued on next page

Table 1.1 cont.

Author	Basic approach		Data source			Form of analyzed material			Level of microanalysis			
	Quantitative	Qualitative	Video file	Audio file	Interview	Musical activity	Verbal interaction	Non-musical behavior	1 Session	2 Episode	3 Therapy event	4 Moment
Pavlicevic	X		X	X		X				X		
Plahl	X		X			X		X			X	X
Ridder	X	X	X			X		X		X		
Scholtz et al.	X		X	X		X		X		X	X	X
Schumacher and Calvet	X		X			X				X	X	
Sutton		X		X		X			X	X		
Trondalen		X (phenomeno-logical)		X		X				X	X	
Wigram	X			X		X			X	X		
Wosch IAP	X			X		X				X	X	X
Wosch EQ	X			X		X				X		
Total: 20	14	7	7	12	1	17	2	4	5	15	10	4

files, or recorded interviews) and in their basic approach of analysis (qualitative or quantitative).

This book offers a wide diversity of microanalyses. However, other methods of microanalysis or those with the potential for microanalysis exist, for example, the analysis of clinical improvisation in morphological music therapy (Weyman 2007) and the deep hermeneutic analysis of associations in clinical improvisation (Metzner 1999).

References

American Music Therapy Association (2000) *Effectiveness of Music Therapy Procedures: Documentation of Research and Clinical Practice.* Silver Spring: AMTA Publications.

Baker, F. and Wigram, T. (2005) *Songwriting: Method, Techniques and Clinical Applications for Music Therapy Clinicians, Educators and Students.* London: Jessica Kingsley Publishers.

Bastine, R., Fiedler, P. and Kommer, D. (1989) "Psychotherapeutische prozessforschung. Editorial." *Zeitschrift Klinische Psychologie 1,* 1–2.

Bruscia, K. (1987) *Improvisational Models of Music Therapy.* Springfield, IL: Charles C. Thomas.

Bruscia, K. (ed.) (1991) *Case Studies in Music Therapy.* Pennsylvania: Barcelona Publishers.

Bruscia, K. (1995) "Differences between Quantitative and Qualitative Research Paradigms: Implications for Music Therapy." In B. Wheeler (ed.) *Music Therapy Research: Quantitative and Qualitative Perspectives.* Pheonixville: Barcelona Publishers 65–76.

Bruscia, K. and Grocke, D. (2002) *Guided Imagery and Music: The Bonny Method and Beyond.* Gilsum, NH: Barcelona Publishers.

Decker-Voigt, H.H. (ed.) (2001) *Schulen der Musiktherapie.* Munich: Reinhardt-Verlag.

Dorsch, F. (1994) *Psychologisches Wörterbuch.* Bern: Hans Huber.

Elliott, R. (1991) "Five Dimensions of therapy process." *Psychotherapy Research 1,* 2, 92–103.

Elliott, R. (2006) "Qualitative Methods in Psychotherapy Research." Unpublished conference paper (57th annual conference of Deutsches Kollegium für Psychosomatische Medizin in Magdeburg).

Frith, C.D. (1969) "Abnormalities of Perception." In H.J. Eysenck (ed.) *Handbook of Abnormal Psychology.* London: Pitman Medical.

Gregory, D. (2000) "Test instruments used by the *Journal of Music Therapy* authors 1984–1997." *Journal of Music Therapy 37,* 2, 79–94.

Greving, H. (2000) *Geistige Behinderung-Reflexion zu einem Phantom: ein interdiziplinärer Diskurs um einen Problembegriff.* Bad Heilbrunn: Klinkhardt.

Grocke, D. and Wigram, T. (2006) *Receptive Methods in Music Therapy: Techniques and Clinical Applications for Music Therapy Clinicians, Educators and Students.* London: Jessica Kingsley Publishers.

Hilliard, R.B. (1993) "Single-case methodology in psychotherapy process and outcome research." *Journal of Consulting and Clinical Psychology 61,* 373–80.

Holck, U. (2002) "Music Therapy for Children with Communication Disorders." In T. Wigram, I.N. Pedersen and L.O. Bonde (eds) *A Comprehensive Guide to Music Therapy* (section 4.4, pp.183–7). London: Jessica Kingsley Publishers.

Kenny, C.B. (2004) "A Holistic Framework for Aboriginal Policy Research." Ottawa, Ontario, Canada: Status of Women Canada. Available at http://www.swc-cfc.gc.ca/pubs/pubspr/0662379594/index_e.html.

Metzner, S. (1999) *Tabu und Turbulenz. Musiktherapie mit psychiatrischen Patienten.* Göttingen: Vandenhoeck & Ruprecht.

Nordoff, P. and Robbins, C. (1977) *Creative Music Therapy.* New York: John Day.

Plahl, C. (2000) *Entwicklung fördern durch Musik.* Münster: Waxmann.

Robson, C. (2002) *Real World Research: A Resource for Social Scientist and Practitioner-Research.* Malden, MA: Blackwell Publishing.

Röhrborn, H. (2004) "Regulative Musiktherapie in der Dyade-Erfahrungen aus einer Psychotherapieklinik im Versorgungskrankenhaus." In I. Frohne-Hagemann (ed.) *Rezeptive Musiktherapie-Theorie und Praxis*. Wiesbaden: Reichert Verlag.

Scherer, K.R. and Zentner, M.R. (2001) "Emotional Effects of Music: Production Rules." In P.N. Juslin and J.A. Sloboda (eds) *Music and Emotion*. Oxford: Oxford University Press, pp.3–92.

Schindler, L. (1996) "Prozessforschung." In Bierbaumer, N., Frey, D., Kuhl, J., Prinz, W., Weinert, E.F. (eds) *Enzyklopädie der Psychologie*. Hogrefe: Verlag der Psychologie Göttingen, Berne, Toronto, p.272.–298.

Schwabe, C. (1974) "Die Verfahren und ihre Anwendungen." In C. Schwabe *Musiktherapie bei Neurosen und funktionellen Störungen*. Jena: Gustav Fischer Verlag, pp.108–197.

Schwabe, C. (1978) "Methodensystem der Musiktherapie." In C. Schwabe *Methodik der Musiktherapie und deren theoretische Grundlagen*. Leipzig: Johann Ambrosius Barth, pp.191–231.

Schwabe, C. (1983) *Aktive Gruppenmusiktherapie für erwachsene Patienten*. Leipzig: VEB Georg Thieme Leipzig.

Schwabe, C. (2004) "Regulative Musiktherapie (RMT) – Wegmarken einer Konzeptionsentwicklung." In I. Frohne-Hagemann (ed.) *Rezeptive Musiktherapie-Theorie und Praxis*. Wiesbaden: Reichert Verlag.

Schwabe, C. (2007) "Regulatory Music Therapy (RMT) – Milestones of a Conceptual Development." In I. Frohne-Hagermann (ed.) *Receptive Music Therapy: Theory and Practice*. Wiesbaden: Reichert Verlag, pp.203–10.

Schwabe, C. and Röhrborn, H. (1996) *Regulative Musiktherapie-Entwicklung, Stand und Perspektiven in der psychotherapeutischen Medizin*. Stuttgart: Gustav Fischer Verlag Jena.

Schwabe, C. and Stein, I. (2000) *Ressourcenorientierte Musiktherapie*. Crossen: Akademie für angewandte Musiktherapie.

Smeijsters, H. (2005) "Quantitative Single-Case Designs." In B. Wheeler (ed.) *Music Therapy Research,* 2nd edn. Gilsum, NH: Barcelona Publishers.

Stuhr, U. (1997) *Therapieerfolg als Prozess-Leitlinien für eine künftige Psychotherapieforschung*. Heidelberg: Roland Asanger Verlag.

Trevarthen, C. and Malloch, S.N. (2000) "The dance of wellbeing: defining the musical therapeutic effect." *Nordic Journal of Music Therapy 9,* 2, 3–17.

Unkefer, R. (ed.) (1990) *Music Therapy in the Treatment of Adults with Mental Disorders*. New York: Schirmer.

Vink, A. (2001) "Music and emotion. Living apart together: a relationship between music psychology and music therapy." *Nordic Journal of Music Therapy 10,* 2, 144–158.

Weymann, E. (2007) "Beschreibung und Rekonstruktion." In H.-H. Decker-Voight, P. Knill and E. Weymann (eds) *Lexikon Musiktherapie*. Göttingen: Hogrefe.

Wheeler, B.L. (1995) *Music Therapy Research: Quantitative and Qualitative Perspectives*. Gilsum, NH: Barcelona Publishers.

Wheeler, B.L. (2005) *Music Therapy Research*, 2nd edn. Gilsum, NH: Barcelona Publishers.

Wigram, T. (2004) *Improvisation: Methods and Techniques for Music Therapy Clinicians, Educators and Students*. London: Jessica Kingsley Publishers.

Wigram, T. and De Backer, J. (1999a) *Clinical Applications of Music Therapy in Developmental Disability, Paediatrics and Neurology*. London: Jessica Kingsley Publishers.

Wigram, T. and De Backer, J. (1999b) *Clinical Applications of Music Therapy in Psychiatry*. London: Jessica Kingsley Publishers.

Wigram, T., Nygaard Pedersen, I. and Bonde, L.O. (2002) *A Comprehensive Guide to Music Therapy. Theory, Clinical Practice, Research and Training*. London: Jessica Kingsley Publishers.

Wosch, T. (2002) *Emotionale Mikroprozesse musikalischer Interaktionen. Eine Einzelfallanalyse zur Untersuchung musiktherapeutischer Improvisationen*. Münster: Waxmann.

Wosch, T. (2004) "Gefühlswandel in musiktherapeutischen Improvisationen. Eine Mikroanalyse." In K. Schumacher (ed.) *Musik-Kommunikation-Therapie*. Vienna: Herbert-von-Karajan-Centrum, pp.37–44.

Part One

Video Microanalyses

Chapter 2

An Ethnographic Descriptive Approach to Video Microanalysis

Ulla Holck

Introduction

In the ethnographically informed approach to observational research one studies everyday settings, and seeks to understand actions and meanings in their social context (Silverman 1993; Wolcott 1990. This approach is a strong tool for investigating interactions of a more or less implicit character. Combined with video microanalysis, the ethnographic approach is, furthermore, very useful in recognising small indicators of communication and social interaction in music therapy with clients with severe communicative limitations. Especially with this client group, the method can be used to confirm or reject interpretations of the client's actions as being social attempts to take part in the interaction, even though these actions may seem vague, arbitrary or even ambivalent.

Because the method is suitable for describing what actually happens between client and therapist, it can also be used when the therapist, student or trainer wants to be aware of interactions taking place partly or fully outside of the therapist's awareness, either because they are taken for granted or because of 'blind spots' in the way they are perceived. The following describes some selected relevant steps of analysis, illustrated by a case from my doctoral study on music therapy interactions with children with severe functional limitations, including children with autism (Holck 2002).

Theoretical basis

The ethnographically informed approach to observational analysis focuses on everyday settings, where common sense is held to be complex and sophisticated rather than naive and misguided (Silverman 1993; Wolcott 1990). Observation is chosen instead of interviews

when it is presumed that the participants[1] cannot answer questions on the subject, because the knowledge in question is implicit. The epistemologies of the two methods are in this way essentially different, as observation often gives information about unacknowledged patterns of action, while the interview requires that the participants can express their thoughts on the subject verbally (Kvale 1996; Rasmussen 1997).

Acording to Wolcott, the following question is a good guide to the process of observation: 'What do people in this setting have to know (individually and collectively) in order to do what they are doing?' (1990, p.32). 'Knowledge' includes here implicit knowledge as well as purely procedural experience. In answering this question, the aim of the investigation is to search for the 'practices' of the people being observed (Silverman 1993). 'Practices' are the (often implicit) ways in which people do things together, habits, etc. that are built up gradually through many meetings over time. Therefore the object of ethnographically informed investigations is typically the repeated actions, themes or interaction patterns of everyday situations. Pattern generalisation is one of several qualitative ways of addressing the question of validity (Lincoln and Guba 1985; Silverman 1993), as repeated interactions between people show that these actually are interactions and not arbitrary parallel incidents.

Two related approaches are useful in this connection: culture analysis and interaction analysis. In culture analysis the breaking of patterns (deviations) is explored. After having determined patterns in the material, pronounced deviations from the patterns are searched for (Rasmussen 1997). In music therapy with a child with communicative difficulties, a typical pattern could be:

Therapist (initiative) → Child (weak response or withdrawal)

And an interesting deviation:

Child (initiative, invitation) → Therapist (response)

In interaction analysis, a holistic perspective on communication is applied. This means that words, prosody and gesture in both partners are all involved (Rasmussen 1997), which is only possible to analyse through the use of video recording. Interaction analysis of music therapy interactions thus involves analysis of both music and prosody, as well as gesture, facial expression and bodily movements. When the clients, as here, have weak or arbitrary communication, the micro-perspective is almost unavoidable.

Method

In the following, the steps of the method are shown, as well as the choices made in the process, depending on the level of detail required. The approach utilises a four-stage sequence:

1 The observed are called participants in this research tradition.

Stage 1: Data selection

Stage 2: Transcription

Stage 3: Pattern generalisation – horizontal and vertical analysis

Stage 4: Interpretation.

Stage 1: Data selection

All investigations require precise selection, but because of the time commitment involved this is especially true in the microanalysis of video recordings that often involve frame-by-frame analyses (Holck, Oldfield and Plahl 2005).

In clinical practice it is often more typical that a specific 'problem', as, for example, the lack of response from a client, creates a need to analyse the interaction more closely. We could call this approach the *problem-based analysis approach*. In this case, a series of typical examples of lack of response would be selected (pattern), and possibly also a series of examples where the wished-for response takes place (the breaking of pattern).

Another possibility of data selection is by reviewing sequences of 5–10 minutes' duration, in order to see clearly what actually is happening between the client and therapist. This approach could be called the *open analysis approach*, because here one is interested in all the kinds of interaction patterns ('practices') that the participants have created together. This selection procedure is closest to the ethnographic approach described above.

One camera angle is often sufficient for analysing interaction patterns, but if required one can choose in advance a specific series of sequences to record utilising two camera angles: one facing the child and one the therapist. The two recordings can later be joined into one frame, as shown in Figure 2.1. This method, inspired by infant research, makes it

Figure 2.1: An example of video recordings from two angles (Holck 2002)

possible to compare the child's as well as the therapist's musical and gestural/facial contributions to the interplay.

Stage 2: Transcription

Whether and how to transcribe the material depends on the level on which one wishes to analyse the material. In the problem-based analysis approach, it may be sufficient to transcribe specific sequences at a less detailed level, while in the open analysis approach more detailed transcriptions are necessary, if all the information found in the video material is to be effectively recorded and thereby remembered. The transcription process in itself makes subtle connections visible that would not be seen without it.

The music notation systems (classical or graphical) can record *temporal* occurrences between partners (voices – client/therapist), i.e. succession, relative lengths and, to a certain degree, qualities (*pp, legato* etc.). Just as music does, interactions take place in time, therefore precise recording of succession becomes important (Aldridge 1996).

One way of recording the interactions for further analysis is to start with the classical music notation system and then to add gestural and facial movements over/under the notation line (see Figure 2.2). In sequences with musical pulse, the music is transcribed first, and then gesture and facial expression are noted in relation to the musical notation. In sequences without musical pulse, a time line with seconds (clock time) is drawn first, and music and gesture are placed in relation to the line. The method is very time consuming, and it is a good idea to consider, depending on the reason for the analysis, whether or not a computer-based notation system would be sufficient.

Stage 3: Pattern generalisation – horizontal and vertical analysis

Pattern generalisation is undertaken through horizontal and vertical analyses. In the horizontal analysis the material is analysed parallel to the temporal axis in the material (Aldridge 1996). In relation to the focus of the investigation, the first review of the material will show some 'interesting' chains of interactions. If the material is transcribed the chains can be noted underneath the transcription (by which method the transcription becomes a very explicit working tool). In the vertical analysis the chains of interactions are compared across the material, for the purpose of finding interaction patterns or 'practices' (as discussed above).

Interactions between people will never be exactly the same, so only by moving back and forth through the material is it possible to determine whether or not two interactions are alike. The vertical analysis will always lead to a need to review the material horizontally again, to see whether or not the right interactions are being compared. If doubt still exists, it is the right time in the process to involve others' opinions on the findings.

By repeated horizontal reviews of the material new 'interesting sequences' will usually emerge. These may not have attracted attention at the beginning, but will turn out to be at least as interesting as the more immediately visible patterns. The process of analysis is in this way far from linear and it continues until no new patterns emerge – not even after a break in the analytical work. The result is a continuum going from the pronounced interaction

Figure 2.2: Section of transcription with (playing) movements and facial expressions placed in relation to musical notation

patterns, which are seen by most from the beginning, to the more implicit interaction patterns that require much more work to explicate.

At the same time as the fundamental interaction patterns are determined, or perhaps afterwards, it is important to explore 'special' chains of interaction that put the discovered patterns in perspective (as in the method of culture analysis). Either in the way of a marked deviation from the pattern, for example when a very passive child suddenly takes the initiative spontaneously, or, more subtly, when by closer analysis it becomes apparent that the very passive child actually takes the initiative several times in starting a small interaction that the therapist is barely aware of him/herself. In the case of communicatively weak clients, the last type of sequence is often difficult to see, and a detailed transcription is therefore necessary. At the same time, these sequences can be of significance for the therapeutic process as they often refer to the next step in the child's development, or 'the proximal zone of development' according to Vygotsky (1978).

Stage 4: Interpretation

It is human nature to guess why another person does what he's doing. With Wolcott's focus question 'What do people in this setting have to know in order to do what they are doing?' in mind (Wolcott 1990), guesses and suppositions are reconstructed into descriptions of the 'practices' (here interaction patterns) that the participants have specifically created together in a given context. Established interaction patterns refer in this way to a joint interaction history with built-in expectations that the participants refer to along the way during the on-going interaction. By focusing on 'practices' one can therefore observe signs of expectations – especially in connection with deviations from these. For example, if a child and a music therapist start every session in a certain way (a 'practice'), the built-in expectations of the child will appear in the way he/she reacts if the therapist hesitates or, for example, plays something other than that which was expected. Humour as well as frustration is built upon 'cheating' expectations.

All interpretations of interplay where one partner frequently has an arbitrary form of communication require knowledge of the population in question. In my doctoral study it was relevant to use developmental theory and autism research as a basis for the interpretation of the developmental implications of the analysis results, but the use of clinical theories and research regarding aetiology and pathology of cause depends on the group of clients in focus.

In the analysis process itself, the ideas from the so-called 'negative case analysis' formulated by Lincoln and Guba (1985) can be a great help. The aim of negative case analysis is not to omit data material that contradicts the findings. This means that one reviews all the material (also material that was omitted from closer analysis in the beginning), to see whether there is data that contradicts the results. In a research study the negative case analysis is aimed specifically towards validation of the research results, but in my doctoral study I found the constant comparing of micro-level and the whole very useful in the analysis process itself (Holck 2002).

'Member check' is another validation tool that is often mentioned in connection with qualitative approaches to research (Lincoln and Guba 1985; Robson 2002). Usually a member check is used to ensure that the researcher's transcriptions (of interviews), analyses and interpretations can be recognised by the participants in the research. But when the aim is to reveal 'practices' that are wholly or partly unknown to the participants, it does not make sense to use a member check as a validation tool in its original form.

Logically, member checking is only meaningful for clinicians if, for example, relatives or social workers close to the client take an active part in the therapy, or for students/supervisors/researchers when analysing others' work. In these cases it is recommended to show the video recordings while presenting the analysis or results. Due to the epistemological difference between observation and interviews described in the theoretical basis above, one has to be aware of when knowledge actually can be checked by the participants, and when the participant's comments should be considered as just different perspectives to those found through the analysis.

Case example

The case example is a nine-year-old hyperactive boy with infantile autism and developmental disability. Verbally, his development was assessed to be eight months. The boy had been in individual music therapy for one year when the recordings took place. At the beginning of the therapy it was difficult for him to stay in musical interplay for more than a few seconds, but at the time of the recording he could stay in interplay with the therapist for up to five minutes, particularly at the table drum, which was his favourite instrument (see Figure 2.1).

Stage 1: Data selection

Four music therapy sessions were recorded to ensure against marked mood swings, illness and technical problems. Every session started at the table drum, where a certain small rhythmic motif (𝄆 ♩ ♩ ♫ ♩ 𝄇) played a vital role in the interplay. Although the boy often changed the tempo or his way of playing, for example by moving his fingers across the drumhead etc., each time he returned to the little motif in the original tempo, subsequently defined as an *interaction theme* (Holck 2004). As the interplay at the table drum seemed to be most relevant for analysis, the most typical drum sequence from the four recordings was selected for an 'open analysis' (as described above).

Stage 2: Transcription

Despite the boy's many changes in tempo, the improvisation centred around a 4/4 metre. Therefore, the music was transcribed first. Figure 2.2 shows a 13-second extract of the

interplay, and the boy's and the therapist's play are notated respectively over and under the middle line.[2]

After the music transcription was done, every fifth second was notated at the top of the notation, and finally, the child's playing movements and facial expressions were placed precisely in relation to the musical notation. One of the lines above the musical notation was devoted to the boy's playing movements alone, since his many changes in playing movements seemed important in understanding the interaction between the boy and the therapist. However, only the most pronounced changes in the therapist's playing movements were described. The durations of the visual expressions are designated by a line after the entries (statements). As seen, a very detailed transcription was required for the analysis, since I wanted to compare both musical and gestural/facial expressions from a holistic analysis perspective. In most cases this is not required.

Stage 3: Pattern generalisation – horizontal and vertical analysis

The many tempo changes characterised the interplay, and were therefore a natural starting point for the analysis. A vertical comparison of all interactions with tempo changes showed a pronounced difference in places with ritardando and with accelerando. The difference could also be seen in the therapist's reaction, which is shown in the following summary of interaction patterns:

> *Basic pattern 1*: The boy (plays a ritardando, changes his playing gesture [hand position], leans his head back and/or makes faces, sometimes with shifting eyes) → the therapist (plays a counter-rhythm with both hands, leans forward and/or has a serious or expectant facial expression) → the boy (returns to the rhythmic motif in original tempo)

> *Basic pattern 2*: The boy (plays an accelerando, plays fast, amorphous beats or with large arm movements, plays towards the middle of the drum and/or makes vocal sounds) → the therapist (does visual or auditory imitation, smiles, nods and/or stops for a moment) → the boy (returns to the rhythmic motif in original tempo)

Defining these two basic patterns between the boy and the therapist required many reviews of the material, but not transcription. The following example, illustrated in Table 2.1, however, required very detailed transcription (as seen in Figure 2.2). In the left column of Table 2.1 one can follow the analysis steps, while in the right column the results of the analysis steps are shown.

In short, the results of the analysis gives the following interaction pattern, showing that the therapist's imitation is prompted by the boy's gaze:

2 All transcriptions and analyses can be seen in a Danish version at www.hum.aau.dk/ %7Eholck/ (see: forskning, Pd.d.-afhandling, transk. A, B and C).

Gaze-imitation pattern: The boy (gaze) → the therapist (imitation) … sometimes: → the boy (becomes visibly enthusiastic) → the therapist (smiles)

Table 2.1: A correlation of the process of the analysis with the results

The process of analysis	*The (part-) results of the analysis*
Step 1: In the interplay with the boy, the therapist used several techniques that could all be described as 'imitation'. Some of these imitations were pronounced and had a noticeable duration, while others were subtler and did not become visible until the transcription process. This led to the following pattern:	A: The boy (tilts his head to the side with an open facial expression, changes dynamics or tempo) → B: The therapist (imitates the action auditorily or visually, often smiling slightly)
Step 2: A vertical comparison of all the chains of interaction, where there was a kind of imitation from the therapist, did not give an unequivocal pattern. A negative case analysis showed that some of the actions that the therapist imitated would at other times prompt her to stop playing or become a little insistent. By examining what happened in the chain of interaction *immediately before* the therapist did these imitations, it became clear, however, that the boy's fleeting glances played an important role in the interplay:	A': The boy (glances at the therapist, looks at her face or glances sideways at her hands, while at the same time…) → A: The boy (tilts his head to the side with an open facial expression, changes playing gestures, changes dynamics or tempo) → B: The therapist (imitates the action auditorily or visually, often smiling slightly)
Step 3: Immediately after the therapist's 'imitation', there were, moreover, examples where the boy reacted with increased arousal and attention. A negative case analysis showed that only in these situations did he present clear emotional reactions relevant to the situation. The whole pattern can be summed up as shown in the gaze-imitation pattern opposite.	Gaze-imitation pattern: A'+A: The boy (glances at the therapist, looks at her face or glances sideways at her hands, while at the same time tilts his head to the side with an open facial expression, changes playing gestures, changes dynamics or tempo) → B: The therapist (imitates the action auditorily or visually, often smiling slightly) → C (sometimes): The boy (becomes visibily enthusiastic) → D: The therapist (smiles)

In Figure 2.2, in the bottom line parallel to the transcription, two examples of this interaction pattern are listed. (What provokes the boy's gaze is not possible to reveal with the existing data material.)

Stage 4: Interpretation

The analysis shows that the boy, after each interruption, returns to his small rhythmic motif, played in the original tempo. With equal accuracy one can maintain, then, that he interrupts the flow just as he contributes to the continuation of the interplay afterwards.

Regarding Wolcott's question 'What do people in this setting have to know (individually and collectively) in order to do what they are doing?' the revealed interaction patterns show that the therapist must have experience that tells her she can 'allow' herself to stop playing for a moment, while the boy beats the drum enthusiastically (basic pattern 2), because she knows that he most probably will return to the small rhythmic motif and not, for example, run over to another instrument.

The boy must have experience that tells him that the therapist sometimes stops playing and also that she starts again when he returns to the motif. In his own way, then, this severely autistic boy shows that he wants the therapist to play with him – most of the time!

Generally there are two polarities in the boy's participation in the interplay (Figure 2.3). The therapist's different reactions in the two basic patterns show clearly her understanding of these two polarities. She must then have experienced that, in connection with basic pattern 1, the interplay is 'in danger'.

| The boy seems attentive, excited and participates (socially) to the continuation of the music or interplay | | The boy seems distant, unengaged with the danger of the music stopping or the interplay interrupted |

Figure 2.3: Two polarities in the boy's participation in the interplay

Regarding the gaze-imitation pattern, it is not in itself strange that the therapist often does 'imitations' (visual and auditory) when the boy shows visual attention. The connection is subtler than it seems, because the visual attention takes the form of fleeting and shifting gazes. In the clinical setting it is an important detail, that it is (implicitly) the boy who, with his gaze, prompts the therapist to imitate, so that the imitation is timed in the interplay.

The analysis in itself cannot reveal whether or not the boy actually expects to be imitated, but on the other hand he must have experienced that the therapist often imitates him. Moreover, his enthusiastic reactions after some of her imitations seem to indicate that he enjoys being imitated. The last interpretation corresponds to autism research that has pointed out that imitation increases severely autistic children's social reactions and attention (see Holck 2002, for review).

The member check revealed that the two basic interaction patterns were well known to the therapist. His interruptions of the musical flow (pattern 1) are seen as a latent threat in her

expectations of the interplay with him. The analyses showed her, though, that to a greater degree she could trust that he would actually start again after each interruption.

Generally, the therapist was conscious of her musical and therapeutic tools, while the visual/gestural part of the interplay, for example the gaze-imitation pattern, happened on a much more implicit level. She was, for example, surprised to discover synchronicity in many of her visual imitations (which is a good example of an area of knowledge that a participant cannot check). In addition, the therapist also became aware of making playing gestures more obvious, as the boy's attention was often directed towards her hands.

Retrospectively, the gaze-imitation pattern pointed to the next proximal zone for this boy (Vygotsky 1978), as one year later he was able to participate in turn shifts with the therapist, among other things guided by his visual attention to her hands (see Holck 2004).

Summary

The ethnographically informed approach to observational analysis can be used to explicate implicit interactions. Combined with microanalysis of video material (VHS or DVD), it can make clear the visual part of the music therapy interaction and, in the case of clients with weak communicative skills, the method can reveal weak social or communicative initiatives from the client. In this connection pattern generalisation confirms or rejects interpretations that would seem speculative without such an analysis.

Generally, the method can describe aspects of the music therapy profession's field of operation that are seldom the object of empirical research, as in the boy in this case example who, with his gaze, prompts the therapist to react (imitate), so that the imitation technique ends up being 'in time' in the interplay.

Specifically, the method can give the clinician knowledge about what actually influences the interaction, and whether or not this is desirable. In professional consultation the method can then be used to discover clinical habits (appropriate as well as inappropriate), and also to give a specific direction towards the client's next zone of development.

References

Aldridge, D. (1996) *Music Therapy Research and Practice in Medicine. From Out of the Silence.* London: Jessica Kingsley Publishers.

Holck, U. (2002) *'"Kommunikalsk" Samspil i Musikterapi' ['Commusical' Interplay in Music Therapy]. Qualitative Video Analyses of Musical and Gestural Interactions with Children with Severe Functional Limitations, including Children with Autism.'* Unpublished doctoral study, Aalborg University.

Holck, U. (2004) 'Interaction themes in music therapy – definition and delimitation.' *Nordic Journal of Music Therapy 13,* 1, 3–19.

Holck, U., Oldfield, A. and Plahl, C. (2005) 'Video Microanalysis in Music Therapy Research, a Research Workshop.' In D. Aldridge, J. Fachner and J. Erkkilä (eds) *Many Faces of Music Therapy – Proceedings of the 6th European Music Therapy Congress, June 16–20, 2004, Jyväskylä, Finland.* eBook (PDF) available at *MusicTherapyToday.com 6,* 4 (November 2005).

Kvale, S. (1996) *Interviews. An Introduction to Qualitative Research Interviewing.* London: Sage Publications.

Lincoln, Y.S. and Guba, E.G. (1985) *Naturalistic Inquiry.* London: Sage Publications.

Rasmussen, T.A. (1997) 'Video mellem Samtale og Observation.' In H. Alrø and L. Dirckinck-Holmfeld (eds) *Videoobservation*. Aalborg: Aalborg Universitetsforlag.

Robson, C. (2002) *Real World Research. A Resource for Social Scientists and Practioner-Reseachers,* 2nd edn. Oxford: Blackwell Publishing.

Silverman, D. (1993) *Interpreting Qualitative Data. Methods for Analysing Talk, Text and Interaction.* London: Sage Publications.

Vygotsky, L. (1978) *Mind in Society.* Cambridge, MA: Harvard University Press.

Wolcott, H.F. (1990) *Writing up Qualitative Research. Qualitative Research Methods Series, 20.* London: Sage Publications.

Microanalysis of Preverbal Communication in Music Therapy

Christine Plahl

Introduction

Music is known to have a good potential for initiating emotional and social communication (Blacking 1995, pp.31–53; Papoušek 1996, pp.37–55; Papoušek and Papoušek 1981, pp.163–224). In early childhood musical behaviour supports the development of pragmatic communicative functions like joint attention, emotional signalling and behaviour regulation and thus provides an essential basis for language acquisition. The development of these preverbal communication skills can be supported through a developmentally oriented music therapy like Orff Music Therapy (Orff 1974; Voigt 2003), a model that has been characterized as 'developmental music therapy' (Bruscia 1998). As there is extensive clinical experience in the treatment of children with developmental disorders through Orff Music Therapy (Voigt 2002) an interesting question is if and how it promotes the preverbal development of children with developmental disorders. A clinical intervention study was conducted at the Centre for Social Paediatrics in Munich, Germany, to analyse the process and evaluate the outcome of music therapy treatment (Plahl 2003, pp.46–9). A detailed microanalysis of the music therapist's and the child's communicative contributions allows the assessment of whether the music therapist's intervention leads to the intended treatment effect, the process by which that occurs and to what extent it is effective. Using the method of video microanalysis it is possible to both describe and analyse what works and understand how an intervention succeeds or fails. This chapter will explain the potentials of microanalysis in studying preverbal communicative patterns and developmental processes. After explicating the practical application of microanalysis the results are demonstrated in detail with a case example.

Theoretical basis

The development of preverbal communication takes place in an interpersonal context. In the transactional view of developmental psychology the acting persons and their socio-physical

context are interdependent and mutually defining; neither of them can be understood without the other. Development and change therefore are seen as an interplay of biological, psychological, socio-cultural and physical environmental processes (Altman and Rogoff 1987, pp.7–40). This concerns processes of change in long-term individual development and transformations over such short periods of time as hours or minutes or even seconds – as found through microanalysis. In music therapy transaction takes place in a transforming co-constructed process between child and music therapist (Plahl 2004). As music is a genuine social activity, some even use the term 'musicking' or the verb 'to music' to express the participatory constructions of musical performance (Ruud 2004, pp.11–14).

The transformation context in music therapy consists of both the therapeutic interaction and the structuring musical parameters (i.e. rhythm, sound or form). Therefore the promotion of preverbal development through music therapy is supported by musical parameters as well as by coordinated interactions that are characterized through coherence, synchronicity and reciprocity (Tronick 1989).

Coherence means that the music therapist creates a situation with regularly returning elements and rituals in the musical play with the child. Together with structuring musical parameters like rhythm, melody or musical form, cognitive processes in the child's perception and her/his ability of joint attention are supported. The building of expectations is facilitated and thus promotes the understanding of other persons' actions. The recognition of connections improves her/his ability to control her/his own actions. (The issue of musical form is also relevant in Chapter 9 of this book.)

Synchronicity means that the music therapist provides resonance for the child's actions and affections through a synchronous sound feedback to her/his behaviour and her/his emotional state. This is not only achieved by accompanying the child through a song, but is also supported by the contingent feedback of musical instruments making audible every inner and outer movement of the child. The child is enabled to express her/his self through emotional signalling, strengthening her/his ability for self regulation and self efficacy (a similar concept of synchronicity is used by De Backer and Wigram in their chapter in this book).

Finally, reciprocity means that the music therapist creates a mutual exchange of turn-taking that enables the child through dialogical structured improvisations and interactional play to regulate her/his own behaviour as well as the behaviour of the music therapist. The activating effects of musical sound and the reciprocal structure of question and answer in the musical dialogue motivate the child for intentional communication and social referencing, which represents an effective preverbal medium for behavioural regulation.

Method

The method of microanalysis proposed in this chapter is based on the findings from a clinical intervention study conducted in the Centre for Social Paediatrics in Munich, Germany. The development of preverbal communication in children with multiple developmental disorders (n = 12; aged from 2 years 4 months to 5 years 8 months) was analysed and

evaluated before, during and after a music therapy treatment. There was a focus both on the outcome (effect) and on the process (efficacy) of the music therapy treatment. From each child ten music therapy sessions (duration 30 minutes) were videotaped. The research design was a reversal design with five music therapy sessions followed by an interval of three to four months free of music therapy, after which a second series of five music therapy sessions was undertaken. Sessions were undertaken daily while the children stayed with their parents at a parent–child ward. Besides the music therapy treatment the children included in this study only received physiotherapy in the clinic.

A detailed microanalysis of the music therapy videotapes was carried out to assess quantitative (frequency and percentage) and qualitative (sequence and contingency) parameters of preverbal communication abilities. This chapter describes in detail the process of applying the method of microanalysis, from the construction of the category system to the final statistical or visual analysis of different parameters on a micro level. The following list shows the succession of five essential steps in applying the method of microanalysis.

Step 1: Constructing the category system

Step 2: Defining and selecting the sample of sequences (time sampling, event sampling)

Step 3: Choosing the program of analysis and the technique of coding

Step 4: Training application of category system and assessing reliability (inter-, intrarater)

Step 5: Analysing different parameters on a micro level (frames, seconds, minutes)

Step 1: Constructing the category system

The first step for the application of microanalysis consists in constructing a category system for the analysis of behaviour. A category system is usually hierarchically constructed with different categories for distinct behaviour modalities, related codes for each category and detailed rules for coding a specific behaviour. The most difficult challenge in coding the behaviour of children with multiple developmental disorders is that the code descriptions of the category system have to be wide enough to capture their capacities as well as their often multiple idiosyncrasies. Therefore, in constructing the category system for music therapy KAMUTHE (KAtegoriensystem MUsikTHErapie), I took into account the findings of Towle, Farran and Comfort (1988, pp.293–330), who give an overview on parent-handicapped child interaction observational coding systems that are customized for the observation of children with multiple handicaps. Starting with their findings the music therapy videos of several children who were not included in the study were viewed. These children had a variety of different forms and intensities of developmental disorders, resulting in different motor abilities, divergent reaction times and different repertoires of behaviour. Relating to psychological concepts of interaction and transaction, formal criteria in constructing the category system were:

- possible interaction units and their possible functions in the music therapy process
- patterns of reference and regulation in music therapy and their dimensions in time.

The theoretical frame for the construction of the category system stemmed from the communicative modalities of the concept of music in Orff Music Therapy (Orff 1974; Voigt 2001, pp.242–62) – relating to the ancient concept of *musiké* – comprising word, sound and movement as verbal, musical and nonverbal modalities (see also the chapter by Scholtz *et al.* in this book). All musical activities in this sense have been defined as communicative activities comprising each kind of sound expression through voice or instrument or movement expression. To observe relevant preverbal communication modalities of the child the categories have to consist of gaze, gestures, vocalisations and musical or play activity. The categories of the music therapist relate to her/his musical, verbal and nonverbal behaviour. These categories proved to be quite economic for analysing preverbal communication; however, they can be modified in order to answer different clinical or research questions, for example through adding the category of gaze to the music therapist. In developing the different codes of the categories two requirements had to be fulfilled:

1. All codes had to be mutually exclusive, which means that only one coding can be associated with one event.

2. All coding had to be exhaustive, which means that each event is represented by one specific coding.

Table 3.1 shows all categories and codes of KAMUTHE (Plahl 2000) for the music therapist, and Table 3.2 those for the child.

Table 3.1: Communication categories of the music therapist

Musical behaviour	Verbal behaviour	Nonverbal behaviour
MUS>1	VER>1	NON>1
Vocalizing	Verbal comment	Gesturing
MUS>2	VER>2	NON>2
Playing on instruments	Praising the child	Offering an instrument
MUS>3	VER>3	NON>3
Singing a song	Asking the child	Moving an instrument
MUS>4	VER>4	NON>4
Singing a song and accompanying on instrument	Inviting the child	Moving the child

Table 3.2: Communication categories of the child

Gaze	Play/musical activity	Vocalizations	Gestures
BLI>1	SPI>1	VOK>1	GES>1
Gazes at instrument	Touching an instrument	Vocalizing	Conventional gesture
BLI>2	SPI>2	VOK>2	GES>2
Gazes at therapist's face	Creating sound with an instrument	Singing	Unconventional gesture
BLI>3	SPI>3	VOK>3	
Gazes at an object	Playing with objects	Talking	
BLI>4	SPI>4	VOK>4	
Gazes at therapist	Moving instruments on arms (e.g. bells)	Laughing	
BLI>5	SPI>5	VOK>5	
Gazes at mother/father	Moving rhythmically	Moaning	
BLI>6	SPI>6	VOK>6	
Gaze around the room	Guided by therapist in moving	Crying	

Step 2: Defining and selecting the sample of sequences (time sampling, event sampling)

The second step in the application of microanalysis consists of defining and selecting the relevant sequences and events in the music therapy session. In the study in total there was video material of 300 minutes for each child. As it was too time consuming and too expensive to analyse the complete material, the material had to be systematically reduced: either time samples or event samples had to be taken. This also applies in everyday clinical work. The decision for time sampling or event sampling is led by the focus of the question to be answered. As the aim in the study was to evaluate the general developmental effect of music therapy on preverbal communication it was necessary to select the sequences for the microanalysis randomly, without looking for specific events in the music therapy sessions. Thus time samples were chosen comprising the first five minutes of every music therapy session beginning after the music therapist had finished her hello-song (mostly minutes 1–6), and the last five minutes of each session ending before the music therapist sings her farewell-song (mostly minutes 24–29). These time samples represent ten minutes of each music therapy session where the children were familiarized with the setting after the musical welcoming and not yet settled down before the farewell ritual. This resulted in a total of 100 minutes' video material for microanalysis from each child (20 music therapy sequences of

five minutes' duration). In comparing the beginning and the end of each session it was possible to analyse changes taking place during one music therapy session.

Step 3: Choosing the program of analysis and the technique of coding

Step three in the application of microanalysis is the choice of a specific computer program for analysing and the decisions on how to code the events on a mechanical level. We used the software INTERACT® (Mangold 2006), a program especially designed for behaviour analysis that allows conducting a microanalysis on the basis of video frames. For coding we chose the technique of continuous event coding which allows analysing the complete stream of behaviour by marking the beginning and the end of different events. For the person undertaking the analysis, this technique requires concentrating on four different actions simultaneously:

1. Relevant events in the continuous stream of behaviour have to be discovered.

2. The stream of behaviour has to be cut into several distinct events (the different codes).

3. The duration of each behaviour has to be marked (designating the beginning and the end by pressing a key on the computer keyboard as long as the event is going on).

4. Each behaviour has to be labelled with the relevant code from the category system (press the correct key on the computer keyboard).

This technique requires a certain amount of training in application (see Step 4) but it allows the analysis of even very short events and – most important – the technique of continuous event coding is the essential condition for analysing contingencies in behaviour.

Step 4: Training application of category system and assessing reliability (inter-, intrarater)

In step four the people undertaking the coding have to perform an intensive coding training and learn to apply the category system in a consistent way both over time (intrarater-reliability) and when comparing their analysis to others' coding (interrater-reliability). Divergent coding decisions are discussed until a consensus on the correct coding can be found, so the rules of coding sometimes have to be expanded to be more specific. After the coding training interrater-reliability and intrarater-reliability are assessed for each category of the system by means of correlational statistical tests (Cohen's Kappa, Pearson's R and the simple matching coefficient) based on single video frames. The video material for the reliability assessment consisted of randomly chosen video sequences from different children. As the obtained scores of reliability were sufficiently high to assure consistency between different coders as well as stability over time in each individual coder, the category system KAMUTHE can be viewed as a sufficiently exact instrument.

Step 5: Analysing different parameters on a micro level (frames, seconds, minutes)

Finally, step five is the analysis of the coded sequences on a micro level of video frames, seconds or minutes. As both the behaviour of the child and the behaviour of the music therapist have been coded with the technique of continuous real time event coding, the different communicative modalities (gaze, gesture, vocalizations, musical play) can be presented as bars in a graph indicating the beginning and the end of all events in all sequences. In combining all coded categories a specific pattern of interaction between child and music therapist emerges. The so-called 'interaction graph' of the video microanalysis reveals the musical, verbal and nonverbal behaviour of the music therapist as well as the gaze pattern of the child, her/his musical activities and her/his gestures. Figure 3.1 provides an example for such an interaction pattern in a music therapy sequence.

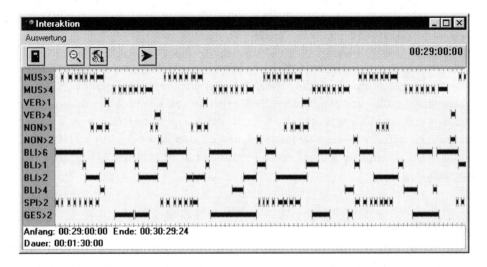

Figure 3.1: Interaction graph showing interaction patterns in a music therapy improvisation

On the y-axis the different codes of music therapist (MUS>3, MUS>4, VER>1, VER>4, NON>1, NON>2) and child (BLI>6, BLI>1, BLI>2, BLI>4, SPI>2, GES>2) – as explicated in Tables 3.1 and 3.2 – are listed. The x-axis is a time scale (here: 1 minute and 30 seconds). The lines represent the exact durations of events in the relevant codes.

Now the preverbal communicative competences of the child and the resulting communicative patterns in the interaction of child and music therapist can be analysed in a very detailed way. This includes the following important microanalyses (among other possibilities):

- The microanalysis of joint attention through the gaze pattern of the child in relation to the musical activities.

- The microanalysis of emotional signalling through vocalizations, gestures and musical play activities of the child.

- The microanalysis of the child's ability of behaviour regulation through intentional communication and social referencing in dialogical turn taking.

The interesting parameters of preverbal communication can be analysed both quantitatively (for example, frequency or percentage) and qualitatively (for example, sequences or contingencies).

This kind of microanalysis reveals not only the outcome and the change that has taken place during a certain music therapy session, but also allows one to examine exactly how the communicative exchange between music therapist and client takes place in the process of the music therapy treatment. Therefore the most interesting feature of microanalysis is to evaluate developmental processes on a micro level on the empirical basis of one music therapy session, to reveal how qualitative and quantitative improvements in the child's preverbal communicative abilities are facilitated through music therapy. The interaction graphs of the microanalysis can be visually analysed for patterns of coherence, synchronicity and reciprocity as defined in the theoretical section in this chapter. For example, Figure 3.1 shows how the music therapist is synchronizing with the child's play on the instrument (SPI>2) through her own singing (MUS>3); how she is creating a coherent frame through her conventional gesture of nodding (NON>1), her unconventional gesture (NON>2) at the beginning and her verbal comment (VER>1) at the end of the child's musical activity; and how she is establishing reciprocity through the dialogical turn taking by singing and accompanying herself on the guitar (MUS>4) in the pauses of the child's play (SPI>2). Last but not least, descriptive and inferential statistics can be applied to the data of the microanalysis.

Case example

The following case example of a five-year-old boy named T (chronological age at the first music therapy period: 4 years 10 months; at the second music therapy period: 5 years 2 months) demonstrates from one music therapy session how the method of microanalysis can be used for both understanding and evaluating the promotion of preverbal communication through music therapy. The boy received a diagnosis of childhood autism and mental retardation (ICD-10: F84 [World Health Organization 1993]). His developmental age was 20 months. According to the ICD-10 criteria for the diagnosis of pervasive developmental disorders as childhood autism there are specific deficits in preverbal communicative and social interaction abilities especially in communicative expression and in relating to other people. In their empirical studies Mundy, Sigman and Kasari (1990, 1994) report deficits of autistic children in the area of declarative preverbal communication in the form of reduced joint attention and less social referencing, which results in severe deficits in their social-emotional and social-cognitive development, such as using less imperative gestures and having difficulties in turn taking.

Meanwhile it is proven that music therapy in general is meeting the challenges of evidence-based practice as a treatment for Autistic Spectrum Disorder (Gold, Wigram and Elefant 2006; Wigram and Gold 2006). Clinical experience of Orff Music Therapy has also

revealed over many years of clinical practice that the preverbal communicative abilities of children with autism can be promoted successfully (Voigt 1999). So the aim of the microanalysis was to demonstrate how Orff Music Therapy is able to promote the development of T's preverbal communication abilities. The music therapy treatment was given by Dr Melanie Voigt.

The data material for microanalysis shown here consists of the first five minutes (0:30–5:30) of T's ninth music therapy session. The microanalysis is taken on the basis of video frames and comprises both quantitative and qualitative parameters. The evaluation of preverbal communicative abilities comprises joint attention, emotional signalling and behaviour regulation. Figure 3.2 shows the interaction pattern of a sequence from the first five minutes from T's ninth session.

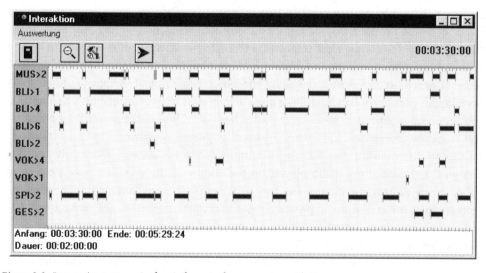

Figure 3.2: Interaction patterns in the ninth music therapy session with T

The bars of the categories BLI>1 (gazes at the instrument), BLI>4 (gazes at the therapist), BLI>6 (gazes around the room) and BLI>2 (gazes at the therapist's face) allow us to analyse T's attention behaviour. In the course of the sequence he obviously shows changes in focusing his attention both on his own activity and on the activity of the music therapist, which means that he succeeds only for a certain period of time in demonstrating joint attention. At the beginning he is directing his gaze several times around the room (BLI>6), especially after he had looked directly into the face of the music therapist (BLI>2) or after he had looked to the hands of the music therapist on the piano (BLI>4). In the course of the first minute the distances between his gazes away from the activity get longer until they disappear completely in the second minute. At the same time T succeeds in regularly focusing his attention on the hands of the music therapist (BLI>4) while she is playing on the piano. This clearly demonstrates his ability for joint attention. However, the end of the sequence shows that his joined and focused attention gets distracted again as he is directing his gaze for

longer periods around the room (BLI>6), interrupted only by one short gaze to the music therapist's hands (BLI>4) at the end of the sequence.

A similar pattern of attention behaviour can be seen concerning his own play on the piano (SPI>2). At the beginning of the sequence his gaze onto his own playing hands on the piano (BLI>1) is frequently interrupted by gazes to the music therapist (BLI>2, BLI>4) and around the room (BLI>6). In the middle of the sequence he succeeds in regularly focusing his attention on his own activity while he is playing on the piano. At the end of the sequence, however, he is mostly looking around the room again during his play.

Interestingly the part of concentrated play with joint and focused attention is accompanied by emotional expressions of humour, two at the beginning of this period and two at the end of this period (VOK>4, laughing). Furthermore, at this point in the sequence T expresses his emotion through a vocalization (VOK>1) and through two unconventional gestures (GES>2) by putting one hand on his ear.

Concerning the preverbal modalities of behaviour regulation, Figure 3.2 shows that at the beginning of the sequence T is mostly reacting to the activities of the music therapist as he is looking at her hands (BLI>4) during and after her play. In the course of the sequence however he is more and more anticipating and expecting the music therapist's answer and is directing his gaze to her hands (BLI>4) immediately after he had finished his own contribution and the music therapist had not yet started her own. This kind of preverbal communication is clearly intentional and related to another person, which means he addresses his musical contribution on the piano to her and expects her answer. Obviously the clear dialogical structure of the piano playing in the middle of the sequence is supporting his ability of intentional communication and social reference. His communicative preverbal expressions at the end of the sequence are not that clearly related to the music therapist – with some seconds of retardation they are only followed by a short gaze to the music therapist's hands on the piano (BLI>4).

The descriptive statistical analysis shows that T improved his ability of joint attention in the course of one session as in the first period his gazes to the music therapist rose from a mean frequency of 19 in the first five minutes to a mean frequency of 25 in the last five minutes of a session. In the second period his gazes to the music therapist rose from a mean frequency of 23 in the first five minutes to a mean frequency of 38 in the last five minutes of a session. Both the comparison of the beginning and the end of the music therapy sessions (mean frequency of 22 at the beginning; mean frequency of 30 at the end) and the comparison of the two treatment periods (mean frequency of 21 in the first treatment period to mean frequency of 31 in the second treatment period) reveal a clear increase in the ability of joint attention.

T also improved his amount of emotional signalling in the course of the whole music therapy treatment as his vocalizations rose from a mean frequency of 14 in the first five minutes of both periods to a mean frequency of 24 vocalizations in the last five minutes of the sessions in both periods. In correspondence with the empirical findings of Mundy *et al.* (1994) T showed more conventional gestures in the course of all sessions and in the course of the whole treatment (from the mean frequency of 0.3 in the first period to the mean frequency of 0.7 in the last period).

The most important finding, however, is the increasing percentage of intentional preverbal communication. Intentional communicative acts are all communicative activities on musical instruments that are followed by a gaze to the music therapist, thus signalling communicative reference after a communicative contribution. They were related to all communicative acts of the child and thus presented in percentages. T's percentage of intentional communication clearly increases from the beginning to the end of the music therapy sessions: in the first period from the mean percentage of 29 per cent intentional communicative acts in the first five minutes to the mean percentage of 33 per cent intentional communicative acts in the last five minutes. In the second period it increases from the mean percentage of 33 per cent intentional communicative acts in the first five minutes to the mean percentage of 42 per cent intentional communicative acts in the last five minutes.

A still more detailed visual analysis of reciprocities reveals the elements of a musical dialogue. The improvisation from the case example on the web-based resources illustrates the musical score of this episode (A3.1). The communication pattern of this sequence clearly demonstrates a dialogical structure that is characterized by reciprocal turn taking (SPI>2, MUS>2). Well-tuned musical contributions are shaped both by the own preceding contribution and the contribution of the partner. The music therapist – representing the stave in the treble clef – succeeded in creating a balanced responsive relationship with the boy – representing the stave in the bass clef. In music T reached a level of communicative exchange that he could not reach in verbal communication, as he usually did not speak.

The case example demonstrates how relevant dimensions of preverbal communication can be described and evaluated through the method of microanalysis. Both in clinical practice and in research a variety of micro-developmental processes can be analysed in such a way.

Summary

The method of microanalysis is able to give instructive answers for clinicians as well as for researchers: it describes how (efficacy) and assesses to what extent (effectiveness) music therapy supports the development of preverbal communication, not only in early intervention. The details of the video microanalysis clarify the transactional processes of development. The responding structure in the communicative behaviour of the music therapist – in accompanying and answering the child – creates a promoting frame and reinforces the child through synchronized resonance. In a case example the detailed analysis of a five-year-old boy with early childhood autism reveals communication patterns with increasing frequencies of communicative activities, an increasing percentage of intentional communication and a developing dialogical structure in music. Interaction graphs demonstrate how these patterns are established in the music therapy session. Statistical analyses of microanalysis data show improvements in his joint attention, in his emotional signalling and in his behaviour regulation. In everyday clinical practice it is possible to apply the method of microanalysis in a more economic way through focusing on only a few crucial parameters and through limiting the video material in relation to the interesting question. This reduces

both the amount of time for constructing a category system (Step 1) and for selecting relevant sequences and events (Step 2). For example, by using a fixed time sampling from the beginning, the middle and the end of a session or an event sampling with predefined specific events of a session. The coding procedure (Step 3) can be simplified through concentration on only few relevant behaviour aspects. Moreover, once a fitting category system is constructed it can be applied for many cases. However, it is always necessary that the coding is done in a consistent way (Step 4) as this determines the quality of the category system as a sufficiently exact instrument. Finally the analysis of the coded sequences (Step 5) can be undertaken in a more economic way on the micro level of seconds or minutes than on the level of video frames. Thus the results of the microanalysis can be used both for evaluating the clinical process and for assessing the treatment success in music therapy.

References

Altman, I. and Rogoff, B. (1987) 'World Views in Psychology: "Trait, Interactional, Organismic, and Transactional Perspectives."' In D. Stokols and I. Altman (eds) *Handbook of Environmental Psychology, Vol. 1.* New York: Wiley.

Blacking, J. (1995) 'Expressing Human Experience through Music.' In R. Byron (ed.) *Music, Culture, and Experience. Selected Papers of John Blacking.* Chicago: University of Chicago Press.

Bruscia, K. (1998) *Defining Music Therapy,* 2nd edn. Gilsum, NH: Barcelona Publishers.

Gold, C., Wigram, T. and Elefant, C. (2006) 'Music Therapy for Autistic Spectrum Disorder.' *Cochrane Database Systematic Review: CD004381.*

Mangold, P. (2006) *INTERACT®. Version 7. Programm zur Analyse von Beobachtungsdaten.* Munich: Mangold Software Development.

Mundy, P., Sigman, M. and Kasari, C. (1990) 'A longitudinal study of joint attention and language development in autistic children.' *Journal of Autism and Developmental Disorders 20,* 115–28.

Mundy, P., Sigman, M. and Kasari, C. (1994) 'Joint attention, developmental level, and symptom presentation in autism.' *Development and Psychopathology 6,* 389–401.

Orff, G. (1974) *Die Orff-Musiktherapie. Aktive Förderung der Entwicklung des Kindes.* Munich: Kindler.

Papoušek, H. (1996) 'Musicality in Infancy Research: Biological and Cultural Origins of Early Musicality.' In I. Deliege and J. Svoboda (eds) *Musical Beginnings, Origins and Development of Musical Competence.* Oxford: Oxford University Press.

Papoušek, M. and Papoušek, H. (1981) 'Musical Elements in the Infant's Vocalisation: Their Significance for Communication, Cognition and Creativity.' In L.P. Lipsitt (ed.) *Advances in Infancy Research, Vol. 1.* Norwood, NJ: Ablex Publishing.

Plahl, C. (2000) *Entwicklung fördern durch Musik. Evaluation musiktherapeutischer Behandlung.* Münster: Waxmann.

Plahl, C. (2003) 'Fostering the Development of Social-emotional Communication through Music.' In R. Kopiez, A.C. Lehmann, I. Wolther and C. Wolf (eds) *Proceedings on CD-ROM of the 5th Triennial Conference of the European Society for the Cognitive Sciences of Music (ESCOM).* Hanover: University of Music and Drama.

Plahl, C. (2004) 'Transactional theory on an empirical ground. Dimensions of relation in music therapy.' *Music Therapy Today* (online), vol. V, Issue 4. Accessed on 10/10/2004 at http://musictherapyworld.net.

Ruud, E. (2004) 'Foreword: Reclaiming Music.' In M. Pavlicevic and G. Ansdell (eds) *Community Music Therapy.* London: Jessica Kingsley Publishers.

Towle, P., Farran, D. and Comfort, M. (1988) 'Parent–Handicapped Child Interaction Observational Coding Systems: A Review.' In K. Marfo (ed.) *Parent–Child Interaction and Developmental Disabilities. Theory, Research, and Intervention.* New York: Praeger.

Tronick, E.Z. (1989) 'Emotions and emotional communication in infants.' *American Psychologist 44,* 2, 112–19.

Voigt, M. (1999) 'Orff Music Therapy with Multi-handicapped Children.' In T. Wigram and J. De Backer (eds) *Clinical Applications of Music Therapy: Developmental Disability, Paediatrics and Neurology.* London: Jessica Kingsley Publishers.

Voigt, M. (2001) 'Musiktherapie nach Gertrud Orff.' In H.H. Decker-Voigt (ed.) *Schulen der Musiktherapie.* Munich and Basle: Ernst Reinhardt.

Voigt, M. (2002) 'Promoting Parent–Child Interaction through Orff Music Therapy.' In D. Aldridge and J. Fachner (eds) *Info CD-ROM IV, Conference – Music Therapy in Europe* (1,012–1,029). Witten-Herdecke: University of Witten-Herdecke.

Voigt, M. (2003) 'Orff Music Therapy – An Overview.' *Voices: A World Forum for Music Therapy.* Accessed on 11/2/03 at http://www.voices.no/mainissues/mi40003000129.html.

Wigram, T. and Gold, C. (2006) 'Music therapy in the assessment and treatment of autistic spectrum disorder: clinical application and research evidence. *Child: Care, Health and Development 32,* 535–42.

World Health Organization (1993) *ICD-10. Classification of Mental and Behavioural Disorders.* Geneva: WHO.

Chapter 4

Microanalysis on Selected Video Clips with Focus on Communicative Response in Music Therapy

Hanne Mette Ridder

Introduction

This chapter describes a five-step procedure for video analysis where the topic of investigation is the communicative response of clients in music therapy. In this microanalysis procedure only very short video clips are used, and in order to select these clips an overview of each music therapy session is obtained with the help of a *session-graph* that is a systematic way of collecting video observations from one music therapy session and combining the data in one figure.

The systematic procedures do not demand sophisticated computer equipment, only standard program such as Excel and a media player. They are based on individual music therapy work with a population that is difficult to engage in joint activities and that shows little response (e.g. persons suffering from severe dementia).

The video analysis tools might be relevant to other groups of clients where it is important to form a clear picture of what happens in the therapy, so that other professionals, peers or the therapist him/herself is able to form an understanding of the therapeutic processes, and the clinician is able to document changes or responses.

Theoretical basis

Video/DVD is a strong medium, and with even very short clips it is possible to provide very rich information about details in a music therapy session. Professionals who do not know anything about music therapy are, in a short time, told a story about the music therapy approach and are not only able to see the method, but also reactions, responses, communication processes, structures, techniques and certain aspects of the context, etc.

The video/DVD medium does not only tell a 'truth' about what is going on, it is also a powerful medium that can be used to manipulate and twist the truth. To avoid a misleading use of a medium where we can get such rich knowledge, the procedures described in this chapter seek to ensure that information or data is collected systematically, sceptically and also ethically, and is employed as an important descriptive and explanatory tool (see Robson 2002, p.18). In qualitative research we have descriptive and explanatory purposes as corner-stones, as well as exploratory purposes (see Marshall and Rossman 1995, p.41), and in the analysis method described here focus is on an exploratory purpose. In the first part video material is used to give an overview of a music therapy session by systemizing descriptive data in session-graphs. In this form it might also function as a primary entrance to further analyses and explanatory purposes in research. In the second part video material forms the basis for microanalysis of very short sequences. These are used with exploratory purposes to use in the clinical practice, and maybe with the goal to answer posed research questions. Video analyses can be very time consuming and might result in a large amount of data. This analysing process is formulated with the purpose to reduce data in a systematic way with a clear focus on observations and relevant/delimited reflections. The method has been thoroughly formulated, tried out and discussed in doctoral and postdoctoral studies, but is not regarded as a definitive and fixed method (see Ridder 2003, 2005; Ridder, Ottesen and Wigram 2006).

The following five steps in the microanalysis will be presented:

Step 1: digital recording of music therapy session

Step 2: session-graph

Step 3: selection of short video clips

Step 4: microanalysis of video clip

Step 5: conclusion.

A *session-graph* (Step 2) offers a valuable overview of a music therapy session. It shows the structure of the session, and how engaged the client seems to be. After a session the therapist might have a feeling that the client slept or had her eyes closed during most of the time. With the help of the session-graph the therapist might get a more realistic picture of how long the person actually slept, or realize that the person in fact sat down for a very long time (if 'sitting down' is a behaviour that is observed), although it *seemed* that the person walked about for most of the session. When the therapist sees that there are no pauses between the songs he or she might realize that maybe he or she was too hectic, not allowing a break in between. Or she might realize a pattern that reveals an increase in engagement as the session advances.

The leading thought in the *microanalysis procedure* (Step 4) is to make a clear distinction between descriptions and observations on the one hand, and subjective reflections and interpretations on the other. This distinction is reflected in the procedure. The subjective reflections are seen as very important, but only if they are clearly connected to precise descriptions of what happens. A similar distinction between observation, experience and interpretation is

implied in a model for feedback in the supervision process developed in communication theory at Aalborg University (Alrø and Christensen 1998).

Method

Step 1: Digital recording of music therapy session

The video data from each session are recorded with a digital video camera (or directly on the laptop with a web cam). If the client moves a lot in the room a cameraman is needed, or more cameras that record from different angles. It is less disturbing if the camera is fixed to the wall or on a tripod and points in the direction of the client (it may soon be possible to obtain cameras with sensors automatically adjusting the position of the camera). Check that there is enough light and avoid backlighting, and that the camera registers time.

The recording of the whole session is saved on the computer hard disk as a movie clip of medium quality and is later burned onto a CD or DVD. When the clip is analysed later it might perform best when it is copied directly onto the hard disk of the computer. The clip can be opened with media players such as Windows Media Player. For ethical reasons consents to recording and using video material are needed.

Step 2: Session-graph

A session-graph is a two axis graph that combines multiple graphical plots and bar-charts (see Figure 4.2). In the session-graph important data is registered in a systematic way that gives a clear overview. As each client in music therapy is different the session-graph is flexible and makes it possible to focus on specific events or responses as well as general issues. The data from the music therapy session is reduced to a minimum in order to create an overview, and the procedure of plotting data is based on video recordings with fixed registration of time.

The session graphs combine the following data with a timescale:

- physiological data (e.g. heart rate)

- when the music starts and stops (e.g. when the therapist sings)

- different responses of the client (e.g. when the client joins in singing, taps the beat, walks out of the room, sleeps, sits down, sobs, shows an orientation towards the therapist, verbalizes, etc.)

- a pointing out of specific sequences that will be included in further analyses.

When the data from the video material is plotted in the Excel spreadsheet the best solution is to have two screens connected to the computer, but it also works to have both video and the file for analysis on one screen. Working on the computer with the video material makes it easy to orientate yourself on the timescale and to watch small sequences repeatedly or in very small sections. When the music therapist looks through the video recording, he or she at the same time (using the pause button) plots in his or her observations into the spreadsheet. In

the web-based resources there is an Excel file (A4.1) in which you can plot your data to automatically produce a session-graph.

The combination of heart rate data and observations might give very important information. One way of registering heart rate is the use of monitors designed for sports (see for example the Polar website, www.polar.fi). These allow measurements of ECG signals from the chest but, in order to work with the data, the music therapist also needs computer interface and software. If these measurements are too complicated to include in daily clinical practice, the session-graph in Excel file A4.2 in the web-based resources is simplified and might be easier to access.

HOW TO PLOT THE SESSION-GRAPH

Column B, C, D (Figure 4.1): If you use a heart rate registering system that registers the heart rate (bpm: beats per minute) every five seconds this needs to be transformed to a one-second scale. Copy your heart rate data from the five-second scale into column C. In column D this will now appear as a modified one-second scale, and will automatically appear in column G.

Column F: Here is a timescale starting from zero and lasting 40 minutes. Going down the scale you can register events or responses that happened every second during the music therapy session. If you want a timescale that includes the exact time, delete the timescale and input your precise start time, e.g. 10:05:05. In the cell below you write 10:5:06 and use the 'draw down function': mark both numbers with the mouse, and you will see a black frame around the cells. Point the mouse at the small square at the lower-right corner, click, and then 'draw down'. Continue 'drawing down' until the time point where the session ends.

Column G: If your heart rate data is already in a one-second scale, copy it directly to column D.

If you have physiological data other than heart rate, include it in this column and transform it to a comparable value on the y-axis. Data registered in column F is seen in the session-graph as a thin line. When you change the title in G1, this will automatically appear in the figure.

Column H: Therapist makes music. In this column register, for example, when the therapist turns on music, sings to the client or starts improvising. If the therapist sings a hello-song in the time span from 00:00:05 to 00:00:49 the HR data from column D in exactly this time span is copied (Ctrl + C) to the same time span in column H (Ctrl + V). This data is registered on the session-graph as a filled-out square that follows the HR data.

Column I: The client makes music. You could note here when the client starts playing music or joins in the songs that the therapist sings. You name the column after the response you register in cell i1. This data is registered on the session-graph the same way as the music in column H, but in the colour pink (see web resources).

Column J: Here you can register other responses, e.g. when the client taps the beat with his or her foot or hand. As a standard you write the number 30 in the time span when this response

occurs, but you can change this value if you want to add other information. Use the 'draw down' function when you write the number.

Columns K and L: You could eventually add more responses, e.g. that the client closes his or her eyes or verbalizes.

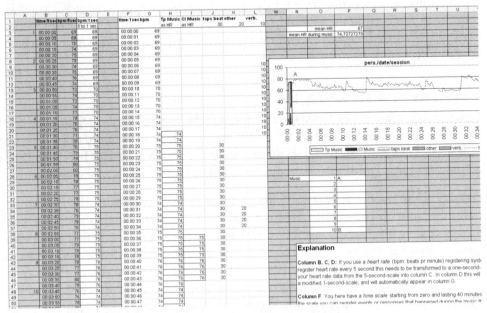

Figure 4.1: How to plot the session-graph in an Excel spreadsheet (screen shot)

Addition of verbal response: when the client verbalizes (and the therapist responds) it is possible to write what they say (e.g. in column M) in connection with the timescale. It is also possible to note the therapist's comments. These comments do not figure in the session-graph, but if the therapist later needs further information it is possible to use the search function in the spreadsheet and see the comments connected with other information about what happens in the session.

Step 3: Selection of short video clips

With the graphical overview of each music therapy session the therapist has a systematic reduction of relevant and selected information from the therapy. This might be helpful in the next step where small video sequences are chosen for further analysis. As a strong reduction of the video data material, the criteria for this selection must be listed as they provide focus for further analysis and pin down clips that show pivotal moments, events where the client responds emotionally, events where the client is involved in turn-taking, or episodes where the therapist uses a certain technique. The following criteria could inform the selection of short video clips:

- In order to permit the analysis of video material to be as thorough and detailed as possible, the number and length of video clips is limited to include only the most relevant clips. For a person who has participated in a long-term music therapy course (more than 15 sessions), the maximum number of clips will be 4–7, all together not exceeding five minutes.

- Each clip is selected by the music therapist, who has important background knowledge about the music therapy course as a whole.

- Each clip shows events that illustrate the client's response in the music, provided that such responses occur.

- The small number of clips from each session will, as a whole, give an expression of the music therapy course of treatment, therefore clips are selected to represent:
 - different categories of music/songs
 - different therapeutic techniques
 - the different phases of the course as a whole
 - a variation in types of response (e.g. response to well known/improvised songs), melody/lyric/phrasing/tempo, as well as emotional and interpersonal aspects.

Step 4: Microanalysis of video clip

It is important to clarify who is carrying out the microanalysis. In clinical practice it might be the music therapist him- or herself; in research it might be an external analyst. If an external analyst is chosen it is essential to make clear which background the analyst has for carrying out the procedure. It should be made explicit whether the analyst is a layman, a professional, a trained professional with specific knowledge about the client group or about music therapy, an 'expert' with regard to the client group and music therapy, contact-staff with specific knowledge about the client, or a relative with specific knowledge about the client's former life.

The analyst must have access to a computer with potential for upgrading in order to work with the digital video material. The analyst receives a CD-ROM/DVD with the material and must, for ethical reasons, delete the data after the end of the analysis, as it constitutes clinical records and should not be held by unauthorized persons. It should be made clear exactly what information the analyst receives about the client and about the music therapy before the analysis is carried out. One solution could be not to inform the analyst about the individual at all, only in general terms about the client-group.

The analyst might have four to seven clips of each client to view. Here the process of viewing and analysing just one clip is described. The analyst is asked to carefully follow each of the following steps, one at a time, in the video analysis procedure.

STEP 4.1: FIRST GENERAL IMPRESSION

The analyst views the whole clip (which typically lasts 30–60 seconds) in full without taking notes.

STEP 4.2: OBSERVATION

The short clip is now cut into even smaller sections. The analyst stops the video as soon as he or she has observed a meaningful event. An event is defined as 'an occurrence, a phenomenon, a slice of reality, indeed anything that happens that has a beginning and an end and can be specified in terms of change' (Reber 1995, p.264). If the analyst is to note as many relevant details as possible, he or she needs to stop the video and write down exactly what he or she observes. The analyst is free to watch the clip as many times as needed. The notes are written in the special form illustrated in Table 4.1 (see A4.3 in the web-based resources).

Table 4.1: Analysis form

Column A	Column B	Column C
Sequence 1	Sequence 1	
Sequence 2	Sequence 2	
Sequence 3	Sequence 3	
Sequence 4	Sequence 4	
Sequence 5	Sequence 5	

In column A of the analysis form the analyst writes what he or she observes. This includes what he or she watches, hears, perceives, and detects. When the first sequence is described the analyst continues with the next sequence in the same way. One clip might contain anything from 1 to 15 sequences. In the form only five are given as a guideline. When the whole chronology of events and occurrences in the clip have been described the analyst proceeds to Step 4.3.

STEP 4.3: EXPERIENCE AND INTERPRETATION

The analyst now views the whole clip again without any breaks and proceeds to column B in the analysis form. In this part of the analysis the analyst is asked to give his or her subjective assessment and ideas. The analyst might be inspired by sentences such as:

- 'I experience/feel/sense/believe/imagine/come to think about that…'
- 'The client/therapist seems to…'
- 'It looks like the client/therapist is…'

The experiences and interpretations are tied to the specific observations in column A, either by writing the text in column B on a level with the observation in column A, or by connecting the text pieces by lines and marks in the text.

STEP 4.4: REFLECTIONS ABOUT MUSICAL RESPONSE

In column C the analyst is asked to reflect on the client's response to the music. The focus is on this question, as this analysis is based on work with clients who are normally described as giving very limited response. If the analyst sees a response he or she is asked to connect this to a specific observation in columns A and B, by writing the text in column C on a level with the observation in columns A and B, and by underlining the text in columns A or B. Then a more general reflection should be given about the client/therapist relation and about the meaning the relation and the engagement in the therapy might have to the client in other social contexts, and what relevance this might have for this specific person and the client group in general.

The reflections in Step 4.4 are formulated through the following question: Does the client respond to the music?

(a) 'How can you see this response?' (underline the text in columns A and B)

(b) 'Can you characterize the relation between the client and the therapist?' (emotional valence, receptive participation, sociality, active participation, communicative musicality, dialogue/intersubjectivity) (these themes are described below)

(c) 'What meaning does this have?' (for the client, the social activity, generally in the application of music therapy...)

In question (b) the analyst is asked to reflect about relational aspects in the therapy, whether a relation between client and therapist has been or is being established, and if an intersubjective meeting occurs. These questions are very relevant with a client group of people that suffer severe attention deficits, have problems in comprehending what is going on, and in taking part in different kinds of social activities in daily life. The analyst is given a direction in his or her reflections with keywords as below:

- *Emotional valence*: Does the client express a certain mood or state of mind (such as restlessness, relaxation, positive/negative emotional valence) that more or less seems to take effect during the whole clip?

- *Receptive participation*: Does the client show some kind of engagement (that cannot be described as active participation), e.g. seems to be listening, be inspired, recognizes, reminisces, is orientated towards or occupied with an object?

- *Sociality*: Is the client orientated towards or does the client show interest in the therapist (e.g. by getting closer to, approaching, touching, imitating the therapist)?

- *Active participation*: Does the client respond to, comment on, or appear involved in the therapy? Does he or she show initiative and intentionality and make choices?

- *Communicative musicality*: Does the client show active participation that involves joint musical expression (the client marks the beat, the phrasing of the melody, sings the tune or the song, or sings some single notes related to the song)?

- *Dialogue/intersubjectivity*: Does the client engage in a dialogue with the therapist? The dialogue or intersubjective meeting has a quality of intimacy, joint creativity, play and emotionality. The client and the therapist 'understand' each other at an emotional level, e.g. by laughing together or sharing the same feelings of sorrow. The communication is no longer two monologues, but one dialogue with an exchange between two subjects. The intersubjective meeting is also seen as a shared understanding of, and reflection about, the relation between the client and the therapist (for the theoretical framework of this, see Ridder 2003).

STEP 4.5: SHORT OVERALL EVALUATION OF THE MICROANALYSIS

Step 4.5 of the analysis is done when the analyst has analysed all the selected clips of the client, preferably after a couple of days so the analyst is able to view the process at a distance. In a separate document the analyst should assess the whole procedure, including the following reflections:

- How long did the analysis as a whole take?

- Were there any difficulties or obscurities in the process?

- Is the process experienced as difficult/tiring/interesting/inspiring/other?

- Did the process lead to other issues about this specific client group, therapy with this client group, music or other?

- Would you consider your way of answering the steps in this analysis as closely connected to your personal involvement and your private understanding, or do you consider your reflections as more general and objective?

This last feedback on the analysing process is important as this way of analysing the video or DVD data is not seen as a final and complete protocol. It needs refinement and further development. These meta-reflections help better understand the answers given in Steps 4.1–4.4.

Step 5: Conclusion

When a music therapist, perhaps in collaboration with an external analyst, has worked through all these steps based on clinical practice and video data material important information is provided about the therapy process and about the client. It might be useful to communicate this in a shortened and conclusive version that contains essential guidelines for the

direction of the clinical work, or information about the client to be used in assessment procedures carried out in a multidisciplinary team. The conclusion contains a summary, discussion of the findings and suggestions for future clinical work.

Case example

The following case example is of Mrs E, who participated in 19 music therapy sessions in four weeks. All sessions were recorded on video and session-graphs were made. All the video material that was registered as relevant for further analysis on the session-graphs was reviewed and, based on certain criteria, one clip lasting 2:08 minutes was selected. This clip, together with video clips with other clients, was analysed by five external analysts in a networking group of music therapists working in psychiatry. Other clips were analysed by the music therapist in order to describe the clinical process.

Mrs E is in her eighties, is diagnosed with a frontal vascular dementia, and scores 3 on the MMSE (Mini Mental State Examination), which is indicative of severe cognitive loss. She lives in a gerontopsychiatric nursing home and is treated with antipsychotic medication (Trilafon, 8 mg) due to aggressive agitated behaviour.

Figure 4.2 is a session-graph from session number 18 with Mrs E. The therapist sang 13 *songs* (grey fields), and Mrs E *sang* with the therapist (pink colour, see A.4) in five songs in the last part of the session. The session lasted about 30 minutes (see timescale at x-axis). When the therapist sings the first song (song G) the heart rate of Mrs E shows more than 70 bpm. When the last song (song L) is sung, her heart rate has decreased to 64 bpm. We see that though her heart rate decreases she is gradually more and more active in the session.

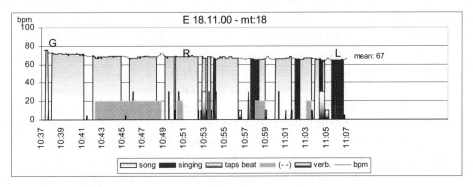

Figure 4.2: Session-graph, Mrs E

During songs 3 and 4 Mrs E has her eyes closed (- -). In spite of this she makes a *verbal comment* (verb.) in the pause between the songs (at 10:45:15), and for a short moment she *taps the beat* of the song (10:46:03). Thus although she seems very little engaged in the first part of the session, there are small signs to show that she is listening. We also see that there are sometimes long pauses between the songs where no one speaks, some of the pauses lasting more than a minute. This might indicate a very relaxed way of being together.

Very often after a song has finished, Mrs E makes a verbal comment (verb.). These comments are noted in the spreadsheet: 'It really works' (10:50:02); 'Well, it is fun now and then' (10:53:13); 'Yes, it seems to be…like it should' (10:58:55); 'That is good' (11:01:32); 'That is nice' (11:03:32); 'Yes, that is funny [laughs] it is almost…oh help [laughs]' (11:04:50).

As part of a research project one clip from the first music therapy session is analysed by five external assessors. Table 4.2 is an example of how one of the assessors filled in the analysis form.

This example is from the middle part of the first session with Mrs E. The therapist sings the song 'R', that is also sung in session 18 (see Figure 4.2). The essence of the analysis is that three clear responses – moving the foot, laughing and vocalizing – reveal that Mrs E is engaged in the songs, and that the contact and communication is described to be at an advanced level as Mrs E shows active participation, communicative musicality and enters dialogue with the therapist by laughing, singing, and commenting on songs.

In a macro-perspective, including all session-graphs and video analyses, it is concluded that there is a connection between levels of arousal and communication in the music therapy. In sessions where Mrs E shows either a very high or a very low arousal level she responds less actively, but after a period where songs are used to regulate (by calming down or by stimulating) she is engaged and enters dialogue.

Summary

Music therapy lies in a field between health care and humanistic science. It is essential for our profession that we develop methods that document our clinical work; a documentation that can be applied in evidence-based practice. We attempt to replicate research methods from well-established research fields, e.g. medical science. When this is done uncritically we might lose important implications of our profession. To include microprocesses and/or subjective impressions in documentations demands ethical, sceptical and systematic procedures in order to secure valid and reliable conclusions. We need to refine such procedures.

The microanalysis procedures described in this chapter suggest one direction in which to go in order to describe details from clinical practice and to do a systematic data collection. The more procedures like this are replicated, discussed, refined and developed, the stronger our chances of building up a solid tradition for reliable and valid documentation.

Music therapy students and clinicians often start from scratch when they are requested to document their work. It will strengthen the credibility of their work if they develop skills in using procedures that have already been tried out in practice. The next generations of music therapy clinicians and researchers will develop these first 'flint-axe-like' tools of documentation into precise and handy instruments.

Table 4.2: Analyst follows Steps 4.1–4.4 in the video analysis of Mrs E

A	B	C
Sequence 1		
<u>Mrs E looks up.</u> MT sits at the left side of Mrs E and is singing. Mrs E <u>bobs her feet up and down in time with the tune</u>.	In the way Mrs E is looking up I see that she is concentrated in her listening and her taking part.	
Sequence 2		
She hums the melody. At the refrain, which is repeated, she sings 'well well' (as an answer to 'ha ha'). She laughs in the last part of the refrain. MT leans her head towards Mrs E when she sings 'ha ha'.	She is very focused on the music. She laughs and seems to feel at ease in this situation, singing together. This seems like a way of engaging Mrs E in a solo. Mrs E catches this and she is amused.	Mrs E is responding to the music (see underlining). Mrs E is evidently 'in' the song all the way through.
Sequence 3		
<u>The humming of Mrs E is increasing in volume.</u> She sings the melody with more accuracy. Her solo is in the refrain.	Their dialogue is at a conscious level.	She feels more and more at ease, she is having a nice time, she laughs and is in dialogue with the therapist.
Sequence 4		
Next time the refrain comes, MT leans against Mrs E. She is here moving her left foot in the rhythm of the song.		
Sequence 5		
<u>She sings the words of the last line of the song</u> ('he who laughs last laughs longest'). <u>When the first line is repeated in a slower tempo she is clearly following the change</u>. The words she is singing are pronounced more clearly. When the song is over she turns her head against MT and says: 'This is a good song.'	As the song continues Mrs E uses more and more words that are pronounced more clearly. Especially in the last line.	From the clip you are not able to see that Mrs E is suffering from severe dementia, perhaps it is seen on her facial expression. The communication, and the contact, is on a very advanced level.

Any reflections and experiences gained by readers from undertaking any of the steps in working with the session-graph and/or the video analysis are welcome and might be useful for further research and meta-analysis. They can be mailed to Hanne Mette Ridder, AAU: Institute for Communication, Kroghstr 6, 9220 Aalborg, Denmark, or emailed to hanne@hum.aau.dk.

References

Alrø, H. and Christensen, M. (1998) 'Supervision som dialogisk læreproces.' *Interpersonel Kommunikation i Organisationer 4.* Aalborg: Aalborg Universitetsforlag.

Marshall, C. and Rossman, G.B. (1995) *Designing Qualitative Research,* 2nd edn. Thousand Oaks, CA: Sage.

Reber, A.S. (1995) *Dictionary of Psychology.* Harmondsworth: Penguin.

Ridder, H.M. (2003) 'Singing Dialogue. Music therapy with persons in advanced stages of dementia. A case study research design.' PhD thesis, Institut for Musik og Musikterapi, Aalborg University, Denmark. Accessed on 06/02/07 at http://www.musikterapi.org/pages/pubhm2.html.

Ridder, H.M. (2005) 'Music Therapy with the Elderly: Complementary Data as a Rich Approach to Understanding Communication.' In D. Aldridge (ed.) *Case Study Designs in Music Therapy.* London: Jessica Kingsley Publishers, pp.191–209.

Ridder, H.M., Ottesen, A.M. and Wigram, T. (2006) *Pilotprojekt: Musikterapi som personcentreret terapiform med frontotemporalt demensramte.* Aalborg: Aalborg University, Institut for Kommunikation and Videnscenter for Demens, Nordjyllands Amt.

Robson, C. (2002) *Real World Research,* 2nd edn. Oxford: Blackwell.

Chapter 5

Microanalysis of Interaction in Music Therapy (MIMT) with Children with Developmental Disorders

Julia Scholtz, Melanie Voigt and Thomas Wosch

Introduction

The use of music therapy in the treatment of children with developmental disorders and disabilities is widespread. Four Fachhochschul-Diplomarbeiten (BA honours theses) by students of the University of Applied Sciences in Magdeburg/Stendal in Germany have led to the development of a method of microanalysis of processes in music therapy with children with developmental disorders and disabilities. Three of these studies dealt with music therapy in the treatment of a child with Rett Syndrome (Fischer 2004; Heitmann 2006; Voigt 2002). The case study which delivered the foundation for the method of Microanalysis of Interaction in Music Therapy (MIMT) presented in this chapter examined processes in music therapy with a child with a developmental disorder and behavioural problems (Scholtz 2005).

Three factors determine the value and relevance of MIMT:

1. It was developed to study video material originating in daily clinical practice. All material used in the studies originated from sessions of music therapy with children at the Kinderzentrum München, the first and largest centre for social paediatrics in Germany and a leading institution for diagnostics and treatment of developmental disorders.

2. The method was developed specifically for examining processes in music therapy with children with developmental disorders and disabilities, taking into consideration factors influencing development within this population.

3. The method uses simple means to study microprocesses within a music therapy session. This makes it appropriate for teaching students to recognize and understand the complex processes which take place within a music therapy session as well as in research, comparing processes over time or between clients.

All three factors make the method relevant for use by the clinical practitioner in examining, understanding and evaluating processes in his or her daily work with children with developmental disorders or disabilities.

The results of the analysis can also aid in demonstrating clinical effectiveness. This is becoming increasingly important because of the demands of evidence-based practice within health care (Plahl and Koch-Temming 2005; Sarimski 2005; Wigram, Pedersen and Bonde 2002).

Following a brief description of its theoretical basis, the method used in MIMT will be outlined and its use explained in detail. The case example mentioned above will serve to illustrate the method. Additional relevant information regarding the method itself and the case example can be found on the web-based resources. Finally, the possibilities for the application of the method in the areas of clinical work, research and teaching will be discussed.

Theoretical basis

Microanalyses are not new to developmental psychology. They have been used to examine the interaction between parents and their infants in order to determine characteristics of and influences on early preverbal communication and interaction disorders (Papoušek 1994, 2003). Used in the therapy of parent–child interaction disorders, they enable parents to recognize their strengths and, with the support of therapists, to find solutions for problematic situations (Papoušek 2003; Sarimski 1993, 2001, 2003, 2005; von Aster and von Aster 2003). In assessing children with developmental disorders or disabilities, microanalyses of the child's behaviour within the context of a particular interactive situation often supplement standardized tests, such as the Bailey Scales III, Münchener Funktionelle Entwicklungsdiagnostik or Kaufman Assessment Battery for Children. This qualitative assessment of the child's capabilities delivers additional information important for planning therapy and for counselling (Sarimski 2003).

Music therapy procedures with children with developmental disorders or disabilities must be adapted to meet each child's changing psychosocial, emotional, physical and psychological needs. This requires continual assessment through methods adapted to accommodate the developmental characteristics of this population (Plahl 2000; Wigram *et al.* 2002). In this area of clinical practice very small changes can often offer important information about development and therapeutic progress, making microanalysis a useful tool for assessment and evaluation.

Many children referred to music therapy exhibit interaction disorders, which can pose a secondary threat to development (Sarimski 1993). The MIMT is the revised form of a tool used in a study designed to assess the interaction between therapist and child within the music therapy setting (Scholtz 2005). It has its roots in a study by Plahl (2000), which measured the effects of music therapy on the pre-verbal development of children with multiple handicaps, and in Bruscia's Improvisational Assessment Profiles (IAPs) (1987).

Based on the example of microanalysis used by Plahl (2000; see also Chapter 3 in this book), a system was developed for categorizing the musical and non-musical interactive

behaviours of the child and the therapist within the music therapy setting. As in Plahl's study, the term 'music' or 'musical behaviour' is understood in the sense of the term *musiké* used in Orff Music Therapy. This definition of music is broader than the usual definition of music and represents a significant difference between Orff Music Therapy and other forms of music therapy such as Creative Music Therapy. Orff defined its meaning as 'a total presentation in word, sound and movement' (1980, p.9). *Musiké* includes the phenomenon of play, ranging from playing music to role-play or playing with non-musical objects such as scarves or balls. Sound can be produced with non-musical objects or body instruments, vocalization can replace words, and movement can include facial expression, spontaneous motions of the body and dance (Voigt 1999). Thus, in *musiké* more behaviours are considered musical than the mere performance of traditional musical parameters used in other assessments of musical behaviour within music therapy, e.g. Bruscia's IAPs.

Bruscia's six profiles, developed to assess clients using 'clinical observation, musical analysis, and psychological interpretation of the client's improvisation' (1987, p.403), have been used in research by others. Wosch (2002; see also Chapter 18 in this book) used the autonomy profile in his research regarding emotion and music therapy. Wigram (1999; see also Chapter 16 in this book) has applied the autonomy and variability profiles for differential diagnostics with children with communication disorders and autism.

In MIMT, the interpersonal interaction between therapist and child is of central importance. The autonomy profile, designed to describe the client's different role relationships during improvisation, was used in a modified form. One of the most important modifications is the classification of musical behaviours in therapy in the sense of *musiké* as well as the inclusion of non-musical behaviours pertinent to interaction (Scholtz 2005). Another is the use of binary nomenclature for the interactive qualities. Bruscia (1987, pp.446–7) uses the terms *dependant, follower, partner, leader* and *resister* to describe qualities of interaction. This terminology was supplemented by terms describing behaviour, emphasizing the quality of interaction and the possibility of change. This was deemed necessary because certain behaviours in children are age-related and change as the child matures, e.g. resistance. Active, deliberate resistance in early childhood can indicate that the child is developing autonomy and, in that case, would need to be rated as a positive occurrence. Bruscia uses the term to describe an avoidance of contact, interaction and relationship, i.e. negatively. The binary terminology used in MIMT is dependant/dependant, follower/adaptive, partner/responsive, leader/dominant and resister/independent.

Method

The MIMT is carried out in three steps:

1. compiling and selecting material

2. developing an instrument of observation

3. evaluating and interpreting results.

Compiling and selecting material

The material used in MIMT consists of video material recorded during the normal therapy session. The focus of the microanalysis is on the interaction between the therapist and the child. This means that facial play, eye contact and other means of expression must be visible in order to evaluate the interaction taking place, a factor which must be taken into consideration when making the recording. A mobile camera enables a better documentation of the client's face, his expression and his movement within the room, making it possible to evaluate the interaction between child and therapist comprehensively. Thus, the camera should be placed on a rolling platform or installed on the ceiling instead of being fixed on a tripod, providing this is practicable in the therapy setting and acceptable to the child and/or his parents.

Often video material exists which was not compiled under ideal conditions. This material can be used when the sequences chosen fulfil the following criteria:

1. Client and therapist are fully visible and can also be seen in a direct facial view.

2. In the full view, movements and direction of movement are recognizable.

3. In the direct facial view, the direction of both persons' gaze is discernible.

4. Situations of play, not situations in which preparations for activities are being made, dominate the sequence.

When the video material has been compiled, a decision must be made regarding the sequence from the therapy session that will be analysed. These sequences can be chosen:

1. based on their position within the session (e.g. at the beginning or end of the session)

2. with reference to particular events in a session which enable important new details to be recognized

3. randomly.

Very small time segments are analysed when studying microprocesses, making it necessary to limit the time range to be used. For this reason, a segment between five and eight minutes in length should be selected, depending on the aim of the analysis. This time range has been used in the studies performed to date and has proven to be practicable.

Developing an instrument of observation

After choosing the time segment to be analysed, the instrument used to make the analysis must be developed. This instrument is designed to be used in two steps. The first step consists of a behavioural observation using a 'category system for behaviour observation'. In the second step the behavioural categories are quantified based on the frequency of observation. These results are evaluated and conclusions are drawn based on the modified category system of interaction quality found in Bruscia's IAP autonomy (1987, pp.446–7).

CATEGORY SYSTEM FOR BEHAVIOUR OBSERVATION

Category systems for behaviour observation already exist. These can be used if desired, or a system can be developed from the video segment itself and from the questions formulated for the analysis. The category system used in our microanalysis method was developed from the video material.

Based on the aim of the analysis, which was to study the interaction between therapist and child during therapy, three major categories of observable behaviour were defined: gaze, vocal activity, and gestures and movement activity. Each category was then differentiated further by specifying different behaviours within each category and the context in which they occurred (Table 5.1). For example, within the category 'gaze' the client can direct his gaze toward an object (e.g. an instrument, a toy, a chair), toward the therapist or toward 'miscellaneous', which may also be found outside of the area within camera range.

Table 5.1: Category system of observation

	Child	*Therapist*
Gaze	Toward object	Toward object
	Toward therapist	Toward child
	Toward miscellaneous	Toward miscellaneous
Vocal activity	Verbalization within musical context	Verbalization within musical context
	Verbalization without musical context	Verbalization without musical context
	Vocalization within musical context	Vocalization within musical context
	Vocalization without musical context	Vocalization without musical context
Gestures and movement activity	Gestures	Gestures
	Movement activity within musical context	Movement activity within musical context
	Movement activity toward object	Movement activity toward object
	Movement activity toward therapist	Movement activity toward child
	Movement activity toward miscellaneous	Movement activity toward miscellaneous

All behaviours and terms must be defined as clearly as possible in a detailed glossary in order to enable exact use of the category system and to provide a standardization of the terms used. For example, in our glossary (see A5.1 on the web-based resources) the term 'musical context' was defined in the sense of *musiké* as described above.

When the categories to be observed have been established and defined, the video segment is viewed separately for each observational category. For example, the five-minute segment selected for this study was viewed first with regard to 'gaze' only.

The analysis begins with recording the occurrence of the behaviour being observed. This is done manually, using a table prepared for this purpose in which events are recorded in intervals of five seconds (see A5.2 on the web-based resources). For example, if a client directs his gaze toward an object within the first five seconds of the segment, a cross is entered in that square. The speed at which the video is played can be varied for the quantification of observations. In the case example presented here, the category 'gaze' was analysed playing the segment at half speed without sound. The categories 'vocal activity' and 'gestures and movement activity' were played at normal speed with sound for analysis. The pause function was used frequently in order to be able to mark the table, and the segment was often replayed in order to enable the observer to register, categorize and record all details.

QUANTIFICATION OF OBSERVATIONS

After all observations have been recorded in the method used in the MIMT, the observations in each category are added. Additionally, their proportional distribution is calculated and can be illustrated by a bar graph if desired. These percentages are then classified using the categories 'predominant', 'average', 'seldom' and 'never' (Table 5.2).

Table 5.2: Classification of proportional distribution of behaviour

Predominant	Average	Seldom	Never
≥66.6%	33.3–66.6%	≤33.3%	0%

These categories for frequency of behaviour serve as the basis for drawing conclusions about the quality of interaction based on the category system of interaction quality found in Bruscia's IAP autonomy (1987, pp.446–7), modified as described above. This modification adds a new dimension to the usual musical characteristics used and reflects developmental processes.

Evaluating and interpreting results

After the behaviours observed have been quantified, the interpretation of the results of the video analysis can be carried out. Three variations are possible:

1. the classification as a particular quality of interaction

2. drawing conclusions regarding tendencies

3. drawing conclusions regarding trends.

The classification as a particular quality of interaction requires that, based on quantification, a concrete interaction quality can be determined for the specific area of behaviour. The *tendency* toward an interaction quality is determined when one or two divergent results are

found. Here, the original proportional scores are used again in the interpretation of results. When the classification to one particular category of interaction quality is not possible based on the quantification of results, the raw percentage scores are also used. This enables the determination of a trend toward either a dependent or a non-connected pole of interaction. The exact classification of the interaction qualities according to percentage can be found in A5.3 on the web-based resources.

There are several possibilities for interpreting the results. The results of the interactive qualities between the therapist and the client can be compared. Another point of consideration could be to determine whether client and therapist interact in opposite roles. Additionally, main distributions within a particular area of observation can become apparent. For example, a child could express himself mainly verbally or vocally without relating to the play situation.

Key questions, formulated to focus the analysis onto particular clinical issues, can provide an important, systematizing structure in interpreting the results. For this purpose, questions were formulated which pertained closely to the category system and to the classification of interaction qualities. The following key questions refer to the categories of observation:

1. *Gaze direction*: Where is the focus of the child's/therapist's attention: on objects, on an interaction partner child/therapist, or on miscellaneous events?

2. *Vocal activity*: Does the child/therapist express himself through verbalization predominantly or seldom within musical context or without musical context? Does the child/therapist express himself through vocalization predominantly or seldom within musical context or without musical context?

3. *Gestures and movement activity*: Can gestures made by the child/therapist be observed? If so, which gestures and how frequently? Can movement activity within musical context be observed in the child/therapist? Where is the predominant focus of the directional movement activity of the child/therapist: on objects, on the interaction partner child/therapist or on miscellaneous events?

Using these questions, the therapist makes notes on the video sequence. On the basis of these notes, clear tendencies of behaviour, shown by the client, can be recorded and focused on for use when planning further therapy. For example, if the child shows a clear preference for an instrument in his gaze direction while the therapist focuses his eye contact on other persons, the therapist can change his gaze to include more eye contact to instruments in his next suggestions for play, aiding communication. This illustration shows the usefulness of the MIMT for everyday clinical use.

Case example

The material contained in this case example originated in the music therapy department of the Kinderzentrum München and illustrates the method described above. A boy of about

three years old, whom we shall call Tim, received six sessions of music therapy during his stay in the clinic with his mother on the parent–child ward.

Tim

Several diagnoses were made according to ICD-10. Tim was born prematurely by caesarean section in the twenty-fifth week of pregnancy (P 07.2 Z) and weighed 785 grams. He had a brain haemorrhage I° (P 52.0 BZ) and was on a respirator for two months. He was being raised by his single mother (Z 63.5) and their relationship was under strain due to mother–child interaction problems (Z 63.1). These two factors described the family's psychosocial circumstances. Diagnoses relevant to his development from the psychologist's point of view were the suspicion of a general developmental delay (F 81.9) and oppositional behaviour with excessive screaming during both days and nights (F 91.3).

The young single mother sought help at the Kinderzentrum because Tim was displaying massive screaming attacks, during which he could not be comforted. This caused her to feel unsure in her relationship to her child. The focus of the stay at the clinic for Tim was placed on developmental diagnostics. For his mother the main goals were to build up her competencies in dealing with Tim and to instruct her in using these competencies in interaction. Tim and his mother came to music therapy together. His mother was in the room during the session and observed but did not actively take part in the therapy process.

THE MICROANALYSIS

A five-minute video sequence from the first therapy session was chosen on the basis of the criteria described above. It was the first contact situation between the child and the therapist but was not the greeting situation. The activity was new to the child and began and ended within the sequence. The sequence fulfilled the criteria for using existing video material. For this reason, the events within the time range between minutes 4:30 and 9:30 were analysed.

In the sequence the child and the therapist can be seen in the first play situation after a greeting song has been sung. Balls are on the drum. When the drum is played, the balls are 'drummed away'. This suggestion for play is made by the therapist. When all balls have been drummed away, they are collected while a situation song initiated by the therapist is sung, describing the activity and signalling that the second part of the activity is to be carried out. She then varies the course of the activity and begins rolling a single ball around the edge of the drum. Tim picks up on this suggestion and carries it out with a second ball. The activity and the video sequence come to an end after the balls have been drummed away and collected a second time.

QUANTIFICATION OF OBSERVATIONS

Tables for the video sequence were drawn up for the categories of behavioural observation defined in the glossary. As described above, the video sequence was viewed separately for each category observed. Each time a particular behaviour was registered a cross was made in the tables. The sequence was repeated several times and was viewed with the settings for

speed and sound mentioned above. The tables and bar graphs of the results can be found in A5.4–A5.6 the web-based resources. Subsequently, conclusions regarding the interaction qualities were drawn based on the possibilities of a concrete classification, a tendency or a trend. The distribution is shown below (Table 5.3).

Table 5.3: Classification of behaviour frequency results to interaction qualities

Gaze	Child	Therapist
Toward object	Average (56.0%)	Average (37.8%)
Toward therapist/child	Seldom (18.6%)	Average (55.6%)
Toward miscellaneous	Seldom (25.4%)	Seldom (6.6%)
Interaction quality gaze	Tendency: partner/responsive	Tendency: partner/responsive
Vocal activity		
Verbalization within musical context	Seldom (21.4%)	Average (59.0%)
Verbalization without musical context	Seldom (28.6%)	Seldom (1.6%)
Vocalization within musical context	Seldom (21.4%)	Average (39.4%)
Vocalization without musical context	Seldom (28.6%)	Never (0%)
Interaction quality vocal activity	No specific classification possible, trend toward resister/independent	No specific classification possible, trend toward partner/responsive
Gestures and movement activity		
Gestures	Seldom (18.2%)	Seldom (19.7%)
Movement activity within musical context	Seldom (22.7%)	Average (44.7%)
Movement activity toward object	Average (33.4%)	Seldom (26.3%)
Movement activity toward therapist/child	Seldom (3.0%)	Seldom (9.3%)
Movement activity toward miscellaneous	Seldom (22.7%)	Never (0%)
Interaction quality gestures and movement activity	Tendency: leader/dominant	Tendency: follower/adaptive

The results show that Tim's behaviour cannot be clearly classified in a particular category of interaction quality. In the area of gaze he demonstrates a tendency towards *partner/responsive* behaviour. Whereas the direction of his gaze meets two criteria in this category, he seldom looks at the therapist, thus failing to meet the third criterion. A trend towards *resister/ independentness* is observed in the area of vocal activity. Tim seldom displays vocal activity, making it necessary to return to the raw percentage scores. These show us that Tim's verbal and vocal utterances occur mainly without musical context. However, it must be taken into consideration that this is the first music therapy session. It is possible that the musical context is very new for him.

The therapist makes suggestions for play in a way corresponding to *partner/responsive* behaviour with a partial display of *following/adaptive* behaviour. The interaction between the therapist and Tim on the level of gesture and movement is very interesting to observe. Here, a complementary distribution of *leading/dominant* and *following/adaptive* roles can be observed. Tim's behaviour shows a tendency towards *leading/dominant* behaviour; the therapist shows a tendency towards *following/adaptive* behaviour. This interpretation can only be made within the context of the situation which is depicted in the five minutes of the video sequence.

The therapist exhibits complementary interaction qualities towards Tim in the areas of eye contact and of gesture and movement. Her visual behaviour in this video sequence shows that she makes Tim an offer in the sense of *partner/responsive* behaviour which he occasionally answers in the same way. However, Tim shows signs of *leading/dominant* behaviour on the level of gesture and movement, moving mainly towards objects or towards miscellaneous. The proportional distribution of the therapist's behaviour shows the predominance of suggestions for movement within musical context, here with more movement towards objects.

While 'leading' on the part of the child could intimate his behavioural problems, his behaviour in the area of eye contact indicates that alternatives could be possible. As a consequence strategies in therapy can be planned to include an increase in the offer of a responsive relationship within the category of gesture and movement in order to lead Tim to change his behaviours in interaction. Maintaining eye contact is important and should be kept at the level of *partnership/responsiveness*. Additionally, the ability to alternate between leading and following roles could be stimulated and practised playfully within dialogue activities, in order to pursue the goal of developing *partner/responsive* interaction in the child.

Summary and perspectives

In the method MIMT, described above, video sequences from a music therapy session are chosen and analysed with the category system which has been discussed. The method can also be used when other questions are posed, other video material is used and category systems with further differentiations are drawn up. The results derived can then be classified within the five interaction categories *dependent/dependant, follower/adaptive, partner/responsive, leader/dominant* and *resister/independent*, using the corresponding proportional calcula-

tions. On the basis of the analysis, further interpretations for diagnostics and the further planning of therapy that are relevant to clinical practice can be made, as illustrated in the case example.

The use of simple means in carrying out the analysis makes it possible to employ it within clinical practice, providing music therapists with a means of evaluating processes in therapy. No complex software is necessary (see A5.7). However, computer-supported data collection as described by Plahl, Ridder, Holck and Wosch (see Chapter 2, 3, 4 and 17 of this book) could provide a perspective for the application of MIMT.

For clinical practice as well as for research, the scope of the areas of investigation can be noticeably expanded. Such areas could include the following:

- a comparison of sequences within a therapy session

- a comparison of sequences from several therapy sessions or the entire course of therapy

- a comparison of sequences from therapy sessions with clients with similar disorders/diagnoses.

If sequences from several therapy sessions are compared, the course of therapy can be examined comprehensively. For example, the successful development of a therapeutic relationship over time could be studied, as for the course of therapy with a girl with Rett Syndrome (Fischer 2004; Heitmann 2006; Voigt 2002). In the same vein, interaction qualities of the areas of observation can be compared with each other. Another possibility is the comparison of different case examples in which different disorders or diagnoses are concerned.

These examples illustrate the potency of MIMT for systematic multi-centre studies which deliver important results for basic research in music therapy. These take place on the basis of clinical material from the natural setting of music therapy. They can be linked directly to university instruction if a multitude of theses deliver first results, followed by meta-analyses within the framework of PhD studies. MIMT offers a means of making students sensitive to the smallest details of a music therapy session. All students who have used the method so far have reported having this experience, whether the session analysed was their own or a session carried out by another therapist.

If MIMT is used by readers, the authors would appreciate feedback and possibilities for planning networks (see the list of contributors at the end of the book for contact details).

References

Bruscia, K. (1987) *Improvisational Models of Music Therapy*. Springfield, IL: Charles C. Thomas.

Fischer, S. (2004) 'Eine Mikroanalyse zum emotionalen Verhalten eines Mädchens mit Rett-Syndrom in der Orff-Musiktherapie.' Unpublished Diplomarbeit, Hochschule Magdeburg-Stendal (FH) (University of Applied Sciences).

Heitmann, S. (2006) 'Videomikroanalysen zum Verhalten eines Mädchens mit Rettsyndrom in der Frühförderung.' Thesis: Hochschule Magdeburg-Stendal, Magdeburg.

Orff, G. (1980) *The Orff Music Therapy*, trans. Margaret Murray. New York: Schott Music Corporation.

Papoušek, M. (1994) *Vom ersten Schrei zum ersten Wort*. Berne: Hans Huber Verlag.

Papoušek, M. (2003) 'Gefährdungen des Spiels in der frühen Kindheit: Klinisch Beobachtungen, Entsteheungsbedingungen und präventive Hilfen.' In M. Papoušek and A. von Gontard (eds) *Spiel und Kreativität in der frühen Kindheit*. Stuttgart: Pfeiffer bei Klett-Cotta.

Plahl, C. (2000) *Entwicklung fördern durch Musik. Evaluation musiktherapeutischer Behandlung*. Münster: Waxmann.

Plahl, C. and Koch-Temming, H. (eds) (2005) *Musiktherapie mit Kindern. Grundlage – Methoden – Praxisfelder*. Berne: Hans Huber Verlag.

Sarimski, K. (1993) *Interaktive Frühförderung*. Weinheim: Psychologie-Verlags-Union.

Sarimski, K. (2001) *Kinder und Jugendliche mit geistiger Behinderung*. Göttingen: Hogrefe.

Sarimski, K. (2003) 'Entwicklungsbeurteilung und Förderung im Spiel mit geistig behinderten Kleinkindern.' In M. Papoušek and A. von Gontard (eds) *Spiel und Kreativität in der frühen Kindheit*. Stuttgart: Pfeiffer bei Klett-Cotta.

Sarimski, K. (2005) *Psychische Störungen bei behinderten Kindern und Jugendlichen*. Göttingen: Hogrefe.

Scholtz, J. (2005) 'Untersuchung von Interaktionsqualitäten im musiktherapeutischen Beziehungsaufbau – anhand einer Einzelfall-Videomikroanalyse bei einem Kind mit Interaktionsstörung im Rahmen der Orff-Musiktherapie.' Unpublished Diplomarbeit. Hochschule Magdeburg-Stendal (FH) (University of Applied Sciences).

Voigt, I. (2002) *Musiktherapie bei Mädchen mit Rett-Syndrom – eine Untersuchung zum kommunikativen Verhalten eines Mädchens mit Rett-Syndrom in der Orff-Musiktherapie*. Unpublished Diplomarbeit, Hochschule Magdeburg-Stendal (FH) (University of Applied Sciences).

Voigt, M. (1999) 'Orff Music Therapy with Multi-handicapped Children.' In T. Wigram and J. De Backer (eds) *Clinical Applications of Music Therapy in Developmental Disability, Paediatrics and Neurology*. London: Jessica Kingsley Publishers.

von Aster, S. and von Aster, M. (2003) 'Eltern-Kind-Spiel und videogestütztes Feedback als Element der begleitenden Elternarbeit in der Kinderpsychotherapie.' In M. Papoušek and A. von Gontard (eds) *Spiel und Kreativität in der frühen Kindheit*. Stuttgart: Pfeiffer bei Klett-Cotta.

Wigram, T. (1999) 'Contact in Music: The Analysis of Musical Behaviour in Children with Communication Disorder and Pervasive Developmental Disability for Differential Diagnosis.' In T. Wigram and J. De Backer (eds) *Clinical Applications of Music Therapy in Developmental Disability, Paediatrics and Neurology*. London: Jessica Kingsley Publishers.

Wigram, T., Pedersen, I.N. and Bonde, L.O. (2002) *A Comprehensive Guide to Music Therapy. Theory, Clinical Practice, Research and Training*. London: Jessica Kingsley Publishers.

Wosch, T. (2002) *Emotionale Mikroprozesse musikalischer Interaktionen*. Berlin: Waxmann.

Chapter 6

The "AQR-instrument" (Assessment of the Quality of Relationship) – An Observation Instrument to Assess the Quality of a Relationship

Karin Schumacher and Claudine Calvet

The "AQR-instrument" has been developed by a developmental psychologist who specializes in early mother–child interaction, especially the interaction with handicapped children, and a music therapist who specializes in working with children with autism and other deep developmental disorders (Schumacher and Calvet-Kruppa 1999, 2001 and 2005). This instrument facilitates the assessment of the quality of a relationship, and focuses on how the relationship of oneself (body and voice) to objects such as music instruments and to the music therapist is accepted. The aim is to assess the quality of the interpersonal relationship with the help of specific characteristics, and thereby to comprehensively classify it. The presentation of developmental psychological knowledge, especially the ability for the regulation of emotional processes, as well as the development of the self, form the theoretical basis of this assessment instrument. A summary of the AQR-instrument is presented here and is applied in conjunction with a therapy sequence from the work with a child with autism.

Developmental psychological foundations of the AQR-instrument

Behavioral organization and its relevance for development

Brazelton (1973, 1990) together with Als (1986, p.15) developed a positive and dynamic model of adaptation for infants, an innate behavioral organization called "A Synactive Model of Neonatal Behavioral Organization," initially for premature babies. This is the product of slow maturity from conception to birth and it enables the baby to adapt to its environment and to interact with it.

The baby has four systems at its disposal in order to process and integrate stimuli:

1. the physiological autonomic system

2. the motor system

3. the state organizational system

4. the attention and interactive system.

Brazelton assumes a principle of balance. The infant tries to organize and process a stimulus according to its type and familiarity. Thereby it strives to keep its inner state always in balance. The behavior of the newborn infant is organized in a circular manner. As soon as the baby can integrate a stimulus, its level of attention becomes stabilized. In this way it is able to exchange a glance calmly and to remain in interaction for a short time. However, if the stimulus is not integrated, an inner tension develops. The infant tries to achieve its inner balance again by motoric self-regulation. Examples of signals of motoric self-regulation are the touching of its own body or sticking a finger in its mouth. If the infant is not able to effect this kind of self-regulation, it shows by further motoric ways of behavior that its inner tension is increasing. This is connected to so-called motoric signs of stress as, for instance, clenching a fist or spreading the fingers. It is important to be aware that during this state of tension the infant cannot activate its attention and interactive system on its own. The newborn infant may then react with averting and resistance. The inner state of tension cannot be released without external help. Ultimately it increasingly demonstrates physiological signs of stress, such as heavy breathing, mottled skin, or facial grimacing. Finally the third state system may be activated: it cries or suddenly falls asleep.

Rauh (1987) describes forming a hierarchy of all these behavioral characteristics of the infants who show the adults with their behavioral repertoire if and how much they are affected. If the inner tension is regulated and the physiology stabilized by the motoric system, the attention and interaction system becomes activated. Then the infants are well regulated and can enter into a positive exchange with their environment. This is an "ascending" developmental model. However, if tension cannot be reduced, signs of stress become evident in all systems (see A6.1 on the web-based resources). Averting can develop into a chronic system of avoidance which underlies a "descending" stress model. If the caregiver, mainly through insecurity, is not able to act as regulator, the child begins to show signs of stress that could become chronic symptoms. Uncertainty and insecurity in the caregiver result in a vicious circle that leads to under- or overstimulation. The signals from the infant are no longer perceived or wrongly interpreted. Unrest and irritability as the basis of further pathological symptoms can indeed be seen at an early stage. The result is the loss of so-called sensitivity (Ainsworth et al. 1978). These dysregulations can only be released with the help of a person sensitive to the infant's needs.

The role of emotional regulation (Alan Sroufe)

Sroufe (1996) also describes the influence of the ability for regulation of the adult on the emotional development of the infant. Immediately after birth the infant experiences its

affects physiologically and is, as mentioned previously, dependent on so-called external regulation. Only when the sensitive caregiver can appropriately perceive and interpret the physiological signals (for example, the color of skin, breathing, digestion) and the physical signals (for example, movement and posture) can the infant learn to control its inner tension with the help of an adult. The child becomes aware of the change from tension to calm by the regulation of this tension. This feeling of inner calm enables the infant to be attentive. Only then can it address the outside world and above all have positive experiences with its environment. If this process is repeated, the infant develops a positive attitude towards states of tension as it has experienced that they can be regulated. This positive fundamental attitude is decisive for the establishment of the ability for dialog. The ability to regulate its own affects and to establish a secure and content interpersonal relationship are mutual requirements.

Daniel Stern's concept of self

Stern's new revised concept of self (2000; see A6.2 on the web-based resources) demonstrates which sensations (the sense of self) must be experienced and positively processed to acquire the ability to establish an interpersonal relationship. In comparison to his first publication (Stern 1985) this revised graphic shows that the sense of the "emergent self" and "core self" are present before birth. The sense of core-self-with-another as the basis for the following ability for intersubjectivity is dependent on three experiences:

1. self-with-a-self-regulating-other
2. self-resonating-with-another
3. self-in-the-presence-of-another.

The music therapist uses the special characteristics of music to enable these experiences in a specific way.

Method: The AQR-instrument

This AQR-instrument contains four scales with different focuses. Three scales have their focus on the patient's instrumental (Table 6.1), vocal-pre-speech (Table 6.2) and physical-emotional (Table 6.3) qualities. The fourth scale focuses on the therapist and his or her music therapeutical intervention (Table 6.4). Every scale differentiates between seven or eight modi, i.e. the way the contact and relationship are developed. Each modus is characterized by specific features. The four scales correspond to Daniel Stern's concept of self in their structure and follow the logic of a normal development.

General presentation of the instrument with its four scales

SCALE 1: INSTRUMENTAL QUALITY OF RELATIONSHIP (IQR-SCALE)

In the IQR-scale focus is on the following aspects: the choice of instrument, relationship to object, musical media and room to play.

Instrument

The choice of instruments depends on whether the instrument is to be shaken, beaten, pressed, blown, plucked, or stroked, as these various activities are considered in a developmental and therefore relationship-psychological context. Primarily there is only a general evaluation of the duration and way of handling, or the way of playing in regard to the quality of relationship.

Relationship to object

Developmental psychological research about the way objects are handled and later how they are played with and related to interpersonal relationships are taken into consideration here and related to the instrumental expression.

Musical media

The way of playing the instrument, the approach and expression are described through analysis of the musical parameters: sound, rhythm, melody (harmony), dynamic, form and expression.

Room to play

Here the playroom and especially the musical range on one instrument including the mutual playroom in joint playing is observed.

SCALE 2: VOCAL-PRE-SPEECH QUALITY OF RELATIONSHIP (VQR-SCALE)
The following characteristics are significant for the three categories: voice, relationship, and vocal-pre-speech expression.

Voice

Initially only a general assessment according to duration and form of the vocal-pre-speech expression is undertaken. Research in developmental psychology is taken into consideration on the ways the patient discovers his own voice, how he plays with it, and if this enables an interpersonal relationship.

Relationship: intra- and interpersonal

Intrapersonal: The vocal expression gives the body a proprioceptive feedback whereby a relationship to one's own voice develops.

Interpersonal: The vocal expression in an interpersonal context.

Types of vocalization and pre-speech expressions

The vocal and pre-speech means of expressions and playing are assessed in their quality of relationship by a description of the types of vocalization. As the vocal expressions of the child are not central in this analysis we refer to Papoušek (1994, p.48), who gives a detailed description.

Table 6.1: Specific characteristics of the instrumental quality of relationship (IQR-scale)

Modus 0 Lack of contact/Contact refusal/Pause	There seems to be no awareness of the musical instruments in the room; they are not inviting. Despite therapeutical intervention they do not lead to any obvious intervention-related contact and relationship stimulating reaction. A third kind of behaviour in this modus is to need a pause in order to regulate the affective tension.
Modus 1 Contact-Reaction	A first awareness of the instruments develops. It is handled in the form of a short reaction whereby as by chance a sound becomes audible. If it's a moveable instrument it is often touched and after that totally neglected.
Modus 2 Functional-Sensory-Contact	The instrument is handled either in a sensory, destructive or stereotype way: • sensory: touch, smell, taste instead of hearing • destructive: the instrument is in danger of being damaged • stereotype way of playing: monotone, unchanging, apparently meaningless.
Modus 3 Contact to oneself/Sense of a subjective self	The instrument is recognized as a "musical" instrument and is explored. The state of affect (tension) which is transferred to the instrument is appropriate to it and its material characteristics.
Modus 4 Contact to others/Intersubjectivity	The instrument is played according to its function. The resulting sound is socially referenced.
Modus 5 Relationship to others/Interactivity	The instrument is played in form of a dialogue, as in question and answer games, often also in connection with vocal expressions.
Modus 6 Joint experience/Interaffectivity	The instrument is played in a consistently positive state of affect, i.e. mostly played with pleasure, and can lead to associations. The instrument helps to playfully demonstrate a state of affect.
Modus 7 Verbal-music space	The instrument sets off emotional changes and/or imaginary contents that lead to verbalization (description/reflection).

Table 6.2: Specific characteristics of the vocal-pre-speech quality of relationship (VQR-scale)

Modus 0 Lack of contact/Contact refusal/Pause	The child is considered to be without speech. Any sounds made are without communicative intention. The child stays in his stereotype behavior or makes a pause.
Modus 1 Contact-Reaction	First vocal expressions, so-called "vitality affects," are audible. The vocal expressions, mostly stimulated by movement, are the result of an internal movement and therefore the first positive expressions.
Modus 2 Functional-Sensory-Contact	The vocal sounds (heavy breathing sounds, unmodulated vocalizations) have the function of expressing inner tension or urgent needs. The voice is used for functional purposes.
Modus 3 Contact to oneself/Sense of a subjective self	The child realizes that he is the source of his own vocal expressions and explores them. The first motifs appear.
Modus 4 Contact to others/Intersubjectivity	The need arises to socially reference his own vocal expressions. The first tonal attuning develops; this can be connected to gesture. Joint phases become audible.
Modus 5 Relationship to others/Interactivity	An internal motivation develops to form a dialogue. An ability to imitate becomes audible. These imitative periods are of longer duration. This dialogue develops further in the form of a question-and-answer game. The alternate picking up on motifs and a joint creating of form are evident.
Modus 6 Joint experience/Interaffectivity	The voice is expressed in an enjoyable game. Frequently this is linked associatively to imaginative ideas. The occurrence of nonsense syllables, nonsense rhymes, nonsense songs is typical for the playful way of using the voice.
Modus 7 Verbal-music space	The voice leads to imaginative ideas that become verbalized.

SCALE 3: PHYSICAL-EMOTIONAL QUALITY OF RELATIONSHIP (PEQR-SCALE)

The following characteristics are significant for the PEQR-scale: sense of body/physical contact, affect, and eye-contact.

Table 6.3: Specific characteristics of the physical-emotional quality of relationship (PEQR-scale)

Modus 0 Lack of contact/Contact refusal/Pause	The main characteristic is the restriction of social interaction. The child is unapproachable and stereotype behavior can be observed, or the child makes a pause and turns away. If it shows affect, this is difficult to interpret. There is no eye-contact.
Modus 1 Contact-Reaction	The main characteristic is the child's short awareness of the therapist. Either the child doesn't yet react to physical contact, or allows some short passive physical contact. First reactions of the child's positive affect can be seen, otherwise they are still very neutral and difficult to interpret. The child reacts only briefly to eye-contact. The contact is positive, but very short.
Modus 2 Functional-Sensory-Contact	The main characteristic is a high inner tension. The therapist must react to this (and allow himself to be functionalized). The child's body expresses high tension and restlessness. The overriding mood is one of tension. The eye-contact may contain a controlling aspect.
Modus 3 Contact to oneself/Sense of a subjective self	The main characteristic of this modus is the curiosity to investigate the body of another with the aim of getting to know his own body as origin of activity (self-coherence). The child allows physical contact in order to perceive himself in his self-effectiveness and authorship. He appears to be attentive and calm. The child's gaze rests on the therapist.
Modus 4 Contact to others/Intersubjectivity	The main characteristic of this modus is triangulation with inter-attentionality, also called joint-attention. The child shows interest in the therapist and in the joint activity. For the first time the body is utilized for interpersonal experience. Social referencing of his own physical sensations takes place. The child is curious about the existence of another person and for the first time is happy about this. The eye-contact has an expression of confirmation.
Modus 5 Relationship to others/Interactivity	The main feature of this modus is the mutually desired physical contact with a dialogue character. The child begins to enjoy the physical contact. The exchange is relaxed and accompanied by positive affect. The child regularly exchanges eye-contact with the therapist. However, he can also regulate himself by averting his gaze.
Modus 6 Joint experience/Interaffectivity	The main feature of this modus is pleasure. The relationship is firmly established. The body serves the playful exchange and can be symbolically expressive. The child can express pleasure and fun. This emotional quality is reflected in the eye-contact.

Sense of body/physical contact

The physical visible signs that a relationship is taking place as well as the way physical contact appears are analyzed (see Kugel 2005). Here posture, tactile reaction and gesticulations are observed.

Affect

A significant characteristic of this scale is the emotional state that can be seen not only in gesture but also in posture and movement.

Eye-contact

Eye-contact is especially significant since it is assessed not only in its quality but also in its quantity.

SCALE 4: THERAPEUTIC QUALITY OF RELATIONSHIP (TQR-SCALE)

In the TQR-scale the following characteristics are significant: the starting point, state of affect of the therapist, intervention and its focus, musical media, and room for play.

The starting point

The starting point is the momentary present state of the patient, i.e. the situation before intervention.

State of affect of the therapist

The therapist is observed in his state of affect in relation to the way the patient is aware of and needs him. His state of affect is assessed with the help of visual, sensory, and audible signals.

Intervention and its focus

Not only the intervention techniques but also their focus are observed. The therapist's "inner working model–IWM" (Bowlby 1988) is evident depending on which focus he addresses: movement, state of affect, vocal and instrumental expression.

Musical media

The musical parameters (sound, rhythm, melody, harmony, dynamic, form, and expression) are analyzed to see which of these are in the foreground or do not appear.

Room for play

Importance is attached both to the focus of the intervention and also the room for play whereby the space that exists between patient and therapist is visualized. In this scale it also becomes clearly evident that it is the quality of a phenomenon that is assessed.

Table 6.4: Specific characteristics of the therapeutic quality of relationship (TQR-scale)

Modus 0 Musical space – surrounding	The child shows no visible reaction yet to the therapist and his offers, sometimes making a pause. Music is offered with the intention of creating an atmosphere that makes a relationship potentially possible, but without forcing direct contact. The therapist feels unacknowledged.
Modus 1 Perception – connecting	The child moves (mostly stereotyped) around the room and notices the therapist's intervention for a short time. His movements become audible by an appropriate musical improvisation. The therapist feels mobilized by the short positive reaction of the child.
Modus 2 Affect attuning/allowing oneself to be functionalized	The focus is on the child's affect. The therapist attempts to find attunement with the child and to form him by physical, musical, or verbal means. The therapist puts himself thereby totally at the service of this problem and therefore feels functionalized in this respect.
Modus 3 Contact to oneself/sense of a subjective self – aiding awareness	The child expresses himself physically, vocally, by means of instruments or an activity. The therapist plays around, accompanies, sings to these expressions to make him aware of his own body, his voice, his instrumental expression, and that he is author of his activities; this helps him to continue this exploration. The therapist considers himself as supportive to this exploration.
Modus 4 Intersubjectivity – being included as a person	The child feels the need for confirmation of his perception and feelings, the so-called "social referencing." This leads to a first awareness of the environment and significantly the therapist is included as a person for the first time. He is able to introduce his own ideas, however, without wanting to bring about any dialogue. Child and therapist follow a mutual theme with interest.
Modus 5 Musical dialogue – musically answering and questioning	The child shows the ability to join in and imitate. A conscious initiation of music and dance ideas, independent from each other, becomes evident. The therapist considers himself as a person separate from the child and as dialogue partner.
Modus 6 Playing space – playing/having fun	One of the child's themes is worked on in a musically acted way. Action and affect are brought together, whereby pleasure and fun from joint music and dance playing, role-swapping, and flexible exchange of ideas become evident. The therapist considers himself as playing partner and can initiate an exchange of roles.

Continued on next page

Table 6.4 *cont.*

Modus 7	The response to the child's verbal expression and the
Verbal space – verbalizing/reflecting	connection of emotional experience and speech are the focus of this intervention. The therapist reflects the child's problems verbally and by appropriate song texts and encourages introspection. The therapist's affect reflects the serious interest in the theme.

Application of the AQR-instrument

Music therapy is often indicated if the main symptom in the clinical picture is a disturbed ability for interpersonal relationships. A significant feature of "deep developmental disturbances" is an impairment in the quality of a relationship. The question is, therefore, whether music therapy can treat this impairment. The AQR-instrument can be applied to confirm the qualities in a relationship (diagnostic) as well as the presentation of a course of therapy (evaluation). By the application of the various scales further questions can be answered. One of the most important considers the ability of the therapist to offer the intervention appropriate to the patient's state of development (method). The analysis of a chosen sequence with the support of the AQR-instrument should also help to work out an appropriate aim for the therapy (prognosis). If more cases with the same diagnosis are examined a comparison of all the courses of therapy is possible (research).

If the AQR-instrument is used to evaluate a whole course of therapy, random samples of sessions and sequences are chosen and the increasing qualities in the relationship can be appropriately compared. If the analysis shows a developing ability for a relationship, a comprehensible proof of effect of the music therapy work is given.

WHAT IS A "RELEVANT" SCENARIO?

The motivation and questioning that causes the therapist to analyze a specific scenario of his or her work with the AQR-instrument can be very informative. Judgment on the relevance of a scenario depends on specific questioning. Frequently an especially successful therapy situation is seen as "relevant" as it demonstrates a positive course of therapy. This consideration of successful moments of therapy is useful to demonstrate the success of the therapy (evaluation). However, more "relevant" are the sequences that show typically repetitive behavior that inhibits the expected success of the therapy. In this way, a scenario showing the therapist as helpless can be considered to be "relevant." It is important to be able to formulate the reasons for the chosen scenario in a comprehensible way and to relate the result of the analysis to the original questioning.

WHICH SCALE IS REFERRED TO?

By means of questioning the decision can be made as to which of the four scales will at first be applied. The patient's expression (instrumental/vocal/physical-emotional) which is in the foreground should first be analyzed. If the patient neither plays nor sings, but shows

significant emotional features, the PEQR-scale is preferred. If information is needed about the kind of intervention, the TQR-scale is applied. If the TQR-scale is combined with the scales that focus on the patient's behavior we gain information on whether the therapist has recognized the state of development of the patient and given the appropriate help. Possible mistakes in intervention can be recognized and remedied.

QUALITY AND QUANTITY: BASIC QUALITIES AND "PICKS"

The modus assessed by the analysis shows the "quality" of relationship that will now be evaluated for its "quantity." If this is a new and only momentary quality, these are known as "picks." This momentary quality refers to the potential possibilities of a patient. Especially because they only appear for a short and irregular moment, they need to be perceived and evaluated. Even when these are "negative picks," e.g. signs of stress that indicate irritation or inner tension that could interrupt the relationship, it is important to be aware of them and to react accordingly.

STEP-BY-STEP INSTRUCTIONS

1. Documentation with the help of video.

2. Choose a "relevant" scenario according to your own specific questions.

3. Choose the scales according to what the patient is demonstrating (IQR, VQR, PEQR).

4. Use the TQR scale to understand whether the assessment of the actual interventions is compatible with the result of the assessment of the patient.

5. Compare all the results with your original questions.

Case example

Using the four scales of the AQR-instrument we analyze a three-minute sequence of active music therapy with Michael, a ten-year-old child on the autistic spectrum (see video example A6.1). It shows a special quality in the relationship between this child and the therapist. Rapid changes in the child's interest levels, and a high state of tension, have first to be regulated through a special intervention of the music therapist to help the child develop some abilities for intersubjectivity. A further pedagogic demand with the expectation to join in and imitate will be possible when this child will be able to interact without breaking contact through internal tension, which he cannot resolve all by himself.

Recapitulation of analysis

This analysis demonstrates that Michael has developed the feeling as initiator and author not only instrumentally but also physically. His desire to play the piano and to jump on the trampoline has been assessed at modus 3. The numerous signs of emotional tension, however, run

through these activities (modus 2) and lead continually to short breaks and pauses (modus 0). They interrupt the feeling of relationship and make turning the attention externally quite difficult. Michael expresses the already developed relationship to the therapist by appropriate glances in her direction (modus 4). This is encouraging for the beginning of an intersubjective relationship. Only by changing from instrumental to movement games is he able to resist the compulsion to stereotype behavior. The analysis demonstrates that the therapist's interventions are directed totally to the child's desire for exploration (modus 3). The therapist attempts to react supportively, imitatively, and with precise accompaniment. It is especially important for the therapist to assess the child's state of affect. This enables the child to experience that activity and affect are connected (Greenspan 1997). The subject of affect regulation is above all evident in the pauses, when the child decides at which moment and for how long he will need these. Because of this the therapist only applies her own ideas on a very few occasions (modus 4). In the last sequence we see why dialogic invitations (modus 5) would be too much for Michael at the moment. It shows that Michael's ability to imitate another person is not yet really developed (modus 5). As long as the invitation to imitate something is too difficult, the ability for dialogue is not yet really developed. The demand within a pedagogic framework for abilities to join in and to imitate as prerequisite would be overtaxing at this point in the therapy.

Summary

The assessment of the ability to establish an interpersonal relationship is important not only for diagnostic reasons. The right therapeutic intervention and the success of all therapy with children and adults with disturbances in their ability to develop or maintain a relationship depends on this assessment.

The microanalysis of the chosen sequences with the help of the AQR-instrument and its four scales showed that Michael, a ten-year-old child with autism, was still suffering from states of tension. The application of the PEQR-scale particularly enables observation and assessment of this distinctive feature. The therapist offers the appropriate intervention that supports his interest in musical and physical expressions. The focus on the quickly changing states of affects of the child and his need for changing activities and breaks is central. It is evident that his abilities for intersubjectivity and interaction in the way of dialogue are not yet fully developed enough to enable a pedagogic demand. Consequently at this point in the therapy a challenge to join in or to imitate shouldn't be initiated. Therefore this microanalysis gives indicators that are relevant for the whole course of therapy. However, these factors changed over the course of therapy and Michael's intersubjective abilities continued to improve.

References

Ainsworth, M.D.S., Blehar, M.C., Waters, E. and Wall, S. (1978) *Patterns of Attachment: A Psychological Study of the Strange Situation.* Hillsdale, NJ: Erlbaum.

Als, H. (1986) "A Synactive Model of Neonatal Behavioral Organization: Framework for the Assessment of Neurobehavioral Development in the Premature Infant and for Support of Infants and Parents in the Neonatal Intensive Care Environment". In Jane K. Sweeney (ed.) *The High-Risk Neonate: Developmental Therapy Perspectives.* New York: Haworth Press.

Bowlby, J. (1988) *A Secure Base.* New York: Basic Books.

Brazelton, T.B. (1973) "Neonatal Behavioral Assessment Scale." *Clinics in Developmental Medicine 50.* Philadelphia: JB Lippincott.

Brazelton, T.B. (1990) "Saving the Bathwater." *Child Development 61,* 1661–71.

Greenspan, S.I. (1997) *The Growth of the Mind and the Endangered Origins of Intelligence.* Massachusetts: Wesley.

Kugel, P. (in press) "Synchronised Moments in the View of a Movement-Dance Therapist." In K. Schumacher and C. Calvet (eds) *Synchronisation: Music Therapy with Children on the Autistic Spectrum.*

Papoušek, M. (1994) *Vom ersten Schrei zum ersten Wort.* Berne: Huber.

Rauh, H. (1987) "Verhaltensausstattung und erste Anpassungsleistungen des Säuglings." In C. Niemitz (ed.) *Erbe und Umwelt. Zur Natur von Anlage und Selbstbestimmung des Menschen* Frankfurt: Suhrkamp.

Schumacher, K. and Calvet-Kruppa, C. (1999) "Musiktherapie als Weg zum Spracherwerb." *Musiktherapeutische Umschau 20,* 216–21.

Schumacher, K. and Calvet-Kruppa, C. (2001) "Die Relevanz entwicklungspsychologischer Erkenntnisse für die Musiktherapie." In H.H. Decker-Voigt (ed.) *Schulen der Musiktherapie.* Munich: Reinhardt.

Schumacher, K. and Calvet-Kruppa, C. (2005) "'Untersteh' Dich!' – Musiktherapie bei Kindern mit autistischen Syndrom." In C. Plahl and H. Koch-Temming (eds) *Musiktherapie für Kinder. Grundlagen, Methoden, Praxisfelder.* Berne: Hans Huber.

Sroufe, L.A. (1996) *Emotional Development. The Organization of Emotional Life in the Early Years.* Cambridge: Cambridge University Press.

Stern, D.N. (1985) *The Interpersonal World of the Infant.* New York: Basic Books.

Stern, D.N. (2000) *The Interpersonal World of the Infant,* 2nd edn. New York: Basic Books.

Teaching films: *The "AQR-instrument" for the Assessment of the Quality of Relationship* (1999–2002) (unpublished, only available from the authors):

- *The Instrumental Expression I and II* (30 min. each, English)
- *The Vocal-pre-speech Expression* (30 min., English)
- *The Physical-emotional Expression* (40 min., English)
- *Musictherapeutical Intervention* (50 min., English)

Chapter 7

The Use of Improvisation Assessment Profiles (IAPs) and RepGrid in Microanalysis of Clinical Music Improvisation

Brian Abrams

Introduction

Microanalysis of improvised, clinical music (hereafter referred to as *clinical improvisation*) in music therapy involves analyzing a single improvisation (or the improvisation within a single therapy session) on a moment-to-moment basis. The purpose of this application of microanalysis is to generate a meaningful understanding of the improvisation as a whole and its role within a larger therapy process.

For effective microanalysis of clinical improvisation, a valid, trustworthy means of analyzing and comparing musical moments is required. Loosely descriptive, anecdotal, and/or speculative reflections are insufficient, as they cannot properly ground meanings and new understandings that may emerge from the microanalysis process. Therefore, micro-analysis requires choosing a specific method, equipped with both a systematic procedure and a consistent theoretical framework for making sense of moments of improvised music.

Existing methods of analyzing clinical improvisations that can be applied to micro-analysis include (among others) Bruscia (1987); Lee (1989, 1990, 2000); Nordoff and Robbins (1971, 1977, 1985); and Priestley (1975). Each method varies in the way that meaning is ultimately derived from the music; however, all have in common that the link between music and meaning is accomplished solely by a person (or the persons) performing the analysis. This is not problematic in and of itself, but it does pose the question of potential limitations in the breadth and depth of results when applied in the microanalysis of a single improvisation. Various significant dimensions of meaning in an improvisation may remain hidden from the analyzer's awareness, or may be subject to the analyzer's potentially distortive biases (on a conscious or unconscious level).

The present chapter addresses one way in which a technological resource can be integrated into the process of linking music to meaning in the microanalysis of clinical improvisation. Specifically, a method utilizing a combination of the Improvisation Assessment Profiles (Bruscia 1987) and the RepGrid computer program (REP IV 2004) is proposed here. This is a theoretical proposal only, as no clinical application has yet been formally documented.

Theoretical basis

Improvisation Assessment Profiles

The Improvisation Assessment Profiles (IAPs), developed by Kenneth Bruscia (1987), are a systematic method for analyzing and interpreting clinical improvisation. A brief overview of the IAPs is provided here. For a comprehensive account refer to Bruscia (1987).

The IAPs consist of six different profiles (or continua), each of which describes the qualities of various musical elements as they occur within a given improvisation. Each profile is based upon a five-point scale with its gradients anchored between two contrasting qualities. The profiles and their scales are given in Table 7.1, as follows:

Table 7.1: IAP profiles and scales

Profiles	Scale degrees and corresponding qualities				
	1	*2*	*3*	*4*	*5*
Integration	Undifferentiated	Fused	Integrated	Differentiated	Overdifferentiated
Variability	Rigid	Stable	Variable	Contrasting	Random
Tension	Hypotense	Calm	Cyclic	Tense	Hypertense
Congruence	Uncommitted	Congruent	Centered	Incongruent	Polarized
Salience	Receding	Conforming	Contributing	Controlling	Overpowering
Autonomy	Dependent	Follower	Partner	Leader	Resister

In the IAPs, specific musical elements are rated along each profile. Musical elements include *timbre, volume, tempo, meter, rhythm, melody, harmony, tonality, texture, phrasing, style,* and so on. Also included are certain *extramusical* elements, pertaining to both the music and the improvisers, such as *lyrics, program, body, motor, verbal reaction,* and so on. Once musical elements have been rated along the profiles, the resulting data are interpreted for possible meanings pertaining to various aspects of the client's therapeutic work.

The primary purpose of the IAPs is to help generate insights that facilitate the therapy process (Bruscia 1987), as has been demonstrated in music therapy assessment (e.g. Wigram

1999, 2004). However, the IAPs have also been employed in music therapy research (e.g. Gardstrom 2004; Hiller 1994; Leeseberg 1994; McFerran-Skewes 2000; Wosch 2002).

RepGrid

RepGrid is one component of the software suite called Rep IV (2004). It is based upon the *repertory grid technique*, originally developed by George Kelly (1955), progenitor of the field of personal construct psychology. A brief overview of RepGrid is provided here. For a comprehensive description of the RepGrid process specific to music therapy research, refer to Abrams and Meadows (2005), upon which much of the information on RepGrid provided here is based.[1] Moreover, for a complete description of RepGrid's features, as well as information on accessing and utilizing RepGrid, consult the Centre for Person-Computer Studies[2] or visit www.repgrid.com.

RepGrid is designed to help one explore various experiences, events, processes, persons, and objects that comprise one's world. This consists of identifying elements, or various dimensions of similarity and distinction among specific members of a given phenomenon. One compares the elements according to where each fits along various *constructs*, or numerical scale continua between two contrasting attributes, pertaining to all elements in ways that describe and differentiate them. Constructs can be pre-specified (as in the application discussed here), or can be elicited through a series of random comparisons among elements. One positions each element at a specific point along each construct's scale range, according to one's sense of how strongly or clearly the element demonstrates the characteristic at one end of the construct scale as opposed to the other. A single scale range is common to all constructs within a given RepGrid session, at a level of precision specified at the outset of the RepGrid session. The process of positioning elements along construct scales generates a single matrix known as a *repertory grid*, from which the term *RepGrid* was derived.

The process of positioning a single set of elements along a single set of constructs establishes a common reference system, anchored in a common scale range. Within this reference system, the element placements along a given construct represent not only the construct's individual character, but also its relationship to all other constructs, according to relative degrees of similarity and/or difference. Likewise, each element's set of positions across all constructs stands in relationship to those of all other elements. Collectively, the interrelationships among all constructs and elements represent a *construction*, a composite structure expressing the relative salience/significance, alignment, and covariance among the core dimensions of the phenomenon being explored. The construction is a whole that transcends

1 The author gratefully acknowledges Barcelona Publishers for kindly providing permission to reproduce certain materials concerning RepGrid from Abrams and Meadows (2005).

2 Centre for Person-Computer Studies, 3635 Ocean View Crescent, Cobble Hill, BC V0R 1L1, Canada.

the sum of its individual parts (i.e. the elements and constructs) in both scope and depth, and as such can help provide important insights about a given phenomenon beyond what the parts alone may reveal.

The application of IAPs and RepGrid to microanalysis of clinical improvisation

There is virtually no question that the IAPs themselves can represent an effective means of analyzing individual moments of an improvisation for the purpose of microanalysis, and that it is possible to synthesize and interpret IAP data in a way that generates holistic meaning for each musical moment. However, the integration of RepGrid into this process offers a systematic dimension that can enhance and enrich it in a number of different ways.

RepGrid can produce composite meaning structures concerning specific moments of an improvisation, based upon simultaneous interrelationships among multiple profiles within a given moment. This provides unique levels of dimensionality and depth in understanding both the individual and collective roles of the profiles within the context of a given improvisation. Because a RepGrid construction of an improvisation can be generated strictly by positioning each individual musical element along each individual profile, the process requires awareness only of the immediate, clear, surface features of the music. No conscious, deliberate synthesis of these surface features is required, as the deep structures are implied by virtue of the purely mathematical relationships among the numerical grid values alone. One is therefore free to remain genuinely naïve to potential patterns of interrelationship (although any deep structures revealed by RepGrid must ultimately be interpreted in some way – a matter addressed here, in the Method section).

Through generating a RepGrid construction, characteristics of the music that appear unrelated, disparate, or paradoxically opposed on their surface may be revealed as closely aligned in the scheme of the construction; likewise, those which appear closely related may be revealed as less related. In either case, one is challenged to reevaluate superficial understandings of the music in light of the construction as a whole. Moreover, while individual distortions (conscious or unconscious) may occur when positioning certain elements along certain profiles, a systematic distortion of the whole construction is relatively unlikely (as it would have to be systematically engineered). Thus a RepGrid construction is a uniquely trustworthy source for potentially valuable insights concerning an improvisation, due to aspects of the music that may otherwise remain tacit, implicit, and/or unconscious.

RepGrid is particularly well suited to IAP microanalysis, as IAPs are essentially construct continua between pairs of contrasting characteristics, along which certain elements (i.e. musical elements) are positioned in order to describe them. It is notable that in the IAPs each profile includes a different set of musical (and some extramusical) element subscales, and thus there is no common set of musical elements across all profiles (Bruscia 1987); yet RepGrid requires that every construct involve the very same set of elements within a given grid (which is the basis for the grid interrelationships that define RepGrid itself). Thus the present application represents an adaptation of the IAPs, based upon the assumption that there remains sufficient commonality among the musical elements across profiles to maintain the original integrity and applicability of the IAPs themselves.

Of course, there are various limitations to the use of RepGrid in music microanalysis. Not every musical phenomenon can be reduced to a set of finite elements and bilateral constructs, nor can every element relate to every construct with equal relevancy (sometimes the matter can be "forced" in this regard). Moreover, no matter how many micro-moments are analyzed within a single improvisation using RepGrid, each grid is a static structure, which is morphologically inconsistent with the way music is actually experienced as flowing through lived time.

Method: RepGrid process for IAP microanalysis

The RepGrid program is flexible and can be tailored according to specific purposes. For application to IAP microanalysis, the RepGrid process consists of a five-stage process:

1. identifying improvisation segments

2. selecting musical elements and preparing IAPs

3. positioning musical elements along profiles

4. processing the data

5. interpreting the processed data.

1. Identifying improvisation segments

The analyzer begins by considering how the overall improvisation (or session) is to be divided into temporal segments. Divisions may be based upon points of functional significance in the music itself, upon some predetermined set of divisions in the music, or upon a random distribution of divisions. Likewise, the music may be divided according to either musical time units (i.e. beats, measures, phrase lengths, etc.) or standard "clock" time units (i.e. seconds, minutes, etc.). These choices should be based upon the specific context and purpose of the microanalysis.

Once the music is divided into segments, the analyzer creates recorded excerpts of each improvisation segment, arranged accessibly in a way that facilitates multiple, comparative listenings (digital sound editing software may prove particularly useful for this purpose[3]). Each segment should be clearly labeled (on the physical recording media and/or electronically, as applicable), according to its temporal location within the improvisation, the session to which it belongs, and the client(s) and therapist(s) involved in the music making.

3 Examples of digital sound editing software include: Audacity, a free, open source software package (http://audacity.sourceforge.net); Wavepad, available from NCH Swift Sound (www.nch.com.au/wavepad); GoldWave, available from Goldwave, Inc. (www.goldwave.com); and SoundEdit/Audio Editor Pro, available from Audioutilities, Inc. (www.audioutilities.com/sound-edit).

2. Selecting musical elements and preparing IAPs

The analyzer selects for inclusion in the microanalysis those musical elements (timbre, volume, tempo, meter, rhythm, melody, harmony, etc.) that are sufficiently salient and relevant across all improvisation segments, and enters verbal labels for each of these elements directly into the RepGrid program. Musical elements may be understood in different ways, in relation to different profiles. For example, in certain instances, elements may best be understood in terms of *part-whole* relationships, or how individual sound components relate the larger musical structures; or, likewise, in terms of *figure-ground* relationships, or how the musical background relates to the musical foreground (Bruscia 1987). However, should very specific elements such as *rhythmic figure* or *rhythmic ground* be included, they must apply meaningfully across all profiles for a given improvisation.

After selecting the musical elements, the analyzer prepares the IAPs to function as the grid constructs. This is accomplished by entering the verbal labels for each profile's scale anchors (i.e. the contrasting characteristics, as described previously) directly into the RepGrid program.

3. Positioning musical elements along profiles

In IAP microanalysis, the analyzer must position the entire set of musical elements along the entire set of profiles, for each improvisation segment. The analyzer positions (or "rates") each element along each profile continua using the five-point IAP scale. Because IAPs involve specific, descriptive terms for each of the scale gradations (as described previously), the analyzer must consider these terms and their meanings when positioning the elements. In addition, the analyzer must consider (as applicable) both *intramusical* and *intermusical* dimensions of the music, as well as both *intrapersonal* and *interpersonal* dimensions of the music making, with respect to each profile. Refer to Bruscia (1987) for an explanation of these terms and how they apply to improvisation analysis.

The process described above produces a grid, in the form of a rectangular matrix of numerical values, each indicating the polarity of a particular element (represented by column, identified by verbal labels at the lower border of the matrix) along a particular profile (represented by row, identified by verbal labels for each of the polar characteristics on the left and right borders of the matrix). The lower the number, the more it indicates polarity of the element toward the profile characteristic on the left border; likewise, the higher the number, the more it indicates polarity of the element toward the profile characteristic on the right border. Refer to A7.1–A7.3 on the web-based resources for examples of completed grids.

It is worthy of note that the orientation of scale values in relation to particular polar attributes is arbitrary. The scale values within constructs serve as reference points only, and are not intrinsically related to the meaning of the polar attributes. Although one must consider meanings of the terms assigned to the poles of constructs in order to position elements, the RepGrid program recognizes these terms as alphanumeric patterns only, with no bearing on the construction itself. Thus for purposes of understanding the construction,

two different profiles with exactly opposite element polarities (with respect to the orienta-
tion in which they were originally entered into the RepGrid program) are considered func-
tionally identical – albeit with one profile's poles reversed from its original orientation. This
happens to be consistent with the nature of the IAPs, as there is no intrinsically common
factor defining lower versus higher scale values across profiles. However, because specific
scale degrees do carry specific meanings in the IAPs, it is important that the profiles are
initially oriented, as specified by Bruscia (1987).

4. Processing the data

While a construction is embodied within a completed grid, it is not immediately accessible in
that form. Therefore, an algorithmic device must be utilized in order to process and "unlock"
the construction within the grid.

An algorithmic device ideal for this purpose is PrinGrid (a device closely related to the
statistical multifactor ANOVA). PrinGrid identifies a set of mathematical structures called
components. A component consists of a particular pattern of weighted values, called *loadings*,
expressing the degree to which each particular element and construct contributes to defining
the character of the component. Thus every component carries loading values for each and
every element and construct, in a certain distribution of relative weightings. In turn, each
component's particular loading pattern accounts for a certain percentage of the overall
variance (or diversity) of the grid data (i.e. its various polarity values), and therefore bears a
corresponding degree of importance in defining the general character of the construction as
a whole.

The PrinGrid algorithm is designed to seek out the most efficient solutions in account-
ing for the overall variance, so that the first component always accounts for as much of the
variance as is possible for any single component (and therefore carries the greatest signifi-
cance in defining the construction's character), and so that the second component accounts
for as much of the remaining variance as is possible (and therefore carries the second greatest
significance in defining the construction's character), and so on. While the percentage of
variance for which each component accounts is different from grid to grid, the *principal* (first
and second) components (from which the "Prin" in PrinGrid is derived) together typically
occupy the greater share of overall data variance, and are thus adequate for a basic under-
standing of the construction.

PrinGrid can represent the processed grid construction in the form of a two-dimen-
sional, spatial diagram, expressing the relative interrelationships among all constructs and
elements simultaneously (i.e. with respect to the construction as a singular whole). In the
PrinGrid diagram, constructs are represented as straight lines (labeled at each end with the
construct's polar attributes) passing directly through the center of the diagram space, collec-
tively forming a "starburst" pattern. Components are represented by the axes of the diagram,
so that the first component involves the collective distinction between all construct poles on
the left side versus those on the right side of the diagram, and the second component
involves the collective distinction between all construct poles on the top versus those on the

bottom of the diagram. Each component axis is labeled with the component's rank number, as well as the specific percentage of data variance for which the component accounts.

The degree to which a given construct is loaded on a component is expressed by its relative alignment with the axis representing that component. Because components beyond the second cannot be represented as axes in the two-dimensional diagram, construct line lengths are shortened to the extent that they are loaded on components beyond the second. Moreover, because each construct line passes through the diagram center at a point representing that construct's mean element ratings values, off-center line placement indicates asymmetrical ratings relative to that construct's two poles (i.e. ratings that favor one end over the other, indicating an asymmetrical influence with respect to various components, and to the overall construction). Thus relative alignment, overall size, and centeredness among constructs are all expressions of each construct's role, with respect to the overall construction.

Elements, too, are included in the PrinGrid diagram. They are represented as labeled points, positioned according to their collective loading values on all components, simultaneously (i.e. their collective, simultaneous polarity ratings on all constructs).

For the purposes of IAP microanalysis, each improvisation segment grid must be processed by PrinGrid. In a given segment's PrinGrid diagram, the spatial arrangement of construct lines represents the interrelationships among all of the profiles simultaneously, revealing the construction's principal components and their relative significance in defining the character of that segment. Similarly, the constellation of element points represents the interrelationships among all of the musical elements, which likewise defines their relative roles in defining the character of the segment. Refer to A7.4–A7.6 on the web-based resources for examples of PrinGrid diagrams.

5. Interpreting the processed data

In RepGrid, the results of an algorithmically processed grid represent interrelationships among the various dimensions of a construction. However, these interrelationships exist on a purely quantitative, relational level only. As such, the results of the computer-analyzed data are not intrinsically meaningful, and therefore require *interpretation* in a manner consistent with specific purposes and theoretical orientations.

In the case of IAP microanalysis, the analyzer must accomplish interpretation in two sub-phases. First, she or he must interpret constructions *within* each segment of the featured improvisation. Second, she or he must interpret constructions *across* all segments, in order to understand the clinical process and any significant changes, occurring within the overall improvisation. Although each of these two steps are discussed briefly here, no specific procedure will be prescribed, both because the IAPs are not bound to any single theoretical orientation (Bruscia 1987), and because interpretations of constructions emerging from the RepGrid process are largely dependent upon the purpose, context, and theoretical orientation within which the process is framed (Abrams and Meadows 2005). In any case, this phase of the process should incorporate the general guidelines for interpreting the profiles, as well as the orientation-specific guidelines for understanding the musical elements, both as delineated by Bruscia (1987).

To interpret constructions within each improvisation segment, the analyzer reviews the grid data as processed by the PrinGrid algorithm, in order to identify the major dimensions of the construction, and to formulate some type of meaning for each of those dimensions. This reveals the primary ways in which the analyzer has construed the improvisation segment – in other words, the most salient, defining features of the segment, and how they interrelate. One way to accomplish this (as featured in the present chapter) is to formulate meanings for the structures emerging from the combination of *all* components (principal or otherwise) within the grid. These structures may be termed *meta-components* (Abrams and Meadows 2005). Meta-components are derived from the visual properties of the PrinGrid diagram, which constitute a single, spatial expression of the overall construction as a whole, and which account for *all* of the data variance at once, by incorporating the entire spectrum of components (i.e. the overall character of the construction) simultaneously.

In the present application, meta-components appear as groupings of profile lines and musical element points on the PrinGrid diagram, each representing composite structures accounting for the overall character of the improvisation segment *across* components (according to the analyzer's visual, qualitative judgment calls of what constitutes such "groupings"). The analyzer then formulates a collective meaning for each meta-component, taking into account both the relative influence of each profile (according to the centrality, the length, and the centeredness of each construct line within the meta-component grouping) and the relative influence of each element (based upon its centrality among a given grouping of construct lines, and its polarity on one side of the grouping versus the other) on the overall character of each meta-component.

The resulting meaning structures take the form of continua (as they are based upon meta-components that are built upon profile constructs, which are themselves continua), but it is up to the analyzer to make sense of these continua in some particular way. For example, the analyzer may blend all individual profile qualities into composite profiles to describe core continua operating in the client's music. By contrast, the analyzer may choose to preserve individual profile qualities, while focusing upon the way(s) and degree(s) to which those qualities interrelate within a given component or meta-component; in turn, this would carry implications about how certain meanings and/or experiences occur together for the client within the context of a given improvisation segment. Likewise, the analyzer may choose whether or not to blend the individual meanings of musical elements.

In addition, the analyzer must take into account the relative significance of each meta-component, in terms of how it describes the overall character of the improvisation segment itself. This is accomplished by considering a combination of the axial alignment and line lengths of each meta-component (in its entirety) – the greater the alignment with the horizontal axis, and the greater the line lengths within the construct grouping, the greater its overall significance with respect to the improvisational segment. This is only one

of a number of possible ways in which to interpret constructions of the improvisation segments.[4]

Once meaning has been derived for each improvisation segment, the analyzer interprets constructions across segments. This is accomplished by comparing and contrasting the meanings across the segments, in order to identify the greater processes and meanings pertaining to the overall improvisation, along with any specific patterns indicating significant clinical change. The specific manner in which the analyzer accomplishes this depends upon the nature of the analyzer's interpretations (of each segment), as well as the specific context and theoretical orientation framing the overall microanalysis.

Case example

The case example (provided in A7.7 on the web-based resources) represents an IAP microanalysis of an approximately five-minute improvisation from a fictitious case example. The improvisation is based upon a five-minute excerpt from one in a series of music therapy sessions involving a 42-year-old male client being treated for depression at a community (outpatient) psychiatric rehabilitation clinic. The therapist who improvises with the client works from within a psychodynamic orientation.

In the case example, the musical characteristics of the improvisational excerpt are described, and rationales both for dividing the excerpt into segments and for selecting featured musical elements for analysis purposes are provided. Next, RepGrid data are provided for each of the identified improvisation segments, including each data set as processed through the PrinGrid algorithm. Finally, based upon the processed RepGrid data, interpretations within and across the improvisation segments are provided, specifically from a psychodynamic perspective (for illustration purposes).

4 For example, an alternative approach that is more precise, but somewhat less comprehensive, is to formulate meanings for each of the principal components themselves (as opposed to meta-components). In this approach the analyzer establishes a threshold criterion for how much data variance a given component must account in order for it to qualify as *principal* (i.e. significant). Then, for each component that qualifies, the analyzer formulates a collective meaning for all profiles in the grid as loaded on that particular component, to determine their relative contribution to the meaning of the component. In so doing, the analyzer considers the absolute values of profile loadings, as any negative loading value simply represents the original profile with its poles reversed from their original orientation (the reason that this original orientation is ultimately arbitrary, as discussed earlier). The analyzer does the same for each principal component with respect to musical elements. Once again, the analyzer considers absolute values for element loadings as signifying each element's strength in defining the component – however, the analyzer does consider that negative versus positive element loading values indicate the polarity of the element's influence, along the component continuum. Finally, the analyzer determines how much influence each component exerts within the overall improvisational segment according to the percentage of data variance for which the component accounts.

The case illustrates the power of this form of microanalysis, in that it uncovers and explicates otherwise tacit interrelationships among the various elements of the music experience as understood by the therapist. The case findings reveal a number of significant dimensions of the client's music-psychological process, which in turn could serve to inform the therapist about ongoing work with the client.

Summary and future considerations

The combination of IAPs and RepGrid offers a potentially valuable resource in the microanalysis of clinical improvisation. In practice, it can be used for assessment purposes, to track client progress, and to evaluate treatment effectiveness. When the client is included as an active participant, it may serve to enhance her or his self-understanding. Simultaneously, it may deepen both the client's and therapist's understanding of the therapy process (including the therapeutic relationship). Moreover, it may also serve to help ground and legitimize a music therapist's often subjective, art-centered understandings of therapy, when collaborating with a more scientifically oriented, multidisciplinary health care team.

There are a number of variations on how RepGrid may be utilized in applications of microanalysis in music therapy. For example, it is interesting to consider the possible outcomes of allowing RepGrid to elicit the musical elements and constructs (from client and/or therapist) pertaining to an improvisation, rather than pre-specifying them. RepGrid may also be applied to microanalysis of sessions featuring forms of music experience other than improvisation, such as Guided Imagery and Music (GIM). An example of an instrument based upon multiple continua that may be adapted for this purpose is the GIM-R (Bruscia 2000), developed to evaluate client responsiveness in GIM sessions. Of course, an analyzer can also develop her or his own set of continua for purposes such as this. Finally, it may of value to apply RepGrid for the purposes of therapist self-microanalysis, in which the microanalysis features the therapist's own moment-to-moment experiences in therapy. For example, a method such as Modes of Consciousness (Bruscia 1995), originally designed as a moment-to-moment analysis of the therapist's experience, may be adapted in the form of multiple continua that are compatible with RepGrid.

Of course, at this purely theoretical phase, it is difficult to assess the various advantages and limitations of the proposed method. It is to be hoped this question will be addressed through future exploration of its role and function in actual music therapy practice.[5]

5 To discuss the application of microanalysis presented in this chapter, please contact the author. See the list of contributors at the end of this book.

References

Abrams, B. and Meadows, A. (2005) "Personal Construct Psychology and the Repertory Grid Technique." In B.L. Wheeler (ed.) *Music Therapy Research*, 2nd edn. Gilsum, NH: Barcelona Publishers.

Bruscia, K.E. (1987) *Improvisational Models of Music Therapy*. Springfield, IL: Charles C. Thomas.

Bruscia, K.E. (1995) "Modes of Consciousness in Guided Imagery and Music (GIM): A Therapist's Experience of Guiding." In C.B. Kenny (ed.) *Listening, Playing, Creating: Essays in the Power of Sound*. Albany, NY: State University of New York Press.

Bruscia, K.E. (2000) "A scale for assessing responsiveness to guided imagery and music." *Journal of the Association for Music and Imagery 7*, 1–7.

Gardstrom, S.C. (2004) "An Investigation of Meaning in Clinical Music Improvisation with Troubled Adolescents." In B. Abrams (ed.) *Qualitative Inquiries in Music Therapy*. Gilsum, NH: Barcelona Publishers.

Hiller, J. (1994) "Relationship between Music and Self-concept." Unpublished master's thesis, Temple University, Philadelphia, PA.

Kelly, G.A. (1955) *The Psychology of Personal Constructs*. New York: W.W. Norton.

Lee, C. (1989) "Structural analysis of therapeutic improvisatory music." *Journal of British Music Therapy 3*, 11–19.

Lee, C. (1990) "Structural analysis of post-tonal therapeutic improvisatory music." *Journal of British Music Therapy 4*, 6–20.

Lee, C. (2000) "A method of analyzing improvisations in music therapy." *Journal of Music Therapy 37*, 147–67.

Leeseberg, M. (1994) "Assessment of Family Relationships through Musical Improvisation." Unpublished master's thesis, Temple University, Philadelphia, PA.

McFerran-Skewes, K. (2000) "From the mouths of babes: the response of six younger, bereaved teenagers to the experience of psychodynamic music therapy." *Australian Journal of Music Therapy 11*, 3–22.

Nordoff, P. and Robbins, C. (1971) *Therapy in Music for Handicapped Children*. London: Victor Gollancz.

Nordoff, P. and Robbins, C. (1977) *Creative Music Therapy*. New York: Harper and Row.

Nordoff, P. and Robbins, C. (1985) "Scale III: Musical Response." Unpublished manuscript.

Priestley, M. (1975) *Music Therapy in Action*. St Louis: Magnamusic-Baton.

Rep IV (2004) [Computer software.] Cobble Hill, British Columbia, Canada: Centre for Person-Computer Studies.

Wigram, T. (1999) "Assessment methods in music therapy: a humanistic or natural science framework?" *Nordic Journal of Music Therapy 8*, 6–24.

Wigram, T. (2004) *Improvisation. Methods and Techniques for Music Therapy Clinicians, Students and Educators*. London: Jessica Kingsley Publishers.

Wosch, T. (2002) *Emotionale Mikroprozesse musikalischer Interaktionen*. Berlin, Münster and New York: Waxmann.

References

Part Two

Music Microanalyses

Chapter 8

Using Voice Analysis Software to Analyse the Sung and Spoken Voice

Felicity Baker

Introduction

The microanalysis techniques described in this chapter were developed to assess changes to the speaking and singing characteristics of clients during and following their participation in music therapy. The techniques employ software programs that were originally designed for speech and language therapists. The advantages of these programs lie in their ability to detect subtle (but clinically important) vocal changes that cannot be accurately perceived by the human ear. The longer a clinician works with a client, the greater tendency the clinician has to 'tune in' to the client's individualised style of speaking. Therefore, the clinician may over-estimate client progress. The software analysis allows for treatment evaluations to be accurate and objective.

The analysis procedures presented here were developed for clinical work undertaken with young males who had sustained traumatic brain injury (TBI) (Baker 2004). However, these approaches would be suitable for other populations, particularly in the area of neurodegenerative diseases, in mental health, and with hearing impaired people, where clients' clinical condition may impact on their potential to express emotion in their voices.

The chapter begins with an outline of the voice, and how the components of the voice are subtly manipulated to express different emotional states. The Method of analysis section then describes the procedures adopted including presenting a series of screen shots which explain how to use the software program. The reader is directed to listen to the audio samples which accompany the screenshots on the web-based resources.

Why analyse vocal intonation patterns?

Intonation is the term used to describe the overall shape and contour of the spoken phrase, the rises and falls in pitch over time without regard for the exact pitch intervals (Patel *et al.* 1998). Intonation is a necessary component in communicating the emotional intent of the speaker. It is well established that intonation contours serve as mirrors of people's emotional

state (Bolinger 1989), the bridge between their inner and outer worlds where mood, emotion, thought and experience are revealed (Newham 1998). Therefore, any loss in a person's ability to manipulate intonation contour during speech places them at risk of being misunderstood by the listener. Every intonation contour is created by combining several individual components related to pitch usage – pitch height, pitch range, pitch variation and pitch slope. When referring to pitch throughout this chapter, the reader is encouraged to consider that pitch may be measured in Hertz (Hz) (the most accurate method) or in semitones. Choice of measurement is dependent upon which measure is the more meaningful and measured the most easily at the time of analysis. Table 8.1 defines each of the intonation components.

Table 8.1: Components of intonation contours

Component	Description	Subjective measure	Objective measure (or software measure)*
Pitch height	Mean pitch/mean frequency of the voice over a specified time	Low, medium or high	Fundamental frequency (F_0) measured in Hz
Pitch slope	Rate of changes in pitch or frequency	Steep – rapid pitch/frequency changes Flat – slow and gradual changes	Frequency per second or semitone per second from one designated point to another
Pitch range	Entire range of frequencies/semitones (lowest to highest) within a specified audio segment	Small, medium or wide pitch range	Semitones Frequency
Pitch variation	The variability of pitch within a specified audio segment	Large or small variability	F_0 variability (F_0 var.)/semitone variability – the standard deviation of the F_0

* Semitones often have more meaning for music therapists than frequency measures. Converting frequency measures into semitone measures will be explained in the Method of analysis section.

Research shows that stereotypical patterns exist when people verbally express each of the four basic emotions – happiness, sadness, anger and fear (e.g. Bachorowski 1999; Mozziconacci and Hermes 1997; Pittman 1994). For example, when people express anger, they typically employ a high pitched voice, steep slopes, wide pitch ranges, and high variability of pitch (Table 8.2).

Table 8.2: Intonation characteristics for basic emotions

Intonation component	Anger	Sadness	Happiness	Fear
Pitch variation	Large	Small	Large	Small/Large*
Pitch height	High	Low	High	High
Slope	Steep	Gradual	Steep	Steep/Gradual
Pitch range	Wide	Narrow	Wide	Wide

* Denotes inconsistencies in the research findings.

The voice and its speaking patterns are influenced by the neurological processes, the physiological state and the emotional state of the speaker (Baker 2005b; Baker and Wigram 2004). One should not underestimate the impact that physiological (tension, relaxation, fatigue) and emotional states (anger, anxiety, depression, elation) have on the elasticity of the vocal folds. For example, fatigue reduces the elasticity of the laryngeal muscles lowering the pitch of the voice, its pitch range, and resulting in a more monotone-sounding contour (Welham and Maclagan 2003). Similarly, hormone secretions associated with emotional responses affect the larynx and therefore voice production (Benninger 1994). It is common for clients with TBI to display poor vocal control and a limited pitch range caused by disruption to neurological pathways, physiological tension and fatigue, and their emotional state. These clients are often angry or depressed as they try to come to terms with acquiring the brain injury and its associated impairments.

In my own clinical work I have found that music therapy techniques such as song singing and vocal exercises can enhance the emotional expressive potential of clients who have received neurological trauma TBI (Baker 2005a, 2005b; Baker and Tamplin 2006; Baker and Wigram 2004; Baker, Wigram and Gold 2005). By analysing the components of intonation (Table 8.1) within audio samples of clients' singing and speaking, the clinician is able to examine how the music therapy sessions affect the expressive potential of his clients.

Method of analysis

There are several steps that the clinician must undertake to analyse session material:

Step 1: Implementation of music therapy session

Step 2: Recording audio material from the session

Step 3: Selecting and storing relevant audio data

Step 4: Uploading the audio wave files into the software

Step 5: Trimming the uploaded wave file for analysis

Step 6: Pitch smoothing

Step 7: Software analysis

Step 8: Interpretation of data.

Step 9: Visually analysing the contour.

Each of these steps contains a set of procedures, each of which will be now described in detail.

The case study of Craig is used throughout this section to illustrate the analysis process. At 27 years of age, Craig was involved in a motor vehicle accident which resulted in a TBI with predominant diagnosis of a diffuse axonal injury and a bilateral frontal injury. On admission to emergency services, he had a Glasgow Coma Scale score of 3 and remained in coma and posttraumatic amnesia for two months. Five months later, he was referred to music therapy to address his poor intonation. Assessment indicated he had a pitch height moderately below the norm for his age, he demonstrated poor pitch control and was monotone in his verbal communication. The described microanalysis that follows is built on the data from Craig's fifth session of music therapy. A total of 15 sessions were conducted with Craig and session 5 was randomly selected for presentation here.

Step 1: Implementation of music therapy session

When working clinically with clients who have had a TBI to address their impaired intonation, a typical session would contain three separate phases, all of which should be recorded using high quality recording equipment (see Step 2). The first phase involves the client participating in a series of speaking and singing-based exercises designed specifically to collect baseline data of the client's speaking and singing characteristics. These exercises could include exploring the maximum pitch range the client can sing, singing a series of intervals increasing in size, asking the client to sing sustained notes, sing at different volumes, etc. (see Baker and Tamplin 2006 for more examples).

As the aim of the music therapy sessions is to rehabilitate the speaking voice, collecting baseline data on spoken phrases is also important. To collect this data for analysis, ask the client to, for example, tell you a little about himself or to read some short sentences or phrases, encouraging him to read them expressively and sensitively. When I work with clients, I ask them to say the sentences 'I feel *happy* (*angry/sad/afraid*) today' and encourage them to say each of the sentences in a way that would best reflect their meaning.

The second phase of the session comprises the client singing songs either solo or together with the therapist. Some musical accompaniment should be provided to assist the client here. In Craig's case, the songs used were: *I heard it through the grapevine*, performed by Creedence Clearwater Revival, *Comfortably numb*, performed by Pink Floyd, and *Under the bridge*, performed by The Red Hot Chili Peppers.

The third phase in the session is a repeat of the singing and speaking-based exercises implemented during phase one. This provides the data which can be analysed and compared with the baseline data.

Step 2: Recording audio material from the session

Data cannot be analysed using powerful software if a poor recording has been obtained. Therefore, the clinician should take time to ensure the best audio signal can be captured prior to commencing a session. First, ensure that the music therapy session is provided in a quiet environment so that interfering external sounds are kept at a minimum. There is nothing more frustrating than the pleasant sounds of a bird singing in the background of an important client recording. As this software analyses all sounds and frequencies, what will result is the generation of data which includes the analysis of high frequencies present in the bird singing (or some other external noise), or the low frequencies caused by the drone of an air-conditioner. In other words, the interference of extraneous sounds will contaminate the analysis and result in unreliable data.

Clients can be unpredictable and turn away from the microphone; they may accidentally knock the microphone, or move their heads around so the microphone does not remain at a consistent distance from the client's mouth. These situations can lead to an inconsistent audio signal with potential contamination from extraneous sounds. Therefore, a small investment in a good microphone headset – microphones used by pop musicians like Kylie Minogue, which are placed on the head – is recommended. Preferably select a uni-directional microphone so the therapist's voice won't contaminate the signal.

Similarly, the audio signal should be recorded digitally using a high quality recording device such as a mini-disc or MP3 recorder which can then be transferred to a personal computer and saved as wave files. Again, the higher quality the recording device, the cleaner your audio recording and the more reliable the data. Alternatively, if convenient, the audio signal can be directly recorded into the personal computer.

Once audio files are transferred to a personal computer, the clinician should set up a clear and systematic labelling system. It is very easy to make errors when working with hundreds of wave files!

Step 3: Selecting and storing relevant audio data

At this point, the audio recording may be of a 30-minute session and is saved as a very large wave file. The analysis software described later in this chapter is unable to upload such large files so the clinician should divide the 30-minute recording into smaller sections and save these as separate files. This can be carried out using relatively inexpensive downloadable software such as Adobe Audition.

Carefully consider what will be analysed and discard unnecessary sections and periods of silence (e.g. between the singing of two songs). Save the files and again label them carefully and systematically. The clinician should always retain a copy of the audio recording of the original session in its uninterrupted form in case previously deleted sections of the audio are later required.

Step 4: Uploading the audio wave files into the software

Several voice analysis tools are available on the market, varying extensively in quality and price. The product described here is Multi-Speech™ model 3700 with the Real Time Pitch 5121 module, a Windows-based speech analysis program that uses standard multimedia hardware to capture, display, analyse and play speech (and singing) samples. The product, along with several other potentially useful products, can be purchased through Kay Elemetrics via online ordering system www.kayelemetrics.com/. Depending upon requirements, Kay Elemetrics product prices vary from US$1500 to US$5000 (in July 2007). The analyses performed by this software generate statistics which include F_0 (fundamental frequency), length of audio sample (in milliseconds), maximum and minimum frequencies, standard deviation, number of semitones, and semitone range. It can also generate information on intensity levels (decibel levels).

To upload the wave files into Multi-Speech™, open up the program and then open and select a wave file from the folder that you wish to import for analysis (Figure 8.1).

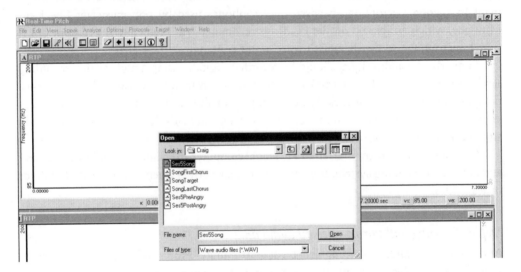

Figure 8.1: Uploading a wave file into Multi-Speech™

The default setting sets the display to five seconds. When the duration of the recording is longer than five seconds, only the first five seconds will be seen on the screen. The display can be adjusted so that wave files longer than five seconds are displayed. To do this, select the *options* function on the toolbar and a window with various tools will appear. Go to the *display* window and adjust the *display duration* to the length of the audio sample or to the maximum of 60 seconds (Figure 8.2).

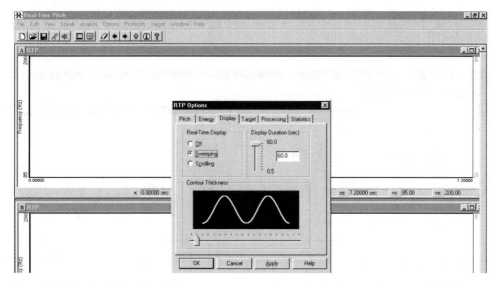

Figure 8.2: Adjusting the duration display

When the wave file has been imported, a graphic representation will be displayed. Figure 8.3 illustrates the first 60 seconds of Craig singing the song *Under the bridge* by The Red Hot Chili Peppers (refer to audio sample A8.1 on the web-based resources).

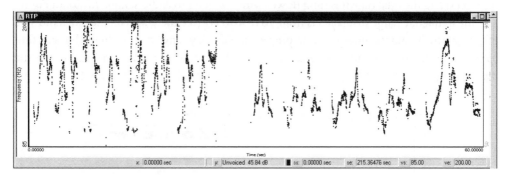

Figure 8.3: Pitch contour of Craig's singing

Step 5: Trimming the uploaded wave file for analysis

In examining micro-changes to Craig's singing, I am interested in establishing whether he becomes more accurate in his singing of the chorus phrase 'Take me all the way' on repeated singing, and I may also be interested in determining how he might perform this phrase relative to the artist (or therapist). Therefore, the next step is to 'trim' the wave file displayed in Figure 8.3 so that only the relevant phrase to be analysed remains. Using the cursor, select the points where you want to delete sections and then trim the wave file accordingly. In Figure 8.4 the audio from the beginning of the recording (left hand side of screen) to the cursor point is being deleted by selecting *edit* from the toolbar, scrolling down to *trim portions*

of the signal, and selecting the item *remove signal start to cursor*. The software is relatively easy to navigate and quite flexible.

Figure 8.4: Trimming the data in Multi-Speech™

Once this process of trimming has been performed, only the target song phrase or spoken phrase should be displayed in the window. A second song phrase can be uploaded in the lower window and trimmed for comparison. Figure 8.5 illustrates the phrase 'Take me all the way' the first time it is sung (upper window; refer to audio sample A8.2 on the web-based resources) and the final time it is sung (lower window; refer to audio sample A8.3). In Figure 8.5, the frequency range displayed is from 50 to 400 Hz (see the y-axis on the left-hand side of the graph). To aid the interpretation process, the display range can be altered by selecting *options* from the toolbar and then selecting the *pitch* window. In Figure 8.5 I am setting the display range to 85–235 Hz, with the resulting graph displayed in Figure 8.6.

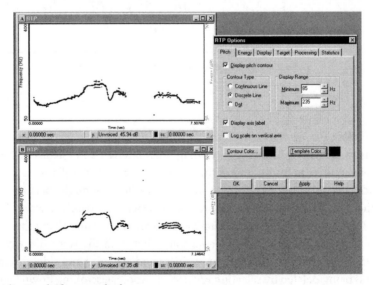

Figure 8.5: Adjusting the frequency display

Step 6: Pitch smoothing

When audio files are uploaded into the software, artefact sounds such as noise, hiss and popping may be seen on the display (as illustrated by the arrows in Figure 8.6). These sounds will invariably distort the analysis and steps should be taken to minimise this impact. Pitch smoothing is a technique which can minimise the effect of artefact noise. Pitch smoothing, a post-processing function of the software, removes isolated and outlying pitch values from the pitch contour, and then redraws the cleaned-up contour. The statistical analysis of pitch that is subsequently performed would not include these values. To perform pitch smoothing, select *apply pitch smoothing* from the Edit toolbar.

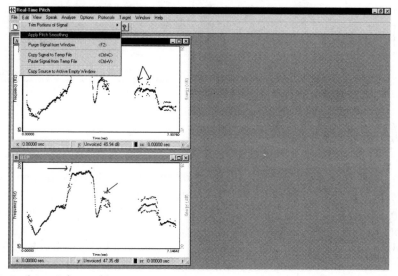

Figure 8.6: Applying pitch smoothing

Step 7: Software analysis

Now that the files have been uploaded and pitch smoothing applied, the statistical analyses can now be executed. This is achieved by selecting *analyse* on the toolbar. The software then provides a summary of the analysis according to various components (Figure 8.7). The important analyses illustrated in Figure 8.7 are: the mean F_0 (the average pitch of the voice); the frequency/semitone range; and the maximum and minimum frequencies/semitones. The standard deviation represents the variability (the higher the standard deviation, the less monotone the person's voice is likely to be). Notice in Figure 8.7 that there is a third window displaying an audio file which, in this case, is the therapist's singing of the same song phrase (refer to audio sample A8.4).

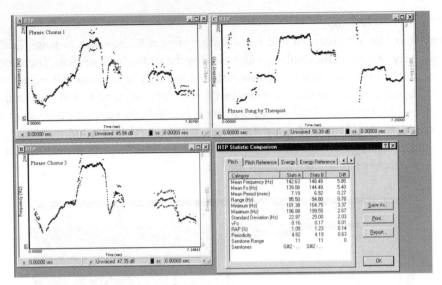

Figure 8.7: Statistical data from audio sample

Step 8: Interpretation of data

The next step in the microanalysis process is the interpretation of the numerical data. Two sentences taken from the beginning and end of one of Craig's sessions were chosen to exemplify the interpretation process. Figure 8.8 illustrates the visual display of the intonation contour of Craig's performance of the words 'feel angry' with the upper window representing the pre-session performance (refer to audio sample A8.5) and the lower window representing the post-session performance (refer to audio sample A8.6). The text box details the statistical analyses for both audio samples which indicate that, at the end of the session, Craig says 'feel angry' with greater pitch height (F_0: post-session F_0 was 6.12 Hz higher than the pre-session); his pitch range was greater (one semitone more post-session) and the standard deviation (which represents the degree of pitch variability) is also greater post-session (5.2 Hz).[1]

To calculate slope, two consecutive syllables in an audio sample should be chosen and the audio file trimmed so that only the two syllables remain for processing. In Craig's case, it was decided to calculate the slope between the syllables 'an-gry', so all remaining audio outside this portion of the recording including the silences has been deleted (Figure 8.9). Note the duration of the audio (circled in Figure 8.9) as this is the duration Craig takes to move from the highest to the lowest pitch. When the analysis is performed on these two samples, the results indicate that the pre-session audio has a smaller semitone range than the post-session but, at the same time, the time it takes Craig to move from the highest to the

1 If the clinician prefers, he may transform the standard deviation into a semitone measure, using the following logarithmic transformation: $SVS = \log_{\sqrt[12]{2}}\left(\dfrac{F_0 + SD(F_0)}{F_0}\right)$.

Figure 8.8: Results of analysis for speech contained in two audio files

lowest pitch is also shorter. This data can be used to calculate the slope by dividing the number of semitones between the highest to the lowest pitch, by the total time. For the pre-session audio, it would equate to 7 (number of semitones) divided by 0.27 seconds. The result is a slope of 25.92 semitones per second. For the post-session, the result is 26.85 semitones per second.[2]

From these interpretations the clinician can then return to the question being addressed in this microanalysis process – is Craig more capable of creating the intonation pattern that reflects a feeling of anger following music therapy? Referring back to Table 8.1, a person would typically use wide pitch ranges, large pitch variations, steep slopes and a high pitch height to communicate anger. As Craig increased his pitch variability, pitch height and slope and widened his pitch range post-session, this suggests that Craig has made an improvement in his potential to express anger.

The same analyses were performed for the sentences expressing happiness, sadness and fear (audio samples A8.7–A8.12) with the associated contour displays and analyses presented in A8.1–A8.3 on the web-based resources. A summary of these analyses from session 5 indicated that Craig became more accurate in his expression of fear and anger but not of sadness and happiness.

The microanalysis of Craig's vocal range was also implemented for his performance at the beginning and end of the session. Pre-session, Craig was able to sing a minimum

2 For a more precise calculation, the clinician could transform the frequency measures (highest and lowest frequencies) into semitones using the following logarithmic transformation: $slope = \dfrac{\log_{\sqrt[12]{2}}(F_{higher} / F_{lower})}{time}$

Figure 8.9: Software displays for analysis of slope

frequency of 99.8 Hz and a maximum of 214.7 Hz and post-session his range increased to a minimum of 86 Hz and maximum of 224 Hz.

Step 9: *Visually analysing the contour*

As mentioned in Step 5, recordings of the songs were also studied to determine whether Craig became more controlled in his singing over the course of singing a single song. The visual displays generated by the program can be used as evidence of change. Figure 8.7 illustrates the contour from the first chorus and the third chorus of the song sung by Craig (audio samples A8.2 and A8.3) and also illustrates the therapist's sung version of this song. The therapist's singing is characterised by clear changes in pitch and controlled sustained notes. Conversely, Craig's singing of this phrase is characterised by slides in pitch from one pitch to the next and difficulties in sustaining a single controlled note. The third chorus is notably more controlled than the first chorus, particularly in the lead up to the high-pitched note. The numerical data generated by the software might also be useful in determining whether Craig managed to pitch the highest note more accurately in one sample when compared with another. This small analysis suggests that Craig's singing becomes more controlled with practice.

Summary

The method of microanalysis used here can be applied by clinicians and researchers to provide objective and precise data on client progress, which may provide more satisfactory evidence to funding bodies and insurance companies of music therapy's clinical efficacy and

value. The method could be taught to music therapy students to illustrate the extent to which music therapy outcomes can be measured at the most 'micro' of levels.

While the focus of this chapter was on clinical work with TBI clients, as intonation is a reflection of a person's emotional state, these techniques could potentially be applied across a range of clinical populations where disturbances in intonation patterns are common place, particularly in the areas of neurology, mental health, hearing impairment and Parkinson's Disease. Technology is rapidly changing and improving, so by the time this chapter goes to print there will undoubtedly be further advances enabling more detailed analysis and potentially simpler to use. It is likely to become cheaper as well. Clinicians, researchers, educators and students should take this into consideration before purchasing any software.

References

Bachorowski, J. (1999) 'Vocal expression and perception of emotion.' *Current Directions in Psychological Science 8*, 2, 53–7.

Baker, F. (2004) 'The Effects of Song Singing on the Improvements of Affective Intonation of Brain Injured People.' Unpublished PhD thesis, Aalborg Unviersity.

Baker, F. (2005a) 'Neuaufbau von fertigkeiten zur verbalisation.' In S. Jochims (ed.) *Musiktherapie in der Neurorehabilitation Internationale Konzepte, Forschung und Praxis.* Bad Honnef: Hippocampus Verlag.

Baker, F. (2005b) 'Verbesserung affektiver intonation.' In S. Jochims (ed.) *Musiktherapie in der Neurorehabilitation Internationale Konzepte, Forschung und Praxis.* Bad Honnef: Hippocampus Verlag.

Baker, F. and Tamplin, J. (2006) *Music Therapy in Neurorehabilitation: A Clinician's Manual.* London: Jessica Kingsley Publishers.

Baker, F. and Wigram, T. (2004) 'Rehabilitating the uninflected voice: finding climax and cadence.' *Music Therapy Perspectives 22*, 1, 4–10.

Baker, F., Wigram, T. and Gold, C. (2005) 'The effects of a song-singing programme on the affective speaking intonation of people with traumatic brain injury.' *Brain Injury 19*, 7, 519–28.

Benninger, M.S. (1994) 'Medical Disorders in the Vocal Artist.' In M.S. Benninger, B.H. Jacobson and A.F. Johnson (eds) *Vocal Arts Medicine: The Care and Prevention of Professional Voice Disorders.* New York: Thieme Medical Pub. Inc.

Bolinger, D. (1989) *Intonation and its Parts: Melody in Grammar and Discourse.* London: Edward Arnold.

Mozziconacci, S.J.L. and Hermes, D.J. (1997) 'A study of intonation patterns in speech expressing emotion or attitude: production and perception.' *IPO Annual Progress Report 32*, 154–60.

Newham, P. (1998) 'Voicework as Therapy: The Artistic Use of Singing and Vocal Sound to Heal Mind and Body.' In S.K. Levine and E.G. Levine (eds) *Foundations of Expressive Arts Therapy: Theoretical and Clinical Perspectives.* London: Jessica Kingsley Publishers.

Patel, A.D., Peretz, I., Tramo, M. and Labreque, R. (1998) 'Processing prosodic and musical patterns: a neuropsychological investigation.' *Brain and Language 61*, 123–44.

Pittman, J. (1994) *Voice in Social Interaction: An Interdisciplinary Approach.* Thousand Oaks, CA, London and New Delhi: Sage Publications Inc.

Welham, N.V. and Maclagan, M.A. (2003) 'Vocal fatigue: current knowledge and future directions.' *Journal of Voice 17*, 1, 21–30.

Analysis of Notated Music Examples Selected from Improvisations of Psychotic Patients

Jos De Backer and Tony Wigram

Introduction

The method of microanalysis described in this chapter was developed in a doctoral study at the University of Aalborg investigating the process from sensorial playing to musical form in patients with psychosis (De Backer 2004). This qualitative study involved phenomenological analysis of musical and verbal material, discussions in intervision and the personal reflections of the therapist. The part of this study that is relevant to this chapter is the explication of a microanalysis of a section of improvised music from a music therapy session that was video recorded and notated. The analysis of notated musical material is strongly advocated by many music therapy researchers (Aldridge 1997; Ansdell 1996; Lee 1996; Schumacher 1998). The results of this analysis provide a framework for associating musical material to pathology and health within a clinical context. This chapter is concerned with explaining the process of analysing and describing musical elements in a notated score.

Theoretical frame

Psychosis and music

A psychotic patient lives in a world of presence. He is the defenceless prey of thoughts and sensorial impressions which haunt him continuously. The frontiers between the inside and outside world are so unstable and transparent that it often seems that his psyche finds itself outside rather than inside. The world and the internal movements of drives are not represented in an inner space, but they are characterized by an immediate and brutal presence. Because they can no longer fulfil their representative activity, even words are treated as meaningless things, as pure sound objects (Lacan 1981; Van Camp 2003).

Working in music therapy with psychotic patients, one sometimes encounters character-istic, repetitive and consistently similar musical patterns. Psychotic patients tend to express their experiences and conflicts in musical improvisations, by 'fragmented' play, or by con-stantly repeating rhythms or small melodic sequences. From clinical supervision and a general overview of relevant psychoanalytic and other psychotherapeutic literature, looking specifically at Bion (1967); Dührsen (1999); Fonagy and Target (1996, 2000); Lacan (1955, 1981); Ogden (1997); Tustin (1990); Van Bouwel (2003); and Van Camp (2003), it became clear to us that this style of playing (with repetitive rhythms and melodic fragments) could be understood as an expression of a psychotic's 'sensorial play'. Patients with acute psychotic disorder cannot experience this music as something from themselves; they are only sounding sounds in which they are not implicated. They are not 'inspired' by the music. That means that music playing is not really an 'experience' for them. We learn that when patients become psychotic, and thereafter, they do not tend to have a psychic space for symbolization by which they could appropriate the musical object. In terms of music therapy that means that they are not able to allow or to reach a musical form.

The capacity to have an experience can be seriously disturbed and even destroyed in psychopathology. Therefore it is extremely important that the music therapist can find out how the transition from sensorial impression to musical form can happen. It is essential that we verify to what extent there might be a correspondence between the obvious, empirical changes on the musical level and the subjective experience by the patient.

Method

Treatment sessions and data collection

The music therapy treatment of the patients took place in their familiar therapeutic environ-ment. The therapist was a full member of the ward staff where the patients were hospitalized. The treatment itself was kept as authentic as possible, without any conscious interventions that could influence or contaminate the research.

To safeguard the validity of this research it was necessary to record all the sessions. Robson (2002) is convinced that a valid description of what the researcher has seen or heard lies in the accuracy or completeness of the data. He suggests that audio or videotaping should be carried out wherever feasible.

In this research project we preferred the video material over the audio material, because video material gives a lot more information about micro movements, physical behaviour, facial expression, ways of playing and moving etc. Louven (2004) made a comparison between sound and video recordings and concluded from the research that video registration demonstrates a greater accuracy towards the interpretation of 'feeling qualities' than audio recordings.

Intra- and interpersonal (i.e. subjective) experiences and physical sensations could not be registered on the video recording. In order to overcome this, it was important that the therapist wrote down his immediate impressions and reflections after each session. From

these impressions and reflections he could register the necessary intersubjective experiences for this research.

The most important research material, the musical material, needs to be selected in a systematic way, and from objective and subjective perspectives, involving a colleague or supervisor. Guaranteeing the reliability and validity in both clinical work and qualitative research demands extra attention. The following areas should be addressed in order to increase the validity in the following three areas: construct validity (Maso 1989), transferential validity (Smaling 1987) and communicative validity (Kvale 1994).

Data selection: Selection of the musical fragments to analyse

Selecting the video fragments was undertaken with great care, because this was the central research material needed to define the phenomena of sensorial play, moments of synchronicity and musical form. The results from the doctoral study enriched the definitions and characteristics of these types of play, and can now inform this method. While sensorial play will be treated in depth in this chapter to illustrate the method of analysis, limitations of space allow only reference to the final definition of musical form. The findings from the study explicating *moments of synchronicity* and *musical form* will be published elsewhere (De Backer 2006 and 2007), and see A9.1 on the web-based resources.

Sensorial play

Sensorial play is a term describing the characteristic playing of a patient where, while producing sounds, the patient is not able to connect with or experience these sounds as coming from him or herself. The patient's music is characterized by repetitiveness and/or fragmentation. The improvisation cannot really be begun nor ended, and there is no clear melodic, rhythmic or harmonic development, no variation and no recapitulation. The patient is perceptually and emotionally detached from his or her own musical production.

Improvising is, therefore, not a real 'experience' for the patient. She or he is not inspired or affected by the music and remains disconnected from the sounds and the playing. There is an absence of shared playing and intersubjectivity with the therapist in the sense that the patient does not engage in the joint music. The sounds remain outside the patient and do not have any connection to him or her. In terms of the psychopathology of psychotic patients, one can say they cannot create a psychic space that allows symbolization, thus making it impossible for them to appropriate musical material. The music therapist experiences the patient as isolated, and becomes completely caught up in the patient's music (behaviour) and is not free to introduce his own musical images. Therefore no interaction is possible, and it is impossible to engage in a shared timbre in the 'co-play' (De Backer 2004, pp.268–9).

The list of features of sensorial play in Figure 9.1, itemized within defined categories, is inclusive, and some (but not all) items are present in an analysis of improvised music.

<table>
<tr>
<td>

Form:

1. There is no anticipation (sensed by the presence of an inner sound) of a musical beginning and ending. This is represented in the music by endless play or by abrupt termination of the music

2. There is almost no musical development. The content and style of the music is repetitive, unchanging and/or fragmented

3. The structure is limited and rigid, with a lack of dynamic variability

4. The individual notes and melodic and/or rhythmic fragments are not related to each other

</td>
<td>

Musical aspects:

1. Random playing (tonal and atonal)

2. Repetitive and/or fragmented play

3. Significant lack of phrasing

4. Significant lack of dynamics

5. Significant lack of variation

6. An absence of silence in the music

</td>
</tr>
</table>

Figure 9.1: Criteria of Sensorial Play (CoSP) (Source: De Backer 2004, p.270)

Further categories of Criteria of Sensorial Play can be seen in A9.2 on the web-based resources.

The analysis involves a number of steps for the selection, transcription, analysis and documentation of the relevant clinical improvisational material for exploring the musical and therapeutic process. Some of the analysis described here was undertaken for a doctoral research study, and in everyday clinical work a shortened version of the process may not include, for example, the clinical intervision stage (although there may be commentary and reflection from supervision that would further validate the conclusions of a clinical analysis). The steps involved are as follows:

Step 1: Overview of improvisations in a session

Step 2: Selection of representative musical characteristics

Step 3: Verification of chosen excerpts

Step 4: Selection of video fragments for analysis

Step 5: Notation of scores

Step 6: Structure of the musical analysis

Step 7: Method for the presentation of results

Step 8: Description of non-musical aspects of the selected video excerpts.

STEP 1: OVERVIEW OF IMPROVISATIONS IN A SESSION

Overview all the video-recorded improvisations in a session. Mark the characteristics in the musical improvisations under the following categories:

- choice of instruments
- musical parameters (rhythm, melody, tempo etc.)
- musical interventions (patient or music therapist)
- interaction
- physical posture.

Compare them with the therapist's personal record. (This step is necessary to have an overview of all the musical material and not to lose the context of the microanalysis.)

STEP 2: SELECTION OF REPRESENTATIVE MUSICAL CHARACTERISTICS

Select the most significant characteristics in musical phenomena that occurred in the musical improvisations; for example: repetitive play, fragmented play, phrasing or no phrasing, rhythmical, melodic or harmonic developing or no developing, silence or no silence. Search for the exact detail from the above categories of the selected excerpt that can be identified through an analysis to represent sensorial play, moments of synchronicity and musical form.

STEP 3: VERIFICATION OF CHOSEN EXCERPTS

Listen to the musical improvisation without visual observation and verify the previous selection from the improvisations.

STEP 4: SELECTION OF VIDEO FRAGMENTS FOR ANALYSIS

Select fragments from the chosen video excerpts that last no longer than one minute each (see Figure 9.2). As seen in the study, in a fragment lasting one minute, there was enough time to 'perceive' the specific features of one of the three phenomena (sensorial play, moments of synchronicity and musical form), so that the nature or the formlessness, the posture, the psychological aspects, the interactions, the interventions and musical parameters could be both audibly and visually experienced by an observer. The rationale for this was that fragments shorter than one minute would not provide enough material to allow the detailed study of different components or offer an overall context for the type of playing (sensorial play, moments of synchronicity and musical form). Longer fragments were not necessary because all of the essential elements that can identify the patient's music to be within the categories of sensorial play could be found. Comparing the selection of the video excerpt with the therapist's impression notes follows on from this part of the process.

Check the selection from the research intervision with a supervisor and an independent, external music therapist recruited in order to provide an objective external opinion. This opinion related to the selection of the excerpts for analysis, which were based in meeting the criteria for the three phenomena of sensorial play, emerging changes in the patient's music and musical form.

The selection of video excerpts of the session is of fundamental importance. These selected excerpts are the central research material for the analyses and results.

Figure 9.2: Example of selection of video excerpts from the patient's sessions

An external music therapist, who was not involved in this research, was recruited to watch the video material of all the improvisations in all the sessions, and to define the musical playing in them into one of three categories, as follows: sensorial play, emerging changes in the patient's music and musical form. The musical material in each improvisation could also be subdivided into any of the three categories. The independent music therapist received the description and the main criteria for each of these three phenomena. The independent music therapist's choice of category for the musical material and the subdivision of the musical fragments to categories was necessary in order to established whether there was a correlation to the categorizations of the musical material in the excerpts selected by the researcher.

The second observer was the supervisor, who had watched the video material of all the sessions during the research intervision and, on the basis of the description and the main criteria of the three phenomena being evaluated, to see if the selected excerpts were representative of the three phenomena.

STEP 5: NOTATION OF SCORES

The process by which the excerpts are notated and analysed, and by which interpretations were made, is important, and the way in which this was achieved is highly relevant in establishing the connection between clinical process and research analysis inherent to this project.

Notated scores of the musical material in the musical improvisations should be made as accurately as possible from the video recordings of the sessions. Where practicable the stable material of the patient can be notated into rhythmic and melodic patterns in order to demonstrate aspects of potential structure. The musical material of both patient and therapist can be included and differentiated in the scores. Dynamics, phrasing and other marks of expression should also be included in the scores to give a sense of the presence or absence of affect in the musical material. The following musical parameters are included as potential descriptors: rhythm, melody, harmony, phrasing, dynamics, tempo, timbre, pulse, silence and volume. (See A9.3 on the web-based resources.)

STEP 6: STRUCTURE OF THE MUSICAL ANALYSIS

The scores should be analysed and the notated figures marked in a structured way to identify the relevant sections and points in the scores.

The common musical structures can be indicated as follows:

1. Major sections are marked with a letter A or indicated by a structural term: Coda

2. Subsequent major sections that are variations on major sections are indicated with an apostrophe. For example, A' is a variation of A.

3. Smaller subsections are marked with a lower case letter; for example: a

4. Phrasing and complete musical phrases are indicated with slur lines, as follows:

5. Repeated motifs are identified with a lower case letter, for example: 'a-motif'

6. Variations of motifs are shown with an apostrophe against the lower case letter, for example: 'a'-motif'

7. Musical cells and their variations are indicated by a lower case letter preceded with a number; for example: 'a1', 'a2'

8. Melodic or rhythmic repetitions are indicated with the following:

9. In order to structure the score wherever possible bars or measures are used, even when the measure is not exact. Where there is an extended play without bars or any sense of metre, timespan is then indicated in seconds.

10. Accents and other dynamics that are important for the structure are shown in normal musical notation terminology.

11. A vertical, wavy line indicates interruptions to the flow of the music, or to the session.

12. Other scoring characteristics are as follows:

 (a) If necessary left-hand or right-hand playing is indicated, in order to illustrate the physical aspect of the music.

 (b) Other specific musical phenomena are indicated as glissandi, ascending, descending, rallentandi and tremolo.

 (c) The tempo is always shown at the beginning of a stave, with any variations in tempi also indicated in the score.

 (d) Dynamic signs such as *forte, piano, mezzo piano* etc. are used to signify the intensity of sound in the music.

 (e) Examples may also include musical intervention where the above parameters identify inter-musical events between patient and therapist.

 (f) References to numbers in the text within brackets () refer to selected points in the notated score.

STEP 7: METHOD FOR THE PRESENTATION OF RESULTS

Each phase of the process should be described and interpreted from an analysis of the data that was collected as described above, and presented in the format listed below:

- description of the selected video excerpt
- a notated score of each excerpt and a description of the musical elements
- selected comments from the patient relating to his/her experience of playing
- selected impressions and reflections from the therapist about the patient's way of playing
- selected reflections from clinical intervision/clinical supervision.

The style of presentation of the results under these headings will vary because some material contains factual description, while other aspects represent personal reflection and interpretation. Therefore, in order to provide a clear method of presentation, each stage in the analysis should be defined regarding the style of information presented and the style of presentation. The presentation of these results represents a process over time. Consequently the interpretations of the musical material in the early stages of the analysis raise questions that are added to these stages, and discussed later following the subsequent analysis of the latter stages of the therapy.

STEP 8: DESCRIPTION OF NON-MUSICAL ASPECTS OF THE SELECTED VIDEO EXCERPTS

The style of presentation of the data is a factual description of the behaviour in patient and therapist together with an interpretation of the general atmosphere. Areas to be considered are as follows:

- position of patient and therapist in the therapy room
- instrument of patient and therapist
- posture (tension of the body) of patient and therapist
- facial expression of patient and therapist
- actions of patient and therapist
- visual references between patient and therapist.

In addition an evaluation of the atmosphere apparent during the excerpt should be described, based on the context of the whole session and the improvisation, and taking into consideration the observed behaviour.

Clinical application of the analysis process

This method of microanalysis was developed for a doctoral research study, and as such it is a method more applicable to research. However, the findings of the study provide a useful and short form of deductive analysis using the definitions of form and musical aspects of sensorial play, and corresponding definitions of form and musical aspects for moments of

synchronicity and musical form are also published in a doctoral thesis, available at the homepage of the Doctoral School of Music Therapy, Aalborg University, Denmark (De Backer 2004). In this thesis further aspects of sensorial play, moments of synchronicity and musical form are defined, including psychic aspects, aspects of body posture and aspects of interpersonality/intrapersonality (from the music therapist's point of view).

Case example of sensorial play

The patient

The patient (Marianne) located the beginning of her troubles around the age of 20, when an intense relationship came to an end. She then began to suffer increasingly from feelings of fear, which did not allow her to lead an independent life. She became increasingly more convinced that her mother was controlling her and that she even hired other people to control her. Marianne expressed her demand for individual musical therapy in the following way, saying: 'I am blocked in my creative possibilities. There are a lot of bottled-up feelings inside of me, but the moment I want to express them, I just can't. What can I do? I would like to work on that.'

Description of the selected video excerpt

The patient and the therapist are sitting at a slight angle to each other and between them are two alto-metallophones. The patient sits motionless, a little bent over, without any facial expression and with her elbows pressed against her body. There is no observable tension in her body. She is not searching for eye contact with the therapist, looking only at the alto-metallophone that she chose for herself. The patient also chooses an alto-metallophone for the therapist.

While the therapist is in the process of putting a mallet on the floor, the patient starts to play, with no preparation or hesitation. Her arms move up and down in endless, alternating motoric movements. Her play is repetitive, never-ending, without phrasing, without any dynamics or nuance and without any apparent self-awareness or interaction with herself or the therapist. No noticeable single rhythmic, melodic or harmonic development occurs. There is no movement in the patient's body that has any connection with what she is playing. The patient's facial expression and body posture seem to be rather frozen and only her arms move loosely. The therapist sits motionless, his head bowed, his elbows resting on his legs, sunk in himself and listening to the patient's play. His listening position seems like a reflection of the patient's, which is that of a depressed person.

The therapist starts playing together with the patient after 24 seconds, sensing and joining the patient's metre. His body is able to move in relation to his own musical phrasing. It is as if his body is breathing with the music he is playing.

The atmosphere is muddy, the music sounds empty and without any intention, interaction or meaning. For the listener, no source of inspiration can be found in this music.

A notated score of the excerpt and a description of the musical elements

The patient starts to play immediately, without any preparation or hesitation. There is no 'anticipating inner silence'[1] at the beginning of her improvisation. Her play is endlessly repetitive and has an interminable quality, which one can interpret as a kind of musical 'rocking'. Musically there is no phrasing, no dynamics and no accentuation, with no melodic or harmonic development. The music has the following characteristics: it is a random, atonal melody with alternating intervals and repetitive play. Rhythmically, there is no development and it is without a metre or pulse. The volume does not change and in this excerpt no musical theme can be heard.

As the therapist could hear and experience in this musical excerpt, and as we can see in the notated score (Figure 9.3), all notes are completely isolated from one another. No single note has any relation to what happened previously or what might happen after. There are a series of successive sounds that are not organized by silence, with no motion and no variety of dynamics. The lack of structure is significant here.

The musical play of the therapist is different. Searching for the patient's metre, the therapist begins to play the bass line. The bass line sounds more peaceful than her sensorial play, and though without much dynamic there is phrasing. Musically, he does not provoke the patient to add any new elements to her play.

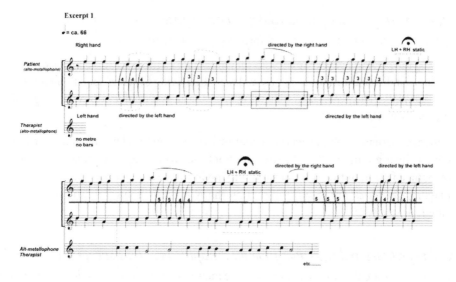

Figure 9.3: Score of excerpt

1 The term 'anticipating inner silence' relates to the silence before the first sound is heard, and the inner sound emerging from that silence. Each authentic musical play originates from this anticipated silence, which makes it possible that one can come into resonance with oneself and, in a music therapeutic context, with the other.

This musical excerpt illustrates clearly the formlessness of the musical subject. Through an initial musical analysis of the succession of sounds within the melody line, the movement and direction of the melody seems to be involuntary and random. Initially one cannot see an obvious pattern, but through a closer examination it is apparent that a few musical structures appear, such as a series of parallel thirds, fourths and fifths (3, 4, 5). The melodic movement is mainly directed by the left hand. We can also notice two musical pauses (organ points in the first and second system), where both hands appear to stagnate. It is possible to state that there is a certain (even though not yet clearly pronounced) phrasing, with structures that originate spontaneously and non-intentionally. It is as if this could be music that starts looking for a form from its own self-generated product, or alternatively music that is the product of pure coincidence. There might also be an inherent musical tendency on the part of the patient to search for a form in the music, evidenced through the presence of traumatic repetitiveness in her playing.

The empathic listening stance of the therapist is illustrated in his musical play, in which he produces an almost identical melody line to the bass line of the patient (second system). This happens intuitively and is definitely not consciously mirrored. The instruments are opposite to one another, so that it is out of the question that there is a direct imitation of the hands.

Selected comment from the patient relating to her experience of playing

The patient's reflection after the free improvisation was as follows:

> During the playing I am occupied with thoughts, but I cannot give this any place in the music. And then I just continue to play and then the playing becomes something routine and automatic. The play is then something mechanical, as if to hit out at something and then not think about it.

The patient experiences her musical contribution as something that is separated from her and something she is not in touch with. She does not have any feeling of connectedness with it. She recognized nothing from this music as relating in any way to her. She is not connected to her playing, and does not 'own' the sounds she is making; therefore, she is not able to describe it in words.

Selected impressions and reflections from the therapist about the patient's way of playing

In the beginning the therapist tried to trace the metre that the patient would use, to join her play and to come into contact with her. But the therapist became desperate when he noticed that all his efforts were fruitless. The sound object remained an amorphous mass, floating in space without any aim, like a mush that neither the patient nor he could grasp. It was something that left from nowhere and that kept on spinning around aimlessly within itself.

Selected reflections from clinical intervision

The patient plays in a motoric way, at a sensorial level and without being consciously aware of what she is doing. Although it does have a flowing motion, the therapist is not able to describe her play as a melody. In the beginning, the therapist sensed her metre and he started with a 'bourdon'[2] in order to give her sensorial play a clear base, so that her music was grounded. He then developed the music towards a melody. In the beginning the therapist faltered a little and played a melody under her flowing music. This introduction of a melody allows for imagination and the possibility of recapturing something and thus developing 'memory'. To recapture something is to take something up again, to vary it and to do something with it – to develop it. In this way the therapist contained the patient's music and brought the repetitiveness to a close. This meant that he created a psychic space in which a communication with the patient could become possible.

It is interesting that in the beginning the therapist only focused on the music; that is, on the sound-world. It was only afterwards that he was focused on the patient, as if he needed a musical space first (i.e. a psychic space) in which to come into contact with the patient. One can only have an image of the other if the right conditions are present where an image might arise. In music, this condition is noticeable in the reprise of a musical form (proto-symbolism). Through a melody, and its reprise, by remembering and through everything that does not fall within the monotony of the patient's music, a musical form was introduced by the therapist. The absence of musical form (melody, bourdon) occurs particularly in the music therapeutic treatment of psychosis. This pathology seems to go hand in hand with it being impossible to remember and imagine anything, or to come to an image. The therapist tried to create conditions, through the introduction of musical form, to make it possible for the patient to come to an image, or to remember something.

Conclusion

From a systematic analysis of the selected video fragments of the sessions, one could clearly observe an evolution in the musical play of the patients, and in their psychological and inter-relational behaviour through, and as a consequence of, their musical material. The musical analysis of these video fragments made clear many hidden musical structures. Through these extended analyses, three clear phenomena (that can also be defined as musical/therapeutic phases) could be distinguished in the music therapy process, each with their own specific characteristics with regard to form, musical aspects, psychological aspects, aspects of body posture and aspects of interpersonal/intrapersonal experiences from the music therapist's point of view.

2 A bourdon is described as the use by client or therapist of a two-note interval played simultaneously. The interval is normally a fourth or a fifth. The bourdon can be played through a stepwise melodic line.

On the basis of the analysis, these three phenomena (i.e. the three phases in the therapy) were described as: sensorial play, moments of synchronicity and musical form. A further musical analysis of aspects of the score was undertaken by a composer, showing musical patterns and forms in the client's playing, and this analysis is explicated in A9.4 on the web-based resources.

Relevance of musical analysis

For clinical practice musical analysis is interesting because it is a way to see if there are specific musical cells or unconscious structures in the improvisations which are not audible and able to be experienced during a superficial listening. These do not need to have any direct consequences for the research, but they are a confirmation that music searches for a structure. Even if one is engaged in sensorial play in which one is not yet able to appropriate the music, it is that music from which those already non-appropriated structures can originate. The music goes its own direction, and as a therapist one has to support that.

In music structures originate to which we escape. At the moment that one is guided by the music, one becomes subjected. From the music a call goes out through which the subject can exist already a little in regards to the music. In improvisation the subject comes under the influence of the music and is caught by the music. In the first place, this is caused by the rhythmic pulsing. There is a kind of repetition phenomenon here, which is not pure repetition. Certain psychotic patients do not have their own internal pulsing, and play without any metre. Within the transference the therapist offers the patient the possibility to come into a kind of pulsing. This is a very magical moment ('moment of synchronicity'), that is the basis of symbolism, and can lead to a breakthrough in the therapy. The music anticipates something which is not yet there, a type of structure, within which the patient possibly can enter. These are mirroring experiences, which are described by Lacan (1966). The mirroring is the fact that one does not coincide with oneself. That there is not one, but something which is torn apart, that is the basis of each symbolization.

Essential in the thinking about music in music therapy is that music acquires a certain autonomy coming from itself, not only in the expression of the person who improvises. This is contrary to the theory of projective identification, which takes as a point of departure the concept of an expression-thought (that is already there as a thought of image). In sensorial play much already happens on the level of the resonance which means that it does not take place on a subjective level. There is already a kind of echo-effect at a sensorial level, and not on the level of the imagination. The symbolizing capacity and potential of music therapy however is primarily connected to the autonomy of the music.

References

Aldridge, G. (1997) 'Die Entwicklung einer Melodie im Verlauf einer Improvisation. Spontane Ausdrucks-möglichkeiten in der Musiktherapie mit einer Brustkrebspatientin.' In D. Aldridge (ed.) *Kairos I. Beiträge zur Musiktherapie in der Medizin*. Berne: Hans Huber, pp.21–7.

Ansdell, G. (1996) 'Talking about music therapy. A dilemma and a qualitative experiment.' *British Journal of Music Therapy 10*, 4–16.

Bion, W.R. (1967) *Second Thoughts. Selected Papers on Psycho-Analysis.* London: Maresfield Library.

De Backer, J. (2004) 'Music and Psychosis. The Transition from Sensorial Play to Musical Form by Psychotic Patients in a Music Therapy Process.' Unpublished doctoral dissertation, University of Aalborg, http://www.musikterapi.aau.dk/forskerskolen_index.htm.

De Backer, J. (2006) 'Musikalische Form und Psychose. Eine klinische Forschung.' In U. Rentmeister (ed.) *'Lärmende Stille im Kopf'. Musiktherapie in der Psychiatrie.* Wiesbaden: Reichert Verlag, pp.55–76.

De Backer, J. (2007) 'The Case of Adrian.' In S. Metzner (ed.) *Psychoanalytische Musiktherapie – Fallstudien.* Göttingen: Vandenhoeck and Ruprecht (in press).

Dührsen, S. (1999) *Handlung und Symbol: Ambulante Analytisch Orientierte Therapie mit Psychosepatienten.* Göttingen: Vandenhoeck and Ruprecht.

Fonagy, P. and Target, M. (1996) 'Playing with reality. I: Theory of mind and the normal development of psychic reality.' *International Journal of Psychoanalysis 77*, 217–33.

Fonagy, P. and Target, M. (2000) 'Playing with reality. III: The persistence of dual psychic reality in borderline patients.' *International Journal of Psychoanalysis 81*, 853–74.

Kvale, S. (1994) 'Ten standard objections to qualitative research interviews.' *Journal of Phenomenological Psychology 25*, 1–28.

Lacan, J. (1955) 'On a Question Preliminary to any Possible Treatment of Psychosis.' In *Ecrits: A Selection.* London: Tavistock/Routledge.

Lacan, J. (1966) 'Le stade du miroir comme formateur de la fonction du Je.' In *Ecrits.* Paris: Seuil, pp.93–100.

Lacan, J. (1981) *Le Séminaire, Livre III, Les Psychoses (1955–1956).* Paris: Seuil.

Lee, C. (1996) *Music at the Edge. The Music Therapy Experiences of a Musician with Aids.* London: Routledge.

Louven, C. (2004) 'Die Beurteilung der Gefühlsqualitäten von Stimmimprovisationen. Ein Vergleich von Ton- und Videoaufnahmen.' *Musiktherapeutische Umschau 25*, 2, 144–53.

Maso, I. (1989) *Kwalitatief Onderzoek.* Meppel: Boom.

Ogden, T.H. (1997) *Reverie and Interpretation. Sensing Something Human.* New Jersey: Jason Aronson Inc.

Robson, C. (2002) *Real World Research*, 2nd edn. Oxford: Blackwell Publishers.

Schumacher, K. (1998) *Musiktherapie und Säuglingsforschung.* Frankfurt am Main: Peter Lang.

Smaling, A. (1987) *Methodologische Objectiviteit en Kwalitatief Onderzoek.* Lisse: Swets and Zeitlinger.

Sutton, J. (2001) '"The Invisible Handshake". An investigation of free musical improvisation as a form of conversation.' Unpublished doctoral dissertation, University of Ulster.

Tustin, F. (1990) *The Projective Shell in Children and Adults.* London: Karnac Books.

Van Bouwel, L. (2003) 'Van een projectiescherm naar een mentale ruimte: residentiële psychotherapie met jonge psychotische patiënten.' In J. Smet, L. Van Bouwel and R. Vandenborre (eds) *Spreken en Gesproken Worden. Psychoanalyse en Psychosen.* Leuven: Garant, pp.119–44.

Van Camp, J. (2003) 'Tijd en tijdloosheid in de psychose.' In J. Smet, L. Van Bouwel and R. Vandenborre (eds) *Spreken en Gesproken Worden. Psychoanalyse en Psychosen.* Leuven: Garant, pp.145–63.

Chapter 10

Music Therapy Toolbox (MTTB) – An Improvisation Analysis Tool for Clinicians and Researchers

Jaakko Erkkilä

Introduction

The development of the MTTB analysis tool is based on the three-year (2003–2006) research project funded by the Academy of Finland. The objective of the project has been to develop automatic music analysis systems that can be used, among other things, for analyzing improvisations produced in clinical music therapy. The development of the analysis methods is based on the research work carried out during the last ten years by the Music Cognition Group at the University of Jyväskylä.

This method differs from the traditional improvisation analysis methods in many ways. When the computer does the analysis work, the result is a realistic visualization of the analyzed improvisation. In addition, unlike most traditional methods, whereby the improvisation has to be listened to many times in order to do analysis, the MTTB is considerably less time consuming. However, it is difficult to get computers to learn complex musical phenomena such as melody, phrase or pattern, for instance. Thus, they are beyond the properties of the MTTB. Moreover, only MIDI-data (the numerical description of music) can be analyzed with the MTTB. This means that certain musical qualities, such as timbre and sound quality, cannot be included in the analysis. Despite its limitations, the MTTB offers a tool for considering various micro-events within the improvisation. Phenomena such as interaction can be precisely modeled in relation to many musical features.

The MTTB focuses on the music. It does not take into consideration phenomena such as facial expressions and bodily movements, nor does it provide any interpretation of the features extracted. Instead, it offers a precise "graphic notation" of the improvisation, to be further interpreted. It is obvious that other data sources such as video, the therapist's notes, etc. are beneficial when searching for meaning in the MTTB graphs.

To illustrate the MTTB, I have chosen one improvisation for analysis. The improvisation is from the initial assessment of a 16-year-old boy with mental retardation (with autistic

features). He improvises together with the music therapist. In addition to the MTTB analysis, the therapist's comments have been included.

Theoretical background and method of the MTTB

In terms of clinical improvisation, the definitions and conceptions of music are crucial when choosing an appropriate analysis method. Music therapists' scientific stance is typically humanistic. Similarly, musicology with its various approaches has typically been associated with the humanities. As a kind of "mother discipline" musicology, with its various theories, has always had great impact on music therapy. Traditionally, there has been a huge gap between the sciences and the humanities especially from the methodological point of view. The gap can be partly explained by the fact that *immanentism* – the view that music does not exist out there but is constructed and, indeed, constituted by social interaction and discourse which is impenetrable by scientific means of inquiry – has been said to pervade current musicological thinking and writing (Cross 1998).

The influence of the immanentist position can be seen in music therapy literature as well. However, during the last decade the gap between the humanities and the sciences seems to have decreased in musicology. This can be partly explained by the cognitive revolution in the sciences. In musicology, this can be seen as a fast development of empirical and computational musicology. Following Henkjan Honing (2004), computational modeling has become a well-established research method in systematic and cognitive musicology. This development has led to many fruitful collaborations between the humanities and the sciences.

Cross (1998), when speaking about *cognitivism*, sees a cognitive-scientific research program as something including all aspects of the musical mind and musical behavior by theoretical and empirical inquiry, using theoretical and formal modeling and practical experiment. He concludes: 'From the cognitivist perspective music is a product of cultural convention and of the facts of embodiment, being instantiated in the cognitions of the members of culture' (p.211).

The MTTB method is based on computational modeling and on the exact formalization of improvisational expression. Thus the method represents the modern systematic/cognitive musicology that Leman (2003) has defined to be interested in content and meaning, or as a science of musical content processing (see also Clarke and Cook 2004). Hence the MTTB method can be seen as an attempt to bring the paradigm and thinking of modern musicology to music therapy.

I want to point out that a method such as the MTTB is relatively value free, which makes it possible to utilize it with various clinical theories or models. At its best the MTTB gives some objectivity for improvisation analysis from the musical content point of view. In this way it may help clinicians and researchers to ground their interpretations in real musical events and processes.

description of the MTTB method

Because the method utilizes MIDI-data, all the complex algorithms of the MTTB are actually based on relatively simple information. Each note is described with four main parameters. Onset and offset times give the precise dates of the attack and the release of each note. Pitches are indicated independently of any tonal context, as the position of the corresponding key on the keyboard. Velocity indicates the strength of the attack of the note, and gives a detailed account of dynamic levels (Luck *et al.* 2006). What makes the MTTB successful as a tool for researchers is its ability to provide a number-based matrix from any group of improvisations to be further analyzed with statistical methods.

When validating the method, a series of psychological tests (listeners' assessments) have been carried out. In this way it has been possible to assess the appropriateness of the features extracted, as well as their relationship to more complex human evaluation (see the schematic representation of the method in Figure 10.1).

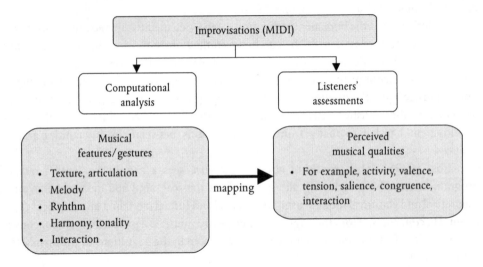

Figure 10.1 A schematic representation of the method for obtaining a system for automated analysis of improvisations

Musical features included in the MTTB

Basically the MTTB is a flexible tool allowing many kinds of feature extraction. However, it is not always appropriate to utilize all the possibilities. Here I will describe only those features that have been utilized in the case example given here. The descriptions below are based on Luck *et al.* (2006).

TEMPORAL SURFACE FEATURES

These features were based on the MIDI note onset and offset positions, and were computed for each position of the sliding window.

- *Note density:* Number of notes in the window divided by the length of the window.

- *Average note duration in the window.*

- *Articulation:* The proportion of short silences in the window. Short silences were defined as intervals no longer than two seconds during which no note was played. These short silences are not included in the silence factor, as they are generally not perceived as real silence, but rather as intermediate pauses characterizing the performance style. Values close to zero indicate *legato* playing, while values close to one indicate *staccato* playing.

REGISTER-RELATED FEATURES

These features were based on the MIDI pitch values of notes, and were computed for each position of the sliding window.

- *Mean pitch.*

- *Standard deviation of pitch*

DYNAMIC-RELATED FEATURE

This feature was based on the MIDI velocity parameter, and was computed for each position of the sliding window.

- *Mean velocity.*

TONALITY-RELATED FEATURE

This feature, based on the Krumhansl-Schmuckler key-finding algorithm (Krumhansl 1990), gives a statistical assessment of the tonal dimension of the improvisations, and was computed for each position of the sliding window.

- *Tonal clarity:* To calculate the value of this feature, the pitch-class distribution within the window was correlated with the 24 key profiles representing each key (12 major keys and 12 minor keys). The maximal correlation value was taken to represent tonal clarity.

DISSONANCE-RELATED FEATURE

- *Sensory dissonance:* Musical dissonance is partly founded on cultural knowledge and normative expectations, and is more suitable for the analysis of improvisation by expert rather than by non-expert musicians. More universal is the concept of *sensory dissonance* (Helmholtz 1877/1954), which is related to the presence of beating phenomena caused by frequency proximity of harmonic components. Sensory dissonance caused by a couple of sinusoids can be easily predicted. The global sensory dissonance generated by a cluster of harmonic

sounds is then computed by adding the elementary dissonances between all the possible pairs of harmonics (Kameoka and Kuriyagawa 1969; Plomp and Levelt 1965). The dissonance measure is based on the instrumental sound (MIDI default piano sound) used during the improvisation. Since successive notes may also appear dissonant, even when not played simultaneously, we also took into consideration the beating effect between notes currently played and notes remaining in a short-term memory (fixed in our model to 1000 milliseconds [ms]). Sensory dissonance was calculated every 1000 ms.

PULSE-RELATED FEATURES

A method was developed which enabled the automatic detection of rhythmic pulsations in MIDI files. More precisely, a temporal function was first constructed by summing Gaussian kernels, i.e. narrow bell curves, centered at the onset point of each note. The height of each Gaussian kernel was proportional to the duration of the respective note; the standard deviation (i.e. the width of the bell curve) was set to 50 ms (see Toiviainen and Snyder 2003). Subsequently the obtained function was subjected to autocorrelation using temporal lags between 250 ms and 1500 ms, corresponding to commonly presented estimates for the lower and upper bounds of perceived pulse sensation (Warren 1993; Westergaard 1975). In accordance with findings in the music perception literature, the values of the autocorrelation function were weighted with a resonance curve having its maximal value at a period of 500 ms (Toiviainen 2001; see also Van Noorden and Moelants 1999). The obtained function will subsequently be referred to as the pulsation function.

Like all the other musical parameters, the pulsation function was computed for each successive position of the sliding window. The analysis of a complete improvisation results in a two-dimensional diagram called a pulsation diagram (Luck *et al.* 2006). From the pulsation diagrams, two musical features were deduced:

- *Individual pulse clarity*: The evolution of the client's and therapist's pulse clarity is obtained by collecting the maximal values of each successive column in the respective pulsation diagram.

- *Individual tempo*: The evolution of the client's and therapist's tempo is obtained by collecting the tempo values associated with the maximum values of each successive column in the respective pulsation diagram.

QUANTIFYING THE CLIENT–THERAPIST INTERACTION

In order to assess the common pulsation developed in synchrony by both players, a new diagram called a synchronized pulsation diagram (Luck *et al.* 2006) was produced by multiplying each individual player's values at respective points of their related pulsation diagrams. Two features were derived from the common pulsation diagram:

- *Common pulse clarity:* Similarly to individual pulse clarity, the evolution of common pulse clarity is given by the maximal pulsation values in the synchronized pulsation diagram.

- *Common tempo:* Similarly to individual tempo, the evolution of common tempo is given by the tempos related to the maximal pulsation values in the synchronized pulsation diagram.

How to use the MTTB

The MTTB is a program available for Windows environments and later for Mac environments as well. The stand alone version (independent on the MATLAB engineering software) is under construction. It will run in both environments and will be released during 2008. Once you have a MIDI-file, created by a digital instrument (such as a synthesizer) and recorded by sequencer software, you are ready to start with the MTTB. For the moment, the MTTB is limited to the analysis of solo and duo (e.g. client–therapist setting) improvisations. Each player should be recorded in a separate MIDI track channel.

Once the MTTB program is launched, a main window is displayed. The list of commands offered by the toolbox is organized along five menus – "Improvisation", "Analysis", "Statistics", "Imitations" and "Preferences" – displayed at the top of the window.

The improvisation to be analyzed is chosen under the command "Load impro" in the "Improvisation" menu. This command opens a file browser, under which the user can pick up the requested file from the computer. A traditional piano roll representation of the chosen MIDI file, for both improvisers, is then displayed at the upper part of the main window.

The "Improvisation" menu also offers the possibility of playing the MIDI sequence through an external MIDI sequencer. The piano-roll representation can be zoomed in and out; the start and end points of the extract to be analyzed can be specified in two ways: either manually by moving a slider or more precisely by entering an exact time in seconds.

The command "Analyze" in the "Analysis" menu opens a new window displaying the list of musical features available for analysis, and offering the chance to select any sub-set of dimensions from this whole list. In addition, the temporal size of the moving window – used in the computation of the musical features – can also be specified in this dialog box. Once the analysis is launched, the musical features specified by the user are computed successively. The results of the analysis are displayed in the window as a series of curves that are all temporally aligned to the piano-roll representation of the MIDI sequence. For each musical feature, the client- and therapist-related components are displayed in two distinct colors: respectively green and black. Synchronicity and synchronized tempo, on the contrary, are features corresponding to both players at the same time, and are therefore displayed by only one black curve. The silence factor is represented by a single numerical value, black for the client, and green for the therapist. Finally, the analysis curves can be zoomed in and out using the same zoom tools presented in the previous paragraph.

To each curve some statistical data can be added: horizontal axes, respectively in solid and dotted lines, represent the average value and standard deviation for each musician – for instance, difference on average pitch between the therapist and client. It is also possible to

compare the particular improvisation with respect to statistics computed from a large collection of improvisations.

The imitation diagrams are computed via the command "Compute" in the "Imitations" menu, and are superimposed on the analysis diagrams, as shown in Figure 10.6. The visualization of each of the different layers of representations (the musical feature curves, the imitation diagrams, and the different statistics) can be toggled on and off via the "Display" command in the respective "Analysis", "Statistics" and "Imitations" menus.

Some general aspects of the results can be modified through the 'Preferences' menu. For instance, the "Scales" command specifies the range of values displayed in each graph. The range of values can be adjusted to the current extract of the improvisation, allowing the range to vary when zooming in or out in the improvisation. Alternatively the range of values can be adjusted to the whole improvisation, or can be fixed to default values, or to extrema computed from a corpus of improvisations. Finally, the resulting graph can be saved as a picture and printed.

Case example

The client is a 16-year-old boy with the following diagnoses: F 71 (Retardatio mentalis moderata), F 84.8 (Extensive developmental disorder with Asperger features), and G 40.2 (Epilepsia). The therapist, who works as a music therapist in an institution for disabled people in Finland, met the client twice. It is typical for this institution that the music therapist participates in the initial assessment of the clients in order to bring his or her expertise into the multidisciplinary team responsible for the residents' treatment plans. The improvisation, the analysis of which will be presented in this chapter, is from the first session.

Before improvising, the therapist made a short musicality test for the client. The tasks that were based on simple turn-taking rehearsals proved easy to the client. When investigating the client's ability to perceive tonality-based exercises, the client did not really listen to the therapist – and did not succeed with these exercises. When they started to improvise freely, the client was very cooperative and eager. The therapist described the act of improvising as dynamic and very interactive. After finishing the improvisation (the length of which was about 15 minutes), the client wanted to listen to it from the tape. According to the therapist, the client really liked the improvisation. At the end of the session, the therapist asked the client to try simple computer-music software. However, he couldn't concentrate anymore and wanted to go back to the ward.

Thus it is obvious that the client enjoys improvising, and that it is somehow meaningful for him. It emerged that he can concentrate on pleasant activities but easily loses his motivation if he does not like the activity.

Realization of the case analysis

Before implementing the MTTB analysis, I had an interview with the music therapist. The idea was to listen to the improvisation and, whenever the therapist wanted to comment on

anything in the improvisation, he asked me to stop the tape. So it was the music which was the focus of investigation, albeit the therapist talked about the meanings of the music to the client as well. Similarly if the therapist wanted to make any therapeutic interpretations he was free to do so. Altogether 12 sequences were identified as based on the therapist's subjective experience. For this chapter, 3 sequences out of 12 were selected: 1, 5, and 6. Sequence 1 is a kind of development phase whereas sequences 5 and 6 represent the change and climax phase in the improvisation. The whole improvisation as the MTTB notation can be seen in Figure 10.2.

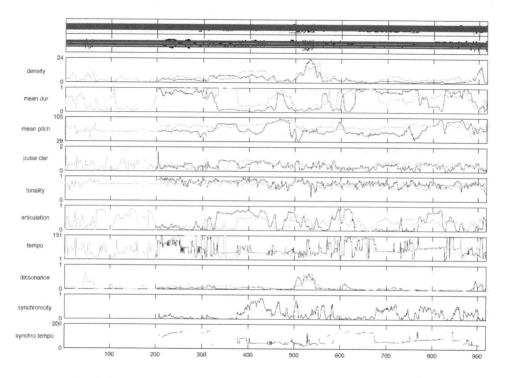

Figure 10.2 The whole improvisation as the MTTB notation

SEQUENCE 1: "DEVELOPMENT"

Musical findings: The therapist tends to accompany the client in a rhythmic way of playing. He has a feeling that the client joins him by also playing accented rhythms that fit to the therapist's play. In the beginning the client imitates the slides by the therapist as well.

Interpretation: There is a preliminary sense of being in interaction. The therapist sees himself mostly as the initiator.

The therapist's feeling about preliminary interaction may be based on his expression, which in a way is contrary to the client's expression (see Table 10.1 and Figure 10.3; see A10.1 for color version) short versus long duration, high versus low pulse clarity, high

versus low articulation. In addition, the therapist tends to structure the improvisation by rhythmic subdivisions.

Table 10.1: Summary of the most salient MTTB contents in sequence 1

MTTB feature	Client	Therapist
Duration	Long	Short
Pulse clarity	Low	High
Articulation	Low	High
Dissonance	Above therapist (clusters)	Rather low
Synchronicity (pulse)	Very low	
Synchronicity (tempo)	Low	

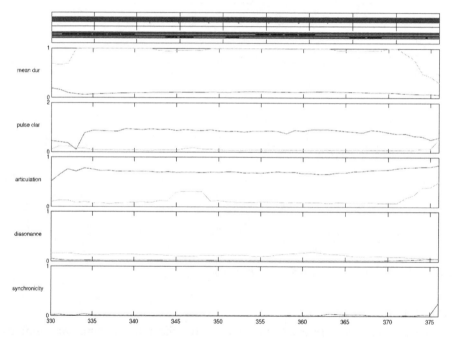

Figure 10.3 Sequence 1 as the MTTB notation

SEQUENCE 5: "CHANGE"

Musical findings: The speed and overall intensity is increasing. The therapist is doing the bass line. The client plays the keyboard on wide range. The therapist even over-emphasizes his musical expression (visually as well) to support the client's expressive way of playing.

Musical parts follow each other without any space and the improvisation keeps on developing.

Bodily findings: There is eye contact between the therapist and the client. The client is smiling. His hands and body are moving in a very lively manner.

Interpretation: The client is very keen on the improvising. There is eye contact between the therapist and client as well as humor and joy. "Playing together" is the core of the ongoing music. However, generally speaking, the client lacks patience, and the improvisation clearly reflects this. If the client does not like the activity, he may stop it suddenly. This time the client even wanted to listen to the improvisation afterwards (from the mini-disc). He had listened to the whole improvisation in a concentrated and quiet manner with only a mild smile on his face.

Growing density and suddenly shortening note durations can explain the therapist's sense of the accelerating speed (see Table 10.2 and Figure 10.4; see A10.2 for color version). His decision to take the bass line position gets the client to stay on the higher register (as the soloist). In this role the client's articulation increases, which can be associated with melody/*legato*-like playing.

Table 10.2: Summary of the most salient contents in sequence 5

MTTB feature	Client	Therapist
Density	Grows (after the therapist)	Grows
Duration	Shortens quickly	Shortens quickly
Mean pitch	Decreases (higher than T)	Decreases
Tonality	High (increasing)	High (increasing)
Articulation	Grows	Decreases
Dissonance	Increasing	Increasing
Synchronicity (pulse)	Peak in the middle	

SEQUENCE 6: "CLIMAX"

Musical findings: Making intensive slides up and down in a certain rhythm is now the main form of musical expression.

Interpretation: The growth of the intensity exceeds the client's motor ability whereupon he begins to play the slides up and down. The intensity is physically strong as well and the client's hands sway a lot. The therapist remembers he was the one who began the expression with slides but the client had adopted the same style quickly. Tumultuousness and joy. Because the client is 16, both his parents and teachers are waiting for more structured behavior from him. However, it is the music which still enables a play-like functioning. The

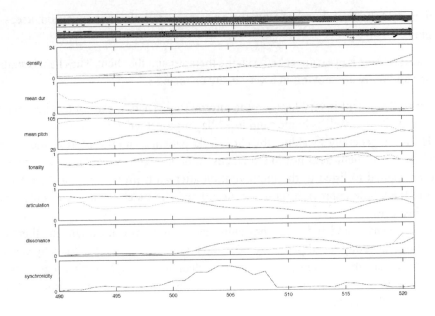

Figure 10.4 Sequence 5 as the MTTB notation

goal of the music therapy is to enhance communication and to offer an alternative form of expression. To be able to play 15 minutes non-stop, and after that to listen to the improvisation for another 15 minutes, shows the client's capacity for intensive concentration.

Psychophysiological activity, joy and euphoria, can be seen as extremely high density, short note durations, using the keyboard on its full range, and as very dissonant playing (see Table 10.3 and Figure 10.5; see A10.3 for color version). All this appears as low articulation, of course.

Table 10.3: Summary of the most salient MTTB contents in sequence 6

MTTB feature	Client	Therapist
Density	High	Very high
Duration	Short	Short
Pitch study	High	High
Tonality	Decreasing	Decreasing
Articulation	Decreasing	Decreasing
Tempo	–	Peak in the middle
Dissonance	Very high	Very high

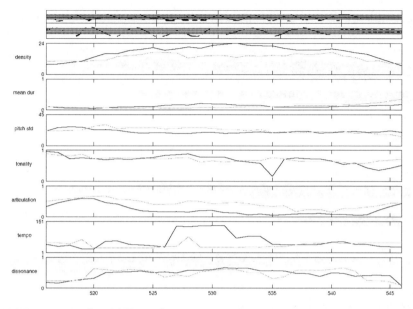

Figure 10.5 Sequence 6 as the MTTB notation

Imitation

An important dimension of musical expression, of particular interest in music therapy, is the degree of communication between the therapist and the client. In particular, when communication takes place, players imitate one another or jointly elaborate the same gestures. The musical dialog may therefore be assessed by observing the degree of local similarity between the temporal evolutions of both improvisations, along the different features.

These local integrations are represented graphically in what we call an integration diagram. Figure 10.6 shows the integration diagram of our case improvisation. Each line of the figure is dedicated to a different musical feature.

The horizontal axis corresponds to the temporal evolution of the improvisation. Lines in the integration diagram indicate local integrations. The darkness of the lines is associated with strength of integration: light-grey corresponds to slight and coarse similarities, while black corresponds to distinct and close imitations. When the line is vertically centered, the integration between both players is synchronous. When the line is in the upper half of the diagram, the client imitates the therapist after a certain delay, displayed by the vertical axis, in seconds. Similarly, when the line is in the lower half of the diagram, the therapist imitates the client. Finally, the length of the line indicates the duration of the integration.

Thus on the basis of Figure 10.6 we can say that the players imitate each other in density as well as in tonality throughout the extract. The therapist seems to imitate the client in mean duration in the same way as he imitates the client in dissonance.

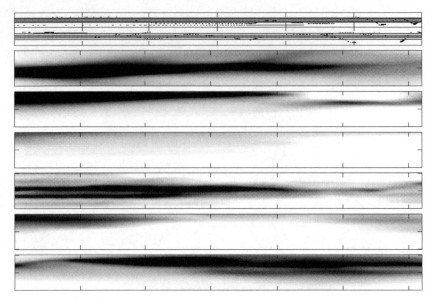

Figure 10.6 An example of the imitation diagram

Some general findings

The improvisation is untypically long, especially when taking the client's impulsivity into consideration. According to the therapist's findings the most eventful sequence seemed to be between 350–600 seconds, which was where he asked to stop the tape for commenting most often.

Music therapists typically tend to adopt the lower register when both the therapist and the client are playing keyboards. This is giving the role of a soloist to the client and thus supporting the client's possibilities for rich self-expression. This tendency can be found in the analyzed improvisation. The client seems to utilize this possibility by staying on the higher register most of the time.

In general the density of the client's playing is higher than the therapist's. This can partly be explained by the client's tendency to produce cluster chords – maybe due to motor limitations – but also by the therapist's natural tendency to give space for the client.

Although the improvisation is rather impulsive with various parts, there is some interesting evolution as well. For instance, it takes rather a long time for the common pulse and tempo to be found. When looking carefully at the MTTB graph one can see that the tempo synchronicity tends to improve along with the improvisation.

In terms of articulation, which can be associated with the *staccato–legato* idea, the therapist is able to reach higher levels. This is in line with the previous findings of our group that the level of retardation correlates with the articulation: the more retarded articulate less and vice versa. This phenomenon can be explained both as lowered motor ability and inability to understand or produce melodic patterns and phrases that require ties between the notes.

Summary

When doing clinical improvisation analysis, one of the crucial things is the actual role of music in the analysis. Some clinicians see that the connection between the worlds of actual music as and extra-musical phenomena is so weak or complex that clinicians do not actually get much benefit from analyzing the music. However, music therapists' interest towards music as such has been increasing lately, for which this book is a good example. This may reflect what is happening in the field of musicology, especially in music and emotion research, which has been in a very active phase in recent years. While applying the MTTB method to clinical context, I have become convinced that the experience and interpretation are actually not so far from what is happening in the music. So far, our project has mainly concentrated on improvisations by mentally retarded clients. The near future will show the benefit of the method with other diagnostic groups.

Despite the limitations of computational methods they have many benefits. Music is a structure of various overlapping events and elements, and it is not easy to focus on details when using aural methods. With methods such as the MTTB, it is possible to focus on various musical features separately, which may sometimes be of great benefit. Furthermore, the method offers an excellent tool for process follow-up. The therapist can record a number of improvisations, analyze them with the MTTB and make group comparisons within a partic-ular diagnostic group, for instance. Similarly, the therapist can compare the improvisations of one client during the whole process. Researchers may be interested in the possibility creating a data matrix and to do statistical analysis with larger sets of data.

However, subjective experience and human perceptions will always remain a crucial part of clinical improvisation analysis. With the MTTB we cannot say much about the emotional content of the improvisation, the meaning of the improvisation, nor create any kind of psy-chological analysis. At best the MTTB is a tool which may help a clinician or a researcher to find some more, some new, or some more detailed aspects for the interpretation.

Acknowledgments

Parts of this chapter are based on "Exploring relationships between levels of mental retarda-tion and features of music therapy improvisations: a computational approach," by Luck *et al.* (2006) and are reproduced with the kind permission of the *Nordic Journal of Music Therapy*.

I want to thank Dr Olivier Lartillot for technical help with the pictures and some last-minute improvements he made to the MTTB in order to make the graphs more illustra-tive. Many thanks also to the other members of the Music Cognition Group of the University of Jyväskylä who helped me with concepts outside my core expertise.

References

Clarke, E. and Cook, N. (eds) (2004) *Empirical Musicology – Aims, Methods, Prospects.* New York: Oxford University Press.

Cross, I. (1998) "Music and science: three views." *Revue Belge de Musicologie 52*, 207–14.

Kameoka, A. and Kuriyagawa, M. (1969) "Consonance theory. Part II: Consonance of complex tones and its calculation method." *Journal of Acoustic Society of America 45*, 1460–9.

Krumhansl, C.L. (1990) *Cognitive Foundations of Musical Pitch*. New York: Oxford University Press.

Helmholtz, H. (1877/1954) *On the Sensations of Tone*, trans. A.J. Ellis. New York: Dover.

Honing, H. (2004) "The comeback of systematic musicology: new empiricism and the cognitive revolution." *Tijdschrift voor Muziektheorie 9*, 3, 241–4.

Leman, M. (2003) "Foundations of musicology as content processing science." *JMM – Journal of Music and Meaning 1*, section 3. Accessed on 08/03/07 at http://www.musicandmeaning.net/issues/showArticle.php?artID=1.3.

Luck, G. *et al.* (2006) "Exploring relationships between levels of mental retardation and features of music therapy improvisations: a computational approach." *Nordic Journal of Music Therapy 15*, 1, 30–48.

Plomp, R. and Levelt, W.J. (1965) "Tonal consonance and critical bandwidth." *Journal of Acoustic Society of America 28*, 548–60.

Toiviainen, P. (2001) "Real-time recognition of improvisations with adaptive oscillators and a recursive Bayesian classifier." *Journal of New Music Research 30*, 2–11.

Toiviainen, P. and Snyder, J.S. (2003) "Tapping to Bach: resonance-based modelling of pulse." *Music Perception 21*, 1, 43–80.

Van Noorden, L. and Moelants, D. (1999) "Resonance in the perception of musical pulse." *Journal of New Music Research 28*, 1, 43–66.

Warren, R.M. (1993) "Perception of Acoustic Sequences: Global Integration versus Temporal Resolution." In S. McAdams and E. Bigand (eds) *Thinking in Sound*. New York: Oxford University Press, pp.37–68.

Westergaard, P. (1975) *An Introduction to Tonal Theory*. New York: W.W. Norton.

Chapter 11

A Structural Model of Music Analysis

Denise Grocke

Introduction

The Structural Model of Music Analysis (hereafter SMMA) is designed for use in clinical practice as well as research. Its original intention was to compare the structural properties of four different selections of music, in order to determine similarities and differences (Grocke 1999), however, the model also serves a useful function as a checklist (Wigram 2004) when a music therapist is assessing the suitability of a piece of recorded music for clinical work.

In this chapter the SMMA will be outlined. Each of the categories will be explained and a working example, the slow movement for Beethoven's Symphony no. 9 (*adagio molto*), will be used to demonstrate how the SMMA is used. The analysis will then be placed alongside the imagery of one client's experience of the Bonny Method of Guided Imagery and Music (hereafter BMGIM).

Theoretical basis

The impetus for developing the SMMA came from a study of pivotal moments in BMGIM. I wanted to compare the music of four clients' pivotal experience to determine if there were commonalities in the music structure or elements (Erdonmez Grocke 1999). I required a model that provided a list of musical elements, so that I could make a comparative analysis across the four pieces of music.

The founder of the method, Helen Bonny, devised 18 music programs that created diverse experiences for clients of BMGIM. Some of Bonny's programs relate to emotional states, while others respond more to therapeutic issues (see Grocke 2002a and 2002b for a comprehensive discussion of Bonny's music programs). Bonny's expertise in creating the music programs came from her extensive experience as a violinist and leader of the Salina Orchestra. Her knowledge of classical music of the Western tradition therefore underpinned her choice of music for BMGIM, and in order to create a list of possible structural elements of music, which might form a model of analysis, I consulted Bonny's lecture notes. Bonny had developed two lecture outlines: 'Characteristics of Music on the GIM Programs', and 'Considerations when Choosing Music for the GIM Programs' (Bonny n/d). The lists had some

similar and some differing features. I combined the elements of these two lecture outlines and these are represented in A11.1 on the web-based resources.

Bonny's ten categories provide an extensive overview of structural components of the BMGIM music; however, in order to compare *across* several music compositions, the list needed to be expanded, and the SMMA is the outcome of that revision and expansion.

For example, category 1, Texture, lists harmonic and melodic, whereas I consider texture is better described in music as thick or thin. Category 4 lists mood and mode together, which could be confusing, as mood relates to feelings and emotions, whereas mode (as Bonny means it here) relates to whether the harmonies are consonant or dissonant. These two aspects needed to be separate, and Mode should include diatonic or pentatonic.

It was necessary, then, to group certain parameters into different categories. I consulted the work of music theorists, such as Ratner (1992) for example, who discussed elements of music within the classical stylistic period from the syntactical point of view. I noted how he grouped the elements for discussion and the terms he used to describe the different features of each element. I also consulted Sloboda's study (1991) of music structures and emotional responses, to ensure that his structural features were included in my list.

I adopted my own model of musical elements for trial in analysing the music that underpinned the pivotal moment. It was anticipated that this model would provide structural information about the music, and that it would serve as a useful model to compare several pieces of music to determine if there were similarities in style and structure. I applied the SMMA to analyse four selections of music and found that some minor changes were required. An amended form of the SMMA emerged, and this version is presented below. Each component is 'assessed' in terms of whether it is predominantly evident, or whether it varies. The SMMA comprises 15 categies, with various components within each category; there are 63 components in total.

In Table 11.1 sections 1–12 refer to music elements, structure and acoustical features. Sections 13–15 relate to the function and affective components of music.

Table 11.1 A Structural Model of Music Analysis (SMMA)

1. Style and form
1.1 Period of composition: Baroque, Classical, Romantic, Impressionist, 20th century
1.2 From: Sonata form, ABA, theme and variations, rhapsodic form, prelude, fugue, tone poem, or other
1.3 Structure: predominantly simple or complex

2. Texture
2.1 (Predominantly) thick/thin texture
2.2 Monophonic, homophonic, polyphonic

3. Time
3.1 Metre – 2/4, 5/4, 3/8, 9/8, etc.
3.2 Complexity and variability in metre

4. Rhythmic features

4.1 Underlyinh rhythm of the work – consistent/inconsistent

4.2 Important rhythmic motifs (notate)

4.3 Repetition in rhythmic motifs

4.4 Variability in rhythm – predicatable/unpredictable

4.5 Syncopation

5. Tempo

5.1 (Predominantly) fast, slow, moderato, allegro, etc.

5.2 Alterations in tempi: change of metre, use of accelerando and ritardando

6. Tonal features

6.1 Key structure, diatonic, modal

6.2 Major/minor alternations

6.3 Chromaticism

6.4 Modulation points of significance

7. Melody

7.1 The main themes in the work (e.g. whether first theme, second theme with development or variations)

7.2 Significant melodic fragments of each melody/theme

7.3 The structure of each melody/theme: propinquity, step-wise progressions, large intervallic leaps, etc.

7.4 Intervals of each melody/theme: conventional/unconventional, significant (e.g. fall of an octave)

7.5 Shape of each melody/theme – rounded, ascending, descending

7.6 Length of phrases in each melody/theme: symmetrical, short, long

7.7 Predominant pitch range of the melody/theme: high, medium, low register

8. Embellishments, ornamentation and articulation

8.1 Trills, appoggiaturas

8.2 Marcato, accents, detached bowing

8.3 Pizzicato

8.4 Legato

8.5 Use of mute

9. Harmony

9.1 Predominantly consonant or dissonant

9.2 Consonance/dissonance alternation within the work

9.3 Significant harmonic progressions

9.4 Rich harmonies

9.5 Predictable shift in harmonies (e.g. I, IV, V progression)

9.6 Unpredictable harmonies

9.7 Cadence points – perfect, imperfect, interrupted

Continued on next page

Table 11.1 *cont.*

10. Timbre and quality of instrumentation

10.1 Vocal – male or female solo, SATB or other combination

10.2 Instrumental – solo

10.3 Instrumental – orchestral

10.4 Small group – e.g. quartet, combinations of instruments

10.5 Instrument groups used in orchestration (strings, woodwinds, brass, percussion, harp) creating distinctive timbral colour

10.6 Interplay between instruments and instrument groups

10.7 Layering effects (adding and reducing instrument parts)

10.8 Resonance

11. Volume

11.1 Predominantly loud or soft – alternations between/gradation between

11.2 Special effects of volume: pianissimo, fortissimo and sforzando

12. Intensity

12.1 Tension/release

12.2 Crescendo, building to peak, and resolution

12.3 Tension in harmony, texture etc. and resolution

12.4 Delayed resolution or absent resolution

12.5 Ambiguity in whether resolved or unresolved

13. Mood

13.1 Predominant mood, as depicted by melody, harmony and predominant instrument

13.2 Feelings and emotions represented

14. Symbolic/associational

14.1 Culturally specific associations – e.g. Vaughan-Williams English idioms

14.2 Metaphoric associations – e.g. horn call

14.3 Symbolism in motifs (leitmotifs), and their imagery potential – visual, auditory or kinaesthetic

15. Performance

15.1 The integrity/authenticity of the performers

15.2 Excellence of performance (technique of the performers)

15.3 Stylistic interpretation – artistic merit

15.4 Articulation of feeling and emotion

15.5 Authenticity with composer's intent

Source: Grocke 1999

Method

The analysis procedure incorporates seven steps:

1. Create a table of three columns. Column 1 has the numerical identifier, e.g. 15.5. Column 2 has the components within the sub-section. The third column is left open for filling in during analysis.

2. Listen to the selection of music several times and complete as many of the components as possible from 'hearing' the music. If the work is complex and includes different sections, then these are described as accurately as possible. For example, in the analysis of Beethoven's Symphony no. 9, slow movement (see A11.2 on the web-based resources), the tonality (6.2) is described as:

 6.2 Major/min alternations Mostly major.

3. Obtain a copy of the music score and, referring to the score when necessary, complete the remaining components.

4. Determine which of the components are either not applicable, or difficult to assess.

5. Verify your analysis by asking a colleague to carry out the same procedure. Where the colleague's analysis differs, place the comments in italics (see Table 11.2).

6. Re-assess which of the 15 categories and 63 components are either not applicable or difficult to assess as verified by the colleague.

7. Create a description of the work, summarising the main features (see description of Beethoven's Symphony no. 9 (*adagio molto*) below).

Case example

The following case example is in three parts. First I present the analysis of the slow movement of Beethoven's Symphony no. 9 using the SMMA. Second, I present the description of the work, drawn from the summary of the SMMA analysis. Third, I place the description of the music alongside the imagery of the client, who identified a pivotal moment in therapy that occurred during this work.

Part 1 of the analysis

A11.2 on the web-based resources presents the analysis of Beethoven's Symphony no. 9, slow movement, created from the steps 1–6 discussed above. The words in italics are the validation comments by a colleague.

Part 2 of the analysis

The SMMA analysis enabled me to determine a description of the slow movement of Beethoven's Symphony no. 9, based on the structural analysis of the work, verification by my colleague, and augmented by the comments of Helen Bonny when I interviewed her about the music programs (Grocke 1999, Appendix 6c). Bonny's comments are in italics. The description follows.

> The movement is in a major key, and its structure is theme and variations form. *The first theme is pensive and spacious,* and initially played *mezza voce. The first variation creates a holding space, and the staccato creates a sense of movement.* The second theme is an inward turning melody, and its variation creates a relaxed mood, over *pizzicato* strings. *The next variation creates a colour tapestry as the lines interweave.* The lower strings play *pizzicato,* creating a steady pulse. The middle line is played *legato* and there is an unceasing movement of semi-quavers. The woodwinds then play the melody against chromaticism in the strings. There is a Coda section, heralded by the horns, which features a strong rhythm contrasting with the *legato* line of the variations. The movement has complex modulation points, each heralding a new section or new variation. Interrupted cadences mark the end of each section, so that there is a sense of anticipating the next. The harmonic structure of the work is consonant. The melodic lines and harmonic sequences are predictable. *Pizzicato* plays an important role in maintaining a steady pulse, and this contrasts with the *legato* line of the themes. (Grocke 1999, p.213)

Part 3 of the analysis

In this section the description of the slow movement of Beethoven's Symphony no. 9 is placed alongside the imagery reported by one of the clients in the study of pivotal moments in BMGIM. In this example the SMMA description has been augmented by a phenomenological description, verified by Bonny's comments about the work. The client, Sarah, presented for a BMGIM session in a private practice setting. She was facing difficulties in her work situation and wanted to explore that issue in her BMGIM session. Sarah identified that the pivotal moment in her BMGIM session occurred when she received a message from a wise old man.

In the BMGIM music program titled 'Transitions', the slow movement of Beethoven's Symphony no. 9 is the third piece on the program, and therefore an amount of imagery had already been generated by the preceding music pieces. However, it was during the Beethoven selection that Sarah entered into dialogue with the wise old man. Table 11.2 shows the parallel analysis of the music and Sarah's imagery. In order to compare the two features temporally, I used a form of phenomenology developed by Ferrara (1984) to create 'music meaning units' (MMUs) grouping the music into units or sections (see Forinash and Grocke 2005 for a more detailed account of Ferrara's method of analysis). Likewise I created units of meaning of Sarah's imagery (IMUs). It should be noted that the parallel analysis cannot be exact, as the BMGIM session from which this data is drawn was not tape-recorded. Therefore the MMUs and IMUs do not correspond, except at the point where the Coda commences – the word 'Coda' was written on the transcript of the session. The shifts in imagery relative to

Table 11.2: Parallel analysis of music and imagery

Beethoven, Sym no. 9, 3rd movt. Adagio molto e cantabile	Beethoven, Sym no. 9 – slow movt. Adagio molto e cantabile
Key of Bb. Theme and variations form.	
4/4	
MMU 1 – A pensive, spacious theme	*IMU 1 – Holding the wise old man's hand*
The first two bars are a series of suspensions leading to the dominant chord, resolving on the tonic at the commencement of the first theme in bar 3. *That movement (of the three chords) is so interesting because it gives the lower, middle and the top and brings it all together.* The first theme is played by the strings mezza voce. It is a spacious theme, with simple and predictable harmonic sequence. Fragments of the theme are echoed by the woodwinds. *Very pensive.* At bar 20, the violins and violas play arpeggiated chords, giving a sense of pushing ahead. The section ends with an interrupted cadence, suggesting more is to come.	He [the wise old man] is now aware of my presence. He's come over to me and taken my hand – my left hand – my right hand [of the tree] is still in my right hand.
	(feel?) – good.
MMU 2 – An inward turning melody	*IMU 2 – A question to ask*
At *Andante moderato* there is a key change to D major and time change to 3/4. The second theme is expressive. The motif turns in on itself within an interval of the third. The motif is repeated by the woodwinds then the strings, and then woodwinds again.	I feel I'd like to ask questions.

(is there a question you'd like to ask?) |
| *MMU 3 – A holding space, a wide container* | *IMU 3 – Voicing the question* |
| At Tempo 1 (Bb major, 4/4) there is the first variation on the first theme. The violins have a rhapsodic line embellishing the melody, over pizzicato accompaniment of the cellos and second violins. *This is a holding space, a space that has a lot of room.* There is a sense of gentle forward movement. *There are a lot of changes from one instrument to another. There is a lot of movement in the staccato.* | I think the question is 'what should I be doing?' He knows what my question is, I don't have to voice it. We're just sitting down side by side.

(is there anything you want to say?) |

Continued on next page

Table 11.2 cont.

Beethoven, Sym no. 9, 3rd movt. Adagio molto e cantabile	Beethoven, Sym no. 9 – slow movt. Adagio molto e cantabile
There are long phrases, there is no ending before another instrument comes in. At 60, the strings repeat the arpeggiated chords. Violins take obbligato over horns. You're moving within a space, but it's a wide container. It doesn't suggest you change, it suggests you stay. There is a bridge passage and chromatic modulation into the key of G major.	He's not giving me an answer – still holding left hand. (how does your left hand feel?) Warm and secure.
MMU 4 – A pastoral scene. The *Andante* section is a variation on the inward turning theme (3/4). *A circular motion.* At 73, the theme is heard in thirds in the woodwinds against an obbligato part for the violins, and plucked lower strings. The overall effect is reminiscent of the Pastoral symphony –. *a gentle movement and relaxed mood.*	**IMU 4 – The answer** In silence he's saying 'what you are doing is good – do it with confidence'. (how does that feel for you?) Good to have approval, affirmation.
MMU 5 – Interweaving Adagio (Eb, 4/4). This is a variation on the first theme. There is an interweaving line between the clarinet, bassoon and horns, supported by light *pizzicato* in the strings. The flute repeats the modified first theme, and the *pizzicato* of the strings becomes more pronounced.	**IMU 5 – Animals appear** Coming in and out of cave there are lots of animals – they love the old man. (what animals?) Squirrels, deer, a dog. The dog nuzzles the old man's hand and my hand – dog gone to the side. Lion coming in.
MMU 6 – A tapestry of colour The section *Lo stesso tempo* is a long second variation on the first theme, and is in 12/8 time. The strings carry a consistent semi-quaver movement over 15 bars, increasing in intensity at 112 by breaking into triplet semi-quaver movement. Throughout this section the lower strings play *pizzicato*, providing a very regular pulse.	**IMU 6 – The lion** Lion ambles in – I'm not scared – puts his chin on my hand, the old man has put lion's chin into his hand and my hand –

The woodwinds alternate taking the first theme. There is a strong sense of rhythmic movement. *Interesting colour of the instruments. A colour tapestry would be complex here. The middle line going up and down, and the lines above and the pizzicato in the bass. Chromaticism in the violins. Creates a rumination of what has gone on, what has brought you to the place where you are. Next step is to look ahead. It creates a place in which to look at that. There are many variations, which bring out memory lines.*

MMU 7 – A heralding

At 120, the Coda is heralded by the full orchestra (except first violins). The striking feature of the Coda is the strong rhythm (te-te-ta) played *forte. A place for strong emotion to come out.* This rhythmic motif is answered by the first violins and repeated.

MMU 8 – Repetition and variation

At 123, there is a drawn-out passage of the first two bars of the theme in dotted minims, creating a layered effect between strings and woodwinds. There follows a return to the variation with first theme in horns and bassoons against the semi-quaver embellishment of the violins. At 130, the rhythmic motif of the Coda is heard again. The long minims are punctuated rhythmically by the second violins. At 139 there is a variation based on the harmonic sequence of the first theme, against embellishment from the violins.

MMU 9 – Wrapping it up

A further development of the Coda at 150 over string accompaniment playing detached notes. Another phrase is added before the close. *Very positive. Wrapping it up. Violins like panting. Pizzicato strong at the end.*

I'm looking into the lion's face and eyes.

(Notice about the eyes?)

They're laughing.

(colour?)

Dark brown.

IMU 7 – On the lion's back

The old man is putting me on the lion's back.

IMU 8 – A procession to the door

['Coda' written on transcript] Walking with us both to the door – me on the lion's back, holding on to his mane. When we get to the forest the old man tells lion to take me.

IMU 9 – Riding on the lion's back

Lion lopes off. I'm waving to the old man – beautiful kindly expression on his face. Lion is taking big strides. I'm enjoying it all, holding on to his mane – it feels safe.

IMU 10 – Atop a little hill

Little hill, lion bounding up, so much energy. Standing on top of the hill, looking at the forest, looking around with him, going down the other side of the hill.

the shifts in the music are only approximations. Words in italics are drawn from Helen Bonny's description of the music, made during an interview about the Transitions program (Grocke 1999, Appendix 6c). Words in brackets in the imagery column are the interventions of the BMGIM therapist, noted on the transcript of the session. The pivotal moment (the message of the wise old man) appears in IMU 4.

Looking at the parallel analysis of music and imagery, it was possible to create a description of how the music influenced the flow of imagery, and to make cautious interpretations about what aspects of the music may have evoked certain imagery experiences.

The description

The first theme is spacious, with slow drawn-out notes, supported by a consonant, predictable chordal harmonic sequence. The old man takes Sarah's hand. She wants to ask him a question, but she feels he already knows what that question is, without her voicing it. The description of the second theme is that it 'turns in on itself' and is repeated many times by different instruments. It is likely that the imagery sequence of dialogue occurred during this part of the music, and the inward-turning melody might have influenced Sarah's dialogue with the wise old man. The dialogue continues: in silence the old wise man's answer is 'what you are doing is good – do it with confidence'. This is the pivotal moment, in which Sarah receives the answer to the question she brought to the session, and she feels affirmed. The therapeutic process inherent in this exchange is worthy of mention. The question is formed in Sarah's mind – it was the issue she brought to the session, and so it is in her conscious mind. The answer comes in symbolic form via the wise old man, who is the archetypal father figure in her unconscious (psyche). Her own psyche therefore answers the question she poses to herself. This interchange occurs when she is in an 'altered state of consciousness'. Not only did she receive the answer she unconsciously needed, but also the message carried an instruction to her – to do what she is already doing *with confidence*. And this was the pivotal moment. Placing this sequence alongside the music, there are several corresponding developments. Bonny (in Grocke 1999, Appendix 6c) comments that there is a 'holding space that has a lot of room', and later that 'you're moving within a space, but it's a wide container'. Bonny is referring to the concept of music as a container for the experience. In this example, the holding space of the music allowed Sarah to address a significant life question to herself and receive the answer she needed.

Having received the message, Sarah enjoys a respite of play with the animals arriving in the cave. Then the lion 'ambles' in, and she comments that she is not scared. The music has undergone some changes. Interestingly this section is described as 'reminiscent of the Pastoral symphony' (MMU 4), which evokes the playful imagery with animals of the forest. There follows a section where there is an interweaving line between the clarinet, bassoon and horns, and the strings provide a *pizzicato* bass. In the next section of the music the first theme undergoes a long, protracted variation, played by the violins. This may have been the point at which Sarah became close to the lion. Initially the old man put the lion's chin in her hand, and she looked directly into the lion's eyes. Then the old man put her on the lion's back. These are imagery sequences that show a close physical connection with a powerful masculine symbol, from which

she draws her 'confidence' to do what she is doing well. Bonny (in Grocke 1999, Appendix 6c) suggests that there is a tapestry of timbral sounds, and that the music 'creates a rumination of what has gone, what has brought you to the place where you are. [The] next step is to look ahead.' This description matches Sarah's imagery experience very well, and also matches the nature of the issue she had brought to the session: 'what should I be doing?'

At the Coda (which is identified on the transcript, therefore the imagery can be placed alongside the music), the orchestra 'heralds' a strong rhythmic motif. Correspondingly, the wise old man is walking with Sarah (who is sitting on the lion's back) to the door of the cave to wave them off. There is repetition and variation on the themes, and in the imagery the lion 'lopes' off taking great strides. As the music comes to an end, there are repeated phrases of the main themes. Bonny refers to this as 'wrapping it up'. In the imagery the lion and Sarah have encountered a little hill, ascending it, pausing at the top to oversee the forest, then going down the other side. (Grocke 1999, pp.181–2)

Summary

In the study of pivotal moments in BMGIM the SMMA assumed a central role in analysing the music that underpinned the client's experience. It provided a method that was grounded in the architectural structure of the music, augmented by information gleaned from the score. However, in order to provide a balanced analysis of the music that underpinned pivotal moments, it was also necessary to combine the SMMA results with phenomenological descriptions, and the two methods combined provided the narrative that enabled the significance of the imagery sequence to be matched and discussed.

Researchers who have used the SMMA in different research contexts (Bonde 2004; Lem 2004; Marr 2000; Trondalen 2004) report similar findings. Bonde used the SMMA in his study of the effect of BMGIM on six women cancer survivors. Bonde found that the SMMA 'served well as one source of analytical information' (p.353), and lists the following advantages:

1. The SMMA 'is very inclusive and precise, and that enables a comparison of musical selections in all relevant musical parameters'.

2. The SMMA 'enables a dialogue with musicologists because it uses well-established terminology'.

Bonde found the following limitations of the SMMA:

1. The SMMA requires that the researcher master the musicological terminology.

2. The SMMA does not 'describe the music as a dynamic temporal sequence and experience'.

3. The SMMA does not 'inform the reader about the clinical or experiential significances of the music elements described' (p.352).

Lem (2004) used the SMMA in his study of the influence of music on the flow of imagery in Unguided Music Imaging, as measured by electroencephalogram (EEG) recordings of brain activity. Lem analysed two of the Bonny music programs: 'Relationships' and 'Nurturing'. According to the SMMA analysis Lem found:

> that the characteristics of music most commonly associated with imagery experiences were:
>
> - diatonic tonal structure
> - tension and release
> - slow tempo
> - predictable rhythm, and
> - romantic style.
>
> (Lem 2004, p.208)

In assessing the usefulness of the SMMA, Lem found that it was helpful on 'selected features of music, namely Timing, Texture, Melody, Pulse, Harmony, Volume, Tension/Release and Genre' (p.221). Lem also noted that the SMMA could not be utilised to capture the temporal changes within the music.

The value of the SMMA therefore appears to lie in the preciseness of each component or element of music. It is a structural analysis, and therefore may be useful when music therapy researchers are looking at how the music is structured, as distinct from how the music feels, or what the music captures or evokes. However, the SMMA can be augmented by other descriptions in order to capture the temporal shifts and affective associations, as was evident in my own study of pivotal moments in BMGIM.

In addition, as Wigram (2004) has noted, the SMMA can be used as a checklist. This function allows components that are relevant to be drawn out. The checklist approach enables the researcher to identify components as 'not applicable', for example. For the most part, however, the SMMA serves a purpose when music therapy researchers are interested in the structural components of a single piece of music, or comparing several pieces of music for similarities and differences.

Applications for music therapy clinicians

Although the SMMA was designed specifically for a research study, it can also be used to assess a selection, or compare a number of possible selections of music, for receptive music therapy experiences. In addition, the act of listening carefully and filling out the SMMA format develops a more rigorous approach to listening. These skills of assessment enable music therapists to make better choices, and to be more aware of the subtleties in music that lead to certain responses in clients.

References

Bonde, (2004) 'The Bonny Method of Guided Imagery and Music (BMGIM) with Cancer Survivors. A Psychosocial Study with Focus on the Influence of BMGIM on Mood and Quality of Life.' Unpublished PhD dissertation, University of Aalborg, Denmark.

Bonny, H. (n/d) 'Characteristics of Music on the GIM Programs' and 'Considerations Choosing Music for the GIM Programs.' Unpublished lecture notes.

Erdonmez Grocke, D.E. (1999) 'The Music that Underpins Pivotal Moments in Guided Imagery and Music.' In T. Wigram and J. De Backer (eds) *Clinical Applications of Music Therapy in Psychiatry*. London: Jessica Kingsley Publishers, pp.197–210.

Ferrara, L. (1984) 'Phenomenology as a tool for musical analysis.' *The Musical Quarterly 7*, 355–73.

Forinash, M. and Grocke, D. (2005) 'Phenomenological Inquiry.' In B. Wheeler (ed.) *Music Therapy Research*, 2nd edn. Gilsum, NH: Barcelona Publishers.

Grocke, D.E. (1999) 'A Phenomenological Study of Pivotal Moments in Guided Imagery and Music (GIM) Therapy.' Unpublished PhD dissertation, University of Melbourne.

Grocke, D.E. (2002a) 'The Evolution of the Bonny Music Programs.' In K. Bruscia and D. Grocke (eds) *Guided Imagery and Music (GIM): The Bonny Method and Beyond*. Gilsum, NH: Barcelona Publishers.

Grocke, D.E. (2002b) 'The Bonny Music Programs.' In K. Bruscia and D. Grocke (eds) *Guided Imagery and Music (GIM): The Bonny Method and Beyond*. Gilsum, NH: Barcelona Publishers.

Lem, A. (2004) 'The Flow of Imagery Elicited by GIM Music Programs During Unguided Music Imaging.' Unpublished PhD dissertation, University of Western Sydney.

Marr, J. (2000) 'The Effects of Music on Imagery Sequence in the Bonny Method of Guided Imagery and Music.' Unpublished Master's thesis, University of Melbourne.

Ratner, L. (1992) *Romantic Music: Sound and Syntax*. New York: Schirmer.

Sloboda, J.A. (1991) 'Music structure and emotional response: some empirical findings.' *Psychology of Music 19*, 110–20.

Trondalen, G. (2004) *Klingende relasjoner. En musikkterapistudie av 'signifikante øyeblikk' i musikalsk samspill med unge mennesker med anorksi* [Sounding relationships. A study of 'significant moments' in musical interplay of adolescents with anorexia nervosa]. Oslo: Oslo University.

Wigram, T. (2004) *Improvisation Methods and Techniques for Music Therapy Clinicians, Educators and Students*. London: Jessica Kingsley Publishers.

Chapter 12

Microanalysis of Emotional Experience and Interaction in Single Sequences of Active Improvisatory Music Therapy

Ute A.A. Inselmann

Introduction

The method described in this chapter was developed to externally investigate *emotional experience* and *interaction* within active, improvisatory music therapy. The aim was to create a structured questionnaire which translates musical perception to verbal symbols for repeatable evaluation of a person's musical playing through resonator function (Langenberg, Frommer and Tress 1995). Thus it should be possible to structurally reflect a patient's or a therapist's playing and the therapeutic process. Additionally, while using the resonator function, the rater's perception of the playing may be structurally reflected and compared with other raters' perceptions. Possibly completed by a questionnaire of self-exploration, this method of microanalysis may be useful for supervision (by oneself or others), for teaching students, for advancing self-perception, and for systematically exploring musical sequences, the process within one sequence or the process over several sequences of improvisations.

Theoretical backround

Within the wide range of possibilities of music therapy (Decker-Voigt 2001) the method described in this chapter refers to active improvisatory music therapy, and in particular it is psychoanalytically oriented. There are several assumptions of this therapy (Inselmann and Mann 2000):

1. There is a particular proximity of emotions and music and indeed this strong connection between music (therapy) and emotion has repeatedly been reported (Inselmann 1995; Inselmann and Mann 2000; Janssen 1982; Langenberg 1996; Langer 1978; Spitzer 2003; Timmermann *et al.* 1991; Wosch and Frommer 2002). Supplementing, the author suggests that, beside *conscious* emotions,

unconscious emotions are particularly expressed by music (therapy). Out of a philosophical–psychoanalytical view there arises the question whether unconsciousness has the capability to think. Out of the theory of Lacan, Lang (1993) explains that the unconsciousness has the capability of thinking, because thinking means being in process and the the unconsciousness may be in a changing process as well. Langer (1978) points out that music has the capability of symbolisation, whereas Meltzer (1995) says that feelings are meaningful symbols of the (emotional) experience and not only accessories of thinking. He expresses the opinion that within dreams (and thus within the unconscious) significant emotional experiences are thought over and acted out within 'trial actions'. All these thoughts are basic for the theory that musical improvisations have the capability of reflecting an *emotional (unconscious) symbolising changing process* (Inselmann and Mann 2000).

2. Active music therapy with someone reflects the typical interactive improvisatory possibilities of someone and thus expresses their *interpersonal characteristics*. Both emotional expression and interpersonal interaction may thus lead to characteristic musical playing, which reflects the typical personality or pathology of a person, respectively (Inselmann 1995; Inselmann and Mann 2000; Timmermann *et al.* 1991).

3. Another characteristic of active music therapy is the chance to try something while acting within the therapy ('trial actions'; German: 'Probehandeln'). Within a verbal therapy this may happen while the patient is acting something out, perhaps to consciously or unconsciously 'test' the therapist to see whether the therapist is just acting back or understanding the typical problem of the patient and 'working it through' (psychoanalytically speaking). Whereas within active music therapy while playing music and acting together emotional expression and communication can become possible, even if emotional experiences are difficult to talk about (Meschede, Bender and Pfeiffer 1983; Priestley 1982).

Thus this method of evaluating music therapy is performed *to measure emotions, interactions, the process and musical characteristics of playing*. In the following there will be a description of how the method will be used for evaluating music therapy; supplementing this will be an explanation of how the method may be used for further research and which parts of the method can be improved in further research.

The development of the scales used in this method are based on the assumption that there is a *quantitative connection* between the differentiation of (emotional) expression and communication and psychical health. In other words human beings as social beings want to be understood. For a better understanding they try to express their feelings and thoughts as differentiated as much as they are individually able to do so. Further on this may be reflected in their differentiated musical playing ability with active music therapy; here differentiation means the degree of musical expression and communication with the aid of musical techniques such as rhythm, tempo, dynamics, range and melody. Of course musical education

will influence this. However, within free improvisatory musical playing, the psychical ability to express oneself influences the degree of expression more significantly than the educated ability of instrumental playing. A few clinical examples are given:

- Depressive people, who are known to have poor emotional expression and little interpersonal interaction due to their withdrawn behaviour, play in a monotonous way using little variance of musical parameters such as range of tone space, rhythms and melodies (Schmidt 1994; see also Chapter 9 in this book).

- A schizophrenic patient typically plays with another person, but is always a little bit 'stepped apart from' the other's playing, probably unconsciously reflecting his fear of getting too close to others. Listening to their 'team-play', you hear that they play something similar which, however, does not really fit with each other's playing (Inselmann 1995).

- A shy, ashamed or self-conscious person may also play in a monotonous way, making little contact with his playing partner.

- An aggressive person may use quite a large range of musical possibilities, but will probably not create much contact with his playing partner.

Thus you get a sense of what the instruments are measuring:

1. Emotional expression and interpersonal interaction are evaluated with a list of suitable adjectives.

2. Musical expression is measured with an instrument which reflects the degree of differentiation of musical parameters.

3. Musical communication is scored with an instrument which differentiates the degree of the patient's making contact while playing.

The main problem of evaluating music therapy is the translation of what the music is symbolising into verbal symbols. Langenberg, Frommer and Tress (1995) suggest using the *resonator function*. That means that the rater tries to feel what the patient's playing is like and writes it down. Timmermann *et al.* (1991) and Inselmann and Mann (2000) supplemented this idea by the suggestion of not writing this in a free essay, but marking suitable adjectives on a given list, which can be used repeatedly.

Method

Step 1: Recording session and therapist report

All sessions of an investigative therapy have to be recorded on tape, video or DVD, and this requires informed consent. The therapist writes a report about each session of musical therapy.

Step 2: Choosing sequences of improvisatory playing for rating

First you have to choose a sequence of improvisatory playing, and document start and end time and duration. You will notice that improvisations often last about two to three minutes. If you listen to the improvisation you will notice, without structured rating, that there are often two to three changes to the kind of playing within the improvisation. You have two options for further rating:

1. Rate the improvisatory sequence as a whole: you may rate fundamental different attributes, for example depressive and aggressive playing.

2. Rate the microprocesses within one improvisatory playing. Carefully listen to the sequence and mark the times when you have the sense of basic changes within the playing. Thus you divide the sequence into two or three smaller parts, and repeat the rating described in Step 3 for each part.

Step 3: Evaluation of selected sequences with instruments for rating musical improvisation

The rating scales for evaluating musical improvisations focus on emotional expression and interaction, musical expression and musical communication. The scales 1.1, 1.2 and 1.3 themselves are in A12.1 on the web-based resources (Figures A12.1–A12.4). In addition to evaluating rating scales, the musical instruments used will be documented for each sequence.

STEP 3.1 SCALE OF ADJECTIVES FOR RATING EMOTIONAL EXPRESSION AND COMMUNICATION (SCALE 1.1)

The scale for rating emotional expression consists of 35 adjectives describing intra- and interpersonal emotional experience. The adjectives were modified by studies by Timmermann *et al.* (1991) and Inselmann and Mann (2000) and were originally chosen from the Questionnaire 'Adjective List' [German: 'Eigenschaftswörterliste'] in Janke and Debus 1978; adjectives were added from the Inventar of Interpersonal Problems (Horowitz, Strauss and Kordy 1994, adjectives nos 22–29).

Rating procedure for scale 1.1

Rate this scale several times. Listen to the sequence and after that, using the method of resonator function (Kenny, Jahn-Langenberg and Loewy 2005), mark the five-stepped adjectives that reflect the patient's (one rating) and the therapist's (second rating) playing, respectively. Originally, the resonator function meant the following instruction for the rater: 'Describe as freely as possible your impressions caused by the improvisation. Feelings, thoughts, pictures and stories – even if they seem to you topsy-turvy – may be reported.' For getting a comparable and structured form within the described method the original resonator idea is adapted in a way that the rater describes his feelings of whether the player expresses the attributed of the given scale.

The first instruction for rating is: 'Please mark on the following list your feelings of whether the *patient's* playing expresses the following attribute none – little – middle – rather – very.'

The second instruction for rating is: 'Please mark on the following list your feelings of whether the *therapist's* playing expresses the following attribute none – little – middle – rather – very.' For calculating, 'none' means '1', 'little' means '2', 'middle' means '3', 'rather' means '4' and 'very' means '5'.

You can compare the rated values with other raters' values, with your repeated rating values or with values from rating another sequence.

STEP 3.2 CALCULATION OF CONDENSED SCALES

Next calculate middle values of items corresponding to one of five 'condensed scales of the scale of adjectives for rating emotional expression and communication', Figure A12.5 on the web-based resources. You can read more about the scaling in the case example. For calculation, just add the values you have marked and divide by the number of the items corresponding to a chosen condensed scale. The condensed scales are: 'self-confident', 'harmonic', 'joyful/turning towards', 'aggressive' and 'depressive'. Thus you get a survey of the main attributes you hear in the playing.

What are you doing, when you have calculated these condensed scales? Dichotomise the middle values of each condensed scale as low or high, based on the following cut-off points: a middle value up from '2.5' for the condensed scales 'self-confident', 'harmonic', 'joyful/turning towards' and 'aggressive' and a middle value up from '2' for the condensed scale 'depressive'. The cut-off point for the 'depressive' condensed scale is lower than the others because of the tendency of lower rating within the depressive attributes. A value lower than the cut-off point means that the corresponding attributes of the condensed scale were too low to have a meaning in the rated playing. In contrast, a value higher than the cut-off point means that the corresponding attribute scale is relevant in the rated playing.

If you rate a whole sequence without dividing it into smaller parts you may notice that more than one condensed scale will be rated; thus you can conclude that several attributes are relevant within the patient's playing.

Variance: simplified possibility for rating scale 1.1

Rating all the 35 adjectives of scale 1.1 makes it possible to reflect the improvisatory playing in a differentiated way. It is also possible to rate only the attributes of the condensed scales: 'self-confident', 'harmonic', 'joyful/turning towards', 'aggressive' and 'depressive' on a five-stepped questionnaire (in Figures A12.7–A12.8 on the web-based resources).

Further research would be necessary to transfer the values onto the computer (for example use StatView® by Apple, a program for statistical analysis on Macs, or SPSS® by Microsoft, a program for statistical analysis on PCs).

STEP 3.3 QUANTITATIVE ANALYSIS OF MUSICAL EXPRESSION (SCALE 1.2)

Count musical parameters as rhythm, dynamics, melody, range and tempo according to their amount of differentiation and expressiveness on a three-stepped scale as in Figure A12.3 on the web-based resources).

STEP 3.4 QUANTITATIVE ANALYSIS OF MUSICAL COMMUNICATION WITHIN THE PATIENT'S PLAYING (SCALE 1.3)

This scale operates on the assumption that the degree of musical communication will increase with the degree of a person's mental and psychical health and differentiation.

Evaluate musical communication on a six-stepped scale, provided in Figure A.12.4 on the web-based resources.

Step 4: Supplementing instruments – perspectives

You may only wish to carry out rating using the instruments described above, but there are options for supplementing evaluations. If you want not only to externally evaluate musical improvisations but also to obtain data about self-exploration and about the personality and the psychical situation of the patient, you can use some of the following methods. You can compare the results with the results of your musical rating and thus you can validate the instruments, on the one hand, or investigate your perception, on the other hand.

STEP 4.1 SCALE OF ADJECTIVES FOR RATING THE RATER'S REACTION TO THE EMOTIONAL EXPRESSION AND COMMUNICATION OF THE PATIENT'S PLAYING

It is possible to compare the perception of what the playing of the patient or the therapist, respectively, is like (using resonator function) with the reaction the *rater himself* has to the improvisatory playing. This may be interesting from a research point of view. But it may also be interesting if the rater is himself the therapist. He can practise to distinguish between the patient's expression as the rater-therapist notices it, and his own reactions. The questionnaire is the same adjective list as in Figure A12.1 and is given in Figure A12.6 on the web-based resources. The instruction for rating is: 'Please mark on the following list which feelings the playing causes in you, none – little – middle – rather – very.' For calculating 'none' means '1', 'little' means '2', 'middle' means '3', 'rather' means '4' and 'very' means '5'.

STEP 4.2 SHORT FORM (CONDENSED SCALES) OF ADJECTIVES FOR RATING EMOTIONAL EXPRESSION AND COMMUNICATION

The questionnaire is given in Figures A12.7–A12.8 on the web-based resources. After rating the attributes the condensed scales 'self-confident', 'harmonic', 'joyful/turning towards', 'aggressive' and 'depressive' a statistical validation should be done. This means that there will be an investigation of whether two or mor raters have similar rating results or whether repeated ratings result in similar values. For this two or more raters have to mark the five stepped attributes of these five condensed scales. Then you compare the values for each scale

with a statistical test; for example Spearman's Rank correlation coefficient for comparison of two raters and Cohen's Kappa for comparison of more than two raters.

STEP 4.3 DIAGNOSTIC INQUIRIES AT THE BEGINNING OF THE THERAPY

Before starting the therapy the patient may fill out several questionnaires; if, for example, we were doing a psychoanalytical interview the patient might complete a personality questionnaire (Freiburger Persönlichkeitsinventar, FPI-R, Fahrenberg, Hampel and Selg 1989) and a shortened version of a psychic and communicative questionnaire (Psychischer und Sozialkommunikativer Befund, PSKB, Rudolf 1993) among others (Inselmann and Mann 2000). It is not possible to provide these on the web-based resources, because they are German and would need new validation, if translated. Suitable questionnaires may already exist in English versions or for other languages.

STEP 4.4 QUESTIONNAIRE FOR SELF-EXPLORATION BEFORE AND AFTER SESSION

The musical rating may be supplemented by a questionnaire for self-exploration. Again the questionnaire described in this chapter cannot be provided on the web-based resources. The questionnaire is, however, reported in the case example to show the possibility for comparing. If you want to do research with this questionnaire, please translate it after authorisation and validate it (great research project!) or choose a comparable questionnaire in your own language. The questionnaire for exploring self-experience ('Stuttgarter Bogen', Lermer and Ermann 1976), used in the case example, was completed by the patient and the therapist at the beginning and at the end of each session. Through introspection, the questionnaire informs about 'here-and-now' situations and is sensitive to short-term emotional changes, which makes it suitable for examining music therapy. Three factors may be extracted (Költzow and Teufel 1984): 'reactive emotionality', 'activity' and 'self-strength'.

Case example

The microprocess over two rated sequences of improvisatory playing from one session of an evaluated case will be described. It was a total of 65 sessions of psychoanalytically orientated active improvisatory music therapy with a female patient. The case and several sequences are described in Inselmann and Mann (2000) and Smeijsters (2005, p.299). The patient came into therapy with depressive symptoms and a lack of self-confidence after separation from her partner. She was used to looking after others and had difficulties in noticing and expressing her own wishes.

Description of evaluation process

The following report describes the first two sequences from session number 10. One rater was a female medical student, who had no information about the patient before rating musical improvisations. The other rater was the therapist, who knew the patient, but had not

evaluated the supplemented questionnaires (which was done after finishing the therapy) and while rating had no information about the evaluated sessions.

The statistical analysis is on the web-based resources in Figures A12.9–A12.20, as are the evaluated values from the case example. As described within the *procedure of rating*, first of all the Scale of adjectives for rating emotional expression and communication for the patient's and the therapist's playing, respectively (Figures A12.1–A12.2), was evaluated. The values of these scales, marked by the student, are enclosed on the web-based resources: Figures A12.9 and A12.10 for the first sequence and A12.15 and A12.16 for the second sequence of improvisatory playing within the rated session. Additionally, the Quantitative analysis of musical expression and the Quantitative analysis of musical communication within the patient's playing were done (Figures A12.3–A12.4, evaluated values on A12.13 and A12.14 for the first sequence and on A12.19 and A12.20 for the second sequence on the web-based resources).

Then the *middle values* from the items of the Scales of adjectives for rating emotional expression and communication (Figures A12.9, A12.10, A12.15 and A12.16) which belong to the corresponding five Condensed scales of the scale of adjectives for rating emotional expression and communication were calculated. The items and the corresponding condensed scales are enclosed on the web-based resources (Figure A12.5). The calculated middle values from the student's rating are also shown: Figures A12.11 and A12.12 for the first sequence, A12.17 and A12.18 for the second sequence. These middle values of each condensed scale were dichotomised at a cut-off point of 2 for the quality 'depressive' and 2.5 for the other scales, respectively, for checking whether the rated attributes were relevant within the sequence or not. (A possible further summarising process for 'patterns of playing' is provided in the Annex section of A12.1 on the web-based resources).

Description and interpretation of the two evaluated sequences of session 10

All mentioned values are in Table 12.1. The single items and the results of calculation are described on the web-based resources (Figures A12.9–A12.20).

The session started with the patient's depressive report of feeling guilty. Accordingly, 'depressive' playing was externally rated within the patient's first musical improvisation (A12.9 and A12.11 respectively). The therapist reflected the patient's 'depressive' playing with the method of 'holding' (after session report) and her playing was rated as 'depressive' as well (A12.10 and A12.12, respectively). ('Holding' means that the therapist plays in a similar way to the patient to give him the feeling of being accepted.) The second improvisation shared the patient's wish to assert herself and to be equal to the other (here to the therapist's playing). Accordingly, the patient's playing was rated as, 'self-confident', 'harmonic' and 'joyful/turning towards' (A12.7), like the therapist's playing (A12.18), which was matched by the therapist's wish to act as a strong partner (after session report). The patient improvised more *expressively* (Figure A12.19) and *communicated with higher musical variation* (Figure A12.20) within her 'self-confident', 'harmonic' and 'joyful/turning towards' playing compared to her 'depressive' playing within her first improvisation (A12.13 and A12.14, respectively).

Table 12.1: Process of external ratings of musical improvisations (and self-ratings) within one session of psychoanalytically orientated improvisatory music therapy for one female patient

	Patient		Therapist	
	Sequence 1	Sequence 2	Sequence 1	Sequence 2
Emotional expression	Depressive	Secure: • self-confident • harmonic • joyful/turning towards	Depressive	Secure: • self-confident • harmonic • joyful/turning towards
Rhythm	Simple	Simple		
Dynamics	One	One/variation		
Melody	No/simple	–		
Range	One octave	–		
Tempo	Simple	Varying		
Patient's musical communication	3/1 (Rater 1/2)	3		
Instruments	Bongos, xylophone	Tambourine	Piano	Sounding dish
For research: Self-experience:	Comparing values after to before session		Comparing values after to before session	
• reactive emotionally	+		–	
• activity	+		–	
• self-strength	+		–	

First are shown the results of the musical analyses (external ratings) of the condensed scales of the 'Scale of adjectives for rating emotional expression and communication' (Figures A12.1 and A12.2, 'Emotional expression'), the 'Quantitative analysis of musical expression' (Figure A12.3, 'Rhythm', 'Dynamics', 'Melody', 'Range', 'Tempo') and the 'Quantitative analysis of musical communication within the patient's playing' (Figure A12.4, 'Patient's musical communication'). Finally, the used musical instruments are listed.

Of interest for further research, the patient's and the therapist's increase (+) and decrease (–) of self-experience is shown within the factors 'reactive emotionality', 'activity' and 'self-strength', comparing values before and after the session.

Discussion

The rating schemes used here enable ratings of emotional and musical expression and inter-action/communication in a *structured, comparable* and *repeatable* way.

The 'Scale of adjectives for rating emotional expression and communication' can be summarised to significant intrapersonal and interpersonal emotional and behavioural attributes, or condensed scales: 'Self-confident' means an integrated, positive narcissistic, active and sure condition. 'Harmonic' represents a calm positive state. 'Joyful/turning towards' expresses a glad open-minded view of the world. 'Aggressive' means rivalry, refusing interpersonal behaviour. Unfortunately, 'depressive' summarises many attributes of the intrapersonal and interpersonal theory of depression and does not discriminate different attributes of mood and behaviour, though those adjectives were originally chosen from different scales of the Questionnaire 'Adjective List' from Janke and Debus (1978) and the Inventar of Interpersonal Problems from Horowitz *et al.* (1994). These attributes of the condensed scales may be evaluated immediately, without rating the whole scale of adjectives. A statistical validation is recommended. But, of course, the evaluation of music therapy always remains to some extent subjective; thus the rating schemes provide the chance to compare the subjective judgements in a structured way. Higher musical expression and interaction within 'self-confident', 'harmonic' and 'joyful/turning towards' playing (summarised to 'secure' playing) compared to the ones within 'depressive' playing confirm the hypothesis that more health may be reflected by a greater range of (emotional and musical) expressive and communicative possibilities.

Summary and conclusion

The instruments chosen to collect data were developed on the hypothesis that active improvisatory music therapy (as psychotherapy):

1. reflects (or should reflect) the emotional experience of a person – within oneself and in relation to others

2. allows testing by acting

3. is a process.

Accordingly, the instruments enable ratings of emotional and musical expression and interaction/communication in a comparable and repeatable way and are able to detect changes within these attributes. All the scales may be interpreted individually and compared with each other or with other scales. Thus comparing self-ratings and external ratings may be a useful method for reflecting clinical work, teaching students, supervision or developing knowledge about processes within music therapy. For clinical work the instruments reflect the subjective perception of a patient's playing in a structured way to provide something to discuss. They are already known to reflect the psychopathology of a patient (Inselmann and Mann 2000).

Thus it is helpful to use the instruments for teaching students. They do not only train their perception of the patient, leading to questions of emotion and behaviour, and intrapersonal and interpersonal aspects, but they also lead to self-perception, if the student evaluates his or her own therapeutic playing and considers more helpful and less helpful aspects of their own expression and interaction. Furthermore the student may reflect his counter transference to the patient, if he evaluates his own, that is the rater's reaction to the patient's playing. This leads to the aspect of supervision, because a trained supervisor may structure his views about the student's playing or the student's perception with the aid of the instruments. Thus the instruments offer the facility of a common language in which to discuss music therapy.

Last but not least the instruments should enable developing knowledge about micro-processes within music therapy, because they evaluate different emotions and changes in emotions and interpersonal behaviour, and thus processes within therapy. If you look at the playing of a patient and the answering or provoking intervention of the therapist, and then again at the patient's reaction to that intervention, and so on within a microprocess within one sequence, you can gather structured knowledge of what is happening in therapy.

References

Bion, W.R. (1990) 'Angriffe auf Verbindungen.' In È. Bott Spillius (ed.) *Melanie Klein Heute. Entwicklungen in Theorie und Praxis, Bd. I, Beiträge zur Theorie.* München Wien: Verlag Internationale Psychoanalyse, 110–29.

Cattell, R.B., Cattell, A.K.S. and Rhymer, R.M. (1947) 'P-technique demonstrated in determining psycho-physiological source traits in a normal individual.' *Psychometrica 12,* 4, 267–88.

Cronbach, L.J. (1951) 'Coefficient alpha and the internal structure of tests.' *Psychometrica 16,* 297–334.

Decker-Voigt, H.-H. (2001) *Schulen der Musiktherapie.* Munich and Basle: Ernst Reinhard Verlag.

Fahrenberg, I., Hampel, R. and Selg, H. (1989) *Das Freiburger Persönlichkeitsinventar. Revidierte Fassung FPI-R und teilweise geänderte Fassung FPI-A1,* 5th edn. Aufl. Göttingen, Toronto and Zurich: Hogrefe.

Hinshelwood, R.D. (1993) *Wörterbuch der kleinianischen Psycho-analyse.* Stuttgart: Verlag Internationale Psychoanalyse [Reference appears in web-based resources].

Horowitz, L.M., Strauss, B. and Kordy, H. (1994) *Inventar zur Erfassung Interpersonaler Probleme – Deutsche Version (IIP-C).* Weinheim: Beltz.

Inselmann, U. (1995) 'Musiktherapeutische Behandlung psychotischer Patienten.' *Zeitschrift für Klinische Psychologie Psychopathologie Psychotherapie 43,* 249–60.

Inselmann, U. (in press) 'Musikimprovisation und Selbsterleben – Eine Mehrebenenerhebung des therapeutischen Prozesses.' Accepted for publication.

Inselmann, U. and Mann, S. (2000) 'Erleben, Ausdruck und Kommunikation in Musikimprovisationen.' *Psychotherapie, Psychosomatik, Medizinische Psychologie 50,* 193–8.

Janke, W. and Debus, G. (1978) *Eigenschaftswörterliste.* Göttingen: Hogrefe.

Janssen, P.L. (1982) 'Psychoanalytische Mal- und Kunsttherapie im Rahmen stationärer Psychotherapie.' *Psyche 36,* 541–70.

Kenny, C., Jahn-Langenberg, M. and Loewy, J. (2005) 'Hermeneutic inquiry.' In B.L. Wheeler (ed.) *Music Therapy Research.* Barcelona Publishers.

Klein, M. (1946) 'Bemerkungen über einige schizoide Mechanismen.' In M. Klein (1983) *Das Seelenleben des Kleinkindes.* Stuttgart: Klett-Cotta, S. 131–63.

Költzow, R. and Teufel, R. (1984) 'Untersuchung zur Faktorenstruktur des Stuttgarter Bogens.' *Gruppenpsychot-hotherapie Gruppendynamik 19,* 221–30.

Lang, H. (1993) *Die Sprache und das Unbewusste,* 2nd edn. Frankfurt am Main: Suhrkamp.

Langenberg, M. (1996) 'Affektivität.' In H.-H. Decker-Voigt, P.J. Knill and E. Weymann (eds) *Lexikon Musiktherapie*. Göttingen, Berne, Toronto and Seattle: Hogrefe, S. 3–5.

Langenberg, M., Frommer, J. and Tress, W. (1995) 'Musiktherapeutische Einzelfallforschung – ein qualitativer Ansatz.' *Psychotherapie, Psychosomatik, Medizinische Psychologie 45*, 418–26.

Langer, S.K. (1978) 'On Significance in Music.' In S.K. Langer (ed.) *Philosophy in a New Key*. Cambridge, MA: Harvard University Press, S. 204–45.

Lermer, S.P. and Ermann, G. (1976) 'Der Stuttgarter Bogen (SB) zur Erfassung des Erlebens in der Gruppe.' *Gruppendynamik 2*, 7, 133–40.

Meltzer, D. (1995) *Traumleben*, 2nd edn. Stuttgart: Internationale Psychoanalyse, S. 28, 49.

Meschede, H.G., Bender, W. and Pfeiffer, H. (1983) 'Musiktherapie mit psychiatrischen Problempatienten.' *Psychotherapie, Psychosomatik, Medizinische Psychologie 33*, 101–6.

Priestley, M. (1982) *Musiktherapeutische Erfahrungen*. Stuttgart: Fischer.

Rudolf, G. (1993) *Psychischer und Sozialkommunikativer Befund (PSKB)*. Göttingen, Toronto and Zurich: Hogrefe.

Schmidt, S. (1994) 'Der musikalische Dialog mit depressiven Patientinnen. Die Implementierung einer Methode zur Dokumentation und Analyse musikalischer Dialoge und deren Validierung an einer klinischen Gruppe.' Human biology dissertation, Faculty of Medicine, University of Ulm, Germany.

Smeijsters, H. (2005) 'Quantitative Single-case Designs.' In B.L. Wheeler (ed.) *Musictherapy Research*. Gilsum, NH: Barcelona Publishers, 293–305.

Spitzer, M. (2003) 'Emotion.' In M. Spitzer (ed.) *Musik im Kopf*. Stuttgart and New York: Schattauer, 379–99.

Timmermann, T., Scheytt-Hölzer, N., Bauer, S. and Kächele, H. (1991) 'Musiktherapeutische Einzelfall-Prozeßforschung. Entwicklung und Aufbau eines Forschungsfeldes.' *Psychotherapie, Psychosomatik, Medizinische Psychologie 41*, 385–91.

Wosch, T. and Frommer, J. (2002) 'Emotionsveränderungen in musiktherapeutischen Improvisationen.' *Zeitschrift Musik- Tanz- Kunsttherapie 13*, 3, 107–14.

The Music Interaction Rating Scale (Schizophrenia) (MIR(S)) Microanalysis of Co-improvisation in Music Therapy with Adults Suffering from Chronic Schizophrenia

Mercédès Pavlicevic

Introduction

The MIR(S) focuses explicitly on the co-improvisation by therapist and client, and excludes body posture, facial expressions, gestures, verbal exchanges, or other information and clinical material that the client may bring to sessions. This specific focus on the musical event is in keeping with the music-centred tradition of music therapy (Aigen 1999; Ansdell 1995), in which the musical event is at the heart of the therapeutic relationship. Also, as this chapter shows, the in-depth microanalysis of clinical co-improvisation reveals a rich, complex and nuanced interactive event. The MIR(S) helps us to 'make sense' of 'what is going on' in the music.

The Music Interaction Rating Scale (MIR(S)) (Pavlicevic 1991, 1995; Pavlicevic and Trevarthen 1989; Pavlicevic, Trevarthen and Duncan 1994) was developed for evaluating music therapy improvisation with adult persons suffering from chronic schizophrenia. Two hundred and forty individual music therapy session recordings (both audio and video) were available for analysis, and the MIR(S) was developed as a result of exhaustive microanalysis of co-improvisation on tuned and un-tuned percussion, with re-analysis of excerpts in order to tease out different kinds of interactions in the improvisations. Finally, the MIR(S) was subjected to inter-rater checks with trained raters – some of whom were music therapists and others musicians – and a high correspondence in scores was found, as well as the relative ease of allocating levels to excerpts.

Theoretical basis

The notion of 'the basic beat' (Nordoff and Robbins 1977) has long clarified for music therapists that clinical improvisation in music therapy is a co-operative business. The more recent term of 'co-improvisation' (Procter 1999) emphasises the dialogical nature of this event, in which, even if the therapist has the clinical expertise, the joint musical impulse needs both therapist and client. The Basic Beat symbolises the delicate and dynamic musical negotiations between therapist and client, which signal the communicative and relational agenda of clinical improvisation. In other words, it takes two to tango.

Research into non-verbal communication between mothers and infants (Beebe 1982; Papoušek 1996; Trevarthen 2000) in the late 1980s and 90s resonated with Nordoff and Robbins' Basic Beat, revealing parallel improvisatory techniques used by mothers and newborn babies in establishing and sharing communication between them. Although neither the mother–infant scenarios nor their communicative techniques were 'clinical' or 'therapeutic', the notion of 'communicative musicality' (Trevarthen and Malloch 2000) suggested a link between the communicative and expressive qualities of human communication (akin to Daniel Stern's vitality affects: Stern 1985, 2004) that music therapists put into effect in clinical improvisation.

In music therapy improvisation, however, the therapeutic dictates require the therapists to identify communicative damage or gaps in clients' spontaneous musical utterances, and to adapt their own improvisation using clinically informed techniques. These clinical interventions, which are explicitly musical, enable both therapist and client to gauge the possibilities and limitations for human relating, and to address and, in some cases, repair these.

The empirically grounded model of Dynamic Form (Pavlicevic 1990, 1991, 1997, 2000a, 2000b) identifies the duality of music therapy improvisation: a musical event that both draws from, and engages with, the social musical traditions of the therapist and clients, and whose purpose is to portray the interpersonal possibilities of relating between them, and extend and deepen these. The musical–relational duality of clinical improvisation means that its musical–relational–neurological fundamental qualities of timing, phrasing and intensity can be decoded as any one of these at any time. In other words, phrasing may be received as a musical phenomenon, a neurological capacity and/or a relational facility.

The MIR(S) is anchored within dynamic form: the musical–relational duality; hence its emphasis on the musical inter-activity between therapist and client, which is both musical and relational. Lower levels focus on the client's responsibility in being part of the joint improvisation: contact between therapist and client cannot be established until the client begins to orientate his or her musical statements towards the therapists. The therapist's task – and skill – is in inviting, guiding and enabling the client to do precisely this.

General considerations

1. HANDS-ON MICROANALYSIS

Although software tools for microanalysis may seem to save time and possibly offer more 'accurate and objective' evidence, nothing replaces the inter-subjective clinical listening that practitioners develop with time and experience. The MIR(S) draws on the listener's informed

clinical intuition. Where used by non-clinicians, for maximal effective use it needs thorough training and familiarising of the rater by the clinician, with clinical improvisation techniques and listening techniques as well as the MIR(S).

2. *RUBATO* TIME AND PLACE: CHOOSING THE MOMENT

Microanalysis is time consuming and, depending on the nature of your evaluation, you may want to consider selective moments in the improvisation for microanalysis. Prior to starting the microanalysis of the recording, you may want to consider doing macroanalysis in some parts, and microanalysis in others.

3. ZOOMING IN AND OUT

The MIR(S) can be used for either and both, as we will see later. Also, macro and microanalysis work in tandem, and need to 'fit' alongside one another. Each is helpful in confirming and in challenging the other.

The Musical Interaction Rating (MIR) considers the whole musical trace, even though it is co-improvised by therapist (T) and client (C). The MIR(S) takes into account the following six aspects of clinical co-improvisation.

1. *Client's performance*: this refers to the content of C's musical statements, rather than interactive responses, since C's performance will have an effect on whether T is able to meet (by mirroring, matching or reflecting) C's playing, and thereby set the tone for any interactive processes.

2. *Therapist's response*: refers to whether T is able to meet C's playing. (1 and 2 are not stated after level four, since for higher levels the therapist must have met C's playing.)

3. *Quality of C's responsiveness*: refers to C's awareness of and response to any clinical interventions by T. This is only applicable to levels two to six, inclusive, since below this level (level one) there is no musical contact, and therefore no potential for clinical intervention by T, and above level six the improvisation moves towards mutuality, where both players initiate and exchange musical ideas, rather than just P responding to T's interventions.

4. *Musical interaction*: is a summary of the interactive content of the improvisation, i.e. who tends to do what in any level. For example, who introduces new musical material, who responds/does not respond, and so on.

5. *Shared musical content*: is a summary of the overall musical content of the joint improvisation, i.e. the overall musical effect. For example, is the joint pulse regular, is there any fluctuation of tempo and is there any development of thematic material?

6. *Clinical adjustment*: is an indication of T's clinical techniques at any level (see nine levels of MIR(S) below), e.g. at level two T cannot intervene frequently since the

contact is tenuous, and at level six, although T may intervene more frequently, since the contact is stronger, T may cease to do so to encourage C to take the musical initiative.

For the complete MIR(S) please see A13.1 on the web-based resources.

Using the aspects outlined above, the MIR(S) describes the following nine levels of musical interaction, which represent a potential 'direction' for therapeutic work – as well as sequential levels of musical interaction:

Level One – No musical contact

Level Two – One-sided contact: no responsiveness from C

Level Three – One-sided contact: non-musical responsiveness of C

Level Four – Self-directed musical responsiveness of C

Level Five – Tenuous, musically directed responsive contact

Level Six – More sustained musically directed responsive contact

Level Seven – Establishing mutual contact

Level Eight – Extending mutual contact

Level Nine – Musical partnership.

The levels of performance described by the MIR comprise an ordinal nine-point scale. Although a global score can be allocated to any co-improvisation, leaving pre-global scores as spread across levels is often a far richer indication of the quality of relationship in the co-improvised encounter.

Method: Step-by-step analysis

Although some of the steps below are generally considered to be part of day-to-day clinical practice, they are listed as part of the context for MIR(S) microanalysis.

1. Recording

Whether you do audio or video recording may depend on your work context and client group. Generally, audio recording is adequate (and in some ways recommended) for listening closely to the musical event. However, where therapist and client play the same instrument (e.g. turn taking or joint playing on one or even two marimbas/pianos/etc.) it can be difficult to hear who is playing. For these kinds of scenarios, and for group work, video recordings are more useful.

2. Session notes

Again this is fairly standard clinical practice: immediately after each session, noting first impressions, spontaneous comments and reflections means that you capture and record your

impressions while they are still 'hot', so to speak. This is not only an *aide-memoire* for later listening, but may come in useful when considering your MIR(S) scores, whether macro or micro.

3. Listening and indexing

Listening is at the heart of assigning MIR(S) scores. Nordoff and Robbins' (1977) insistence on rigorous listening and documenting of the musical content of session recordings has led to a practice in which intensive and finely tuned listening is as important a part of clinical practice as the actual session. While listening to the recording, the therapist formulates clinical–musical thinking, evaluates (even informally) what has happened, and considers any shifts and developments that need to happen in the co-improvisation.

This process of listening is accompanied by a written documentation of the recording (which became known as indexing), which is real-time based (e.g. the seconds on a mini-disc recorder). Session indexing is a detailed document of the session, complementing the session notes, and enabling interpretations of the therapeutic relationship to be drawn directly from the co-improvisational material. Index sheets differ between therapists and, sometimes, between client groups. Figure 13.2 in the case example shows a separation of the therapist and client acts, with a third column where an extra-musical commentary is offered, drawing explicitly from the musical events.

4. Segmenting the time line in the index sheet

Although segmenting is a part of indexing and listening (rather than a subsequent step), here this is treated separately in order to emphasise the use of the MIR(S) for process analysis.

In the index sheet the time line is segmented at the moments of change in the improvisation (i.e., Mc1, Mc2, etc.), rather than at regular (e.g. five-second) intervals (Figure 13.1). This process of segmenting demands micro-attentiveness to the micro-changes in the

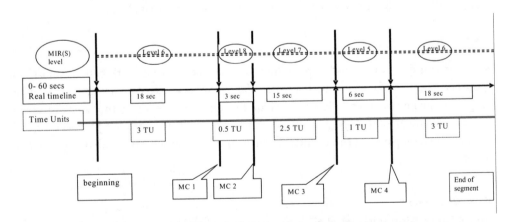

Figure 13.1: Hypothetical example of 60 second co-improvisation showing how four moments of change (Mc) delineate the 10 time units and the MIR(S) levels

co-improvisation as this unfolds over the time. This microanalysis also enables, if necessary, an analysis of the emerging patterns of MIR(S) level sequences over time.

5. Allocating time units (TUs) to MIR(S) levels

Once the musical excerpt has been segmented according to moments of change (or critical moments), then the excerpt is allocated 10 time units (TU), representing 10 equal units of time. (Thus an improvisatory excerpt of 60 seconds will comprise 10 units of 6 seconds; while an excerpt of 180 seconds will have 10 units of 18 seconds each.) These 10 units are now distributed across the entire improvisatory excerpt time line, at the same time as being allocated to any of the nine levels of the MIR(S) scale. This is done in a way that best represents the amount of time spent at each level. (See Table 13.1 and Figure 13.1).

Thus, while the nine levels of the MIR(S) are fixed (Column A), the 10 TUs can be distributed across the nine levels, in a way that best represents the quality and level of musical interaction, of the excerpt being rated. All 10 TUs need to be allocated (Column B).

Table 13.1: Distribution of 10 TUs across MIR(S) levels 1–9

MIR(S) level Column A	10 TU distribution Column B	Score spread TU x MIR(S) level Column C
ONE		
TWO		
THREE		
FOUR		
FIVE	1.0	5.0
SIX	6.0	36.0
SEVEN	2.5	17.5
EIGHT	0.5	4.0
NINE		
TOTAL	10.0	62.5
		Global Score: 6.25

6. Calculating the global score

A global score is then calculated by summing the product of TUs and the scale level. For instance, Table 13.1 shows 0.5 TUs allocated to level eight, 2.5 to level seven, 6 units to level six, and 1 to level five. Their products, in Column C, are 4, 17.5, 36 and 5, respectively, and the total score is 62.5, which signifies a mean score on MIR(S) level of 6.25.

By taking only the global score of 6.25 into account, it appears that the entire excerpt occurred at MIR(S) level six (more sustained musically directed responsive contact). However, as suggested earlier, rich information is lost by only considering the global score. The score spread suggests that this client already shows a capacity to interact at higher levels, which can be borne in mind for future sessions, with a residual functioning at level five. The global score of 6.25 conceals the fluctuations and potential clinical direction of the improvisation.

To reiterate: the MIR(S) can be used as a macro- and microanalytic tool. The same steps can be applied to a much longer improvisation, without the need for micro-timed segments, but rather assigning 10 TUs to the nine levels using a broader, macro sweep of the entire excerpt.

The process analysis can stop after step 4, since the segmenting of the improvisation on the basis of moments of change, which then delineate different MIR(S) levels, constitutes a microanalysis of the improvisatory process.

A global score allocation (steps a to f) is a quantitative, evaluative representation of the music co-improvisation.

Case example

'Harry' is an adult male suffering from a chronic schizophrenic illness. He attends individual music therapy sessions at a day centre in the middle of a busy city. In the co-improvisation, his playing is characterised by a narrow range of expressive qualities, with little variation of tempo, phrasing, dynamic level, or even of rhythmic patterning or melodic contours. His regular attendance and enthusiastic participation in the sessions suggest that he enjoys these sessions.

In session 2, Harry played the bongos for the first time, and the therapist wrote in her notes (Step 2) that she was aware of 'something' happening in the piano/bongo improvisation. After indexing the entire recorded session (Step 3), she decides to 'zoom in' and do a microanalysis of the first minute of playing.

Accordingly, the therapist prepares a detailed index sheet of this segment (Figure 13.2) in which she notes even micro changes, which she might not have on the session indexing. In this indexing, the timing is noted at moments of change (e.g. seconds 9, 17, 20, 27, 35), rather than completing an index sheet with regular (e.g. five-second) intervals (Step 4).

While completing this detailed index, she also writes a commentary on what their co-improvisation might mean in the overall scheme of their work together.

Table 13.2, used in tandem with the index sheet (Figure 13.2), provides a segmented time line of how the co-improvisation develops (Step 4), as well as providing an overall view of the amount of time spent at each consecutive level. In this segment only MIR(S) levels 1–5 are used. It is another way of representing the improvisation's time line, which can also be done more graphically, as in Figure 13.1.

In Table 13.3, Table 13.2 is rearranged to provide a representation of the proportion of time spent at each of the MIR(S) levels. Here, there is no sense of sequence of levels, or progression of the co-improvisation.

Table 13.2: Number of seconds per segment at each MIR(S) level

Time line (secs)	9–16 A	17–19 B	20–26 C	27–34 D	35–45 E	46–56 F	57–61 G	62–71 H	72–82 I	83 J
MIR(S) level										
ONE	8							10		
TWO			7		11					
THREE							5			1
FOUR		3		8						
FIVE						11			11	
SIX										
SEVEN										
EIGHT										
NINE										

Table 13.3: Proportion of total time per MIR(S) level

MIR(S) level/segments	Time line (in secs)	Total time/Level
ONE: no contact (A, H)	9–16 / 62–71	18 (8 +10)
TWO: one-sided (C, E)	20–26 / 35–45	18 (7 +11)
THREE: self-directed (D, G, J)	57–61 / 83	6 (5+1)
FOUR: other-directed (B, D)	17–19 / 27–34	11 (3+8)
FIVE: tenuous m-d contact (F, I)	46–56 / 72–82	22 (11+11)
		75 secs

Table 13.3 shows that, unexpectedly, Harry spends the highest proportion of time at Level 5 (tenuous, musically directed contact). This is unexpected because, had the therapist not done a microanalysis, this may well not have been revealed quite so clearly.

The therapist is now ready to allocate her 10 time units to this excerpt (Step 5). She listens again to the recording, goes over her index sheet, and allocates as follows:

Total time = 9–83 secs = 75 secs (inclusive) = 10 time units (TUs).

Time	Client	Therapist	Relational
9" A	Seated at snare drum – 2 beaters Plays alone alternate L–R movt. [music notation]	Stands next to tape recorder Fiddling with tape recorder	(Why is T not ready?) (H does not wait for her) MIR(S) 1 – no contact possible
17" B	Parallel movt: [music notation] or [music notation] (Motif B)	Sits at piano Hands on keyboard Listening	T waits for opportunity to join in MIR(S) 4? – C 'corrects' himself/not rel. to T
20" C	Musically together Rhythmically matching	Plays Chord clusters. Uses C's B motif	Make contact but not sure how mutual this is MIR(S) 2? One-sided – T seems to do the matching
27" D	Playing becomes less organised [music notation]	Stumbles	C's stumbling seems unrelated to T – doesn't seem relational T is thrown by him – susceptible to him MIR(S) 4 – C self-directed
35" E	[music notation]	Steadies pulse [music notation]	T offers stability in her playing MIR(S) 2 – one-sided, from T

46" F	Moves towards T's steady playing Plays on every beat		C's playing seems related to T's MIR(S) 5 – C is tenuously directed to T
57" G	Loses pulse at end of phrase		As in 27" C's stumbling seems unrelated to T MIR(S) 3 – self-directed
1'02 H		Goes back to alt. beats	T's detached accented playing emphasises the pulse T introduces melodic material within harmonic structure MIR(S) 1 – although T intervening; no contact between T and C
1'12 I	Moves towards beat	play together	C responds to T's music moves towards her MIR(S) 5 – tenuous music. dir. response of C
1'23 J	"I've got pain in my chest!" – stops playing and touches his chest	T stops playing	He stops on the V7 – I cadence Was the contact too immediate? Getting too much for him? MIR(S) 3? – non-musical, but in response to music?

Figure 13.2 Index sheet

Using the information from the index sheet, as well as the proportional allocation of TU per MIR(S) level, we are now ready to have both a score spread and a global score (Step 6). As can be seen in Table 13.4, the score spread (i.e. 2.4 TUs on levels one and two, 3 TUs on level five, and the remaining TUs on levels three and four) is a far richer indication of the interactive content of the co-improvisation than is the global score of 3.02.

Table 13.4: Allocation of TUs and calculation of global score

MIR(S) Level	Secs per level (total 75 secs)	TU (secs/total) (total 10 TU)	Score spread TU X MIR(S)
ONE	18	2.4	2.4
TWO	18	2.4	4.8
THREE	6	0.8	2.4
FOUR	11	1.4	5.6
FIVE	22	3	15
SIX			
SEVEN			
EIGHT			
NINE			
TOTAL	75	10	30.2
Global mir(s) score			30.2

Summary

For clinical work, the process of selecting, segmenting and indexing of music therapy improvisational material is intrinsic to using the MIR(S), since these tasks may already inform the therapist and offer suggestions about clinical direction. Once these tasks are completed, the allocating of MIR(S) levels follows easily. Also, as will be seen from the index sheet (Figure 13.2), in some of the segments there is a question mark after the MIR(S) level has been allocated – this is in keeping with the MIR(S)'s use in evaluating potential clinical direction. In other words, the co-improvisation may not quite be at the MIR(S) level allocated, but is very much pointing in that direction, hence the allocated level.

For music therapy students, the MIR(S) is a useful framework for focusing listening, for developing a clinical vocabulary and formulating thinking about what is happening in co-improvisation in music therapy.

The MIR(S) is a flexible and pliable tool. First, it need not always be used as a tool of microanalysis. The same principles of segmenting, assigning time units and then assigning

the time units to MIR(S) levels can be used in order to rate, for example, an entire improvisation (even one lasting up to 30 minutes), or for rating significant segments. The significance of the segments selected for analysis is part of the clinician's informed intuition – which the MIR(S) can confirm or dispel.

Second, the MIR(S) achieved a high degree of inter-rater reliability by trained observers, whose scores were closely aligned. Thus, although useful as a clinical evaluation tool it can also be used for more quantitative-based research, where inter-rater reliability is a key aspect to ensuring objectivity and lack of clinician-rater bias.

References

Aigen, K. (1999) 'The true nature of music-centered music therapy theory.' *British Journal of Music Therapy 13*, 2, 77–82.

Ansdell, G. (1995) *Music for Life: Aspects of Creative Music Therapy with Adult Clients.* London: Jessica Kingsley Publishers.

Beebe, B. (1982) 'Micro-timing in Mother–Infant Communication.' In M.R. Key (ed.) *Nonverbal Communication Today.* New York: Mouton.

Nordoff, P. and Robbins, C. (1977) *Creative Music Therapy.* New York: John Day.

Papoušek, H. (1996) 'Musicality in Infancy Research: Biological and Cultural Origins of Early Musicality.' In I. Deliège and J. Sloboda (eds) *Musical Beginnings.* Oxford: Oxford University Press, pp.37–55.

Pavlicevic, M. (1990) 'Dynamic interplay in clinical improvisation.' *Journal of British Music Therapy 4*, 5–9.

Pavlicevic, M. (1991) 'Music in Communication: Improvisation in Music Therapy.' Unpublished PhD, University of Edinburgh.

Pavlicevic, M. (1995) 'Inter Personal Processes in Clinical Improvisation.' In R. West, A. Wigram and B. Sapperson (eds) *Music and the Healing Process: A Handbook of Music Therapy.* Chur: Harwood Academic Publishers, pp.167–78.

Pavlicevic, M. (1997) *Music Therapy in Context.* London: Jessica Kingsley Publishers.

Pavlicevic, M. (2000a) 'Improvisation in music therapy: human communication in sound.' *Journal of Music Therapy 37*, 4, 269–85.

Pavlicevic, M. (2000b) 'Improvisation in music therapy: does a musical analysis suffice?' *SA Journal of Musicology 19*, 47–55.

Pavlicevic, M. and Trevarthen, C. (1989) 'A musical assessment of psychiatric states in adults.' *Psychopathology 22*, 325–34.

Pavlicevic, M., Trevarthen, C. and Duncan, J. (1994) 'Improvisational music therapy and the rehabilitation of persons suffering from chronic schizophrenia.' *Journal of Music Therapy 31*, 2, 86–104.

Procter, S. (1999) 'The therapeutic musical relationship: a two-sided affair?' *British Journal of Music Therapy 13*, 1, 28–37.

Stern, D. (1985) *The Interpersonal World of the Infant.* New York: Basic Books.

Stern, D. (2004) *The Present Moment in Psychotherapy and Everyday Life.* New York: Norton.

Trevarthen, C. (2000) 'Musicality and the intrinsic motive pulse: evidence from human psychobiology and infant communication.' *Musicae Scientiae* (Special Issue 1999–2000), 155–215.

Trevarthen, C. and Malloch, S.N. (2000) 'The dance of wellbeing: defining the musical therapeutic effect.' *Nordic Journal of Music Therapy 9*, 2, 3–17.

The Use of Micro-musical Analysis and Conversation Analysis of Improvisation: 'The Invisible Handshake' – Free Musical Improvisation as Conversation

Julie Sutton

In *No Sound is Innocent*, Edwin Prevost stated that:

> The tiniest sound is amplified by intention. Other noises are transformed into counterpoint. The music begins.
>
> The musician waits, trying to anticipate and out-think the unthinking but thinkable direction the sounds will take. Construction overtakes the constructionalist, who can only nod approvingly as the piers and girders of musical form slot automatically into place. Here is the invisible handshake, enjoined before a motion was ever formulated. The music makes itself – just as man makes himself. Here are volition, intention, determination tempered by acceptance of eventuality. Here is definition by action. I am what I am because I do what I do, acted upon and acting upon. (Prévost 1995, p.12)

Introduction

In my doctoral research I explored the music–language analogy, making use of both musical microanalysis and conversation analysis to come to some conclusions about the management of interaction during improvised music. I concentrated on four main areas: how improvisations begin, how improvisations end, turn-taking and silence. My findings revealed some predictable similarities and some surprising differences between improvisation and conversation.

Focusing on one improvised duet, I will explain the musical and conversational analysis that was made, and discuss my findings in terms both of improvised music and conversation, and of clinical music therapy. I aim to show that by identifying small musical cells and their recurrence as the music unfolds between musicians one can make use of concepts from conversation analysis to show both the nature of the musical interaction and ways in which the

music is built by negotiation between musicians. This is a different perspective from which to view aspects of music therapeutic work with clients. Rather than an in-depth view of the dynamic relationship, this approach considers primarily the broader management of the interaction; thus it is useful in that it can inform clinical practice from another angle. A summary will expand upon the usefulness of this approach within clinical practice, with further examples of the potential for application.

Theoretical basis

How does interaction in improvised music relate to conversation? In talk, we negotiate what the words used might mean in relation to the speaker's intention and how this is received at different cognitive and emotional levels. Music does not have words to carry potential meaning, but it does share this aspect of multi-level negotiation between people, which can be seen in relation to the musicians' discovery of shape, form or order in the music. In music the emotional component of interaction is to the fore, and in music therapy form and emotion are central. It might be argued that the method I used in my research has a tangential relevance to music therapy: on the contrary, I believe that it provides further evidence for the existence of purely musical processes that do not merely underpin the work, but provide the fundamental *musical* basis for the uniqueness of music therapeutic work.

Method

My doctoral research originated from a view of free improvised music-making as human communication, and examined the hypothesis that free musical improvisation is like conversation (Sutton 2001). Without ignoring the inherent communicativeness of all music, the moment-to-moment negotiation between musicians was recognised as the raison d'être for free improvisation. The research focused on ten existing audio recordings of free musical improvisations created by well-known European free improvising musicians, spanning the two periods of 1976–8 and 1991–4. Apart from one trio, the music comprised duets played by different combinations of nine musicians.

The combined use of detailed musical analysis with the added perspective of conversation analysis allows the examination of musical process from within the musical material itself. My method for musical analysis uses the following four-stage procedure:

1. Make a written summary of each improvisation.

2. Identify musical cells and code them within the score.

3. Check the coding through repeated listening to the audio recordings of the original improvisations during the process of coding.

4. When the coding process is completed, a second written record is made, outlining the overall and structural development of motivic material, using the codes that identified each musical motif.

For conversation analysis detailed observation has revealed recurring patterns in everyday conversations, which relate to ways in which the participants work together to keep a

conversation going, as well as what it is necessary to do to stop a conversation breaking down or failing. Rather than deal with levels of meaning between people, conversation analysis relates to the negotiation of improvised talk in everyday situations. There are sets of rules for the sustaining of talk between people, identifying, through analysing spontaneous or natural conversation, the commonly occurring patterns and features observed when people converse. These rules offer a macrostructure from which to examine negotiation related to the preservation of interaction, alongside which psychodynamic or psychoanalytic theory can also be placed.

Case example

Rather than describe the method in detail, it is illustrated through an example of the analysis of one improvisation. The improvisation focused on is one of a suite of four, improvised by Markus Stockhausen (trumpet) and Evan Parker (saxophone) in a BBC studio in 1991.[1] This suite is of special interest because the musicians had not met before they improvised and, unaffected by previous musical meetings, they later discussed the experience in words. As in a music therapy process, one could see differences between the four improvisations and chart the progress of the two musicians becoming more confident in working together.

For the musical analysis I focus on musical cells or motifs, as well as the overall structure of each improvisation. The small motivic features of each piece are identified and their occurrence in restatements and altered form described. The sequence of motivic events in relation to the overall structure of the music is given, as well as the ways in which motivic material was exchanged and passed between the musicians. It was shown that the ways in which this material is developed by the musicians' interaction is the same as for word, topic and structural development in conversation.

Within my doctorate the analysis commented on four features relating to conversation analysis (i.e. openings, closings, turn taking and silence); however, due to space limitations here I will concentrate only on silences within the improvisation. I will introduce the relevant conversational analysis theory as necessary within the analysis.

Step 1: Written summary of the improvisation

The improvisation is one of four Stockhausen–Parker duets that are linked musically in the following ways, in that each contains:

- an exploration of the home pitch
- a move away from the home pitch and an eventual return to it at the end
- a cohesive link in motivic development
- similarities in the structural use of silence and sustained pitches.

1 © BBC 1991: Recorded for transmission by BBC Radio 3 for the programme 'Mixing It'.

Perhaps this is not surprising, because all four improvisations were recorded during the same studio session and were discussed as part of the broadcast radio programme. However, it *is* surprising that there is such a large amount of retrospective cross-reference both within each piece of music and the suite as a whole.

The final improvisation contrasts with the previous three and is very different in mood. The music begins loudly with a tension created by high dissonant pitches, which is eventually resolved. The trumpet elaborates while the saxophone retains the held, sustained pitch, rather as if balancing the previous roles (i.e. the trumpet in the accompanying role). This piece is also characterised by the creation of a balance between dissonance and consonance, or the resolution of tension. In comparison to the other three improvisations, this is more confident, where the musicians are more familiar with each other. It is also indicative of the ending of the meeting between the musicians, drawing their improvisations to a close.

Step 2: Identify musical cells and code them within the score

Five motives were identified. The first motif (stated by Player 1: *bar 1*) begins the piece and is a single, sustained pitch. The second motif is a falling minor second played by the second musician (*bars 1–3*). The third motif is an elaboration of motifs 1 and 2, containing a minor second and a single sustained note (*bars 3–4*). The fourth motif comprises the intervals of a third and a second (*bars 16–17*) and the fifth motif is a single note with a downward glissando (*bar 16*). While closely related, these motifs can also be described as separate musical cells; however, in the analysis they are designated as different motifs because of the ways in which they recur as separate entities:

> *Motif 1*: single, sustained high pitch that opens the piece and recurs throughout in developed forms.

> *Motif 2*: 2-note figure of a downward second comprising sustained, high pitches that occur throughout in developed and contracted forms.

> *Motif 3*: rhythmic, 3-note figure with 2 semiquavers and a quaver, comprised of upward then downard third, fourth (and sometimes second) intervals; it only appears twice near the beginning of the piece and then twice towards the end.

> *Motif 4*: 2-note figure of an upward minor third, which appears in altered form throughout the piece (although not as frequently as motifs 1 and 2).

> *Motif 5*: downward glissando figure appearing a quarter of the way into the piece, again just before the halfway point to the end.

Step 3: Check the coding

Check the coding through repeated listening to the audio recordings of the original improvisations during the process of coding.

Step 4: Outline of overall structural development of motivic material

In terms of motivic material within each section, the overall form of the improvisation can be expressed as A–B–B–C. Within all four main sections certain groups of motifs are explored. The sections differ in length, with the final being the longest, containing a closing, cadence-like coda. This is also related texturally to the previous section; it could be the longest simply because this is the final improvisation of the group, having the dual role of finishing the piece and completing the suite. This suggests that both musicians retained an overall sense of the four improvisations fitting together, rather than working on each as a completely separate entity.

There is also an interesting background dissonance–resolution pattern in this piece. The dissonances occur as strongly stated, loud clashing pitches (*bars 1–2, 16–17, 28, 31, 34–5*). Contrasting sustained concordant intervals (major sixth at *bars 8–10*, perfect fourth at *bars 26–7* and octave at *bar 40*) provide a form of resolution and are rare in the context of the atonality of the piece. Significantly, the music ends with one such resolution. The fifth motif is also implicated in this dissonance–resolution pattern. The piece resolves with a clear, rather neat cadence-like closure, with both players stating the same note ('g-sharp'). This is heralded by seven statements of the fifth motif, taken in turn by each player. Player 2 lowers the pitch of each statement of this motif, from the 'd' three octaves above (*bar 35*), to the 'g-sharp' below middle C (*bars 40–1*). Player 1 centres all pitches around the 'g-sharp' above middle C, with an overall range of the same 'd' three octaves above middle C to the 'b' below.

There are five silences in total – those that begin and end the piece and three shared silences within the body of the music. They are all clear pause points in the music and, while there is little actual motivic development compared to the previous improvisation, each silence marks a change in the composition of the music. Figure 14.1 compares the different motif groups in each section bounded by a shared silence between players:

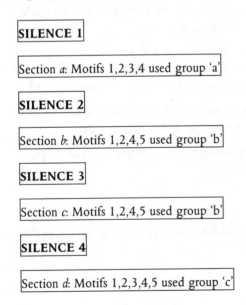

SILENCE 1
Section *a*: Motifs 1,2,3,4 used group 'a'
SILENCE 2
Section *b*: Motifs 1,2,4,5 used group 'b'
SILENCE 3
Section *c*: Motifs 1,2,4,5 used group 'b'
SILENCE 4
Section *d*: Motifs 1,2,3,4,5 used group 'c'

Figure 14.1: Structure of Stockhausen–Parker 4 with reference to silences

The sections differ in length, with *(b)* the shortest, followed by *(a)* and then *(c)*. The final section *(d)* is the longest and contains a closing, cadence-like part-section. Section *(a)* is the slowest moving of the four and is answered by the shorter section *(b)* that provides a contracted version of section *(a)* pitch changes. Section *(c)* rhythmically develops motif 1 and is the only section without the feature of striking dissonance. Section *(d)* is related to the previous section in terms of texture and begins with a quicker contracted repetition on motif 2. Table 14.1 outlines the motivic elements immediately before and after each silence.

Table 14.1: Stockhausen–Parker 4 – motivic events immediately before and after each silence

Silence	Motivic events before	Motivic events after
Begins		P1: sustained note [1]
		P2: extended min2nd [2]
Silence 2	P1: sustained note [2]	P1: extended min2nd [2]
	P2: sustained note [1]	P2: developed min2nd [2 developed]
Silence 3	P1: *glissando* figure [5]	P1: reduction of motif [reduction of 1]
	P2: triadic figure/extended min2nd [4/2]	P2: reduction of motif [reduction of 1]
Silence 4	P1: combination of motifs [(3)/4/2]	P1: extended motif [2 extended]
	P2: sustained note [1]	P2: extended motif [2 extended]
Ends	P1: combined motifs [2/1]	
	P2: sustained note [1]	

Key: P1 = Player 1; P2 = Player 2
Note: the five types of thematic material are differentiated with the numbers 1–5

In this improvisation the first two motifs stated reappear at the end just before the final silence. There is evidence that these motifs are also the basis for material played by both players at certain points before or after a silence. Both players develop motif 1 after Silence 3 and motif 2 is extended by both musicians after Silence 4. There is a structural role for silences, with motivic material developed only in the central sections of the music. While there are other clear structural features in this improvisation (such as the use of motif 5), silence takes an overall structural function.

CONVERSATION ANALYSIS OF SILENCES IN THE IMPROVISATION

The concepts of *lapse*, *gap* and *pause* are used in conversational analysis to denote silences of different durations. *Switching pauses* occur between utterances and define the space between speaker turns. They are seen as part of the current speaker's turn, although McLaughlin questioned this and suggested that such silences could relate to both speakers and be defined as a

dyadic phenomenon (McLaughlin 1984, pp.111–12). There can be variations in the length of the silence relating to switching pauses, with the shortest often heard within telephone conversations. Longer pauses could be perceived as uncomfortable when participants judged these silences as having a negative quality. McLaughlin recognised that some switching pauses could correspond to 'encoding difficulty' (1984, p.113) or prove troublesome if not accompanied by other activity (this might partly explain the decrease in length of telephone pauses, where speakers cannot see each other). It is hypothesised that, in music, player turns relating to the same motivic material can be identified around silences that could be described as *musical switching pauses*.

In Table 14.1 there is an example that could relate to a switching pause at Silence 2. Here Player 2 ornaments a sustained note after the silence, which echoes the high, sustained note of Player 1 immediately before the silence. Instances where the players changed turn without reference to the same motivic material also occur. There are clear instances where turns are exchanged, as well as cases of some simultaneous playing before and/or after silences that complicate the picture.

The concept of a *hesitation pause* is also of relevance, relating to silences in conversation within a speaker's turn. Hesitation is an example of a type of silence that can interrupt the flow of conversation and these seem to occur more often in natural or spontaneous speech. Stylistic hesitation in formal speech is a means by which meaning is accentuated, or a point emphasised. Some types of hesitation in spontaneous speech also relate to the personality of the speaker (Crown and Feldstein 1985). Silence that can be classified as hesitation also has significance within the type of conversation found in psychotherapy sessions. This type of silence focuses on coming to an understanding of potential communicative intent or meaning (Cook 1964).

These silences differ in length and quality. Note McLaughlin's example below of a four-second hesitation pause after a question (which invites an answer from another speaker, who does not respond) after which the original speaker repeats the question before it is answered:

A: When do we have our test in history?

 (4.0)

A: Alan. When do we have our history test?

B: Friday

 McLaughlin (1984, p.112)

Compare this example with a hesitation silence within a political speech or during joke telling. In these cases the silence creates a tension that functions as a means of gaining the listener's attention, as well as emphasising what has been said and what is to follow. Silence in music is utilised frequently as a function of tension. In music therapy such silences can be indicators of defence mechanisms, held differently by therapist and patient. In conversation silences categorised as *hesitation* can cause difficulty and are found commonly in spontaneous or naturally occurring talk between people. *Hesitation* is more difficult to identify in improvisation but is nevertheless potentially present, as in this example, where there are instances of

the same player who was playing before the silence continuing after the break in sound. This would appear to correspond with the concept of *hesitation pause*. Turns with different motivic material are also exchanged at Silence 4.

In addition to five shared silences there are nine silences attributable to single players (six for Player 1; three for Player 2). In the first duet, where the piece is more extended and the texture complex, it is difficult to identify silences attributable to single players. There are instances where one player has broken off their playing in order to give the floor to the other musician. Here the silence can be interpreted as relating to turn taking. The extended, exploratory nature of this piece as well as its position in the suite of four suggests that the form of the music is influenced by an underlying agenda of novelty. The musicians had never met before, are taking great care to find out about each other and giving each other space to take the floor. That there are longer and more frequent periods of solo playing in this piece seems to add evidence to this. As expected, these examples of hesitation silences differ in nature. It is possible to relate these hesitation silences to different categories of hesitation pause in conversation. Using the categories (types) of hesitation pauses that emerged as common categories in all four duets analysed for the doctoral study (listed in the left hand column of Table 14.2, and defined in the central column of the same table), examples from the fourth duet used as an illustration in this study are denoted in the right hand column of Table 14.2, together with examples from improvisations 1 and 3. This shows that, in the fourth improvisation, two types of hesitation pause were present (Emphasis point and Breath point) while three others were not.

Table 14.2: Examples of types of hesitation pause in Stockhausen–Parker duets

Type of hesitation pause	Description	Examples
Emphasis point	Pauses between sustained notes that accentuate or emphasise the sounds occurring either side of the pause	• Player 1 (*bar 21*) • Player 2 (*bar 39*)
Rest point	The space between one motivic utterance and the next	• (Improvisation 1)
Turn point	Where one player has influenced the other by echoing material	• (Improvisation 3) • (Improvisation 1)
Linking point	After a pause the player links the next utterance with material from before the pause	• (Improvisation 3)
Breath point	Both instrumentalists play wind instruments; breath points relate to momentary pauses for breath	• Player 1 (*bar 26*) • Player 2 (*bar 30*)

Within these categories, *rest point* and *linking point* most closely correspond to hesitation within a turn. *Breath point* relates to the physical act of playing the instrument. Here there is the possibility of a dual function because the musicians often use these points to begin new musical phrases, or repeat material. Sometimes an emphasis point can arise from what began as a breath point, although the silence is usually of longer duration here and the breath itself more emphasised. The term *emphasis point* relates to the example of a political speech or joke telling. It is interesting to note that both forms of speaking relate to performance, in that an audience hears a single speaker's utterance. In musical improvisation there is always an underlying agenda of performance, whether because there is an audience, or the music is being recorded and there is therefore a potential audience. When seen as dyadic interaction, the example of a musical *turn point* is turn exchange and not hesitation. There is overlap between players in that for a period both play simultaneously. In response to this the first player pauses while the second continues their turn. The pause is caused by the first player's response to the second. However, applying the definition that the pause is part of the first player's turn, this becomes a hesitation pause. This added complexity is influenced by the frequent occurrence of simultaneous playing in music. This differs from simultaneous speech because both musicians can be heard as separate entities while at the same time as playing together.

Summary and discussion

The silences in the Stockhausen–Parker improvisation examples fell into broad categories: 1. micropauses; 2. pause points; 3. fermata.

1. Micropauses (momentary pauses in the music played simultaneously by both players). These were subdivided into *technical* (such as an inbreath for the trumpet player) and *functional* (providing a brief rest point after which an equally brief period of sounded music followed; several micropause-theme fragment events result in a slowing of the musical pace).

2. Pause points (short-lived points of rest in music played by one or both players). While still brief, these silences commonly occurred before a structural point, a change of thematic material, texture, dynamic timbre.

3. Fermata (accentuated pause points of one second duration or more, seen particularly at the ends of pieces).

The silences in the three broad categories above have been noted with particular reference to:

- silence as an integral part of the overall musical form or structure
- the conversation analysis concept of *switching pause* and *hesitation pause*
- the concept of *pause* and *lapse* from conversation analysis.

Silence in the improvisation has been considered as an integral part of the overall structure of the music, as a musical event and as a function of the interaction between the musicians. It has

been possible to compare silences in music with silences in conversation in a way that further illuminates the complexity of interaction in both areas.

While we can interpret or put a meaning to the ambiguous qualities of silence, we can also note that a silence can serve more than one function. Silence can mark an exchange of turn between the musicians and also mark a structural point in the music. This is frequently further emphasised by accompanying changes in musical texture and pace before and after such silences. Similar observations could be made about conversation if different levels of interaction are analysed. Jaworski (1993) undertook an extensive analysis of the subject, including making comparisons with silence in different art forms. However, there was no detailed look at silence in music, although this was recommended for future research and this challenge has now been taken up by this author (Sutton 2002, 2005, 2006, in press).

Through microanalysis, hypothesised musical switching pauses and hesitation pauses were shown to exist. There were also many examples of turn exchange relating to the same motivic material, with far fewer instances using different motivic material. This suggests a strong link between motivic material as a defining factor relating to musical turn exchange, which has a relevance to therapists' attitudes to clinical musical material.

The analysis revealed both a *stylised* as well as what could be termed an *interactive* use of silence. The *stylised* use of silence probably developed out of compositional techniques, with the improvisers informed of this either by training or exposure to pre-composed music. Yet the *interactive* use of silence has its roots in communication between people and could well be a unique feature of improvised music. In addition, the prevalence of a structural function of silence in the improvisations studied was an unexpected outcome, as was the important role that silence can have during the ending of a piece.

Silence has been seen to have an overall structural function and this can occur at the same point as a turn exchange. A silence can define a turn exchange and also be serving a structural function. This can be further emphasised by differences in musical pace of texture before and after the same silence. There is also the added complexity of long periods of simultaneous playing by both musicians, including immediately before or after silences. While this makes it difficult to identify clear-cut examples of turn exchange in relation to silences, it nonetheless presents a hypothesis with which to think outside our usual theoretical framework.

Like other researchers, music therapists have tended to write more about the musical sounds than the musical silences. While the literature does indeed give emphasis to silence in clinical sessions, it is frequently placed in a non-musical context, such as developmental psychology theory. But we cannot forget that whatever is sounded comes from and returns to silence. By not breaking a silence the therapist might allow something to begin within it. It has been noted that verbal interaction in other professions (psychoanalysts and journalists) makes use of silence in this way for different purposes. As well as in everyday conversation, there is scope for exploring these attitudes to silence in this type of professional setting, such as in the more recent work of De Backer (2005) and this author (Sutton 2005, 2006, in press).

As well as providing a new way of analysing improvisations the original research had potential to inform the clinical work of music therapists, noting the following points:

- there is an intense quality of listening required to perform – and analyse – free musical and clinical improvisation

- form and structure evolve from the interaction between musicians engaged in free musical and clinical improvisation

- the process of interaction is the focus of the free musical and clinical improvisation

- the communicative intent inherent in free musical and clinical improvisation is the essential factor of human communication that is also seen during conversation.

The major finding of my original research was the identification of interactive devices that, while rooted in conversation research, can be applied successfully to musical improvisation. The classification of devices offers future improvisation researchers a means by which the examination of improvisation as music in interaction is possible. In working from inside the music, by paying attention to musical detail, we work from the fundamental personal qualities of our art. Balancing this with frames of reference that occur both in the musical and psychoanalytic literature as well as those fundamental to the structural features of conversation, we gain insight into what passes in the air between therapist and patient.

Rather than thinking generally about sounds and silences exchanged between us and our clients, we should make a far more detailed musical analysis of what takes place within and between those in the therapy room. In remaining analytically with the music, we stay with the *musical* therapeutic process. The method outlined in this chapter offers a means of comparing in detail the ongoing negotiation taking place between people in order that they maintain the integrity of an intersubjective space. To paraphrase the musician quoted at the beginning of the chapter, such microanalysis also speaks to the tiniest sound that is amplified intention, by our attentiveness to it and by our openness to what it might bring. In some way this allows the invisible handshake at the root of our work to be heard.

References

Cook, J.J. (1964) 'Silence in Psychotherapy.' *Journal of Counselling Psychology 11*, 1, 42–6.

Crown, C.L. and Feldstein, S. (1985) *'Psychological Correlates of Silence and Sound in Conversational Interaction'* In D. Tannen and M. Saville-Troike (eds) *Perspectives on silence.* Norwood, NJ: Ablex, pp.31–54.

De Backer, J. (2005) 'The Transition from Sensorial Impression into a Musical Form by Psychotic Patients.' PhD thesis. University of Aalborg, Denmark.

Jaworski, A. (1993) *The Power of Silence. Social and Pragmatic Perspectives.* London: Sage.

McLaughlin, M.L. (1984) *Conversation. How Talk is Organised.* London: Sage.

Sutton, J.P. (2001) 'The Invisible Handshake: An Investigation of Free Musical Improvisation as a form of Conversation.' PhD thesis, University of Ulster.

Sutton, J.P. (2002) 'The pause that follows...silence, music and music therapy'. *Nordic Journal of Music Therapy*

Sutton, J.P. (2005) 'Hidden Music – An Exploration of Silences in Music and Music Therapy'. *Music Therapy Today (online) 6*, 3, 375–95. Accessed on 10/03/07 at http://www.MusicTherapyWorld.net.

Further Reading

Albert, S. and Kessel, S. (1978) 'Ending social encounters.' *Journal of Experimental Social Psychology 14*, 541–53.

Ansdell, G. (1996) 'Talking about Music Therapy: A Dilemma and a Qualitative Experiment.' *British Journal of Music Therapy 10*, 1, 4–16.

Bunt, L. (1994) *Music Therapy – An Art Beyond Words*. London: Routledge.

Cappella, J.N., and Planalp, S. (1981) 'Talk and silence sequences in informal conversations III: Interspeaker influence' *Human Communication Research 7*, 117–132.

Carberry, T. (1997) Silence – its use and value in music therapy. Unpublished thesis, Diploma in Music Therapy, University of Bristol.

Clark, H.H. and French, J.W. (1981) 'Telephone goodbyes.' *Language in Society 10*, 1–19.

Clifton. T. (1976) 'The poetics of musical silence.' *The Musical Quarterly 62*, 2, 163–81.

Crawford, J.R. (1977) 'Utterance rules, turn-taking, and attitudes in enquiry openings' *IRAL 15*.

Heritage, J.C., Watson, D.R. (1979) "Formulations as conversational objectives." In G. Psathas (ed.) *Everyday Language: Studies in Ethnomethodology*. New York: Irvington.

Knapp, M.L., Hopper, R. and Bell, R.A. (1980) 'The rhetoric of goodbye: Verbal and nonverbal correlates of human leave-taking.' In B. W. Morse and L.A. Phelps (eds) *Interpersonal Communication: A Relational Perspective*. Minneapolis: Burgess.

Lerdahl, F. and Jackendoff, R. (1983) *A Generative Theory of Tonal Music*. Cambridge: Cambridge University Press.

Levinson, S.C. (1983) *Pragmatics*. Cambridge: Cambridge University Press.

Mey, J.L. (1993) *Pragmatics: An Introduction*. Oxford and New York: Blackwell.

McLaughlin, M.L. and Cody, M.J. (1982) 'Awkward silences: Behavioural antecedents and consequences of the conversational lapse.' *Human Communication Research 8*, 299–316.

Monson, I. (1996) *Saying Something. Jazz improvisation and interaction*. Chicago and London: University of Chicago Press.

Neugebauer, L. and Aldridge, D. (1998) 'Communication, Heart Rate and the Musical Dialogue.' *British Journal of Music Therapy 12*, 2, 46–52.

Nosfinger, R.E. (1975) 'The demand ticket: A conversational device for getting the floor' *Speech Monographs 42*.

Nosfinger, R.E. (1991) *Everyday Conversation*. London: Sage.

Prévost, E. (1995) *No Sound is Innocent*. Copula.

Ratte, M. (1997) 'Improvisation as Form.' *Resonance 6*, 1.

Sacks, H., Schegloff, E.A. and Jefferson, G. (1978) *A Simplest Systematics for the Organisation of Turn-taking for Conversation*. In J. Schenkein (ed.) *Studies in the organisation of conversational interaction*. New York, Academic Press, pp7–55.

Schegloff, E.A. (1979) 'Identification and Recognition in Telephone Conversation Openings.' In G. Psathas (ed.) *Everyday Language. Studies in Ethnomethodology*. New York: Irvington Publishers.

Stern. D. (2004) *The Present Moment in Psychotherapy and Everyday Life*. New York and London: W. W. Norton and Company.

Sutton, J.P. (2006) 'Hidden Music – An Exploration of Silence in Music and Music Therapy' In I. Deliège and G.A. Wiggins (eds) *Musical Creativity: Current Research in Theory in Practice*. New York and London: Psychology Press.

Steele, P. and Leese, K. (1987) 'The Music Therapy Interactions of One Session with a Physically Disabled Boy.' *Journal of British Music Therapy 1*, 1, 7–12.

Sutton, J.P. (in press) 'The Air between Two Hands: Silence and Music Therapy.' In N. Losseff and J. Doctor (eds) *Music and Silence*. London: Ashgate Press.

A Phenomenologically Inspired Approach to Microanalyses of Improvisation in Music Therapy

Gro Trondalen

Introduction

This chapter will address a phenomenologically inspired approach to microanalyses in music therapy. The procedure for analysing the data emerges from 'music as perceived', includes musical and interpersonal data and consists of nine steps. The microanalyses will be illustrated by one musical improvisation, which was performed during individual music therapy in an outpatient setting. The clinical approach is expressive music therapy where the client and the music therapist improvise together, followed by a verbal dialogue. Before leaving the session, the client is asked to write a word, a sentence or a small drawing to 'sum up' the session.

First, I would like to present the theoretical framework for the procedure of the microanalyses. Then follows the method itself, illustrated by an improvisation performed by a young female adult and a music therapist. Finally, there is a summary focusing applications of the method in clinical work, research and in the teaching of students.

I suggest a phenomenologically inspired procedure, including both verbal and musical elements, to be equally relevant in analysing expressive music therapy as in analysing receptive music therapy, e.g. 'self-listening' (Trondalen 2003).

Theoretical basis

This method of microanalysis developed during a research study, focusing on both the music and the interpersonal dialogue (Trondalen 2004, 2005).

'This music describes my feelings...is my inner being...is me' were the client's immediate words after having improvised together with the music therapist. Accordingly, I needed an approach focusing on *how* relating experiences through music were perceived in the here-and-now, in the subjective experience of time. This led to phenomenology, with its

closeness to the empirical material, focusing on the immediate and sensuous lived experience in the musical relationship.

Phenomenology aims at searching for the essential structures or essence of experience by bracketing (*epoché*) the researcher's beliefs about the phenomenon being studied. There is a focus on individual and contextual independence when perceiving the phenomena. It is the phenomenon itself that *emerges*. Phenomenology appears to be without any theoretical foundation or consideration (Føllesdal 1969, 1993).

Phenomenology may be understood as a counterpoint to *hermeneutics*, which focuses understanding and interpretation of musical processes based on personal, historical and cultural contexts. Reality is *constructed* on the basis of our pre-understanding, including an alternation between parts-and-wholes in the phenomenon being studied. The researcher may describe the musical improvisation rooted in the client's perception but add her own understanding of the musical processes, i.e. construct reality based on knowledge, language and historical situated-ness (cf. the hermeneutic circle/spiral) (Nerheim 1995; Ruud 2005).

However, both phenomenology and hermeneutics are process-oriented approaches, searching for meaning, supporting a belief of a subjective consciousness, in addition to an affirmation of – and attention towards – the perception of the physical world.

Another important aspect in the theoretical framework is connected to the living body (Leder 1990). The phenomenology of the body states that the body is our primary source of knowledge/knowing and the subject of all our actions (Merleau-Ponty 1945/89). The theoretical frame for the clinical approach is contemporary psychotherapy based on infant research (Stern 1985, 2000; Trevarthen 1999) and humanistic psychology (Yalom 2002).

In the 1980s I had become familiar with Ferrara's phenomenological approach to music analysis (1984). Later, I was inspired by the book in which he elaborated upon the procedure (Ferrara 1991). In music therapy research there seems to be a growing number of studies starting data analyses from a phenomenologically inspired point of view (e.g. Amir 1992; Arnason 2002; Forinash and Gonzales 1989; Grocke 1999; Ruud 1987; Skewes 2001; Trondalen 2004).[1]

Summing up, the scientific framework of the method is inspired by phenomenology, i.e. a closeness to *music as perceived*, but there are also some elements from hermeneutics, e.g. when describing the client's context (cf. Step 1 below), before allowing the music to emerge within open listening. Hence, the data analysis includes a phenomenologically inspired description, which also takes hermeneutic aspects (interpretation) into consideration.

Method

This part suggests a procedure for analysing empirical data emerging from *music as perceived* and includes both musical and interpersonal data. The procedure consists of nine steps.

1 See a comparison of methods in A15.1 on the web-based resources.

There are different ways to follow such a list:

- One way is to do the entire nine steps on the whole improvisation/music event being analysed, e.g. as shown in this text.

- Another way is to sort out some important passages (e.g. 'significant moments') of a long improvisation. In such a case, Steps 1 and 2 should be used on the whole improvisation, while Steps 3–6 should be used when analysing in detail the parts of the improvisation. After these in-depth analyses (steps 3–6), Steps 7–9 should focus on the whole improvisation again.[2]

The music should be audio- or videotaped, to be able to revisit the improvisation during the microanalysis procedure.

Step 1: Contextual

The first part of the analysis is a contextual step. It is important to sort out contextual issues and write these as notes before the open listening (cf. bracketing/*epoché*), to be able to be as open-minded as possible when listening to the music during the analysis procedure. Such topics include the client's *personal, social, biological, clinical* and *musical* history.

THE CLIENT'S PERSONAL HISTORY

The personal history is connected to, for example, leisure activities, school, work, mental state of mind and humour.

THE CLIENT'S SOCIAL HISTORY

The social history is about, for example, the client's background, family, friends, place of living and stable/unstable surroundings during her lifespan.

THE CLIENT'S BIOLOGICAL HISTORY

The biological story informs the client's biological and psychological condition. The client may suffer from a disease, which influences the improvisation and the music therapy process in a broad sense. Such aspects may be of mental and/or physical character.

THE CLIENT'S CLINICAL HISTORY

The clinical history enlightens the emergence of the client's constraints. In addition, it clarifies issues such as earlier hospitalization, previous therapy and what kind of professional help has been experienced.

2 An example of such a procedure can be found in Trondalen 2005.

THE CLIENT'S MUSICAL HISTORY

The last point is the musical history. Very often the client has never been to music therapy or played any instruments at all. Occasionally, the client may be a professional musician with a certain preferred repertoire. Another option is that the client may be inexperienced with expressive music but very familiar with listening to music, e.g. through headphones. The musical history may also include an awareness of the client's preferred repertoire. Within the musical history, one should also include when the actual improvisation took place, i.e. at what point during the whole therapy process and a clarification of when during the exact session.

Step 2: Open listening

LISTENING TO THE IMPROVISATION AS ONE ENDURING WHOLE

The first part of the open listening is to get a sense of the improvisation as a whole. Open listening should be done several times, allowing different layers of sensations, feelings and meaning to emerge. The open listenings are written into one personal narrative, including all dimensions of the musical experience.

BODY LISTENING

The second aspect of the open listening is body listening. When listening to the music, the therapist/researcher can move her body to the music with her eyes closed. I think this is an important step, not least because many of the clients have embodied mental or psychical constraints. It is my experience that more dimensions of the improvisation are emerging during such a bodily performance – that is, to dwell over and over again until new dimensions are emerging while listening.

Step 3: Structural

SOUND AND INTENSITY EXPERIENCED IN TIME

The first part focuses on sound and intensity experienced in time, illustrated by a description and an intensity profile, based on sound and intensity as perceived within time. The written description includes the sound characterized in different ways, while the intensity profile is shown as a graphic illustration.

SOUND/MUSIC MEASURED IN TIME

The second part focuses on sound/music measured in time: a structural analysis of the music illustrated by a traditional or graphic score. It focuses a structural analysis in a generic way. I suggest a modified version of the Structural Model of Music Analysis (SMMA).[3] Elements

3 The SMMA in this text is a modified version of Grocke's SMMA presented in Grocke 1999 (see also Chapter 11 in this book).

which may be included in this part are: style/form, texture in terms of horizontal/vertical direction, rhythm, structural form, tempo, mode, range of mode, dissonance/consonance, melody, intervals, chromatics, articulation, harmony, instruments, dynamics, intensity, mood, symbolic/associational, performance and duration. Accordingly, this emphasis of sound/music as measured in time is written into a score or illustration/drawing of a more graphic character. The most important thing, however, is to notice musical codes and musical relationships between the client and the therapist at a structural level.

Step 4: Semantic

EXPLICIT MEANING, I.E. REFERENTIAL

The first part focuses on explicit meaning, i.e. referential meaning. This includes looking at – and describing – musical structures in relation to other information, e.g. the client's personal comments, body gestures or verbal metaphors related to the interplay. By such a procedure it might be possible to say what the music may refer to or be a signal of.

IMPLICIT MEANING, I.E. ANALOGY

The second part puts focus on inter-musical aspects and includes looking at what sign and symbols in the music may mean to the interplay between the client and the therapist. In this sense, the music may be understood as a metaphor for being in the world (self-with-other).[4] In other words, it might be interesting to link the relating experience through music in the therapy session to experiences outside the treatment room.

Step 5: Pragmatic

The most important thing at this level is to search for a potential effect of the music within the music therapy process. An example would be that the analysed music provided a turning point concerning the client's perception of the therapist during the music. Another would be if the music contributed to a strengthening of the client's recognition of himself within the interplay.

Step 6: Phenomenological horizonalization (informed by Steps 3–5)

During Step 6, the phenomenological horizonalization, the therapist/researcher returns to Steps 3, 4 and 5, which have been carried out earlier in the analysing process. The different unit blocks which have been brought forward are listed and given equal value. The main point is to dwell within the results so far, before bracketing (epoché) this information, to allow oneself to engage in a new open listening.

4 Music may also be seen as 'absolute expressionism', i.e. music is not connected to anything outside itself (Benestad 1976). This perspective is not put into focus in this text.

Step 7: Open listening

LISTENING TO THE IMPROVISATION AS ONE ENDURING WHOLE

Step 7 is a return to open listening, allowing every significant element of the improvisation to emerge: form, structure, mode, musical interaction etc. These new open listenings allow the listener to weave all the earlier experiences into one new multilayered pattern of music. All the different steps (1–6) have been dealt with separately and, on the one hand, will remain like that. On the other hand, there is room for new dimensions of the musical experience to emerge, at both a conscious or unconscious level. These open listenings are also written into one description.

BODY LISTENING

During this second open listening, there should also be a new body listening. When listening to the music, the researcher can move her body to the music in different ways. This means that even more dimensions of the improvisation may emerge during such a bodily dwelling towards the end of the analyses, after the steps mentioned above have been carried out.

Step 8: Phenomenological matrix

The aim is to synthesize the previous information from the analyses into three unit blocks (essence).

THE MUSIC

First, there is a description of the music, rooted in the analysis based on the structural level of the music. Music as experienced and measured in time.

THE POTENTIAL MEANING OF THE MUSIC

Second, there is a focus on the meaning of the music, established through the analysis at a semantic level. Music as referential and/or analogous to real life, outside the music therapy setting.

A POTENTIAL 'EFFECT' OF THE MUSIC WITHIN THE TREATMENT PROCESS

Finally, the focal point is on a potential 'effect' of the improvisation within the music therapy process. This unit block takes into consideration the client's personal comments and gesture, as well as the music performed.

Step 9: Meta-discussion

After the analyses of the music, there is a meta-discussion rooted in the analysis. This discussion may take into consideration different philosophies of science and theories, in addition to the client's personal history and process in music therapy. In this ninth step, it is relevant to include information from different data resources, e.g. transcriptions from sessions including

both verbal and musical interactions, a written score, the client's personal 'summing up' and comments, an interview (if that is accomplished) and the therapist's own experience of the analysed music and the therapy process itself.

Adaptation to everyday clinical work

In a normal day-to-day approach, this method of microanalysis may be too extensive to use. Nevertheless, my experience is that the method can be applied in everyday clinical work by making a shorter version, including steps 1, 2, 3, 4 and 9. This means a focus on context, open listening and structural and semantic steps, in addition to a reflective part (meta-discussion). The most important thing in such a procedure is to allow the different layers of experience to melt into one new multilayered pattern of music and meaning.

Case example[5]

Step 1: Contextual
THE CLIENT'S PERSONAL HISTORY

Julie was a woman of 26. She was a former athlete but stopped competing after college. During the outpatient treatment in music therapy, she was studying full time at the university. She also had verbal psychotherapy during the music therapy process. The music therapist and the psychotherapist met twice (without the client) to discuss the therapeutic process. In her daily life, she was constantly vacillating from one happening to another ('turbo life'). Julie changed very quickly from intense vitality and laughter to sadness and crying.

THE CLIENT'S SOCIAL HISTORY

Julie was the youngest of three, following close after a brother and a sister. She had been living most of her childhood in the same city but now resided in her own apartment in another part of the country. She had many friends but found it hard to really trust anybody except her siblings.

THE CLIENT'S BIOLOGICAL HISTORY

The client had suffered from anorexia nervosa for the last six years. She became ill during end of college. Her anorexia was of the restricted type (AN/R), which means it occurred without bingeing and vomiting. Striking features were her ambivalence, audible through her usual comment 'I don't know' and her need for control.

5 This case is now offered with focus on *one improvisation as a whole*. Versions of this case example published earlier have different foci than this text. One article focuses on 'self-listening', while elaborating upon 'significant moments' in the improvisation (Trondalen 2003). Others present the phenomenon of 'significant moments', illustrated by two different cases (Trondalen 2005, 2006).

THE CLIENT'S CLINICAL HISTORY

The client had been hospitalized twice in psychiatric departments due to her anorexia. She had been in psychotherapy for two and a half years before I met her. She also received psychotherapy while attending music therapy, which lasted for ten months.

THE CLIENT'S MUSICAL HISTORY

The client was a fairly good piano player and accompanied an amateur choir in her spare time. Julie was especially fond of melodies in music, of which she had a very good memory.

The actual improvisation was the second improvisation in the second session out of ten music therapy sessions all together. In the initial phase of this session, the therapist and the client were sitting on separate African drums, when the therapist started to sing in a 'Spanish mode' (i.e. normal/harmonic minor key). After a few minutes the therapist moved to the piano, while Julie was still performing the drum. When the therapist arrived at the piano, Julie initiated a new rhythm on the drum. Immediately, the therapist picked up Julie's rhythmic initiative, offering the same 'Spanish melodic mode' as had been presented earlier, but now performed at the piano. After a few seconds, Julie started to sing in the same mode, still performing on the drum. Before leaving the session she wrote a summing up: 'a possibility for peace in mind'.

Step 2: Open listening
LISTENING TO THE IMPROVISATION AS ONE ENDURING WHOLE

The client did ten sessions all together. The exemplified improvisation took place in the second session and was the second of two improvisations. The 'self-listening' experience took place in the third session and was the only activity in that third session. In this second improvisation, the client was singing, while playing an African drum. The therapist performed on the piano. The improvisation has a quiet start, where the drum initiates the rhythm. The piano offers a certain mode and the client is singing and playing the drum. During the first bars, the intensity is increasing while the piano is filling the 'empty' melodic space. There is high energy, clear rhythm and flow in the improvisation. In the middle of the improvisation there is a heightened state of intensity. The drum rhythm is changing and the voice seems to unfold and explore the melody in a broader way than earlier, while the piano is performing a steady rhythmical ground built on a repetitive chord schema. The voice seems to elaborate on 'holding back' and 'let go'. The improvisation ends with a controlled cadenza where the intensity and the descending chords come to an end tonally, i.e. where everything started.

BODY LISTENING

Moving to the music gives a sense of a controlled giving and holding back in succession. There is a variety in the intensity and a feeling of moving forward. There is rhythmical ground providing a safe frame.

Step 3: Structural
SOUND AND INTENSITY EXPERIENCED IN TIME

The sound shifts between a sharp and a more smooth sound. The sound of Julie's voice seems concentrated and a bit 'dry'. In the middle of the improvisation, the sound stands out as distinct and clear. The piano seems broad and rich in the bass register, while the treble stands out with a metallic sound. The timbre of the drum is short and distinct. Towards the end, the sound of the piano seems softer than in the beginning, while the voice seems to express concentrated power. The client and the therapist follow each other quite close in the music. There are three arousals in the intensity, illustrated in the intensity profile (see A15.2. on the web-based resources).

SOUND/MUSIC MEASURED IN TIME

The improvisation lasted for 2 minutes and 46 seconds (see A15.3 on the web-based resources). The drum initiates a fluent rhythm and the piano structures the rhythm by introducing steady quavers. The structural impression is 'tight'. Drum, piano and vocal are close in harmony and rhythm. However, the voice starts to syncopate (0:55–1:04) while the piano keeps the steady quavers going for four bars. In the middle of the improvisation (1:10–1:23) the piano accelerates the tempo, while vocal and drum follow. The drum moves from a steady syncopated rhythm to a distinct pulse based on quavers in addition to a melodic syncopation.

From a structural point of view, there is a rhythmic force, distinct melodic progression and intense dynamics. Shortly after the rhythmical change in the middle of the improvisation, both the vocal and the piano introduce a syncopated rhythmic pattern simultaneously (1:43–1:49). In short, there is a change in the rhythm and an increasing arousal in both piano and voice, during three periods within the improvisation.

Step 4: Semantic
EXPLICIT MEANING, I.E. REFERENTIAL

It may seem as if the client is 'sailing' her own way, supported by rhythmic grounding and strength in the piano. This may correspond to the client's need for movement and high speed in her life. There is a turn-taking in the musical interplay between the client and the therapist. These exchanges at a dynamic and rhythmic level may be associated with a dichotomy of 'control–freedom' and 'hold on–let go'.

IMPLICIT MEANING, I.E. ANALOGY

From a semantic level the piano seems to produce a holding position, while the client experiments with syncopation through rhythmic change. The rhythm, melody and dynamics all seem to contribute to the feeling of 'flow' and joint attention in the music, in spite of syncopation both in the singing and in the drumming during three periods in the improvisation (see A15.3 on the web-based resources). The legato melodic lines may represent the opposite

position: the need for peace and rest. In other words, a musical 'counter-movement' to Julie's 'turbo-life', of which she says she is so tired.

Step 5: Pragmatic

From a pragmatic point of view the interplay seems to contain a testing of boundaries through various modalities. The client and therapist seem to put up with the differences, which are observable through different instruments and unequal phrasing. By a syncopated pattern in the drumming rhythm, the client moves 'in and out' of the interplay. On this basis, one might argue that the music promotes new ways of relating.

Such a pragmatic view may suggest that the client experiences that the relationship is able to contain equality and diversities at the same time, without falling apart. Consequently, to improvise in this way may contribute to a stronger feeling of being connected to different parts of oneself and others simultaneously. There seems to be sufficient safety and space for testing personal boundaries. The client appears to 'float' with the music, i.e. to let go of a rigid control without 'falling apart'. Accordingly, there seems to be a mutual regulation and turn-taking, which the client approves.

Step 6: Phenomenological horizonalization (informed by Steps 3–5)

Rich in the bass register, treble stands out with a metallic sound, steady quavers, a fluent rhythm, syncopation through rhythmic change, feeling of 'flow', joint attention in the music, grounding and strength in the piano, high intensity and rhythmic pulse, vigorous *accelerando* rapidly increasing, decreasing arousal, client's need for movement and high speed, contain equality and diversities, 'control–freedom' and 'hold on–let go', without 'falling apart' etc.

Step 7: Open listening

LISTENING TO THE IMPROVISATION AS ONE ENDURING WHOLE

Listening again gives a feeling of flow, even though the improvisation includes a variety of musical details. At some places the intensity is nearly importunate and the dynamic is rich. The music gives a feeling of ebb and flow and the harmonization stands out as fresh and new in spite of a repetitive harmonic progression. There is a rhythmic force which seems to push the music forward. Julie's voice seems a bit squeezed at the top but has its personal force.

BODY LISTENING

The body listening gives a feeling of flow and striving forward at the same time. The underlying rhythm seems to promote flexibility in the dynamic expression and gives the feeling of waving motions. There is retention in the human voice at certain places, which influences the body movement in the sense of micro-pauses. The cadenza is long and promotes the feeling of resting in subjective time.

Step 8: Phenomenological matrix
THE MUSIC

In the music, the sound is tight and concentrated. The rhythm develops through acceleration and/or syncopational shifts against the steady pulse. The structure and harmonic progression is predictable (Dm–C–Bb–A7) and the dynamic is intense and condensed. Melodic lines are progressing by rising and falling. When the melodic line in the treble is steady during several bars, this emerges as a counter movement to the falling and steady bass line in the piano.

THE POTENTIAL MEANING OF THE MUSIC

A phenomenological reduction of the meaning may be that the solo voice creates the illusion of seeking towards control and controlled retreat. The piano has a containing function but at the same time initiating and energizing. The soloist takes time and space to 'spread out', in other words showing herself.

A POTENTIAL 'EFFECT' OF THE MUSIC WITHIN THE TREATMENT PROCESS

The 'effect' in the treatment may be that the client feels recognized, while experiencing a development of the interpersonal relationship. Due to the music's ambiguity, there was space for diversities, which could be explored and tolerated. She seemed to be able to benefit from the music to 'fill' her emptiness, bear her ambivalence and promote 'peace in mind'. At the same time the music supported an experience of being connected in time and space.

Step 9: Meta-discussion
After the improvisation Julie said:

> This music is my inner being…everything is opening without doing anything to make it happen…the finest part was when you played the piano and I sung and played the drum, which I never do. It was that combination that contributed the most to a peace in mind.

The improvisation seemed to promote an experience of being *connected in time and space*. The improvisation included sequences of *regulation*, which were mutually harmonized by the therapist and the client through musical elements such as rhythmic change and dynamic arousal (Trondalen 2005).

Julie struggled with control and self-regulation (Surgenor *et al.* 2002). She used her body as an external, concrete tool for promoting the internal life, i.e. as a psychological and social manoeuvre for the promotion of self-esteem ('embodiment'; Duesund and Skårderud 2003). During the improvisation Julie seemed to experience adequate safety and space to 'float' with the music, i.e. to let go of rigid control without 'falling apart'. Such a performance of her subjective body seemed to promote vitality and the feeling of being alive. This means an exploration and softening of rigid and 'stiffened' patterns of relating, leading to new relating experiences through music. Accordingly, stored memories of feelings ('RIGs'; Stern 1985,

2000) can be affected and updated through *musical interactive experiences* and provide a basis for active contact with non-verbal senses of self during the verbal communication after the improvisations have been completed (Trondalen 2005). These relating experiences through music may be recalled as *relational knowing* outside music therapy and support a link between body and mind, which subsequently support a more coherent sense of self. This is particularly relevant in anorexia nervosa (cf. 'Alexithymia').

Summary

This phenomenologically inspired approach to microanalysis in music therapy can be applied in everyday clinical work. However, I would then suggest a shorter version, including context, open listening and structural and semantic steps, in addition to a reflective part (meta-discussion). The most important issue, however, is to allow the different experiences of the improvisation to merge into one new multilayered pattern of music and meaning.

During a *research* process, I would suggest using the whole method. My experience is that dwelling in so many different layers in a music improvisation provides for a new strata of musical significance, emerging from the procedure of the analysis itself. Allowing oneself to deal with the music, over and over again, promotes a multifaceted approach to the music, which may contribute to an improved clinical practice.

Teaching students microanalysis of music is of vital importance for many reasons. Music is our main tool in music therapy, and therefore students should be acquainted with methods of understanding music therapy processes emerging from the music. In addition, I think it is important to include both interpersonal and musical processes in the data analysis instead of focusing only on one of the aspects. It is my experience from teaching that a multiplicity of levels emerges through rigorous investigation of an improvisation. On this basis, I suggest using the whole procedure in the teaching of students, getting them to respond through an abundance of feelings and a focused reflection.

References

Amir, D. (1992) 'Awakening and Expanding the Self: Meaningful Moments in the Music Therapy Process as Experienced and Described by Music Therapists and Music Therapy Clients.' Unpublished doctoral thesis, New York University.

Arnason, C. (2002) 'An eclectic approach to the analysis of improvisations in music therapy sessions.' *Music Therapy Perspectives 20*, 1, 4–12.

Benestad, F. (1976) *Musikk og tanke. Hovedretninger i musikkestetikkens historie fra antikken til vår egen tid.* Oslo: Aschehoug.

Duesund, L. and Skårderud, F. (2003) 'Use the body, and forget the body. Treating anorexia nervosa with adapted physical activity.' *Clinical Child Psychology and Psychiatry 8*, 1, 53–72.

Ferrara, L. (1984) 'Phenomenology as a tool for musical analysis.' *The Musical Quarterly 70*, 3, 355–73.

Ferrara, L. (1991) *Philosophy and the Analysis of Music. Bridges to Musical Sound, Form, and Reference.* New York, Westport, CT, and London: Greenwood Press.

Føllesdal, D. (1969) 'Husserl's notion of noema.' *Journal of Philosophy 66*, 20, 680–7.

Føllesdal, D. (1993) 'Edmund Husserl.' In T.B. Eriksen (ed.) *Vestens tenkere.* Oslo: Aschehoug.

Forinash, M. and Gonzales, D. (1989) 'A phenomenological perspective of music therapy.' *Music Therapy 8*, 1, 35–46.

Grocke, D.E. (1999) 'A Phenomenological Study of Pivotal Moments in Guided Imagery and Music Therapy.' Unpublished doctoral thesis, University of Melbourne.

Leder, D. (1990) *The Absent Body*. Chicago: University of Chicago Press.

Merleau-Ponty, M. (1945/89) *Phenomenology and Perception*. London: Routledge.

Nerheim, H. (1995) *Vitenskap og kommunikasjon*. Oslo: Universitetsforlaget.

Ruud, E. (1987) 'Musikk som kommunikasjon og samhandling. Teoretiske perspektiv på musikkterapi.' Unpublished doctoral thesis, University of Oslo.

Ruud, E. (2005) 'Philosophy of Science.' In B. Wheeler (ed.) *Music Therapy Research,* 2nd edn. Gilsum, NH: Barcelona Publishers.

Skewes, K. (2001) 'The Experience of Group Music Therapy for Six Bereaved Adolescents.' Unpublished doctoral thesis, University of Melbourne.

Stern, D.N. (1985) *The Interpersonal World of the Infant. A View from Psychoanalysis and Developmental Psychology*. New York: Basic Books.

Stern, D.N. (2000) *The Interpersonal World of the Infant,* 2nd edn. New York: Basic Books.

Surgenor, L.J., Horn, J., Plumridge, E.W. and Hudson, S.M. (2002) 'Anorexia nervosa and psychological control: a reexamination of selected theoretical accounts.' *European Eating Disorders Review 10*, 85–101.

Trevarthen, C. (1999) 'Musicality and the intrinsic motive pulse: evidence from human psychobiology and infant communication.' *Musicæ Scientiæ*. Escom European Society for the Cognitive Sciences of Music (Special issue 1999–2000), 155–215.

Trondalen, G. (2003) '"Self-listening" in music therapy with a young woman suffering from anorexia nervosa.' *Nordic Journal of Music Therapy 12*, 1, 3–17.

Trondalen, G. (2004) 'Klingende relasjoner. En musikkterapistudie av "signifikante øyeblikk" i musikalsk samspill med unge mennesker med anoreksi.' NMH-publikasjoner, vol. 2. Oslo: Norges Musikkhøgskole.

Trondalen, G. (2005) '"Significant moments" in music therapy with young persons suffering from anorexia nervosa.' *Music Therapy Today 6*, 3, 396–429. Accessed on 10/03/07 at http://www.musictherapyworld.de/index_mtt.php?issue=342andarticle=142.

Trondalen, G. (2006) '"Bedeutsame Momente" in der Musiktherapie bei jungen Menschen mit Anorexia nervosa.' *Musiktherapeutische Umschau 2*, 31–144. Accessed on 10/03/07 at www.musiktherapie.de/fileadmin/user_upload/medien/pdf/mu_downloads/trondalen_anorexia-nervosa.pdf.

Yalom, I.D. (2002) *The Gift of Therapy. Reflections on Being a Therapist,* 2nd edn. London: Judy Piatkus Ltd.

Chapter 16

Event-based Analysis of Improvisations Using the Improvisation Assessment Profiles (IAPs)

Tony Wigram

Introduction

The Improvisation Assessment Profiles (Bruscia 1987) were conceptualised, designed and formulated into a clinical tool in order to undertake a primarily qualitative analysis of improvisational material in music therapy. Bruscia explains that the IAPs are meant to be an analysis of the music as sound object (Bruscia 2000). Each of the six profiles developed for the IAPs offers a framework for undertaking a comprehensive analysis of musical improvisation, for both sole players and groups, within the area of defined interest by that specific profile. The criteria for all the profiles form a 'continuum of five gradients or levels, ranging from one extreme or polarity to its opposite' (Bruscia 1987, p.406).

To use these profiles in an economic and effective way to analyse musical material, it is necessary to consider the recommendations and guidelines that Bruscia offers for using the IAPs. Part of this process involves reducing the amount of material to be analysed to that which is both pertinent and essential, and then choosing the appropriate profile(s) to apply. The practical application of the IAPs has been developed by various researchers and practitioners for both quantitative and qualitative analysis (Abrams 2007; Bellido 2000; Erkkilä 2000; Frederiksen 1999; Jacobsen 2006; McFerran and Wigram 2004; Stige 1996; Scholtz, Voigt and Wosch 2007; Wosch 2002, 2007). This chapter will focus on one model for applying this comprehensive and excellent analysis tool within the clinical field, explaining the method of analysis of one improvisation through an event-based analysis (EBA), and the means by which the results should be documented for the understanding of other professionals.

Theoretical context

Bruscia formulated six profiles – Salience, Tension, Congruence, Variability, Autonomy and Integration. He argues strongly that the Salience profile is the starting point for any analysis using the IAPs:

> I did not emphasize the Salience Profile enough; it's the one that determines how all the other ones will be used. Salience deals with fluidity! The problem is that I assumed that everyone would want a step-by-step explanation of how to use the IAPs, and in doing that I did not convey the fluidity needed to use them. I always knew that the Salience Profile is the one that leads your consciousness into different musical elements and different profiles, and thereby pointed out what was most important to listen to analytically. When you use the Salience Profile first, it serves as the access point to other IAPs. (Bruscia 2000)

Depending on whether one is applying the profiles for analysis of material within a clinical context or for research purposes, this position leads to the need for a decision arising from three different choices:

> *Choice 1*: I don't know what I am looking for, and want to be open to what may be there.

> *Choice 2*: I know what I am looking for, have a bias, but still want to consider all options of what to focus upon in my analysis.

> *Choice 3*: I know what I am looking for, and am using chosen profiles to limit my analysis to that which is necessary for assessment, diagnosis or treatment decisions.

Wosch in Chapter 18 of this book (Wosch 2007) proposes a model where a quantitative analysis is undertaken for a specific goal, and he reports this author's previous publications where this is also demonstrated for diagnostic assessment in child psychiatry (Wigram 1999, 2002). Wosch emphasises the analysis of chosen musical parameters in a score of notated music to find specific events: 'This score is examined second by second using the IAP-Autonomy to determine which of the three musical scales "rhythmic ground", "melody" and "timbre" can be identified.' He has specifically focused on the Autonomy profile in his chapter.

 The two profiles that I use most frequently for the analysis of musical material with children who have communication disorder[1] are autonomy and variability (Wigram 1999, 2000, 2002), and so these profiles are chosen here to exemplify the method used in this analysis. In this chapter the use of the IAPs will be adapted specifically for everyday clinical

1 For the purpose of illustrating this method in this chapter, a population of children with autism spectrum disorder (ASD) is used to exemplify the procedure. However, the author believes that this event-based analysis and the pre-choice of specific profiles and musical elements for that analysis could be undertaken on any population where improvisational music therapy is being used, and with any age range.

work, and a functional and reductionist approach will be described. Typically, this approach is intended where a clinician *does* know what they wish to find out, and needs to make a short, focused assessment of some specific aspect of musical improvisation relevant to a specific case. Using the above-mentioned two profiles is deliberate, but equally any combination of two (or more) profiles could be applied using this method, closely connected to a clinical issue.

When applying the profiles in clinical cases, one issue that remains unresolved in my opinion is still the use of certain words to denote the gradients in a profile. In the Autonomy profile, for example, the extreme points are denoted by the terms 'dependent' and 'resister'. They represent the polarities of the scale, and Bruscia has suggested that when applying the gradients of the IAPs these descriptors should be used rarely. In fact, the context and the population will determine whether scores of musical elements chosen can be assigned to these descriptors, and an excellent tool for that decision is Bruscia's own definitions for the gradient description of a playing style within a particular musical parameter in both the Autonomy and the Variability profiles (Bruscia 1987, pp.465–96). When working with strong pathologies, the extreme gradients can be used, as they can provide quite relevant musical descriptors of pathological behaviour or characteristics. This is one of the most important contributions the IAPs make to the 'language' use in music therapy. The descriptions provided by Bruscia provide very explicit definitions of a specific type of musical 'behaviour' applied within the general field of human behaviour, response and interaction. Using these descriptors allows music therapists to *consistently* apply a well thought out, precise description of musical behaviour that can be common across populations, settings and individual contexts. Therefore, it would be highly advantageous to conform to one set of well described definitions such as these, rather than to continuously make up new formulations.

The Autonomy and Variability Profiles

For the original and comprehensive text on the IAPs, as well as the detailed definitions and descriptors of the Autonomy and Variability gradients as they apply to the musical scales, see Bruscia (1987). Described below are the profiles and scales for autonomy and variability.

AUTONOMY

 1 = Dependent

 2 = Follower

 3 = Partner

 4 = Leader

 5 = Resister

- Rhythmic Ground
- Rhythmic Figure
- Tonal and Melodic
- Harmonic

- Texture

- Phrasing

- Volume
- Timbre

- Program/Lyrics

The autonomy profile deals with the kinds of role relationships formed between the improvisers. The scales within the profile describe the extent to which each musical element and component is used to lead or follow the other. (Bruscia 1987, p.405)

VARIABILITY

 1 = Rigid

 2 = Stable

 3 = Variable

 4 = Contrasting

 5 = Random

- Tempo
- Meter/Subdivisions
- Rhythmic Figure

- Melodic Figure
- Tonal Ground
- Harmonic
- Style

- Texture: Overall

- Texture: Roles
- Texture: Register
- Texture: Configurations

- Phrasing
- Volume
- Timbre
- Body

- Lyrics

The variability profile deals with how sequential aspects of the music are organised and related. Scales within the profile describe the extent to which each musical element or component stays the same or changes. (Bruscia 1987, p.404)

The example in this chapter, and the basis upon which this author has developed the use of the IAPs, is from the field of Child and Adolescent Psychiatry, where the author has for many years been concerned with eliciting evidence from a music therapy assessment to support a diagnostic formulation. For the purposes of diagnostic assessment these two profiles are relevant and useful in differentiating between children who have autism, or some other variant of Pervasive Development Disorder, such as Asperger Syndrome and Pervasive Developmental Disorder Not Otherwise Specified (PDDNOS), or communication disorder. Autonomy helps one look closely at the interpersonal events that are going on, particularly the readiness of a child to work together with a therapist or another, take turns, share and act as a partner. The profile also identifies style and quality of playing that demonstrates either resistance to suggestion, maybe an independent attitude, or conversely becoming extremely dependent and reliant. Variability can illustrate at an inter- and intra-musical level a child's capacity for creativity, or evidence of a child's rigid or repetitive way of playing that might support a diagnosis on the autistic continuum. This profile is helpful for teasing out the quality of a child's play and, as the music therapy improvisational approach searches for and promotes creativity and expression as the medium for both social engagement and communication, the degree of variability helps identify a child's flexibility and creativity.

Method

The first part of this method of EBA (Stage 1) involves following the recommendations and guidelines that Bruscia offers for using the IAPs. Essentially one has to follow a process of reducing the amount of material to be analysed to that which is both pertinent and essential, and then choosing the appropriate method within the IAPs to do it.

Stage 1: Selection profiles and improvisational material

Step 1: Consider whether one is focusing on intra-musical or inter-musical events, or both.

Step 2: Choose the relevant profiles for analysis, related to either the focus of the therapy or the questions raised for the assessment.

Step 3: Review the entire session to be analysed, and select sections or improvisations from the session that contain some of the most relevant material that will reap pertinent and valuable information when analysed. (Bruscia 1987, pp.418–21)

Steps 2 and 3 can be reversed (step 3 and then step 2). The original order implies that a decision for Choice 3 (above) has been made. If they are reversed, Choice 1 or Choice 2 would apply.

I have added to this some criteria that are particularly helpful in the process of diagnostic assessment, and also continue to reduce the amount of analysis that is necessary to produce some relevant information through which one can interpret and evaluate what is happening musically:

(a) Based on issues related to the referral or the child's behaviour, and having reviewed musical events and the musical behaviour of the child in this session, I choose the particular musical elements on the scale it is most relevant to use in the analysis. The scales are quite detailed and lengthy, and it may be beneficial to select out, for example, rhythm, volume and phrasing as three particular elements that will be fruitful for analysis.

(b) I use an event-charting system where, on looking at a video recording or listening to an audiotape, I search for musical events that can be categorised using the gradients of the profiles. I have generated a simple form for undertaking this analysis (see Figure 16.1).

Figure 16.1 is the raw score sheet within which I place the gradients of the chosen profile, and the chosen musical parameters from Bruscia's scales. Then I record with a mark or a tick each time an event occurs. This can be applied through either video analysis or audio analysis. However, my method has exclusively involved video analysis. The lines underneath are a stave to write in musical motifs or fragments.

DECISION MAKING FOR THE ANALYSIS

The procedure for analysing improvisation excerpts for the purpose of diagnostic assessment involves selecting two (or a maximum of three) improvisations that occurred within the session. Dependent on the length of the improvisations, a further reduction of data to be analysed may be necessary, or not. This decision requires that the initial overview where the most fruitful and relevant selection is made is based on what is in focus for the analysis. Actually, choosing a longer or shorter excerpt of an improvisation to analyse may be influenced by a number of factors, including expectations regarding duration, frequency, consistency and intensity of the musical events in focus. Consequentially, a 'chicken–egg' decision process occurs over what comes first – the relevant section, or the relevant musical focus. I usually decide this based on diagnostic questions, therapeutic relevance, and individual needs (see case example).

Name ... Date ..

Profile...

	Gradient 1	Gradient 2	Gradient 3	Gradient 4	Gradient 5
Musical parameter					

Figure 16.1: Event-based analysis (EBA) raw score sheet

The procedure then requires selecting the musical elements that are most in focus, and decisions about that depend on the child's use of musical equipment, media and type of production. With many children, if they select to use un-pitched percussion (drums, cymbals, wood-blocks, djembes etc.), the elements on the scale are often tempo, rhythm, volume, timbre, and phrasing, while if they play on pitched percussion, keyboards or flutes etc., melody and harmony may become more relevant. This choice is based on clinical perspectives as well as musical. But one thing is important here – there should be a maximum of three musical descriptors.

Watching the sections I have chosen to analyse on video, often two to three times, I will score the number of events in the boxes where I can see, for example, variability in tempo. As mentioned previously, Bruscia provides a very rich resource in his descriptors and definitions of types of musical material that come under these gradients where he describes the five different levels of either variability or autonomy in his descriptions of the IAPs (Bruscia 1987, pp.430–1, 445–7).

Stage 2: Event-based analysis (EBA)

Stage 2 of the EBA involves a sequence of steps through which decisions are made and analysis is systematically undertaken by repeated video observation. For this to be realistic within the working timeframe of clinical practice, limiting the amount of material to be analysed, and also selecting the parameters (musical elements for the scales) that are to be applied, needs to be very carefully considered on the basis of what is relevant and essential. As the steps in both Stage 1 and Stage 2 are all necessary in order to do the analysis, there is no short form for clinical practice, but this two-stage analysis will be short enough if the constraints described above are applied.

Step 1: Watch or listen to the extract from the improvisation and decide which musical/other parameters will be monitored from the profile (a maximum of three). The therapist may have already made this decision from a memory check of the relevant improvisation in the session.

Step 2: Choose one musical parameter to begin with and watch the video again.

Step 3: Events. Make a tick in the box *each time* an event occurs in the improvisation. Pause the tape while doing so. For example, if the client changes tempo, and the therapist follows, and the client then remains stable for a few seconds in the new tempo, make a tick in a specific box:

Autonomy: Rhythmic Ground – *Leader*
Variability: Tempo – *Variable* or *Contrasting*

Step 4: Where relevant, pause the tape/CD/DVD to notate any clear 'leit-motifs/themes' as they occur in the stave at the bottom of the scoring sheet (Figure 16.1) for future reference in reports.

Step 5: When finishing this parameter, choose the second parameter and analyse the events again (Steps 4–6).

Step 6: Add up the events in each box, and put total scores onto the raw score table (Figure 16.2) under the column for the first improvisation or excerpt from an improvisation.

Step 7: Interpret the scores for this section of improvisation in relation to aims of therapy or the diagnostic questions. Here, the therapist should already have established the pre-criteria for the analysis, in order that the evidence from the analysis either supports or does not support a diagnostic formulation. Also, for analysing the process over time in therapy sessions, the analysis may reveal a shift in playing style and interpersonal/intermusical behaviour.

Step 8: If another profile is to be applied, repeat the process from Steps 1–7.

Depending on both the musical and the therapeutic situation, events can be identified by frequency alone, or by frequency and duration. In many cases, the complexity and multi-layered nature of the music in improvisations makes it quite difficult to identify the duration of an event. For example, you may note when a client (or therapist) has changed

tempo, and if the other follows – but how long that new tempo remains stable (duration of the event) can be difficult to see when other related or unrelated events are occurring simultaneously. Therefore, for some purposes, it is enough to record a moment when an event starts. Following recording of the scores during the analysis, the total scores for each musical element on each profile can be transferred to another form (Figure 16.2) to give an overview of what is occurring.

Case example

Ben was a five-year-old boy referred to the clinic for a second opinion on a suggested diagnosis of ASD. He had the following characteristics:

- very limited and disordered speech
- echolalia
- obsessions with mechanical objects
- lack of interest in sharing activities
- enjoying self-chosen activities
- unstable cognitive ability as he was not able to engage in cognitive tests.

This profile of difficulties may suggest an ASD diagnosis, but can also be seen in the more severe end of the developmental disability population. Prior to the music therapy assessment Ben had undertaken an art therapy assessment. During this he had demonstrated compliance and cooperation, but a lack of engagement with the therapist, except to echo the last words in a communication the therapist made to him. He was interested in the art materials, but not in engaging through them with the therapist.

The music therapy assessment contained a number of improvisations, the most significant of which were:

1. In the opening improvisation Ben played on two drums with two separate beaters and I played on the piano. During this section, Ben showed the ability to 'control' the improvisation, by stopping and starting when he wished. He played mainly in a pulse, without much rhythmic variation, therefore Rhythmic Ground/Tempo where relevant on the Autonomy and Variability profiles. Ben showed some differentiation in volume, so this was also scored on both profiles. Finally, as there was quite a lot of turn-taking, and musical events where Ben followed me, Phrasing was also a relevant musical parameter for the autonomy profile.

2. In the second chosen short improvisation, Ben came and sat next to me on the piano in the treble position, and we played together. The significant elements during this improvisation were the turn-taking and together playing. Therefore the Autonomy profile was relevant in identifying events where Ben led, but more importantly also followed the therapist. Phrasing and Rhythmic Ground/Tempo were the most significant musical elements.

Patient's name ... Date ..

Improvisation 1:

Improvisation 2:

Improvisation 3:

Autonomy *Variability*

Dependent	1	2	3	Rigid		1	2	3
Follower				Stable				
Partner				Variable				
Leader				Contrasting				
Resister				Random				

Figure 16.2: IAPs raw score table (Source: Bruscia 1987)

Figures 16.3–16.6 provide the raw sources for the analysis of events in both Improvisation 1 and Improvisation 2 of the selected samples from Ben's session. They show the results for the Autonomy profile (Figures 16.3 and 16.5) and for the Variability profile (Figures 16.4 and

16.6). Figure 16.7 shows the final scoring sheet where the cumulated scores for all gradients of the Autonomy and Variability profiles are entered for both selected improvisations.

Name: Ben .. Date: ..

Profile: Autonomy

	Gradient 1	Gradient 2	Gradient 3	Gradient 4	Gradient 5
Musical parameter	Dependent	Follower	Partner	Leader	Resister/ independent
Rhythmic ground		1111111111		111	1
Volume		111		1	11
Phrasing		11111111		111	1

Figure 16.3: Ben's analysis scores for the Autonomy profile, Improvisation 1

Name: Ben .. Date: ..

Profile: Variability

	Gradient 1	Gradient 2	Gradient 3	Gradient 4	Gradient 5
Musical parameter	Rigid	Stable	Variable	Contrasting	Random
Tempo	1	11	111111		
Volume	111	11	1111		
Phrasing		1111	1111111111		

Figure 16.4: Ben's analysis scores for the Variability profile, Improvisation 1

Name: Ben .. Date: ..

Profile: Autonomy

	Gradient 1	Gradient 2	Gradient 3	Gradient 4	Gradient 5
Musical parameter	Dependent	Follower	Partner	Leader	Resister/ independent
Rhythmic ground		1111		1	
Phrasing		1111111		1	

Figure 16.5: Ben's analysis scores for the Autonomy profile, Improvisation 2

Name: Ben .. Date: ..

Profile: Variability

	Gradient 1	Gradient 2	Gradient 3	Gradient 4	Gradient 5
Musical parameter	Rigid	Stable	Variable	Contrasting	Random
Tempo	1	11	111111		
Phrasing		1111	11111111		

Figure 16.6: Ben's analysis scores for the Variability profile, Improvisation 2

The scores reported in Figure 16.7 show that Ben demonstrated good *Follower* abilities during the first improvisation in Rhythmic Ground and also in Phrasing, which was scored mainly from the turn-taking events. There were no *Dependent* events in either improvisation, and a very small number of *Rigid* events. The balance between *Follower* events and *Leader* events on all parameters (cumulated scores *Follower* = 32; *Leader* = 9) shows a tendency in these two improvisations to following behaviour, unusual in ASD, but not necessarily in music therapy.

Patient's name: Ben ... Date ...

Improvisation 1: Ben playing the drums, the therapist (Tony) on the piano

Improvisation 2: Ben and the therapist (Tony) playing on the piano

Autonomy *Variability*

Dependant	1	2	3	Rigid	1	2	3
Rhythmic ground	0	0	–	Tempo	1	1	–
Volume	0	–	–	Volume	3	–	–
Phrasing	0	0	–	Phrasing	0	0	–
Follower				**Stable**			
Rhythmic ground	10	4	–	Tempo	2	2	–
Volume	3	–	–	Volume	2	–	–
Phrasing	8	7	–	Phrasing	4	4	–
Partner				**Variable**			
Rhythmic ground	0	0	–	Tempo	6	6	–
Volume	0	–	–	Volume	4	–	–
Phrasing	0	0	–	Phrasing	10	8	–
Leader				**Contrasting**			
Rhythmic ground	3	1	–	Tempo	0	0	–
Volume	1	–	–	Volume	0	–	–
Phrasing	3	1	–	Phrasing	0	0	–
Resister				**Random**			
Rhythmic ground	1	0	–	Tempo	0	0	–
Volume	2	–	–	Volume	0	–	–
Phrasing	1	0	–	Phrasing	0	0	–

Figure 16.7: Summary IAP for a case example – Ben

The *Partner* events are actually difficult to score as events (as this needs to be considered much more over time), but are more represented through this balance between *Follower* and *Leader*.

In terms of Variability, Ben's scores certainly represent *Variable* playing, with just a few events noted in the *Rigid* gradient. There are some *Stable* events, as would be expected. The scores here are closely linked to the Autonomy scores, as the greater number of events where

the child is following the therapist the more likelihood there is for variable and flexible playing style (assuming the therapist's improvising is variable, not rigid).

Previous results from this method of EBA have demonstrated how the scored events help identify characteristics in musical play that relate specifically to diagnosis, and have been reported in previous publications, in illustrating different profiles of children referred for diagnostic assessment (Wigram 1999, 2000, 2002, 2004).

Statistical analysis of the IAPs

Finally, I would like to reflect on the potential for analysing numerical or categorical data from a functional analysis of musical improvisation. The functional, quantitative use I have made of the IAPs so far has involved scoring (counting) events in musical improvisation and assigning scores to pre-determined categories (Wigram 1999, 2000, 2002). For example, having decided that I want to look specifically at changes in tempo as a musical indicator related to autonomy, I have counted the number of times one or other person in a client–therapist improvisation changed tempo, and what provoked it. Therefore it is relatively easy to make a 'judgement' about the initiative that was taken to change tempo – whether it was independent or dependent on another – and to identify the event as standing somewhere on the gradients of the Autonomy profile. This event, together with others within the same category (tempo – rhythmic ground), provides data that can be initially used for *descriptive statistics. Frequency data*, such as numbers of events (as described above), is ripe for analysis through descriptive statistics, and appropriate conclusions can be drawn from such analysis in single cases. Neither the gradients in the IAPs nor the scales can be scored using a *ratio* or *interval* scale, and therefore *parametric statistics* cannot be undertaken on a set of data if one is computing on the basis of equidistant points on a scale. However, *non-parametric* tests can be used, and this has been discussed in the *Nordic Journal of Music Therapy* (Wigram 2001).

The IAPs are a highly sophisticated descriptive tool for undertaking qualitative analysis. Bruscia (1987) stated that they were used extensively as a teaching tool (p. 410), and I would also like to reinforce this aspect, because they are so useful in getting students to listen to what is happening, and then analyse it at a music level, before jumping to conclusions in psychological, intuitive, but sometimes impetuous interpretation. Bruscia emphasises the importance of listening to and hearing what is happening in the improvised music, as he recommends the starting point for using the IAPs is with the Salience Profile. This profile helps identify which musical elements are most prominent, and exert most influence over other elements, and can be used to analyse intra-musical and inter-musical events. I think that when you know what you want to look for, you don't necessarily have to start with establishing the salience of characteristics of the improvisation.

Conclusion

The method described here can also be used for analysis of improvisations in clinical work, and is effective in determining changes over time. The time-frame may be what changes occur in a single session or over a course of sessions. Bruscia comments on the differences of analysing one or several improvisations.

> The insights gained from analyzing a single improvisation are quite different from those gained from comparing an entire set of improvisations. The reliability of the analysis of a single improvisation is established only through repeated occurrences within the same improvisation, but even this provides no evidence that the improvisation is typical of the individual, or that the individual's tendencies or style when improvising has been revealed. (Bruscia 2001, para.21)

This comment upon reliability tends to suggest a perspective where the characteristics of a client present in their musical 'behaviour' should recur enough in order to establish consistency of evidence, and is actually a supportive argument to the event-based analysis that is the method articulated in this chapter. Event-based analysis inevitably leads to an accumulation of events over time.

What also makes the IAPs a remarkable tool for determining change over time is the bi-directional aspect of each of the profiles. Initially, a therapist might look for evidence that the client is playing in a way that matches the middle gradient on any one of these six profiles. Taking the Autonomy profile as an example, the mid-point (*partner*) can be perceived as a 'healthy' position, while the gradients immediately either side of that mid-point (*leader* and *follower*) may denote either a 'state', the behaviour of a person in a certain period of time, or a personality 'trait' – evidence of a consistent pattern of behaviour. The potential of therapy, and of this profile to identify change over time, is that a client with a *follower*, perhaps *dependent*, way of behaving may be working in therapy in the direction of increasing their autonomy, making more decisions, taking the lead (*leader*), and even demonstrating 'independence' (an alternative term to that of *resister*). Conversely, in the field of ASDs, the pathology tends to present a person with a high level of autonomy, to the degree that everything that happens has to be on their terms, and attempts to elicit a response can be met with rejection and avoidance (*resister*). Here, the therapeutic direction, and the focus of the analysis, can be searching for examples over time where events in the music making showing the client as a *follower*, or even *dependent*, can denote a significant and important shift (or potential) in that client's readiness to engage with others.

Musically structured or free improvisation provides a complex source of data for analysis, and the applied use of the IAPs is effective in identifying music events that relate to therapeutic issues, as well as in analysing creativity and musical interaction. Depending on the client(s), the analysis of musical material through EBA can provide concrete evidence in the form of the events that take place on specific musical elements to identify important aspects relating to the direction, process and outcome of therapy. It is necessary to make such an analysis both for single improvisations (microanalysis) and of a series of improvisations or sessions (session analysis) in order to support an intuitive understanding of a client's musical behaviour.

References

Abrams, B. (2007) 'The Use of Improvisation Assessment Profiles (IAPs) and RepGrid in Microanalysis of Clinical Improvisation.' In T. Wosch and T. Wigram (eds) *Microanalysis in Music Therapy*. London: Jessica Kingsley Publishers.

Bellido, G. (2000) 'IAPs revisited.' Online discussion forum on IAPs, 2 March, Paragraph 21. *Nordic Journal of Music Therapy*. www.njmt.no

Bruscia, K. (1987) *Improvisational Models of Music Therapy*. Springfield, IL: Charles C. Thomas.

Bruscia, K. (2000) 'Reflection on IAPs.' Online discussion forum on IAPs, 25 September, Paragraph 10. *Nordic Journal of Music Therapy*. www.njmt.no

Bruscia, K. (2001)Response to the discussion forum on IAP, 2 March, Paragraph 21. *Nordic Journal of Music Therapy*. www.njmt.no

Erkkilä, J. (2000) 'A proposition for the didactics of music therapy improvisation.' *Nordic Journal of Music Therapy 9*, 1 (The article is based on a paper presented at the second West-Norwegian Conference on Music Therapy, Sandane, October 1998.)

Frederiksen, B.V. (1999) 'Analysis of Musical Improvisations to Understand and Work with Elements of Resistance in a Client with Anorexia Nervosa.' In T. Wigram and J. De Backer (eds) *Clinical Applications of Music Therapy in Psychiatry*. London: Jessica Kingsley Publishers.

Jacobsen, S. (2006) 'Musikterapi som assessment af specifikke Foraeldrekompetancer.' Unpublished master's thesis (Danish), Aalborg University, Denmark.

McFerran, K. and Wigram, T. (2004) 'Articulating the dynamics of music therapy group improvisations. An empirical study.' *Nordic Journal of Music Therapy 14*, 2, 33–46.

Scholtz, J., Voigt, M. and Wosch, T. (2007) 'Microanalysis of Interaction in Music Therapy (MIMT) with Children with Developmental Disorders.' In T. Wosch and T. Wigram (eds) *Microanalysis in Music Therapy*. London: Jessica Kingsley Publishers.

Stige, B. (1996) 'Om Improvisational Assessment Profiles (IAP). Del II: Klinisk og forskningsmessig relevans.' *Nordic Journal of Music Therapy 5*, 1, 3–12.

Wigram, T. (1999) 'Assessment methods in music therapy: a humanistic or natural science framework?' *Nordic Journal of Music Therapy 9*, 1, 6–24.

Wigram, T. (2000) 'A method of music therapy assessment for the diagnosis of autistic and communication disordered children.' *Music Therapy Perspectives 18*, 1, 13–22.

Wigram, T. (2001) 'Quantifiable data, statistical analysis and the IAPs.' IAPs Revisited. Online discussion forum on IAPs, 25 February. *Nordic Journal of Music Therapy*. www.njmt.no

Wigram, T. (2002) 'Indications in music therapy: evidence from assessment that can identify the expectations of music therapy as a treatment for Autistic Dpectrum Disorder (ASD): Meeting the challenge of evidence based practice.' *British Journal of Music Therapy 16*, 1, 11–28.

Wigram, T. (2004) *Improvisation: Methods and Techniques for Music Therapy Clinicians, Educators and Students*. London: Jessica Kingsley Publishers.

Wosch, T. (2002) *Emotionale Mikroprozesse musikalischer Interaktionen*. Berlin: Waxmann.

Wosch, T. (2007) 'Microanalysis of Processes of Interactions in Clinical Improvisation with IAP-Autonomy.' In T. Wosch and T. Wigram (eds) *Microanalysis in Music Therapy*. London: Jessica Kingsley Publishers.

Chapter 17

Measurement of Emotional Transitions in Clinical Improvisations with EQ 26.5

Thomas Wosch

Introduction

This chapter introduces a microanalysis method that enables emotional micro-processes from clinical improvisations to be visualised. The analysis concerns itself with locating changes from one emotion to another within a clinical improvisation. Measurements are based on the 'resonating body function' concept [German: Resonanzkörperfunktion] (Kenny, Jahn-Langenberg and Loewy 2005; Langenberg 1988), which can also be called a type of counter-transference function. Using the questionnaire described below (EQ 26.5, Wosch 2002), objective listeners provide feedback regarding emotions perceived whilst listening to a recording of a clinical improvisation. Measurement of experience (Mayring 1992) within the context of emotion measurement in Emotion Psychology is the area of analysis in focus here. Up until now, physical behaviour that can be measured such as heartbeat, electro dermal activity (EDR), respiration rate and electrical activity in the brain (EEG), or observed (such as facial expressions[1]), was what was taken into account (see, for example, Gembris 1996; Machleidt, Gutjahr and Mügge 1989; Peretz 2001). However, the phenomenon of emotion has proven itself to be the most pertinent, all-encompassing and reliable source for describing experience (Mayring 1992, pp.58–67). Experience can be described in a qualitatively open manner, such as through an interview, by using standardised, quantitatively pre-determined lists of words describing emotions, or emotion questionnaires. The newly developed EQ 26.5 is a realisation of the latter form, and its development is described below.

1 In this area, CT-readings are used with increasing interest and success, whereby machines in use still restrict and change the natural setting of the music therapy session too much to be of use in practical clinical research.

Theoretical basis

There are two primary questions that need to be addressed in developing and applying a questionnaire to evaluate emotional response and behaviour in clinical improvisations:

1. decisions concerning which emotions are to be determined

2. which of these emotions play a role in relationship to music.

In answer to the first question, a review of the current psychology of emotion literature reveals 21 different compilations of emotions (Ortony and Turner 1990; Wosch 2002), with the number of emotions identified by any particular author ranging from 2 to 24. A total of 42 emotions are mentioned in all of the studies. A system based on differential psychology (Izard 1994), which differentiates between ten emotions, is the one most frequently in use. Several recent German studies in music therapy also use this system (Busch *et al.* 2003; Willms 2004), which then leads to the second question. It is interesting to note that, in Willms' study, only four to five of the ten emotions, happiness, grief, anger, fear (and surprise), played a role in music within music therapy. Willms (2004) noted that following basic assumptions of psychoanalysis, these emotions especially characterise the symbiotic phase within the psychology of human development. Moreover, if other literature of music therapy research into the differentiation of emotions is examined, a smallest common denominator of a maximum of five emotions is common to all studies (Bodner *et al.* 2005; Bonde 1997; Bunt and Pavlicevic 2001; Busch *et al.* 2003; Hevner 1936; Louven 2004;[2] Priestley 1994; Thaut 2002; Willms 2004; Wosch 2002).

These are:

1. intention/love/tender

2. anxiety/fear

3. anger/aggressive

4. sadness/guilt/depression/grief

5. happiness/joy.

Returning briefly to emotion psychology, this music therapy differentiation of five emotions is found in two emotion theories in the German literature, both held in little regard by researchers in the field of emotion psychology. The first is by Machleidt (Machleidt 1999; Machleidt, Gutjahr and Mügge 1989, 1994), and is based on an older theory by the German psychobiologist Lungwitz (1970). According to this theory, only five basic emotions exist: hunger, anxiety, anger, sadness and joy. These are considered to be the smallest basic elements of which all other emotions are made. They are emotional entities, basic building blocks of emotions, and are not further divisible. Moreover, emotions in music therapy are mainly limited to these five emotions. If these five emotions are basic elements of human experience then music therapy is based on the kernel of emotional experience. The second

2 Louven 2004 is based on Wosch 2002.

emotion theory, by Mayring (1992), divides 24 different emotion terms used the world over into four groups of emotions. These are affection emotions, dislike emotions, uncomforted emotions and comfort emotions. In discussing this theory, Wosch (2002) divided the group of dislike emotions, which contain anxiety and anger, into dislike emotion qualities (anxiety, etc.) and dislike emotion qualities with 'go up to' (anger, etc.). Thus, an emotion system for music therapy came into being, which includes all five basic emotions as well as a maximum variety of emotions similar to one another in experience (Figure 17.1). This system is the basis of the standardised emotion questionnaire EQ 26.5 in the emotional micro-process research of clinical improvisation presented below.

Intention – affection emotion qualities	Anxiety – dislike emotion qualities	Anger – dislike emotion qualities with 'go up to'	Sadness – dislike emotion qualities	Happiness – comfort emotion qualities
Interest, love, compassionate, proud, yearning	Anxiety, fear, timid, surprise	Anger, enraged, scorning, annoyed, hating	Sadness, melancholy, dejection, shame, emptiness, guilt, lonesome	Joy, relish, happiness, satisfaction, relief

Figure 17.1: System of emotions in music therapy

A further important theoretical basis for studying emotional micro-processes within clinical improvisations stems from Machleidt's (1994) emotion theory as described above. Machleidt is the only author in the field to relate the five basic emotions of hunger/ intention, anxiety, anger, sadness and joy to each other in a continually recurring process. According to Machleidt (1994), each action (and according to Wosch (2002) each experience of object relationships in music therapy[3]) begins with hunger/intention. It is then made insecure by anxiety, and can be realised by means of anger (and pain) (or, according to Wosch, be truly experienced). It then leads to separation from the action (or, according to

3 At this point, great importance is given to recent psycho-neurological theories, such as those by Blood and Zatorre (2001), Grawe (2004) and Spitzer (2002), according to which the particular therapeutic effect of both the experience of music and of psychotherapy is seen in that experience in music together with all psychic and bodily reactions provides a substitute for real-life actions, which then do not have to be carried out physically. Music functions as a substitute with maximum reality content.

Wosch, from the experience) with sadness, and can finally be looked upon with a feeling of relief and pride in one's own actions (or, according to Wosch, in the experience). In this last step, new experiences are successfully integrated into the continually maturing self. One of the questions examined by the method presented here deals with the extent to which such a process can be found to act as a micro-process within clinical improvisation.

Method

The method will be introduced here in such a form as to be used in studies or clinical practice without undertaking computer-based analysis. In the case example that follows, the first computerised version of the study was used (© ClouSoft 1999), and will be described here parallel to the version mentioned above. The author and colleagues are now at work on a further version, with which audio or video material from clinical improvisations can be analysed. The new version will include all previous computations regarding data analysis. A cooperative data analysis service for universities is also being developed (for more information regarding the newest version and cooperative services, see the contact address in the list of contributors at the end of the book).

For a standardised analysis of emotional micro-processes of clinical improvisations, the following are necessary: an audio or video recording of the clinical improvisation, the Emotions Questionnaire 26.5 (EQ 26.5), one or more assistants with timers (when the non-computerised version is used), the statistical software SPSS, and 20 listeners who evaluate the clinical improvisation.

An audio or video recording of the clinical improvisation must be available when emotional micro-processes within the improvisation are to be determined. In the first computerised version, four clinical improvisations were transferred from audio-cassette to computer using a sound edit. In both versions, the improvisation is then played to at least 20 listeners. Ideally, the 20 listeners are music therapy students.[4] While listening to and experiencing the clinical improvisation, the listeners fill out the Emotions Questionnaire 26.5 (EQ 26.5) as shown in Figure 17.2. A short version for clinicians is described at the end of this method's section.

The content of the standardised questionnaire is based on the emotion system from Figure 17.1, developed by Wosch in the theoretical section (Smeijsters 2005; Wosch 2002; Wosch and Frommer 2002).

In summary, the steps in analysing emotional micro-processes using EQ 26.5 are as follows:

Stage 1: Data collection by means of EQ 26.5

Stage 2: Calculation of section lengths with data analysis using cluster analysis in SPSS

4 On the one hand, music therapy students are relatively objective concerning clinical improvisations. On the other hand, improvisations are not completely foreign to them. In this case the majority were first semester music therapy students (Wosch 2002).

Stage 3: Counting emotions to determine the emotion profile of each section

Stage 4: Documentation of results.

| | Try by Thomas Wosch | | | | |

Click with the mouse in the first line below the emotion words to define what emotion group you find expressed by the music you are listening to at this moment. If you have the impression that more than one emotion is being expressed at the same time, you can choose several groups.
If the emotion is changing while the music is playing, immediately click on "NEW" and then click again in one or several fields in the new line.
When the music stops, click on "CONTINUE".

Start Music

Section	interested affectionate compassionate proud yearning surprised	anxious scared timid	annoyed enraged angry scorning hating	sad depressed melancholy ashamed responsible empty lonesome	joyful relishing satisfied relieved happy

Figure 17.2: Emotions Questionnaire 26.5 (EQ 26.5)

Stage 1: Data collection by means of EQ 26.5
INSTRUCTIONS TO ANALYSER

- The listener's task is to indicate, using pre-determined emotion terms from the EQ 26.5, at which point in the improvisation which emotion or emotions were perceived by him or her.[5]

5 Further studies have shown that in the first case studies the emotion terms here were sufficient for clinical improvisations. In qualitative sections of further studies no further emotion terms were reported (Wosch 2002).

- The analyser must mark emotions which they perceive to be expressed by the music, rather than emotions they experience personally as their own emotional reaction to the emotion/s of the music.[6]

PROCEDURE

Step 1: Selecting emotion/s: At the beginning of the clinical improvisation the listener chooses one or more emotions to be perceived by him during the improvisation, and places an 'x' next (or click in computerised EQ 26.5) to this emotion or emotions.

Step 2: Time recording of changes of emotion/s: The first hearing of the improvisation takes place and the listener records 'x's against the monitored emotions. In the non-computerised version, an assistant sits next to each listener. When a transition from the first emotion or emotions to another emotion or emotions is perceived later, an 'x' must immediately be placed in the first column or 'section' of the EQ 26.5. Using a stopwatch, the assistant times the exact point at which the beginning of a transition from one emotion to another is marked. The listener then places one or more 'x's in the new section, to mark a new emotion or emotions.

In the first computerised version of this study, times were recorded by the software in a table for each listener.[7] These steps are repeated for subsequently perceived changes in emotion. If the clinical improvisation includes more than one person or instrument, these are coded next to the listener's 'x' following the listening and evaluation processes. For example, when drum and piano are heard, drum = 1 and piano = 2. This allows differentiated relationships to be drawn between emotions and players in the clinical improvisation. Raw data is thus made available to each listener directly following listening and emotional evaluation of a clinical improvisation.

When using the non-computerised version, the raw data consists of the filled-out EQ 26.5 and the assistant's timetable for the respective listening sections.

Stage 2: Calculation of section lengths with data analysis using cluster analysis in SPSS

STATISTICAL ANALYSIS

Step 1: From both versions (computerised and non-computerised) data must be transferred to a table in SPSS (each listener is number-coded).

Step 2: These numbers are transferred to rows in the table, which must, as a minimum of 20 listeners is required, have at least 20 rows. Additionally, emotions are number-coded (intention = 1, anxiety = 2, anger = 3, sadness = 4, joy = 5).

6 For the first study, further studies were able to show that in this case listeners primarily evaluated emotion qualities of the music heard (Wosch 2002).

7 See, for example, A17.1 on the web-based resources.

Step 3: The rows and columns in this table are ordered as shown on the web-based resources in A17.1, which shows a table of data for a clinical improvisation. In the first computerised version of the study, the table is already shown in this form, and can be copied into an adaptable SPSS File (using CTRL C and CTRL V).

Step 4: The first and main step in evaluating the raw data is a cluster analysis in SPSS. Using cluster analysis, a statistical average can be found for the total improvisation, which takes into account the myriad subgroups resulting from the listener's division of the improvisation into varying emotion sections. In addition, cluster analysis is performed on the column marked 'Start' (of the improvisation) in the table in A17.1. In the method shown here, this is done on computer in SPSS, using the steps: > Analysis > Classification > Hierarchical Cluster Analysis. This column or the variable 'Start' from the raw data (see A17.1) is then loaded as a variable. In this method, the 'Within Group' (average linkage) is selected as a variable. The Block-Distance is selected as the interval. The dendrogram is activated as the diagram. The dendrogram and the table of results from the cluster analysis are the basis for the next evaluation step and lead, together with the graphic evaluation described below, to the emotion sections. The web-based resources show an example for a portion of the data from the respective data table of this cluster analysis and for a dendrogram (A17.2a and A17.2b). Using the cluster analysis table of data, the dendrograms and the graphic portrayal (histogram) of the cluster analysis data table significant groups are formed, and the clinical improvisation divided into smaller sections.

Step 5: The next step in obtaining these sub-sections is a review of the data tables (see, for example, A17.2a). The column 'coefficient', at the end of the table of cluster calculations, shows a multiple increase in the coefficient. In the example shown (A17.2a) this coefficient does not increase at the beginning of the table (coefficient = 0). Following increases are merely in absolute values of 1 to 2. In the last three steps, however, the coefficient increases from 10.96 to 22.85, more than double the previous value, an absolute value of 11.19. It then increases to 45.52 (again, more than double the previous value, an absolute value of 22.67). These are significant leaps, which indicate a calculation of three sub-sections or clusters in this example. The dendrogram (A17.2b) shows a boundary between the clusters within the two large parentheses at cases 40 and 67.[8] The somewhat smaller parenthesis (in right-angles somewhat less to the right) has a boundary between cases 65 and 26.[9] The dendrogram shows what cases are included in what cluster.

Step 6: The last step in determining the exact time boundaries of the three clusters is shown in a further graphic of the results. These are histograms/icicle diagrams. These histograms/icicle diagrams show exact boundaries for the end of one cluster and the

8 This is the main difference from the aforementioned value (coefficient), from 22.85 to 45.52.

9 This is the second-largest variation from the aforementioned value (coefficient), from 10.96 to 22.85.

beginning of a new one. For the execution of this graph in SPSS, the following steps are used:

(a) analyse

(b) classify

(c) hierarchical cluster analysis

(d) diagram

(e) icicle diagrams/histograms.

In determining the three clusters for this example, in the diagram window 'icicle diagrams' are limited to:

(a) given cluster area

(b) start-cluster '1'

(c) the three clusters '3' are entered as 'stop-cluster'.

(d) the standard value '1' is used as the 'step'.

This process produces three graphics, as shown in the example (A17.3a–c on the web-based resources). This shows Cluster 1 from 0 to 50 seconds, Cluster 2 from 50 to 85 seconds, and Cluster 3 from 85 to 126 seconds (end) in the clinical improvisation. These are the time frames determined for the three sub-sections in the clinical improvisation.[10]

Stage 3: Counting emotions to determine the emotion profile of each section

The starting point for ordering responses is the data table shown in A17.1 on the web-based resources. The number of emotions per time section are taken from this table. It has also been taken into account that transitions from one emotion to another may be indicated with a slight delay. As the listener is dealing with feelings, a certain amount of time may pass before he or she becomes conscious of a change in emotion. Thus, when counting the emotions, those beginning in a previous section *before* a distinct growth of similar changes becomes visible, and whose total time extends into a new section, are included in the total for the previous section. (This is shown in the histograms/icicle diagrams, A17.3a–c).[11] All other longer-lasting emotions are counted for both the previous and current sections.

An example for growth as described above is shown in the Cluster or Emotion Section 2 in A17.3a. From 60 seconds on, listeners' reports increase distinctly. In the graph of A17.3b you can see in this moment an increase of feedbacks of listeners from two to ten. However, as

10 In this example, it is interesting to note that a decided increase can be seen in the feedback in the histogram/icicle diagram at 95 seconds. In the example, the metre changes here from 6/8 to 4/4. Thus, statistical evaluation of listener feedback also reflects a clear and elementary musical transition.

11 In this table, both beginning and end of the emotion section are shown for each listener. The end of the section is the point under discussion.

the section starts at 50 seconds, all reports (Column 'End', A17.1) before 60 seconds were included in Cluster or Emotion Section 1. All longer reports were included in both the first and second sections.[12] The time-span necessary for the realisation of new emotions ranged from 10 to 20 seconds. This corresponds to the profiles in single histograms/icicle diagrams of the emotion sections in the examples examined up until now. These examples were between two and eight minutes in length. In the example in A17.3a–c, the time-span was 10 seconds.[13]

Stage 4: Documentation of results

Using this method of counting, a table is made showing the frequency of reported emotions within the time sections of the clinical improvisation. An example is shown in A17.4 on the web-based resources, based on A17.1–A17.3 (for complete details, see Wosch 2002, p.211). An overview of the emotion profile of the respective emotion sections of a clinical improvisation emerges in a graphic version of the table (Excel or PowerPoint, for example). This overview is presented in Figure 17.3 as the result of measurements of emotional transitions and emotional micro-processes within clinical improvisations using EQ 26.5.

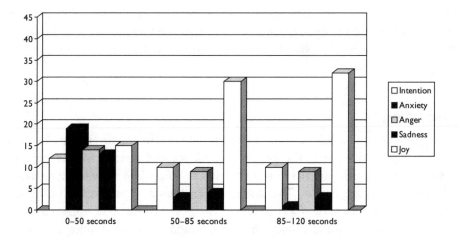

Figure 17.3 Course of emotions in a clinical improvisation

Thus, a complete emotion profile of all five emotion groups is included in each emotion section of the clinical improvisation. A dominating emotion can often be found in each

12 This corresponds to the requirement of the EQ 26.5 questionnaire that changes be noted as quickly as possible. Time should be provided for noting the corresponding emotion in a second step. The second mouse-click for the report of specific emotions was not timed.

13 It must be taken into account that this two-minute-long example was an extremely brief clinical improvisation. The three emotion sections are correspondingly short, each less than one minute.

section. As far as dominant emotions are concerned, transitions within single clinical improvisations became visible in earlier studies within a time-period ranging between two and eight minutes.

Previous studies in evaluating clinical improvisations have shown that listeners require a brief period in which they accustom themselves to using the EQ 26.5. A short improvisation, not to be included in analysis, should be used for this learning process as a first listening example. Due to varying listener concentration spans and capability to act as a resonating instrument, the total time of the investigation should not exceed a maximum of 90 minutes. Furthermore, sufficient time should be calculated for when players or instruments are added, as well as for transitions between improvisations.

A short version for clinicians can be used with Stage 1 without using a computer. The music therapist and one or two more colleagues or internship students listen to the audio file of the clinical improvisation and fill out an EQ 26.5. The music therapist works as an assistant. In the end the music therapist has his or her own EQ 26.5 plus one or two more. The mean of the two or three results gives very important feedback to the impressions of the music therapist of the emotional transitions of the clinical improvisation. It can confirm or broaden these impressions of one clinical improvisation for the clinicians and can provide very important new information about a clinical improvisation of special interest. Another service this time is developed, which will offer an internet service of using this method for clinicians. For this please contact the author (see contact address in the list of contributors at the end of the book).

Case example

A case example using this form of measurement follows. The twelfth session of a 24-session music therapy is described. The patient is a 32-year-old woman with atypical bulimia nervosa. Differential diagnostics show her as suffering from bulimia with depressive-hysterical personality components. The music therapist used a psychoanalytically oriented approach. The therapy session was 30 minutes long, and consisted of a preliminary conversation, an improvisation and a concluding conversation. The clinical concept was psychoanalytically oriented, and consisted of psychotherapy conducted by medical doctors, medicinal treatment and other accompanying therapy forms.[14]

An audio recording of Session 12 was available. In this session, the therapist played the piano and the client chose to play a bongo. The improvisation was 6 minutes and 55 seconds

14 This is the same case study introduced with a different method by Ortlieb *et al.* in Chapter
 21 of this book . That chapter deals with the clinical improvisation that serves as a model
 for the examples using EQ 26.5 in the section 'Method' in A17.1–4 on the web-based
 resources.

in length. It was evaluated by 41 listeners,[15] and formed a part of the author's PhD thesis (Wosch 2002).

Results

The 41 listeners evaluated this improvisation using the computerised version described above. The listener's table of data after filling out EQ 26.5 is shown in A17.5 on the web-based resources. A distinct majority of the listeners, 85 per cent, indicated more than one emotion section.[16]

A17.7a–d on the web-based resources shows that four sections were calculated using cluster analysis. The increase in the coefficient within the last four values is from 40.98 to 60.63 (50%, whereas previously an increase of only 17% from 34.14 to 40.98 was measured), from 60.63 to 103.28 (circa 60%) and from 103.28 to 153.21 (again, circa 50%). Section lengths of the four clusters are: 0 to 125 seconds, 125 to 235 seconds, 235 to 305 seconds, and 315 to 415 seconds. The histograms/icicle diagrams and the dendrogram for these four sections are shown in A17.6a and b on the web-based resources.

In the histograms/icicle diagrams it becomes evident that the first increase used in determining margins for counting individual emotion profiles as mentioned above is after the first 20 seconds. In the third and fourth sections, the increase is after the first 15 seconds. This was taken into account when counting emotions within the sections in A17.5, and resulted in the table in A17.8 on the web-based resources. This made portrayal of emotion profiles in the graphic in A17.9 possible.

In the later process of adding instruments to the graphic diagram, emotion intention bars from emotion section 1 were assigned to the client's bongo. In emotion sections 2 and 3, emotion anger bars were assigned to both the client's bongo and the therapist's piano. In emotion section 1, there were few reports associating the bongo with emotion anger or the piano with emotion joy. In emotion section 2, there were few reports associating emotion sadness with the bongo. The same was true of both instruments in section 4.

Discussion

Emotion intention dominates somewhat in the first emotion section. It is musically interesting that the client tries to adjust her playing to the therapist's opposing time signatures and

15 The 41 listeners were students of music therapy, special education [German: Heilpädagogik] and social pedagogy [German: Sozialpädagogik]. The listeners were between 18 and 31 years old, 88 per cent were female, and 12 per cent male. The largest age-category consisted of 20-year-olds. Forty-two per cent were first-semester students; 86 per cent were music therapy students or students in special education with a music therapy emphasis.

16 It is interesting that the same minority of listeners, 15 per cent, who evaluated the improvisation as consisting of only one section, were those who had little contact with music therapy during their courses of study. In previous studies using EQ 26.5, more than 75 per cent of the listeners listed more than one emotion section.

metrical forms.[17] The client's futile attempts may have been the reason for scattered reports of emotion anger on her part (second-largest bar in this section). The third-largest bar is that of emotion joy, shown in scattered mentions associated with the therapist's piano. This is confirmed by further feedback from the therapist, writing subsequent to the therapy session that, especially at the beginning of the improvisation, his thoughts had centred more on his holidays than on the client.

In the second part of the clinical improvisation, the client gives up trying to conform to the therapist musically, and develops distinct metrical forms of her own. Now, the therapist takes up and connects with the client's metre and volume to some extent. This continues more strongly in part three. A transition occurs in the music. The emotion changes and emotion anger begins to dominate, as shown by the emotion feedback. Emotion intention takes a second place. The emotions fear and joy recede distinctly. In the description after the therapy session, the client confirms being occupied with anger: 'From my Poesie-Album: The human will needs obstructions in order to steel itself' (Wosch 2002, p.205). The client is concerned with obstructions, with grappling. This grappling originates as a conscious impulse within the client. She is, however, left alone with it. There are short pauses in the therapist's playing. The client leads the music. These periods of 'being alone' could be an explanation for the few reports of emotion sadness associated with the client's bongo. After the session, the therapist writes that it is already late in the day, and that she was dissatisfied, in part, with her own piano playing. This could simultaneously support the anger emotion. In the client's 'solo effort', it is interesting to note that the emotion fear is almost at zero. Compared with the large emotion fear bar in a previous session shown in Figure 17.3 (the emotion anxiety is primarily associated with the client's instrument), the client's struggle occurs here practically free of anxiety. This can be understood as an increasing and acceptable feeling of independence (in this case, also supported by momentary 'weaknesses' of the therapist).

In the fourth and final section, the client plays an almost one-minute-long concluding solo on the bongo. Irritation still dominates slightly. It is, however, now accompanied and marked by a clear increase of sadness and joy (fear increases as well). Sadness and the feeling of being alone (as well as slight fear while soloing) seem to be the main themes, as well as relief, shown by the increasing emotion joy bar.

Taken as a whole, the improvisation seems to indicate great potential for change. This potential, as well as micro-transitions in emotional areas, were not fully clear to the therapist. The analysis introduced here can provide the therapist with important assistance in this regard.

17 A listening example corresponding to this and the following description can be found on the web-based resources, audio sample A17.1.

Summary and perspectives

Microanalysis with EQ 26.5 is a method with which fine emotional transitions and nuances in clinical improvisations can become visible and be utilised using three steps: data gathering by means of EQ 26.5 filled out by a minimum of 20 music therapy students; SPSS cluster analysis for the determination of time sections; and counting emotion profiles of individual emotion sections. A short version of this for clinicians, which also can be used in music therapy education and supervision, was described above. Further perspectives are the development of an internet service in cooperation with university-level music therapy teaching. This would be able to provide clinics with such analyses, including a final emotion profile graphic, within one to two weeks (for more information, see the contact details in the list of contributors at the end of the book).

At the same time, an extensive data pool can be developed for examining basic emotional micro-processes in meta-analyses in music therapy research. Additionally, it can provide proofs of changes occurring in and through clinical improvisations, and examine extensive musical analyses and analyses of therapist reactions to emotional transitions in clinical improvisations. Five dimensions of microanalysis are thus made clear:

1. as individual analysis in clinical practice with the above-mentioned short version

2. as an instrument in music therapy education for the systematic training of perception of emotional transitions

3. as an internet service for clinical practice

4. as a meta-analysis in multi-centre studies for statistically relevant common statements about music therapy through examinations with one method

5. in the function of relating different microanalyses to each other in order to provide answers to highly complex questions of music therapy.

In this book, relationships between this method and further microanalyses such as those by Ortlieb et al. (Chapter 21, text analysis), Wosch (Chapter 18, IAP microanalysis), Baker (Chapter 8, emotional voice analysis) and Erkkilä (Chapter 10, musical interaction computer analysis) have already been made, or are being planned.

References

Blood, A.J. and Zatorre, R.J. (2001) 'Intensely pleasurable responses to music correlate with activity in brain regions implicated in reward and emotion.' *Proceedings of the National Academy of Science of the United States of America 98*, p.11818–23.

Bodner, E., Mazor, A., Gilboa, A. and Amir, D. (2005) 'Putting the Sad Affect of Music into Words as a Way to Communicate with the Depressive Patient.' In D. Aldridge and J. Fachner (eds) *Info-CD ROM VI Music Therapy World.* Witten: Witten-Herdecke University.

Bonde, L.O. (1997) 'Music analysis and image potentials in classical music.' *Nordic Journal of Music Therapy 6*, 2, 121–8.

Bunt, L. and Pavlicevic, M. (2001) 'Music and Emotion: Perspectives from Music Therapy.' In P.N. Juslin and J.A. Sloboda (eds) *Music and Emotion: Theory and Research.* Oxford: Oxford University Press, pp.181–203.

Busch, V., Nickel, A.K., Hillecke, T.K., Gross, T., Meißner, N. and Bolay, H.V. (2003) 'Musikalische und mimische Emotionserkennung: Eine Pilotstudie mit psychiatrischen Patienten.' *Musik-, Tanz- und Kunsttherapie 14*, 1, 1–8.

Gembris, H. (1996) 'Rezeptionsforschung.' In H.-H. Decker-Voigt, P. Knill and E. Weymann (eds) *Lexikon Musiktherapie*. Göttingen: Hogrefe, pp.321–6.

Grawe, K. (2004) *Neuropsychotherapie*. Göttingen: Hogrefe.

Hevner, K. (1936) 'Experimental studies of the elements of expression in music.' *American Journal of Psychology 48*, 246–68.

Izard, C.E. (1994) *Die Emotionen des Menschen*. Weinheim: Beltz Psychologie Verlagsunion.

Kenny, C., Jahn-Langenberg, M. and Loewy, J. (2005) 'Hermeneutic Inquiry.' In B.L. Wheeler (ed.) *Music Therapy Research*. Gilsum, NH: Barcelona Publishers, pp.335–51.

Langenberg, M. (1988) *Vom Handeln zum Behandeln*. Stuttgart: Gustav Fischer.

Louven, C. (2004) 'Die Beurteilung der Gefühlsqualitäten von Stimmimprovisationen. Ein Vergleich von Ton- und Videoaufnahmen.' *Musiktherapeutische Umschau 25*, 2, 144–53.

Lungwitz, H. (1970) *Lehrbuch der Psychobiologie. Erste Abteilung*. Berlin: Hans Lungwitz Stiftung.

Machleidt, W. (1994) 'Ist die Schizophrenie eine affektive Erkrankung?' *Psychologische Beiträge 36*, 348–78.

Machleidt, W. (1999) 'Affekttypologie schizophrener Psychosen.' In W. Machleidt, H. Haltenhof and P. Garlipp (eds) *Schizophrenie – eine affektive Erkrankung?* Stuttgart: Schattauer, 94–112.

Machleidt, W., Gutjahr, L. and Mügge, A. (1989) *Grundgefühle*. Berlin: Springer.

Mayring, P. (1992) 'Eine Klassifikation der Gefühle.' In D. Ulich and P. Mayring (1992) *Psychologie der Emotionen*. Stuttgart: Kohlhammer, pp.58–67.

Ortony, A. and Turner, T.J. (1990) 'What's basic about basic emotions?' *Psychological Review 97*, 315–31.

Peretz, I. (2001) 'Listen to the Brain: A Biological Perspective on Musical Emotions.' In P.N. Juslin and J.A. Sloboda (eds) *Music and Emotion: Theory and Research*. Oxford: Oxford University Press, pp.105–34.

Priestley, M. (1994) *Analytical Music Therapy*. Phoenixville: Barcelona Publishers.

Smeijsters, H. (2005) 'A Quantitative-Naturalistic Hypothesis-Generating Single-Case Design.' In B.L. Wheeler (ed.) *Music Therapy Research*. Gilsum: Barcelona Publishers, pp.302–5.

Spitzer, M. (2002) *Musik im Kopf*. Stuttgart: Schattauer.

Thaut, M.H. (2002) 'Neuropsychological Processes in Music Perception and Their Relevance in Music Therapy.' In R.F. Unkefer and M.H. Thaut (eds) *Music Therapy in the Treatment of Adults with Mental Disorders*. Saint-Louis: MMB, pp.2–32.

Willms, H. (2004) 'Ist die Musik die Sprache der Gefühle?' *Zeitschrift für Musik-, Tanz- und Kunsttherapie 15*, 3, 113–19.

Wosch, T. (2002) *Emotionale Mikroprozesse musikalischer Interaktionen. Eine Einzelfallanalyse zur Untersuchung musiktherapeutischer Improvisationen*. Münster: Waxmann.

Wosch, T. and Frommer, J. (2002) 'Emotionsveränderungen in musiktherapeutischen Improvisationen.' *Musik-, Tanz- und Kunsttherapie 13*, 3, 107–14.

Chapter 18

Microanalysis of Processes of Interactions in Clinical Improvisation with IAP-Autonomy

Thomas Wosch

Introduction

The Improvisation Assessment Profiles (IAP) by Bruscia (1987) are an assessment tool for research and clinical practice that has been used and discussed frequently in music therapy teaching, research and practice over the last 20 years (see, for example, Gardstrom 2004; Pavlicevic 1997; Stige and Østergaard 1994; Wigram 1999, 2004; Wosch 2002). In this book other contributors discuss its application for microanalysis (see Abrams in Chapter 7, Scholtz, Voigt and Wosch in Chapter 5 and Wigram in Chapter 16). The IAP contains six profiles and is a highly differentiated instrument of measurement for diagnosis and examination of clinical improvisations, especially within a framework of musical analysis. The method is highly suitable for examining microprocesses, which are the subject of this book, and the modification presented here originated in emotion research in music therapy (Wosch 2002). Within the context presented in the following theoretical section, the IAP described here focuses on the use of just one of the profiles in the IAPs – autonomy. Microprocesses can change frequently from one interaction quality to another within an improvisation. This modified IAP shows these microprocesses in musical interaction between client and therapist in a single clinical improvisation. In addition, the modified form can indicate how musical interactions within a clinical improvisation begin. It mirrors both therapist's and client's use of varying musical parameters in musical interaction and reaction. In the emotion research work described in this book (see Wosch in Chapter 17; Wosch 2002, p.234) different musical interactions associated with particular emotions can be calculated.

Theoretical basis

The history of the IAP begins with its creator, Kenneth Bruscia (1987) (see also Table 18.1). He developed this assessment instrument for clinical improvisation out of his own clinical

practice. The analysis primarily emphasises musical criteria, which are observed and evaluated within six profiles described below. An example can be found in the profile Integration relating to clinical improvisation, which refers to the relationship of one musical element to another, for example relationships between rhythmic figure and ground (Bruscia 1987, p.465). The integration is divided into five categories, which are defined by Bruscia. In the profile Integration, for example, the category 'over-differentiated' refers to too much integration. All categories are defined for each of the six profiles using a series of musical levels and scales, and are examined and evaluated accordingly. The scales used are rhythm, tempo, metre, tonality, harmony, melody, volume and timbre.[1] A highly differentiated picture of the client's clinical improvisation emerges, a musically based assessment of the client based on a current clinical improvisation.

Wigram (1999, 2004) points out that the range of profiles and scales is too extensive to be used in its entirety in clinical practice. In the everyday life of a clinic, there is neither space nor time for lengthy and differentiated analysis of clinical improvisation. For this reason, Wigram developed a shortened, modified version (1999, 2004) for use particularly in diagnostic assessment work with children and adolescents with autism, Asperger Syndrome and developmental and behavioural problems. First, he chose two profiles out of the six that were particularly relevant for analysing relationships and style of play: variability and autonomy. Second, he limited the possible goals of IAP to a single aspect, different from those mentioned by Bruscia. Wigram also proposed that for longer term clinical interventions sections of individual clinical improvisations be taken from a course of therapy extending over a period of weeks and compared with each other (see Chapter 16 in this book). Analysis of a process, as opposed to pure assessment, enables transitions during the course of music therapy to be visualised and controlled. Additional alternative applications of the method, exemplified in my Chapter 17, involve the use of only one profile for a specific type of analysis – autonomy. Here, a clinical improvisation or individual sections of the improvisation are not analysed as a complete entity. The course of events, or process, of the *entire* clinical improvisation is evaluated. Second-by-second client and therapist use of rhythmic scales, volume scales etc. is continually evaluated as to whether previous categories of autonomy are retained or diverged from. During this process, the original IAP assessment tool becomes a micro-process analysis using IAP (an Improvisation Microprocess Profile, IMPP). In addition, the IAP used as a quantitative measurement instrument provides a complete picture of processes that occur in the clinical improvisation. In comparison to other 'objective methods of data collection' (Bruscia 1987, p.411), the IAP becomes more objective. Results can immediately be understood by the reader, as the score of the clinical improvisation, the description and tabular portrayal of the IAP-Autonomy microanalysis (see the Method section below) are used together.

In the version presented here, client and therapist are examined with respect to their autonomy categories. This is using Bruscia's suggestions for examination of interpersonal

1 According to the question posed in the assessment, a physical scale can also be evaluated.

relationships. The question is 'how the intermusical relationships relate to roles and role rela-tionship between the improvisers' (Bruscia 1987, p.410).[2] Of the six profiles, the IAP-Autonomy is the most applicable as it 'helps one look closely at the inter-personal events that are going on' (Wigram 2004, p.219).

A further use of the IAP can be found in Gardstrom (2004). Gardstrom applies the IAP in its original form, as developed by Bruscia. However, she utilises the IAP less as an assess-ment, and more as a source for understanding the meaning of clinical improvisations. The centre of attention is not the client alone, as both client and therapist are examined equally. To some extent, musical differentiations are made between varying sections within a clinical improvisation, allowing processes within the improvisation to become visible. Analysis is not performed second by second, as in the process by Wosch, but over the course of two to three transitions within an improvisation. Table 18.1 summarises these developmental steps of IAP.

Method

The procedure used in microanalysis of interpersonal transitions using the IAP-Autonomy modification follows. It must be noted that the microanalysis presented here is related to a music therapeutic dyad. Wigram's modification above also analysed dyads. It would be possible, however, to examine group improvisations with microanalysis using the form described here.

The process of analysis consists of the following five steps, which will be described in detail:

1. Audio or video recording of the clinical improvisation.

2. Transfer of the audio recording onto computer using SoundEdit (or another program).

3. Production of a score of the clinical improvisation.

4. Microanalysis of the clinical improvisation using IAP-Autonomy in tabular form and written description.

5. Production of a diagram that displays all the important interpersonal transitions during the improvisation.

2 This reduction was the result of an analysis of emotional processes in clinical improvisations carried out using the above modification. According to emotion definitions by Ulich and Mayring (1992), on which the study is based, emotion consists of four inseparable elements: the body-soul-state, being touched, passive experience in the sense of 'something happening to me' and reactions to inter-personal relationships. The version of the IAP presented here is particularly suited for examining the last element.

Table 18.1: Basis and modifications of IAPs

Author	Profiles	Goals
Bruscia 1987	• Integration • Variability • Tension • Congruence • Salience • Autonomy	• Model of client assessment • Provide global perspective on client's problems and assets through objective methods of data collection • Guiding the therapeutic process
Wigram 1999, 2004	• Variability • Autonomy	• Assessment procedure for analysing change or lack of change in client with comparing different clinical improvisations • More use of IAP in clinical practice
Wosch 2002	• Autonomy	• Analysing all interpersonal micro-processes between client and therapist within one clinical improvisation • Understanding emotional transitions
Gardstrom 2004	• Integration • Variability • Tension • Congruence • Salience • Autonomy	• Analysing main states of processes of client and therapist in one clinical improvisation • Understanding meaning of clinical improvisations

Step 1: Audio or video recording of the clinical improvisation

Step 1 restates the necessity that an audio or video recording of the clinical improvisation be available. When video recordings are used, interpersonal activity can be observed as well as heard. The audio recording provides the raw material for the study, and the recording should thus be made under optimum circumstances. Microphones should be positioned so as not to emphasise only one instrument. As volume is evaluated by the IAP, false microphone placement can cause grave distortions of results. While distortions cannot be eliminated completely, they can be minimised. If excellent recording conditions exist, wireless mini-microphones could be installed in each instrument available for the improvisation. The result

would be a many-channelled recording in which each instrument could be identified individually. Step 3 could then be computerised, which would save time in producing the score.[3] The case presented here used audio tape recordings, which of course also served the purpose.

Step 2: Transfer of the audio recording onto computer using SoundEdit (or another program)

In Step 2 the recording, regardless of original form, is scanned onto the computer as an audio file. This is of especial importance for the next two steps. The example provided in this chapter was scanned using the software SoundEdit. However, other similar software can also be used. It is important for score-writing and for evaluation in microanalysis with the IAP-Autonomy profile that the recording of the improvisation can be slowed down. Using sound software, individual sections can then be identified and small details perceived. When the listener is able to choose the speed at which he listens to the improvisation he can better differentiate between and objectively perceive individual musical details and their relationship to one another. This is the most important benefit of working with software. Length and beginnings of specific musical occurrences are exactly timed, and rewinding and fast-forwarding digitally is quicker, easier and much more precise than with other audio equipment. SoundEdit produces a curve or visual representation of the music, which provides an objective reading and shows both changes in overall volume and differences in volume between instruments. All sounds and rests are timed precisely and shown by the curve.

Step 3: Production of a score of the clinical improvisation

Step 3, the production of a score of the improvisation, now follows. In the microanalysis presented here, conventional musical notation was used. Contemporary music and music therapy provide us with many forms of music notation, for example graphic notation (Karkoschka 1966; Langenberg, Frommer and Tress 1992). Advantages of traditional notation are, however:

- exactitude
- portrayal of many dimensions of musical elements
- the way the clinician or the researcher listen becomes comprehensible.

Conventional notation provides the most differentiated and suitable basis for evaluating musical scales in the IAP-Autonomy. However, the researcher or clinician should also attempt to understand and transmit the clinical improvisation ethnologically and ethnographically (for ethnography, see also Aigen 1995). He should not, for example, focus too quickly on a certain known style, such as a waltz, but listen to the improvisation carefully and critically, in order to determine whether this rhythmic–metric form can really be found

3 These conditions would be perfect for research with this method.

in the improvisation. In some of the previously examined improvisations, no time signature could be determined. This was left open in the score. At the same time it remained important that the exact length and position of each tone be notated.

In this step dynamics and rhythmic characteristics from each player are evaluated and differentiated. These are important moments, some of which occur within the space of milliseconds. For this reason, a timetable is included in the notation (see notation example, A18.1 on the web-based resources). In this example, intervals of five seconds were used, and each new five-second interval was notated in the piano score (0:05, 0:10, 0:15, etc.). Changes in metre, or whether 2½ or 3 measures are included in a single time interval, can be precisely determined by means of entries in the time scale. In evaluating rhythm and timbre in microanalysis using the IAP-Autonomy, further ethnologically based symbols are used in addition to conventional notation. Their usage depends on the individual musical expression found in the clinical improvisation. It becomes increasingly clear that a clinical improvisation is not traditional, middle-class concert music, for which standard notation can be used, but consists of elementary musical forms. Figure 18.1 lists the symbols and meanings used in the example here.

Figure 18.1: Additional score signs

In the example (A18.1 on the web-based resources), drum accents were of great importance for microanalysis evaluations, and the analysis thus differentiates between stronger and weaker accents. Lower-sounding drumbeats in the middle of the drum skin were differentiated from higher drumbeats nearer to the rim. In addition, there were metrical occurrences of special interest. These included fluctuations in metre (see measure 3, A18.1), and minimal accelerations towards a point of emphasis or certain tone within a particular motif (see from the second half of measure 8 to interval 1, measure 9, A18.1). This example shows how conventional notation is supplemented by other symbols, in order that individual characteristics of the musical system behind the elementary musical form of the clinical improvisation can

be visualised. It is important that the score includes everything that can be used to evaluate the clinical improvisation on the level of rhythmic ground (including metre and, when applicable, time signature; melody, including harmony and tonality, when applicable; as well as timbre and volume). The score thus already represents a first level of microanalysis.

On a theoretical level, it must be taken into account that the score, despite all ethnological considerations, is naturally influenced by the score-writer's own subjectivity. The importance of this factor is dependent on the paradigm used, whether positivist or constructivist. Using a positivist approach to the microanalysis method, an attempt is made to reduce the problem in that another specialist (ideally another music therapist or music ethnologist) listens to the recording with the newly written score as a control. He notes differences in the score and discusses these with the writer, which leads to production of a final version. In clinical practice this part of the microanalysis process would not be realistic, but some validation or second listening could be undertaken in supervision or intervision.

Step 4: Microanalysis of the clinical improvisation using IAP-Autonomy in tabular form and written description

Step 4 is the microanalysis of the score with IAP-Autonomy. Categories within the profile autonomy, its musical scales and a description of the microanalysis IAP-Autonomy procedure are listed below. The clinical improvisation is evaluated according to definitions of and differentiations within the profile autonomy according to Bruscia:

> Autonomy…deals with the kind of role relationships formed between the improvisers. Scales within the profile describe the extent to which each musical element and component is used to lead or follow the other. The five gradients are:
>
> * Dependent
> * Follower
> * Partner
> * Leader
> * Resister. (Bruscia 1987, p.405)

In 'following', the gradient 'follower' is seen as freer steps, 'dependent' as more restrictive or compulsive steps. In 'leading', the same applies to the 'leader'. An excessive desire to lead is associated with the role of 'resister', who strives to avoid communication and interaction. At the gradient 'partner', the central point, an ideal or healthy situation is reached, where leading and following are balanced. Musical impulses are given and developed in the same measure as they are taken up by the partner. In contrast to Bruscia, who defines the five roles in the autonomy profile using nine musical scales and a standardised form of observation (1987, p.409), Wigram selects those musical scales that are relevant to the improvisation, and which stand out on a first, open listening. In a published example the three chosen musical scales were rhythmic ground, melody and timbre (Wigram 1999, p.17). These are the scales used in the method here. An example of Bruscia's five autonomy categories, rhythmic ground, is defined on the web-based resources, A18.2.

In the modification presented here, Wosch (2002) added the elementary musical element volume to the third scale, timbre. Fifteen definitions (five categories within three musical scales) can be used to analyse microanalytical transitions in interpersonal activity within a clinical improvisation. This is evaluated measure by measure, or second by second. Results are noted in a table as shown by Figure 18.2 (based on Wigram 1999, p.17). Two aspects are new. The first is that *every* transition in interpersonal activity in the clinical improvisation is registered by microprocess analysis, not only an exemplary section of the clinical improvisation. The beginning of each transition is noted in the first row of each new table, as these transitions can occur at different times within the improvisation. Each table is thus valid for *one* clinical improvisation. Wigram's table (1999) was intended for a maximum of three.

Time																						
Dependence																						
Rhythmical basis																						
Melody																						
Timbre																						
Following																						
Rhythmical basis																						
Melody																						
Timbre																						
Partner																						
Rhythmical basis																						
Melody																						
Timbre																						
Leading																						
Rhythmical basis																						
Melody																						
Timbre																						
Resister																						
Rhythmical basis																						
Melody																						
Timbre																						

Figure 18.2: Micoranalysis IAP-Autonomy table

The second new aspect is that both client and therapist are analysed. In the table, C is entered for client and T for therapist in the respective autonomy category or categories in each new column.

A18.3 on the web-based resources gives an example of filling out the table, and for the microanalysis using IAP-Autonomy based on the score. The example uses material from the first 17 seconds of a clinical improvisation, and is shown together with the score in A18.1 on the web-based resources. The client plays a drum (upper system), and the therapist plays the piano (lower two systems). The client is considered to be leading, as she plays alone. This gradient is shown in the musical elements in the scales 'rhythmic ground' and 'timbre'. As the drum is a rhythm instrument, the melody scale is omitted for the entire clinical improvisation. A scale can only be of importance in an interpersonal sense (i.e. when evaluating with the autonomy profile) when *both* players have access to it, and are able to relate to it and to each other.

The piano (therapist) starts at second 9. The preceding 6/8 time signature implied by a stronger emphasis on beat 1 and weaker emphasis on beat 4 on the drum (client) is made insecure by the piano (therapist) entering on a different rhythmical level. The client attempts to follow the therapist's new metre and time signature by changing the drum emphasis. The therapist retains the shift in time-signature. In the scale 'rhythmic ground', the therapist is now leader and the client follower (see A18.3). In the scale 'timbre', both are resisters, as shown in articulation used by both instruments. The client plays rather choppily and staccato, and intensifies this articulation form after second 9. In contrast, with the exception of the first note, the therapist plays long, held legato tones.

The next micro transition in musical interpersonal activity is at 15 seconds. The client returns to 6/8 time, and indicates this more distinctly than in measures 1 to 3 by accenting only beat 1. The piano (therapist) stays with his time signature shift and both thus take up the role of resister. On the level of timbre, however, they approach each other, each playing one *portato* tone. This moment is evaluated as belonging to the gradient 'partner'. This articulation form is new to both client and therapist. Looked at 'under a magnifying glass', it is not begun as an impulse by one player, but simultaneously. This 18-second-long section also shows that within interpersonal activity different autonomy categories can be used within different scales. Brief transitions can be an indicator for interpersonal transitions within the microprocess of an entire clinical improvisation. For example, the resister category in the second micro section of the timbre scale in the example described above is a premonition of the resister role taken up by both client and therapist on the rhythmic ground level in the second micro section. This section shows that both a differentiated picture and a high level of objectivity can be obtained using this form of microanalysis. Verbal descriptions of the musical process, which make the process more comprehensible (see A18.4 on the web-based resources), further the process of differentiation.

In contrast to Bruscia's and Wigram's analyses, the microanalysis using IAP-Autonomy does not analyse every musical scale in the entire clinical improvisation or in a representative section of the improvisation. Instead, all three chosen scales are observed over short time-periods in order to determine the extent to which the scales change according to inter-

personal content. If a change occurs in one of the scales, a new micro section and starting time are noted. This allows change in the autonomy category and interpersonal content to be observed within individual scales. Tables can show, for example, 19 sections or interpersonal transitions within a two-minute improvisation (as in the clinical improvisation shown in previous examples).

Step 5: Production of a diagram that displays all the important interpersonal transitions during the improvisation

In the fifth and final step, all sections are summarised and portrayed graphically. In the clinical improvisation described above, this was done in relationship to a further study using the microanalysis method as described in Chapter 17. The study determined emotional time sections using statistical cluster analysis.[4] Interpersonal activity during emotion sections of a clinical improvisation was calculated and added together, as in Wigram's version (1999). In contrast, however, results are not used to compare improvisations with one another, but to compare sections within a *single* clinical improvisation. This allows interpersonal characteristics of each section to be exhibited. In the clinical example described above, the graphs for client and therapist (Figure 18.3) emerged through the addition of the categories, 'dependent', 'follower', 'partner', 'leader' and 'resister', found in all musical scales contained within the three emotion sections calculated in the other study. This clinical improvisation was 120 seconds long. In the first emotion section, from 0 to 50 seconds, anxiety dominated; the second emotion section, from 50 to 85 seconds, and the third section, from 85 to 120 seconds, were both marked primarily by joy. The vertical axis shows the absolute value of an autonomy-category within each of the three sections. The graph was created using Excel or PowerPoint graph function, filling out a table with each category in each line and, in each column, each time section of the clinical improvisation.

The graphs clearly show that the first section is characterised by the client in the role of 'leader' and the therapist in the role of 'resister'. In section two, both of these characteristics recede; at the same time the client can no longer be seen as a 'follower'. The most distinct transition occurs in the last section, in which the therapist clearly takes the lead and the client follows. Microanalysis IAP-Autonomy alone or together with other studies[5] makes it possible to investigate important interpersonal transitions in clinical improvisations in a form standardised on the basis of musical scales.

4 Only working with microanalysis IAP-Autonomy can create interaction-sections of a clinical improvisation with search for clusters of each of the five categories in the course of the clinical improvisation.

5 Although the emotional content varies, the three interpersonal profiles of each emotion section were able to be labelled. In other words, varying emotion contents could be correlated to differing interpersonal contents. This can also occur when an emotion appears twice.

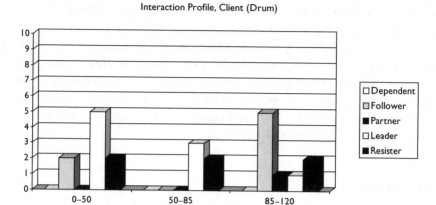

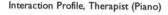

Figure 18.3: Musical interaction profile

Conclusion

Microanalysis using IAP-Autonomy can be used to summarise and portray all interpersonal transitions within a clinical improvisation, or a series of micro sections within a clinical improvisation. In the example above, an additional microprocess can be identified for the entire clinical improvisation of session 12. In the first section, from 0 to 34 seconds, the client leads and the therapist follows. This is interrupted by two short sections in which client and therapist both take up the role of 'resister'. The section between seconds 35 and 79 contains several phases in which the client leads and the therapist resists. The section from 80 to 96 seconds is interpersonally the same as the first section. This can be said to be an interpersonal rondo-form, although the melodic themes, for example, differ from those in section one. The particular importance of musical analysis in music therapy as opposed to musical analysis in music pedagogy and musicology is made clear at this point. Musical observation of interpersonal transitions relevant to music therapy has a different structure from that found by music theory analyses.

The fourth and final section contains a completely new element. From 97 to 126 seconds, the therapist leads and the client follows in all scales. The new quality of musical interaction is characterised by a brief episode in second 125, which contains the only partner-category in which 'rhythmic ground' can be observed. This practical importance of this particularity will be enlarged upon briefly in the following case study in the form of a micro-section portrayal. On the whole, microanalysis using the IAP-Autonomy investigates the process of interpersonal activity and change within a clinical improvisation in a very detailed, visible and demonstrable manner.

Case example

The following section examines a portion of the microanalysis IAP-Autonomy of a clinical improvisation already referred to in the method section, and illustrates immediate advantages for clinical use in supervision and therapy planning.

The case and the clinical improvisation can also be found in the chapter by Ortlieb *et al.* in this book. The patient was a 32-year-old female in-patient diagnosed with atypical bulimia nervosa. Differential diagnostics categorised the illness as bulimia with depressive-hysterical personality components. Both music therapist and clinic used a psychoanalytical approach. However, microanalysis IAP-Autonomy can be used in every approach of music therapy. Clinical treatment consisted in the case example here of music therapy, psychotherapy conducted by medical doctors, medicinal treatment and other accompanying therapy forms. The clinical improvisation examined here was the only improvisation in the first music therapy session.

With regard to interpersonal transitions, both the beginning and the course of the clinical improvisation have already been described in the 'Method' section. Using microanalysis with the IAP-Autonomy, an important observation of interpersonal activity was made within an important micro detail, one second in length. The observation enabled the therapist to become aware of the potential for development within the improvisation. The micro detail is found in the last section of the improvisation. From 1:37 minutes on, a stable role-exchange takes place over the course of several measures/bars. The client is the 'follower' and the therapist is the 'leader' (see A18.5 on the web-based resources: section 1:34–2:06). This is interrupted shortly before the end of the improvisation for one second at 2:05 minutes. At this point, both client and therapist undergo an interpersonal transition from 'follower' and 'leader' respectively, to 'partner'. The score shows strong accents from the client on beat 1 of measures 86 and 87 (upper system, drum). The piano (therapist, lower two systems) continues to play on beats two and three, as in the two preceding measures. At the same time, he reduces in volume, playing 'after beats' in the bass and leaving out descant tones. The therapist leaves the role of leader to a certain extent, and the client increases in timbre. They approach each other in an equal manner and in the scale 'rhythmic ground' even interlock. The client plays on beats one and four, the therapist on two and three. A new rhythmic pattern emerges as a give and take between client and therapist, which could mark the beginning of a longer interpersonal section; qualitatively completely new in comparison

to the interpersonal activity in the clinical improvisation up to this point. For the therapist, however, this marks the end of the improvisation, and he plays a single, final note in the next measure. For the client, the end appears not yet to have come. A strong accent follows on beat 1 of the last measure. On beat 2, he hits the centre of the drum skin in *mezzo-forte*, as if to indicate that the improvisation should continue. She then realises that the therapist has finished, and reduces in volume abruptly from *mezzo-forte* to *pianissimo* on beat 3. The playing stops.

Such microanalyses of interpersonal transitions can make minimal transitions, their interpersonal meaning and potency visible. In clinical practice, it is important for the therapist that he or she is able to perceive such details and react to them quickly with doing something or not doing anything. Microanalysis with IAP-Autonomy provides a systematic and objective instrument of measurement. In this case, microanalysis with IAP-Autonomy overreaches client assessment and, as a standardised analysis instrument, offers the therapist potential for perception, control and understanding of interpersonal transitions within the therapist–client dyad. The method is time consuming but can, however, provide important information for supervision in music therapy, as well as systematic learning of competence in music therapeutic practice.

Summary and perspectives

Microanalysis using the IAP-Autonomy makes interpersonal transitions within clinical improvisations visible and allows them to be viewed objectively. The analysis bases itself on audio recordings from which a detailed score of the clinical improvisation is made. This score is examined second by second using the IAP-Autonomy to determine which of the three musical scales 'rhythmic ground', 'melody' and 'timbre' can be identified. Each interpersonal transition is noted in a table (see Figure 18.2). Various musical interaction profiles can be drawn upon as interaction transitions in the course of a clinical improvisation. This is described in the Method section above.

This method can greatly assist in clinical practice when one is dealing with interpersonal problems not perceived or understood by the therapist. Two steps can be taken to reduce the time necessary for analysis. First, when only certain sections of the improvisation are not able to be understood interpersonally, or when the therapist's feelings towards the client in certain sections are unclear, only these sections are analysed. The second step is cooperation with a university at which microanalysis IAP-Autonomy is taught. Material is analysed by students, who at the same time learn from the process (for information on this service see the contact details in the list of contributors at the end of the book).[6] For teaching music therapy, the method provides an instrument with which students can increase their sensibility to interpersonal processes in clinical improvisations and learn a system for interpersonal

6 The author is interested in receiving information regarding work with microanalysis IAP-Autonomy in clinical practice or at other universities.

understanding of musical elements. For music therapy research, the analysis offers an approach for a wide-ranging standardised multi-centre study, in which all microanalyses using IAP-Autonomy in clinics and in music therapy teaching can be collected and basic music therapeutic and musical processes examined using meta-analyses. In order to increase the clinical use of microanalysis more quickly, computerised versions should also be developed. These already exist in reference to other musical interaction criteria in work by Erkkilä (see Chapter 10), and in reference to singing by Baker (see Chapter 8).

References

Aigen, K. (1995) 'Principles of Qualitative Research.' In B, Wheeler (ed.) *Music Therapy Research: Quantitative and Qualitative Perspectives*. Phoenixville: Barcelona Publishers, pp.283–311.

Bruscia, K. (1987) *Improvisational Models of Music Therapy*. Springfield, IL: Charles C. Thomas Publishers.

Gardstrom, S.C. (2004) 'An Investigation of Meaning in Clinical Music Improvisation with Troubled Adolescents.' In I. Abrams (ed.) *Qualitative Inquiries in Music Therapy*. Gilsum, NH: Barcelona Publishers.

Karkoschka, E. (1966) *Das Schriftbild der Neuen Musik*. Celle: Hermann Moeck Verlag.

Langenberg, M., Frommer, J. and Tress, W. (1992) 'Qualitative Methodik zur Becshreibung und Interpretation musiktherapeutischer Behandlungswerke.' *Musiktherapeutische Umschau 13*, 258–72.

Pavlicevic, M. (1997) *Music Therapy in Context. Music, Meaning and Relationship*. London: Jessica Kingsley Publishers.

Stige, B. and Østergaard, B. (1994) *Improvisation Assessment Profiles av Kenneth E. Bruscia. Kartlegging gjennom Musikkherapeutisk Improvisasjon*. Sandane: Høgskulen i Sogn og Fjordane.

Ulich, D. and Mayring, P. (1992) *Psychologie der Emotionen*. Stuttgart: Kohlhammer.

Wigram, T. (1999) 'Assessment methods in music therapy.' *Nordic Journal of Music Therapy 8*, 1, 17.

Wigram, T. (2004) *Improvisation. Methods and Techniques for Music Therapy Clinicians, Educators and Students*. London: Jessica Kingsley Publishers.

Wosch, T. (2002) *Emotionale Mikroprozesse musikalischer Interaktionen. Eine Einzelfallanalyse zur Untersuchung musiktherapeutischer Improvisationen*. Münster: Waxmann.

Steps in Researching the Music in Therapy

Lars Ole Bonde

Introduction: Purpose of the analysis

"Researching the music in music therapy" was the topic of my contribution to the second edition of *Music Therapy Research* (Bonde 2005c). That article presented an overview of methods, procedures, and techniques used to operationalize, analyze, and interpret music in improvisational and receptive music therapy. The aim of the present chapter is to "translate" this overview into practical guidelines for the clinician or researcher who wants to include substantial musical observations in his or her clinical documentation, research or EBP material.

This chapter highlights what I regard as the most important criteria for choice of method at certain points in the analytical process, and based on this I outline the possible analytical procedures. This is synthesized in a detailed flowchart.

Two examples will be chosen to illustrate the procedural steps and possible choices:

1. a composition often used in GIM (Vaughan Williams: *Rhosymedre Prelude*)

2. clinical improvisation (Dyad piano ex. from *A Comprehensive Guide – CD cut 3*) (Wigram, Pederson and Bonde 2002).

Theoretical framework

Ruud (1990, 1998, 2001) has proposed a theoretical definition of music addressing four main properties or encompassing four levels of experience and analysis:

1. the physiological and biomedical level of *music as a sound phenomenon*

2. the level of music as non-referential meaning or syntax; *music as a structural phenomenon*

3. the level of music as referential meaning; *music as a semantic phenomenon*

4. the level of interpersonal communication; *music as a pragmatic phenomenon.*

One or more of these equally important levels may be addressed when the music in music therapy is researched. It is likely that the paradigmatic position of the researcher or clinician will influence the choice of research method. However, the choice of method should always be based on a clarification of the aims of the research and derived from the specific research questions. The vast spectrum of positions and methodological possibilities can be seen in A19.1 on the web-based resources. Figure 19.1 is an attempt to ask the generic questions in a systematic way, thus leading to clear and well-founded decisions.

1. The trace:
Is a recording of the music available? (Type)?
If not: what then is the trace?
Are verbal comments from client(s)/therapist/other(s) included/available?

2. The scope:
Does the analysis address one short segment, some segments or many segments?
Does the analysis cover part of one session, a whole session, or a series of sessions?
If segments are selected, what criteria will the selection be based on?

3. Focus and purpose
Is a description/analysis/interpretation of the music needed? (cf. Nattiez' model)
Does the analysis focus on sound, syntax, semantics, pragmatics? (cf. Ruud's model)?
Is the focus on the music, on the musical experience, on musical interactions, or on the relationship between the music and the experience?
Do you have any analytical or theoretical assumptions to guide you? Is a specific theoretical frame necessary and helpful?

4. The representation
Is a visual representation of the music necessary?
If no: How then will the analysis refer to the music in detail? If description is sufficient: What kind of description is appropriate?
If yes: Is a representation available (e.g. score, sheet music), or will you have to produce it?
If you must produce the representation yourself: What type of representation is relevant and possible: midi file, score, transcription, graphic notation, verbal description, waveform, intensity profile, other?

5. The presentation (could also be step 1!)
Is it an oral or a written presentation?
Who is the audience/target group and what is the purpose of the presentation?
What types of auditive an visual documentations are relevant and appropriate in the context?

Figure 19.1: How to make a qualified and explicit choice of method

Method

This section introduces and explains a possible generic sequence of decisions and procedures in the form of a flowchart or "step-by-step guide," based on the analytical levels in the Nattiez/Aldridge *Aesthesis/Poiesis* model (Aldridge 1996; Nattiez 1990).

The premise for using the flowchart and guide that follows is that you can answer a motivated *yes* to the question: "Is the analysis of musical material, musical meaning and/or musical processes/interaction relevant for me in this specific context (study, documentation, EBP)?"

In the next section the questions are transformed into a flowchart and step-by-step guide to inform the choice of analytical procedures. The flowchart offers answers to the questions in a general way, indicating premises and decisions. In the following section two examples illustrate the procedure. (In steps 1 and 2 "analysis" covers both description, analysis and interpretation.)

1. The trace

Is a recording of the music available? Audio, vide, midi-file (type)?

- If a recording is available: Go to the question "Are verbal comments...available?
 - Audio-files can be represented in different graphic formats (Audacity, Mia).
 - Midi-files can be converted to music notation through the use of computer software (examples in Lee 2000; Erkkilä *et al.* 2005).

If not: what then is the trace? (e.g. session notes, logs, interviews)

- Written verbal descriptions of improvisations *cannot* be the basis of valid music analysis, however, they can be subject to content analysis through coding and categorizing (e.g. coding of therapist's choice of "givens" instruments, or repertoire) based on Grounded Theory principles; or in phenomenological descriptions of the therapist's considerations and/or the client's reactions, as documented/recorded.
 - Computer software is available for both quantitative and qualitative analysis/coding of verbal material (Atlas.ti, Nud*Ist/NVivo).

Are verbal comments from client(s)/therapist/other(s) included/available?

- Oral/verbal comments recorded by audio or video can – if appropriate – be subject to transcription and analysis/coding of same principles as described above. Non-verbal comments (e.g. dance/movement to the music, like "Body Listening" (Bonny 1993) can also be subject to analysis and coding.
 - Computer software is available for transcription, enabling playback of the recording in a slower temp (e.g. Express Scribe, freeware).

↓

2. The scope

Does the analysis address one short segment, several segments or large amounts of segments?

- The time factor is crucial here. Be realistic and remember that a thorough analysis of even just one session takes a long time (especially when transcription is included).

- "Rule of thumb": transcription of one minute of music takes at least one hour. It is *not* necessary to analyze a complete improvisation: representative samples or segments can be selected by explicit criteria (see below). Analysis of segments may be accompanied by a (graphic) overview or verbal description of the complete improvisation.

- These principles are also applicable to composed music, even if transcription is unnecessary.

 ○ It is a good idea to study clinical and scientific articles, dissertations and theses to see how researchers/clinicians/students have selected samples or segments with a duration of only one or a few minutes, and how many pages the analysis of a few minutes takes up (examples: Aldridge 2002 [seven improvisation segments with verbal description + musical notation]; masters theses (Aalborg University) with different types of analysis: K. Schou; L. Normann; M. Jordan; M. Gregersen; A. Faaborg).

Does the analysis cover part of one session, a whole session, or a series of sessions?

- In principle the considerations related to choosing samples from a series of sessions or a complete case are the same as above. It is often both realistic and appropriate to limit data to comparable material from a few sessions, e.g. early–middle–late phases of the therapy. The complete therapy progress can be illustrated graphically or described verbally (cf. below).

 ○ Examples of (graphic/verbal) description of a complete BMGIM therapy can be seen in Bonde 2005b (graphics also available at www.njmt.no). Here a description format is developed to describe salient elements of each session and the therapy as a whole. Other examples of verbal descriptions can be found in Aldridge 1998a.

If segments are selected, what criteria will the selection be based on?

- Selection criteria must always be explicit. Criteria may be clinical (e.g. specific pathological or non-pathological musical interactions or expressions), musical (typical musical interactions, "givens," repertoire), theoretical (examples of countertransference or alliance building in the music), or pedagogical (easily understandable examples).

 ○ "Go for the gold." It may take a long time to develop selection criteria, especially if some kind of objectivity or representativity is wished, as this in principle demands intersubjective agreement (and in that case other "raters" must evaluate the material). However, it is also acceptable to select

segments/sequences/material based on the criterion that "something important is happening here." You must then not forget to describe the selected material in a holistic perspective: is the sample typical (how) or exceptional (how)?

3. Focus and purpose

Is a verbal description/analysis/interpretation of the music needed (cf. Nattiez's model 1990)?

- A description is typically either phenomenological or descriptive in a professional musical language. In both cases a time line or an exact indication of start time for any new unit/even within the segment is provided (corresponding to the real time recording).

 ◦ A verbal description can be phenomenonological, with precise information on timing. The music is described continuously, emphasizing salient features in the listening experience (e.g. Ferrara 1991).

 ◦ An example of a description in a musical language is Aigen 1998.

- If a verbal description is not sufficient or appropriate a focus must be chosen. See below.

Does the analysis focus on sound, syntax, semantics, pragmatics (cf. Ruud's 1998 and 2001 model)?

- If the analysis has focus on the "sound" aspect an exact, natural science approach is indicated, e.g. the measurement of low frequency sounds and their effects on specific symptoms, as in vibroacoustics (Wigram 1997); or the characteristic and measurable overtone spectrum of specific instruments or voices as related to client behavior or preferences; or tension/intensity as a measurable feature. In most cases sound analysis requires special technical equipment, such as tone generators, spectographs, or computer software, to edit and analyse waveform (e.g. Audacity, freeware) or intensity profile (Mia: Rickman 2005).

- If the analysis focuses on "syntax"/structure, a more or less comprehensive analysis of the music itself is indicated, and often a graphic representation is necessary as a visual reference. Traditional methods of musical analysis focus on musical elements or parameters such as melody, rhythm, tempo, form, texture etc. (a comprehensive method is Grocke's SMMA; see Chapter 11), while more specific methods of analysis focus on, for example, phenomenological description (Ferrara's method), intensity profile (phenomenological-hermeneutic: Trondalen 2003 and Bonde 2005a), musical events as related to dimension of time and space (Christensen's 'Musical TimeSpace' (Christensen 1996), a method also called "intensive listening"), or core motives and their development (Lee 2000).

- If the analysis focuses on "semantics" this will indicate either a more objective or intersubjective interpretation of musical-psychological profiles of expression

(Bruscia's IAP (1987, 1994)), of musical metaphors and/or symbols (cf. Cooke's "The language of music" (1972) or Tagg's "Musematic analysis" (1982)); or a more subjective experience-oriented interpretation of the meaning of the music for the client, conferring the music and the experience (Event Structure Analysis (ESA), Ansdell's confrontation interview (Ansdell 1996)).

- If the analysis focuses on "pragmatics" an analysis of the musical interaction between therapist and client(s) and its context is indicated, e.g. IAP, Trondalen's Intensity Profile, Arnason (2002), Skewes (2001).

- It is of course possible to focus on two or more of the four levels, as in Ferrara's "eclectic method," where sound, syntax, and semantics are approached with different methods (Ferrara 1991).

Is the focus on the music, on the musical experience, on musical interactions, or on the relationship between the music and the experience?

- The analyst must always reflect on and be explicit about these four different foci of the analysis. The same data can often be approached from all four perspectives.

- Focus on the music itself indicates syntactical and, if desirable, semantic analysis.

- Focus on the musical experience indicates semantic analysis of the therapist's or the client's experiences. Different types of data may be available: as transcriptions of clients' reports during BMGIM music listening; as retrospective reports through interviews; and as transcribed dialogues on improvisations (from the clinic or from confrontation interviews). A semantic analysis may be based on a theory of analogy between musical and psychological features (Bonde 2005a; Bruscia 1994; Smeijsters 2003).

- Focus on musical interactions indicates pragmatic analysis. Examples are IAP, Trondalen's IP and Pavlicevic's MIR (Pavlicevic and Trevarthen 1989).

- Focus on the relationship between the music and the experience indicates some sort of correlation between experience data/analysis and musical data/analysis, as in Event Structure Analysis (ESA) or Intensity Profiles (IP). Correlations between musical data (analyzed for example by SMMA) and more exact data, e.g. waveform and EEG, is also possible, as in the analyses of Alan Lem (1998, 1999).

Do you have any analytical or theoretical assumptions to guide you?

- Assumptions or hypotheses must always be explicit in the method description.

- Analytical assumptions can be based on more or less intuitive perceptions of tendencies in the data material, e.g. that personal melodies are developed in an improvisation based therapy (G. Aldridge); or that the number and duration of musical dialogues increase during the therapy. Such assumptions can be formulated usng the terminology from existing methods of analysis, e.g. IAP.

- Theoretical assumptions can be based on specific psychological or psychothera-peutic theories, e.g. that a therapy process frames the development of a twinship experience of the music in the client (self psychology), or that the client's development can be interpreted as a development of more mature defense mechanisms or maneuvers (object relations theory; see for example Moe 2002).

Is a (psychological) interpretation of the music necessary or appropriate? If yes: what is the theoretical framework?

- If an interpretation (Nattiez: external esthesics) is appropriate the theoretical basis for the interpretation (psychological or psychotherapeutic theories and their basic concepts) must be explicit.

 ○ Examples of interpretations can be found in Langenberg, Frommer and Tress 1993; Metzner 2000; Smeijsters 2003; Tüpker 1988. Bruscia's IAPs make use of more or less "theory-free" psychological interpretations (see Stige 2000 and the *Nordic Journal of Music Therapy* forum discussion of IAP).

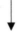

4. The representation

Is a visual representation of the music necessary?

- The analysis must enable the reader or listener to refer very accurately to details in a music example. This does not always indicate the necessity of a traditional musical notation, a score, or a graphic notation of the music. If an audio recording is presented or included on an accompanying CD or an audio file it can be sufficient to describe the music verbally with precise indication of time. This is typical of presentations in multi-disciplinary teams.

 ○ See point 3 about phenomenological and musical descriptions.

- Musical notation and/or graphic notation must be considered when the analysis focuses on the music itself (the syntax).

 ○ Data collection can be designed to secure visual representation, e.g. by performing improvisations on midi-keyboards or by video recording sessions enabling a clear identification of instruments/parts/roles. Musical notation (transcription) can be made manually or by using computer programs (e.g. Cubase, Finale, Sibelius). Graphic notation (Bergstrøm-Nielsen 1993) is appropriate and useful when the music is not suited for musical notation (e.g. if an improvisation is chaotic or dominated by complex rhythms, dynamics and interactions). Musical and graphic notation can be combined, so that exact transcriptions of, for example, important melodic or rhythmic motives are included in a graphic notation.

 ○ Waveform, Mia Intensity profiles are computer-generated, exact graphic
 representations of musical dynamics.

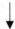

5. The presentation (could also be step 1!)

Is it an oral or a written presentation?

- In oral presentations short audio examples with correspondingly short analytical comments are useful, if necessary supported by handouts with verbal descriptions including time indications or notation.

- In written presentations (report, articles etc.) the music analysed should be accessible as an appendix (audio/video on CD or DVD) and informations/ considerations on points 1–4 above should be included. Transcriptions and analyses are part of the data processing and the presentation should follow a logical sequence: transcription–description–analysis–interpretation.

Who is the audience/target group and what is the purpose of the presentation?
What types of auditive and visual documentations are relevant and appropriate in the context?

- The choice of terminology is dependent on the audience and its level of knowledge and expertise. Professional musical language should not be used with non-professional audiences. Carefully selected metaphors and easy-to-understand audio or video examples are appropriate with lay audiences.

Case examples

The flowchart procedure will now be illustrated by two examples.

Example 1. Receptive music therapy: A musical selection from the GIM repertoire

In 1997 I presented a paper on "Music Analysis and Image Potentials in Classical Music" for the third Nordic Conference in music therapy (Bonde 1997). The audience was predominantly music therapists – clinicians, researchers, and students – enabling me to use professional musical terminology. I wanted to demonstrate how quantitative and qualitative methodologies could be used to address and study different aspects of how music and imagery are related in BMGIM. In order to do that a short piece of music (3:55) from the BMGIM repertoire was chosen: A string arrangement of R. Vaughan Williams' *Rhosymedre*, composed in 1920 as an organ prelude. I presented two methods of analysis in my effort to answer the questions "How can we study the connection between the imagery and the music? How can we study the music and its effects on the listener?"

 Method #1 was a quantitative method for analyzing musical syntax, developed to describe, select, and rate music in any style in a context of media research into radio listeners' musical preferences. A panel of musical experts developed an intersubjectively valid analytic model with seven parameters, representing meaningful aspects of the music experience. In Box 19.1 the parameters and the rating procedures are defined and illustrated with ratings of *Rhosymedre*.

Box 19.1: Quantitative model for the rating of musical elements and dimensions

Power The experience of intensity (impact, energy) – as a complex of density, soundscape and musical complexity. Not to be confused with volume!

Rating procedure: A five-point Likert scale going from very low to very high sound/density/complexity.

Rhosymedre: 2.5

Mood The mood expressed by/in the music. Also influenced by the soundscape (ambience) and opacity determined by the producer/production aesthetics. (This is a revision of Kate Hevner's Mood Wheel (Hevner 1935, 1936), adding an extra category.)

Rating procedure: Identify which mood wheel category the piece belongs to.

Rhosymedre: 3

Rhythm vs. Melody/Harmony The balance of the rhythmic versus the melodic-harmonic element in the music. "Rhythmic" understood with the connotations of "rhythmic (Afro-American) popular music," "melodic-harmonic" as within the Western (classical) music tradition: "Can I whistle this tune?" – The rating does not concern aesthetic quality, only the intended balance between the elements.

Rating procedure: A five-point Likert scale going from "the rhythmic element is dominant" to "The melodic/harmonic element is dominant."

Rhosymedre: 4.5

Text The experience of the importance of the text/the verbal message. Not determined, but influenced by text being in vernacular/foreign language.

Rating procedure: A five-point Likert scale going from "Text has only secondary importance" to "text has primary importance" (+0= Instrumental piece).

Rhosymedre: 0

Performance Level of individuality in the performance of the music (compared to other versions/performances and related to style conventions/traditions). Not to be confused with an evaluation of quality!

Rating procedure: A five-point Likert scale going from "no traces of personality" to "highly personal."

Rhosymedre: 3.5

Style and Genre This is a general model, not specifically concerned about "classical music." It therefore includes 20 different genres, from pop, world music, rock, dance, hip-hop and techno, jazz and classical to folk and traditional music.

Rating procedure: Identify the genre of the piece.

Rhosymedre: 11

Tempo The experience of tempo, not only based on BPM but also subdivisions, staccato, phrasings etc.

Rating procedure: A five-point Likert scale going from "fast-fast" to "slow-slow."

Rhosymedre: 2.5

In the context of music therapy this method of analysis can be used for selecting/rating music for clinical or research purposes. For example, it can be used by the music therapist or researcher who wants to investigate the preferences of specific clients or client groups in order to select (unknown) music for specific purposes within receptive music therapy. The method offers a precise and standardized description and rating of the music, which is theoretically informed and valid for quantitative research. But the methodology has also shortcomings: it is best applied to short pieces of music with no or very few significant changes in the parameters of the model (longer pieces must be divided and rated in sections). And it does not say anything specific about image potentials of the music.

Method #2 is developed to confer analysis of musical syntax with analysis of semantics as represented by imagery of the listeners (e.g. clients) to the same music. Thus, the focus is on the levels of syntax and semantics, and the methods chosen were Ferrara's phenomenological description (Ferrara 1984) combined with (elements of) Bruscia's heuristic analysis (Bruscia 2005). The results of this analysis is presented in Table 19.1 and Box 19.2.

Table 19.1: Collated description of music (syntax) and imagery (semantics)

Syntax 1	Syntax 2	Syntax 3	Semantics 1
Time/Score	Motive(s)	Phenom. description	Personal imagery
0:00 A (Bars 1–8)	# (Violins)	Gentle, sequencing tune with an important descending melodic sequence	I'm a boy playing in my home yard. My mother hums. It's all very safe.
0:35 B1 (9–16)	#1 + #2a	#2 in violas, half time #1 as background (violins) = obbligato counterpoint	My father joins us, asks me if I want to play or listen to a fairy tale
1:09 B2 (17–24)	#2b	2nd part of B in violas, ending like a chorale	We could sing a song together, if I want to? (I am surprised!)
1:42 B1' (25–32)	#1 + #2a'	Violins taking over the #2 Cantus firmus Obbligato ctp. in violas	Mother joins the circle! We are a happy family! Sun and joy all over.
2:17 B2' (33–40)	#2b'	Continued, as above	I couldn't wish it better
2:48 A' (40–45)	#1 'Coda'	Beginning of #1 + Chorale	Father lifts me up and turns around, wonderful
3:08 A" (45–53)	#1 Violins	Identical with 0:00 but ending softly, *rallentando*	He gives me a hug, mother watching happily

Vaughan Williams: *Rhosymedre. Prelude* (used in the GIM program *Nurturing*)

Box 19.2: Further observations on syntax and semantics

Syntax 4: Form
Modified song form:
The core melody is a Welsh tune of a genuine *cantus firmus* quality. The form could also be called a (secular) chorale prelude: what t first seems to be a melodic figure (motif #1) appears to be background (*obbligato* counterpoint) to the hymn tune (motif #2a+b) which has an irregular metrics: #2a 4+4 bars; #2b 5+3.

Semantics 2/Ontology (in Ferrara's model = composer's intentions and style):
Composed by R. Vaughan Williams in 1920 as no. 2 of *3 Preludes on Welsh Hymn Tunes* for organ. Based on a tune by J.D. Edwards (1805–85). In *The New Grove's Dictionary* Hugh Ottaway describes the composer's style and intentions in the years round 1920: A. (1909–19, including works such as *A London Symphony, The Lark Ascending, Tallis Fantasia*) "The common ground is the assimilation of folk song, the confident use of a distinctive body of imagery, at once national and personal, and the achievement of a unified style." B. (1919–34) "A deepening of the visionary aspect, an extending of the expressive range, embracing new forms of imagery. Composing at all levels and in many fields."

Semantics 3: Image potential:
based on seven listeners' imagery reports: all listeners reported spontaneously to the author immediately after first hearing in a relaxed state, followed by a second hearing aimed at localizing/grounding images and shifts in the music. Mood consensus: Tranquility, harmony, peace, comfort (all seven listeners).

Imagery examples (relating to BMGIM image modalities):

(a) Stream of consciousness: Summer, roses, cornfields, wood, river, meadows – like in a painting by Carl Larsson – the nature was identified as Danish and/or Swedish! (7)

(b) Sensory/kinesthetic: Physical relaxation; release of tension in legs (2)

(c) Memory: Childhood scenes of great pleasure (being with parents) (2)

(d) Metaphoric fantasy: Party in baroque castle; flying like Niels Holgersen over Swedish landscape (2). – There were no examples of transpersonal or healing imagery.

Location of significant shifts in imagery:
- From A to B: Going deeper/higher (e.g. from meadow to wood, from ground to sky).
- From B to B': Same; from stream of consciousness to memory; from father to mother.
- From B' to A': Returning to initial image or feeling.

Conclusions:

Rhosymedre is a very comforting and safe piece of music, evoking images and feelings of harmony and wellbeing. The predictable, yet refined form creates three definite "points of change" where transformation of the imagery may take place.

Table 19.1 shows how a structural analysis plus a brief phenomenological description of the music and the associated imagery can be collated in a format that gives a concentrated overview. The format is almost similar to the so called Event Structure Analysis (ESA). Box 19.2 adds further information on both syntax and semantics.

Box 19.2 shows how the analysis of the music and imagery relationship can be enhanced through a combination of analytical and heuristic procedures.

A score was not consulted in this analysis. For the context of this chapter I will also present an example of a computer generated Intensity Profile. This IP is made in the music charting program Music Imaging Analysis (Mia, version 0.3 Beta). Rickman writes:

> Mia charts the progression of the musical sound against time, providing a visual contour line on your computer screen. In other words, with perfect synchronization of line, sound and time, MIA draws a chart, mapping the contour of the selection as the music progresses. The map can be printed and saved, along with the music sound track. (Rickman 2005; see Figure 19.2)

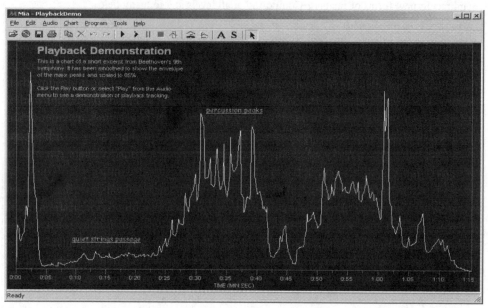

Figure 19.2: Playback demonstration of the music charting Music Imaging Analysis (Mia)

The Mia intensity profile in Figure 19.3 clearly demonstrates the phrasing and it is easily correlated to the phenomenological description in Table 19.1. It demonstrates also how the A sections in the beginning and in the end correspond to each other and frame the two "verses" or B1+B2 sections. It also shows that the intensity (= as volume) increases slowly but surely from A to B2'.

About this piece Helen Bonny (1978, p.39) said: "One of the most beautiful melodies I know, a hymn tune... the strings lace themselves around one another...an emphasis, a

renewal of the goodness of life, a resting place." I think this statement is underpinned by the analyses.

Example 2. Active music therapy: A musical improvisation dyad from psychiatry

This dyad improvisation belongs to a case study included in *A Comprehensive Guide to Music Therapy* (Wigram, *et al.* 2002) to illustrate active, psychodynamic music therapy in psychiatry. The context is thus didactic, and the readers are not expected to have any expertise. My colleague, Professor Inge Nygaard Pedersen, worked with this client over two years, and the example is their very first improvisation. In Wigram *et al.* 2002 (p.161; CD cut 3) Pedersen gives a verbal description of the instructions, the music, and the dialogue after the improvisation. She also provides follow-up information and an interpretation of the material (Box 19.3).

Box 19.3: A verbal description and interpretation of one improvisation segment

The excerpt is from the first music therapy session. The patient has been asked to choose an instrument (he chooses one of the two pianos in the music therapy room). He is asked to play a note, listen to it carefully, and let the note lead him to the next note. In other words, he is asked to try to direct his attention to the sound of the note, instead of focusing on his preconceived idea of how it is supposed to sound.

The patient plays alternately in the high and deep register, avoiding the middle register. He seems to become gradually more absorbed in listening – to immerse himself in the sound. The music therapist plays a simple repeated note as an accompaniment during the whole improvisation (one note in the middle register of the piano). The notes of the therapist and the patient join together and create harmonies that invite them to focus inwards and listen. The patient's body language shows intense concentrations in the improvisation. The music therapist hears quite a lot of intentional contact between the patient and the therapist in the music.

In the conversation after the improvisation, and after hearing the tape of the music, the patient states that he barely heard the therapist's music. However, he had a sense of a musical center somewhere that he felt drawn to. He knew he needed this center, in order to allow himself to be aware and present in his own music.

In this case, the patient gave his permission for the examples to be used for analysis and research. When he was invited to the clinic four years later and listened to this example, he was asked to focus on the contact between the patient and the therapist. He was asked to score his interpretation of the contact on a scale of 1 to 10, where 1 meant no contact and 10 meant very close contact. The music in this example was scored at 9. This shows that the patient's perception had changed significantly through the treatment.

(The patient's narrative can be found on p.166 of Wigram *et al.* 2002, and a discussion of this and other examples from the case can be found in *Nordic Journal of Music Therapy 6*, 2. The discussion is based on Christensen (1996), and the participants are Pedersen, Bonde and Christensen.)

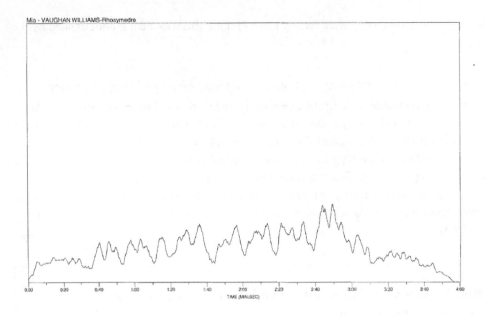

Figure 19.3: Intensity Profile of rhosymedre made by using the Mia program

The analysis is descriptive and interpretive and addresses issues on the levels of syntax, semantics and pragmatics, and it is based on audio recordings of the improvisation and the conversation.

For the purpose of this chapter I provide further material in the form of a transcription (in traditional musical notation) of the first minute of the improvisation (Figure 19.4) and an Intensity Profile/Mia analysis (Figure 19.5). This is in order to discuss potentials and problems in these analytical techniques.

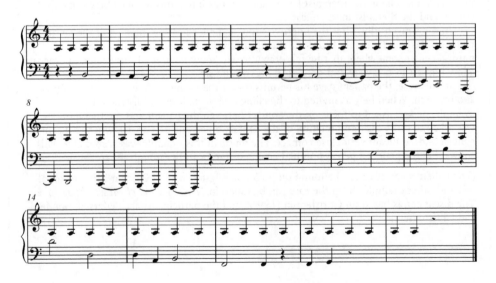

Figure 19.4: Musical notation/transcription of Example 2 using the Sibelius program.

Figure 19.5: Intensity Profile of Example 2 using the Mia charting program

The transcription may look simple, persuasive and informative, but many important details are not indicated (and can only be added through careful editing): the tempo is not constant, as the client often hesitates from note to note. The meter is indicated as 4/4, but is there really a steady meter? The dynamics in the recording show subtle changes almost from note to note; this is not indicated here. The recording renders the improvisation in B flat minor – this cannot be true! Therefore the transcription is made in a minor. My conclusion: a graphic notation focusing on the interplay between therapist and patient may be more appropriate.

The IP in Figure 19.5 clearly shows that there are no major, but many minor, shifts in intensity and dynamics; single notes may vary from *pp* to *mf*. However, the IP does not give much information about the interplay of patient and therapist. An IP *ad modum* Trondalen (2003) would be more informative on this point.

Summary

This chapter presents a generic flowchart and "step-by-step guide" to be used by clinicians or researchers who wish to include some type of music description, analysis, and/or interpretation in their oral or written presentation of case material. In the flowchart/guide important questions, problems and options related to selecting data and choosing a method of analysis are reviewed in five steps. The specific methods recommended are presented in Bonde 2005c or in the text.

References

A19.2 on the web-based resources.

Part Three

Text Microanalyses

Chapter 20

Understanding Music Therapy Experiences Through Interviewing: A Phenomenological Microanalysis

Katrina McFerran and Denise Grocke

Introduction

Phenomenological microanalysis is a valuable method for investigating client and therapist's perceptions of the music therapy experience in depth. Whether this method is used to investigate how a single session has been understood, or to reflect on a longer process of intervention, its intention is to elucidate the experience in a way that captures its essential meaning to the person who is describing the event. When more than one person has participated in the experience, phenomenological microanalysis can be useful for identifying the essential features described by those involved.

The following chapter will articulate a methodological procedure developed by the authors over a number of research investigations. Its philosophical roots are found in the writings of Husserl and others, with applications to research in the health arena being evolved by the Dusquesne School of Empirical Phenomenology (Giorgi 1975). A seven-step process will be identified, comprising the identification of 'Key Statements' and their categorisation into 'Structural' and then 'Meaning' categories, leading to the construction of a 'Distilled Essence' of the individual's experience. The process also outlines the identification of 'Individual' and 'Common' themes across a group of interviews that form the basis of a shared description of the 'Essential Elements' of an experience. This method is illustrated through the examination of the experience of group music therapy for six bereaved adolescents, the details of which are on the web-based resources, A20.1.

Theoretical basis

Edmund Husserl (1859–1938) is considered the founding father of phenomenology and the basic tenets of phenomenology emerged as a reaction to the scientific development he

saw at the turn of the twentieth century (Polkinghorne 1989). He believed researchers should return to study phenomenon within the natural world. Husserl was also concerned that existing beliefs should be bracketed out, a process undertaken in mathematics where any numbers appearing within brackets are processed first, before other calculations. The process of bracketing in phenomenology is therefore undertaken as a primary step so that the researcher's existing beliefs about the phenomenon under investigation do not contaminate the findings.

Husserl's protégé Heidegger developed phenomenology further, and his concept of *Dasein* (being-in-the-world) asserted the need to investigate the *experience* of the phenomenon (Guignon 1993). This led to another of the basic tenets of phenomenology, that of the exploration of a lived experience, examined entirely from being in that experience.

The European school of phenomenology derived from this philosophical stance, and through the Dutch school kept true to the philosophical forefathers (Polkinghorne 1989, p.43). Phenomenology underwent transition however in the hands of Amadeo Giorgi at the Dusquesne University in Philadelphia, US. Giorgi's great contribution to phenomenology was to apply the method to the study of psychology and psychological concepts. Giorgi (1975) outlined clear steps to be taken in the analysis of phenomenological enquiry, and in a sense created a more procedural model of analysis than the European forefathers would ever have contemplated. The Giorgi model was based on gathering rich descriptions from participants who had experienced the phenomenon being studied via the phenomenological interview. Steinar Kvale (1983) subsequently gave more attention to how interviews should be conducted in order that the person's lived experience could be drawn out. The phenomenological interview underpins many of the studies mentioned in this chapter, and is remarkably well suited to music therapy research where the central players are participants and recipients of music therapy experiences.

Another proponent of phenomenology at the Duquesne University was Colaizzi, who developed Giorgi's procedural steps one stage further, suggesting that the researcher should return to the participants in the study to ask whether the analysis had kept true to their experience (Colaizzi 1978). This additional step is seen in the procedural steps that follow below. Moustakas (1990) also developed his own form of existential phenomenology where the steps of analysis are similar to Giorgi's, but use different terminology and incorporate a further articulation of two stages of imaginative variation, which are referred to in this chapter as Structural Meaning Units and Experienced Meaning Units. A comparative table of the subtle differences in approach to phenomenology analysis can be found in Forinash and Grocke (2005, p.326). It is interesting to note that some music therapy researchers have remained true to the more European model of phenomenology (Forinash 1990, 1992; Kenny 1996), while others, including the authors, have adopted the more structured and procedural form of phenomenology (Comeau 1991, 2004; Dun 1999; Grocke 1999; Hogan 1999; Racette 1989, 2004; Skewes 2001; Wheeler 2002).

Method

In the following section a seven-step process will be outlined that precisely explains how this phenomenological method is applied as microanalysis to interview data. A case example of the application of this process can be found on the web-based resources (A20.1) and may be useful to follow whilst working through the process. The method can be seen as occurring in two separate phases, the first an examination of individual experiences, and the second a collective investigation. Before commencing the phenomenological microanalysis three processes must be undertaken – the development of the *epoché*, the selection of participants and the collection of the data through interviews. Each of these processes will be explained. The seven steps of microanalysis that occur following these processes are:

1. Transcribing the interview word for word.

2. Identifying Key Statements.

3. Creating Structural Meaning Units.

4. Creating Experienced Meaning Units.

5. Developing the Individual Distilled Essence.

6. Identifying Collective Themes.

7. Creating Global Meaning Units and the Final Distilled Essence.

Epoché

Prior to undertaking the data generation stage of this method, the researcher engages in a process of bracketing out biases (Bruscia 2005). This stage has been titled *epoché* (Polkinghorne 1989) and involves an identification of biases and expectations of the phenomenon under investigation. The qualitative basis of phenomenology acknowledges that meaning is constructed, and therefore the final description will represent the researcher's interpretation of what was said by the interviewees. However, in an attempt to minimise the influence of the interpretation, the *epoché* functions as a process for identifying these largely unconscious expectations and then bracketing them out from the interview and microanalysis process.

The *epoché* itself is produced by writing about the beliefs that underpin the study. It can be created by writing a list of the expectations the researcher has, even in point form to begin with. The list includes assumptions that are drawn from the researcher's clinical experience, reading the literature, and other pressures on the outcomes of their investigation. Bruscia's (1998) process for identifying counter-transference has been a useful guide in further eliciting material that the researcher has not yet identified. This list is then transformed into a narrative that the researcher returns to regularly during the microanalysis process, noting the times when the analysis seems remarkably similar to the *epoché*. Once noted, the researcher returns to the original data to determine whether the interpretation is truly based in the experience described by the interviewee, or whether the data has been influenced by the researcher's stance.

Participant selection

Once the *epoché* has been created, the interviewees are selected in order to generate the data for microanalysis. The researcher does not intentionally identify a specific number of people in this method although Cresswell (1998) does state that a phenomenological enquiry should include only up to ten participants. Rather, the phenomenological approach suggests that diversity is sought, and the number of participants is often determined by the search for this diversity, e.g. in gender, in age and other demographic factors.

Phenomenological interviews

It is helpful to pilot the entire interview as a rehearsal for the actual research interview. This would occur once an initial schedule of questions has been developed (see below) and allows the interviewer to sense whether there is a smooth flow to the order of the questions, as well as to resolve any anxieties or nervousness about posing the questions. Based on the pilot interviews, the researcher may alter some wording, or the order of the questions.

Interview is one of the most common methods of gathering data in phenomenological studies, although other methods have also been utilised (see Kenny 1996). The interview techniques used to generate the data for microanalysis are based on the semi-structured qualitative interview. Kvale (1996) has developed an influential technique for developing an interview schedule, or list of questions, that serves to draw information from the interviewee without unduly influencing its direction. He notes that 'a good interview question should contribute thematically to knowledge production and dynamically to promoting a good interview interaction' (p.129).

Kvale identifies types of interview questions such as: introducing, follow-up, probing, specifying, direct, indirect, structuring and interpreting questions, as well as the use of silence. The intention is to value the interviewee's experience of the phenomenon under investigation, and to gather as much information about their perspective of the experience as possible. Inevitably phenomenological studies search for an authentic account of the client's experience of music therapy. The researcher uses a process of summarising and clarification throughout the interview process in order to verify that their interpretation of what the interviewee has said is accurate, which Kvale suggests enhances the trustworthiness and accuracy of the subsequent analysis. Strategies such as reminding the interviewee of the focus, or asking another directly related question, could return the discussion to the topic if the interviewee has drifted. This may need to be couched with an acknowledgement of the importance of the other topic, and the expression of interest in it, but highlight the importance of going deeper into their perceptions of the experience under investigation.

It is important to note that ethical practice demands that, before commencing to interview participants for research study, the participants must provide informed consent to have the interview recorded. The Plain Language Statement must explain the purpose of the research, and that the participant is free to withdraw from the study, and to withdraw any material already provided. There must be assurance of confidentiality of data.

The interview is recorded using technology familiar to the researcher. This may be on mini-disc, tape-recorder, DAT or MP3. It is essential that the researcher confirm that the technology is working successfully at the outset of each interview, as it is not possible to re-interview without altering the initial perspective gathered. The audio taped material is then transcribed into a computer file, typically using a word processing program, which forms the data for microanalysis. Following transcription, the researcher must re-listen to the audio whilst reading through the transcript in order to ensure that the material has been accurately portrayed.

The phenomenological microanalysis

Step 1: Transcribing the interview word for word

It is necessary that the entire interview is transcribed and that the researcher does not short-cut the investigation by avoiding this task for reasons of economy. The transcription forms the fundamental data for microanalysis, with the subsequent identification of key statements providing the opportunity to discard irrelevant information. Some researchers find it useful to utilise software that slows the recording down in order to reduce the need to stop and start, whilst others find MP3 recordings to be simpler in comparison to working with a mini-disk recording.

It is customary for interviewees to drift into discussion of tangents, related to the topic, but not specifically discussing the experience under investigation. Although this tangential material is not relevant for microanalysis, it may form an important part of the interview and needs to be included in the original transcript. The opportunity to discuss the related topic may enhance the level of rapport between the researcher and the interviewee. It may remind the interviewee of further material that does relate specifically to the experience under investigation. It may provide the interviewee with time away from the topic so that they are able to return to the focus of the discussion after a short period of respite. However, it is important that the researcher does return the interviewee to the topic as soon as possible in order to draw the most detailed description possible on the experience itself.

Step 2: Identifying Key Statements

This is the first step in the distillation process of this method, that is the reduction of data to its essential elements. It involves systematically identifying which parts of the interview are focused on the experience being investigated and then discarding any other discussion topics. In developing the key statements as a separate document, any material contributed by the researcher should also be reduced. It may be necessary to include any leading questions or prompts in brackets at the beginning of the statement in order to provide an important context. It is important to be sure that only material related to the topic is being included and although it can be tempting to include powerful statements that support the value of music therapy, for example, if it does not relate to the actual experience under investigation it

should not be included. This would be an example of bias and should be avoided. Bracketing expectations should be helpful in identifying when this is the case.

The material should be structured in point form, and in the sequential order that the statements appear in the interview protocol. Each point should contain any immediately chronological discussion of the topic, but should not blend information on the same topic from other parts of the interview (although this will occur in the next stage). It is useful to include a reference at the end of each point that states which page in the original transcript the material was drawn from. This can help if the researcher needs to return to the context in order to determine if the material is being authentically represented in subsequent stages of the microanalysis. The use of bullet points is also helpful for further stages of analysis, and serves the additional purpose of moving away from regarding the data as an interview and focusing on the consideration of each individual statement made by the interviewee.

Step 3: Creating Structural Meaning Units

In this first stage of real microanalysis the researcher classifies all the statements made by the interviewee into categories. These categories are concrete in nature, that is they are literally related to what the interviewee is talking about. For example, one meaning unit may contain statements that discuss the interviewee's experience of the music. Another may contain statements that discuss the other people involved in the experience. It is important that the researcher does not pre-empt the creation of the Experienced Meaning Units that are developed in the next stage of the microanalysis by creating categories that are more focused on the underlying experience than the physical experience. This stage is focused on the physical/structural/explicit meaning of the experience.

Each meaning unit is given a title that directly conveys the content of the material contained within it. This title should be simple, drawing on the actual words of the interviewees where possible. The material categorised underneath this heading should remain in point form and should be overtly connected to the title. The number of Structural Meaning Units that are generated by a single interview protocol should directly reflect the number of physical elements of the experienced that are discussed by the interviewee. This may range from 4 to 15 as an estimate.

Step 4: Creating Experienced Meaning Units

A fundamental tenet of phenomenology is attempting to view an experience from a range of perspectives in order to determine what is essential. Those aspects of the experience that continue to be perceived from various perspectives are what is ultimately identified in the distilled essence. Moustakas suggests that researchers 'vary perspectives of the phenomenon…*to view it*…from different vantage points' (1990, p.180), which includes the structural and the experienced meanings.

In contrast to the previous stage, the creation of Experienced Meaning Units categorises information together that discusses the same underlying experience, rather than the same physical experience. It is this level of imaginative variation that allows new perspectives to

emerge from the data. It is common for the researcher to perceive unexpected categories of meaning in this stage of the microanalysis, and this quality of discovery is fundamental to phenomenological microanalysis.

In order to undertake this stage of microanalysis, the researcher needs to become immersed in the data. It requires a re-examination of each point made by the interviewee in order to contemplate what they meant by what they said. This introduces a further level of interpretation and subjectivity, as the researcher reconstructs the data from a different perspective – a meaning perspective. If an Experienced Meaning Unit contains information primarily from only one Structural Meaning Unit, this should alert the researcher to a processing issue as this is meant to re-order and re-conceptualise the material, not repeat a previous categorisation. It may be that the researcher has unintentionally created an Experienced Meaning Unit in the previous stage, although they were able to classify the information together based on a structural meaning as well. This requires the researcher to select which meaning is more important and not to repeat the classification. The Structural Meaning Unit may be discarded and the material from it placed into other categories. Or it may be the Experienced Meaning Unit that lacks sufficient depth and should be discarded. In either case, no two categories should be primarily made up of the same material and the researcher should move back and forth between the two stages in order to determine where the most appropriate categorisations can be found.

The titles of the Experienced Meaning Units should once again remain in the language of the interviewee. The use of professional jargon to capture the meaning of the material is more likely to assist the researcher in creating categories that they expect to find, or hope to find. In an attempt to avoid this predictable construction of ideas, and to remain open to what is truly present in the data, the use of the interviewee's language can facilitate a more authentic search for meaning. If the material is not clearly related to the title on further review, the researcher should consider their potential bias in interpretation and examine why they have chosen to classify the information in that category despite the fact that it does not obviously relate to the title itself. This may be a labelling issue, or it may be the result of the researcher unconsciously attempting to lead the microanalysis towards the desired result. However, it is worthy of note that material may appear in more than one Experienced Meaning Unit as this type of overlapping can often occur when grappling with meanings that may cross over boundaries created by a category and a category heading.

Once the Experienced Meaning Units have been developed, the researcher should refer to their *epoché* and actively attempt to identify any categories that are fulfilling their expectations, and then examine them to ensure that they are truly the perspective being expressed by the interviewee. The material remains in point form at this stage in order to assist in the verification of validity of each meaning unit. The number of Experienced Meaning Units created should be a reflection of the many implicit meanings contained within the descriptions. They will often be greater in number than the Structural Meaning Units, and often between 10 and 30 are created, as an estimate.

Step 5: Developing the Individual Distilled Essence

The creation of a distilled essence for each interviewee captures the experience for the participant in its core essence. The distillation process is not completed quickly, and often the researcher revisits the interview protocol yet again to 'indwell' the experience of the participant. The distilled essence is often rich in meaning, particularly when it is drawn from the participant's words. Once the Individual Distilled Essence is written, the researcher returns the transcript of the interview and the meaning units, together with the distilled essence, to the participant for verification. Once the response has been received from the interviewee, it may be necessary to incorporate any changes into the distilled essence.

Colaizzi (1978) suggests that the Individual Distilled Essence is returned to the interviewee with the question: 'How do my descriptive results compare with your experience?' In this way a further level of trustworthiness is provided to the construction of meaning that is otherwise left solely in the domain of the researcher. Another such technique can be added by consulting with experts to compare the interview transcript to the final distilled essence. Once again, the purpose is to identify whether the researcher has captured the true essence of the experience as expressed by the participant.

The construction of the distilled essence may be drawn from the Experienced Meaning Unit headings created in the previous stage. These can be drawn together into a narrative that makes the material accessible to the interviewee. A number of paragraphs are often required to include all the meaning unit headings. These may group together various Experienced Meaning Units that discuss the same structural elements, or they may be ordered chronologically in order to facilitate the reading of the material by the interviewee. The decision about ordering is not important except in making the material accessible to the reader. It may also be important to flesh out the titles used and to link material with words or sentences for the same purpose.

Step 6: Identifying Collective Themes

This is the first moment in the microanalysis where individual opinions are gathered together and examined collectively in order to identify commonalities and distinguishing features of the various descriptions offered. It is a process of broadening out, of seeking more global understanding of the phenomenon under investigation. This movement away from an exclusive focus on individual perspectives is a crucial step when analysing an experience that involves more than one music therapy client. It is grounded in the results of the individual microanalyses performed, which have been verified by the interviewees prior to this stage. Although this involves a search for similarities it does not value those ideas that are agreed upon any more than those ideas that are unique to various individuals. Spinelli (1994) explains this as horizonalisation and is an essential element of phenomenology.

In practice, horizonalisation occurs through the identification of a number of different types of themes that are identified by collective microanalysis. Common themes are those that include contributions from all the participants in the study. Significant themes are those that include contributions from many of the participants in the study. Individual themes are

those that include contributions from only a few individuals in the study. Similarly to the creation of the individually experienced meaning units, it is essential to note when one theme is dominated by the opinions of one interviewee and to classify this as an individual theme, not a significant theme simply because it contains a large number of points made in a more repetitive interview.

The individually experienced meaning unit headings form the basis of this stage of the microanalysis. The headings from all participants are gathered together and categorised with other headings that seem to convey a similar meaning. The value of having maintained the language of the individual interviewees becomes apparent at this stage, because it assists in hearing the voice of each title and maintaining integrity in classifying material together. In addition, this stage of the analysis is best undertaken creatively using colour and visual guides to identify each participant. One participant's individually experienced meaning unit headings may be coloured in purple, another in pink, another in green, and so on. This makes it easy to see how many different participant opinions are grouped in each theme and continues to support the sense of individual voices being collected together.

The titles of the identified themes, whether they are common, significant or individual, are now in professional language. It is no longer possible to maintain the language of any individual and therefore this is often the appropriate moment to transform the data into the language of the researcher. The selection of an appropriate title to capture the meaning of all the individually experienced meaning units gathered together is fundamental to the success of the microanalysis. If the title does not accurately convey the intention of all the con-tributions within the theme then it either needs to be changed, or the material needs to be re-categorised. This shuffling between various categories is both creative and grounded. Imaginative variation is used once again to consider how each individually experienced meaning unit might be gathered with another, and to see that there are many possible inter-pretations of each. Returning to the content of the individual meaning units can help to determine if the classification is authentic to the intention of the interviewee and this process should be undertaken over several sittings in order to take a break from the material and to view it again with fresh eyes to identify any short-cuts or biases that may still be trying to make their way into the microanalysis. The number of themes identified should vary depending on how congruent the various perspectives are, or how much variety is found between different participants. Between 10 and 25 themes may be identified, as an estimate.

Step 7: Creating Global Meaning Units and the Final Distilled Essence

The creation of the distilled essence is the result of the progressive distillation process that has occurred in the previous six steps. Each stage has moved the microanalysis from the in-depth descriptions gathered from various interviewees towards a succinct and grounded statement of the data. Polkinghorne (1989) provides an example of the essence of a triangle: despite the dimensions, or colour, or angles of any triangle, the triangular essence is nothing more than being a shape with three sides. The essence should capture the fundamental elements of the experience.

In order to arrive at the essence from the identification of Collective Themes, a final stage of creating Global Meaning Units is utilised. This is a further level of categories that incorporate all of the titles of the common, significant and individual themes. The Global Meaning Units identify the broad concepts that underpin the themes and are given a title that identifies these substantial constructs. Imaginative variation is once again required, and the process of shuffling the titles of the themes into various possible categories is helpful. Ultimately, a small number of Global Meaning Units should become apparent, usually between three and six.

Joining these titles together into a narrative statement creates the Final Distilled Essence. The titles of the Global Meaning Units may need to be altered in order to promote a smooth flow. Additional linking words and short statements may be required to further promote the readability of the essence. The Final Distilled Essence is the result of the phenomenological microanalysis.

For the complete case example see A20.1 on the web-based resources.

Conclusion

Although grounded in the philosophical underpinnings of Husserl's phenomenological vision and strongly influenced by the Dusquesne School's application of these ideas to psychology, this microanalysis method is also unique in some elements. The inclusion of the two stages of imaginative variation, as influenced by Moustakas (1990), has not been described previously in the music therapy literature. In addition, the emphasis on using the language of the participants in titling the meaning unit headings is a unique contribution used by students at the National Music Therapy Research Unit at the University of Melbourne. The experience of developing this chapter has also created an odd tension between the intuitive and creative approach to analysis advocated by the forefathers and the specific application of the phenomenological microanalysis method as detailed for the purposes of this text and for the teaching of students at the University of Melbourne. This method is the unique adaptation of phenomenological thought as applied to a number of research projects under the supervision of the authors. It will no doubt continue to evolve with the influence of each new research project and will always reflect the needs and desires of those with whom we work. We would like to acknowledge all of these influences, including those yet to be published, and look forward to the continued development of phenomenological microanalysis in music therapy.

This method has proved very useful for postgraduate students who are utilising phenomenological strategies as part of their research for the first time. The phenomenological approach is rooted in philosophical debate and can be overwhelming for some students. In contrast, the procedural application of phenomenology as advocated in this chapter can be grasped at a more concrete level that illustrates the application of its philosophical underpinnings. Nonetheless, the method is time-consuming and challenging, particularly in exploring biases and investigating personal motivations that may influence the analysis. A clinician who does not have access to the formal supervisory relationship

provided by a research degree would be advised to seek support and guidance for its implementation and readers are welcome to contact the authors for suggestions (see contact details in the list of contributors at the end of the book). The results are frequently rewarding and insightful and well worth the sometimes significant effort, in our opinion.

Acknowledgements

The authors would like to thank their research students, both past and present, for informing the development of this chapter by their questions, challenges and successes. This includes the research of Bridgit Hogan, Beth Dun, Emma O'Brien, Sanka Amadoru and Kathryn Lindenfelser.

References

Bruscia, K. (ed.) (1998) *The Psychodynamics of Music Therapy.* Philadelphia: Barcelona Publishers.

Bruscia, K. (2005) 'Designing Qualitative Research.' In B. Wheeler (ed.) *Music Therapy Research,* 2nd edn. Gilsum, NH: Barcelona Publishers, pp.129–37.

Colaizzi, P. (1978) 'Psychological Research as the Phenomenologist Views it.' In R. Valle and M. King (eds) *Existential-phenomenological Alternatives for Psychology.* New York: Oxford University Press, pp.48–72.

Comeau, P. (1991) 'A Phenomenological Investigation of being Effective as a Music Therapist.' Unpublished masters thesis, Temple University, Philadelphia.

Comeau, P. (2004) 'A Phenomenological Investigation of being Effective as a Music Therapist.' In B. Abrams (ed.) *Qualitative Inquiries in Music Therapy.* Gilsum, NH: Barcelona Publishers, vol. 1, pp.19–36.

Cresswell, J. (1998) *Qualitative Inquiry and Research Design: Choosing among Five Traditions.* Thousand Oaks, CA: Sage.

Dun, B. (1999) *The Experience of Music Therapists Working with Children in Coma.* Unpublished masters thesis, University of Melbourne.

Forinash, M. (1990) 'A Phenomenology of Music Therapy with the Terminally Ill.' Unpublished doctoral dissertation, New York University.

Forinash, M. (1992) 'A phenomenological analysis of Nordoff-Robbins approach to music therapy: the lived experience of clinical improvisation.' *Music Therapy 11,* 120–41.

Forinash, M. and Grocke, D. (2005) 'Phenomenological Enquiry.' In B. Wheeler (ed.) *Music Therapy Research,* 2nd edn. Gilsum, NH: Barcelona Publishers.

Giorgi, A. (1975) 'An Application of Phenomenological Methods in Psychology.' In A. Giorgi, C.T. Fisher and E.L. Murray (eds) *Duquesne Studies in Phenomenological Psychology,* Vol. 2. Pittsburgh: Dusquesne University Press.

Grocke, D. (1999) 'A Phenomenological Study of Pivotal Moments in Guided Imagery and Music Therapy.' Unpublished doctoral dissertation, University of Melbourne.

Guignon, C. (ed.) (1993) *The Cambridge Companion to Heidegger.* Cambridge: Cambridge University Press.

Hogan, B. (1999) 'The Experience of Music Therapy for Terminally Ill Patients.' In R.R. Pratt and D. Grocke (eds) *Music Medicine 3.* Melbourne: Faculty of Music, University of Melbourne, pp.242–52.

Kenny, C. (1996) 'The Story of the Field of Play.' In M. Langenberg, K. Aigen and J. Frommer (eds) *Qualitative Music Therapy Research: Beginning Dialogues.* Gilsum, NH: Barcelona Publishers, pp.55–78.

Kvale, S. (1983) 'The qualitative research interview: a phenomenological and a heuristic mode of understanding.' *Journal of Phenomenological Psychology 14,* 171–96.

Kvale, S. (1996) *Interviews: An Introduction to Qualitative Research Interviewing.* Thousand Oaks, CA: Sage.

Moustakas, C. (1990) *Phenomenological Research Methods.* Thousand Oaks, CA: Sage.

Polkinghorne, D. (1989) 'Phenomenological Research Methods.' In R.S. Valle and S. Halling (eds) *Existential-phenomenological Perspectives in Psychology.* New York: Plenum Press, pp.41–60.

Racette, K. (1989) 'A Phenomenological Analysis of the Experience of Listening to Music when Upset.' Unpublished masters thesis, Temple University, Philadelphia.

Racette, K. (2004) 'A Phenomenological Analysis of the Experience of Listening to Music when Upset.' In B. Abrams (ed.) *Qualitative Inquiries in Music Therapy*. Gilsum, NH: Barcelona Publishers, vol. 1, pp.1–18.

Skewes, K. (2001) 'The Experience of Group Music Therapy for Bereaved Adolescents.' Unpublished doctoral dissertation, University of Melbourne.

Spinelli, E. (1994) *The Interpreted World: An Introduction to Phenomenological Psychology*. London: Sage.

Wheeler, B. (2002) 'Experiences and concerns of students during music therapy practica.' *Journal of Music Therapy 39*, 274–304.

Chapter 21

Text Analysis Method for Micro Processes (TAMP) of Single Music Therapy Sessions

Kerstin Ortlieb, Maria Sembdner,
Thomas Wosch and Jörg Frommer

Introduction

Io la musica son, ch'ai dolci accennti
So far tranquillo ogni turbato core
Et or di nobil ira et or d'amore
Poss 'infiammar le piu gelate menti.[1]

In the prologue of *Orfeo*, premiered in 1607 and dedicated by Monteverdi to the myth, librettist Allessandrao Striglio, Jr presents the drama's central message. Music, represented allegorically in the form of 'La Musica', announces the story of Orfeo, conqueror of the underworld with song and lyre, to a princely gathering.

Using an interpretation suggested by the myth itself, the 'underworld' metaphorically stands for the world of unconscious memories and emotions. These are hidden, so as not to overwhelm the conscious self, which then might lose control. Threatening experiences, primarily those associated with strong negative emotions such as pain, anger, hate, resentment, guilt, shame and sorrow, are not integrated into certain phases of life, and thus cause a multitude of symptoms.

1 I am Music, who in sweet accents
 can calm each troubled heart,
 and now with noble anger, now with love,
 can kindle the most frigid minds.

An important task of active music therapy in psychoanalysis is to gain access into this underworld, where verbal therapy sometimes fails. This is a process not only touched on within psychoanalysis. Emotions, thoughts and behaviour, whether learned or forgotten, repressed, projected, displaced or rationalised, belonging or foreign to personal development, are the concern of all branches of psychotherapy and music therapy. The method presented below, which has been further developed, refined and enlarged over the past 15 years, purports to show scientifically how repressed emotions, thoughts and behaviours in music therapy intervention become visible to patient and therapist as continually progressing time-forms, and how negative emotions and processes of experience are transformed into positive emotions and experiences in interplay and verbal interchange in music therapy. The method originated within a psychoanalytic framework. The form of analysis introduced and developed here can, however, be applied within all music therapy models.

Theoretical basis

This method was developed in undergraduate theses at the University of Applied Sciences of Magdeburg and Stendal in Germany. It is especially recommended for masters theses. Modified versions for clinicians will be described in the Method section below. The method is theoretically based primarily on work by Langenberg, Frommer and Tress (1992, 1995; Langenberg, Aigen and Frommer 1996) and was further developed in a microanalysis direction up to 2005, attaining the form presented here.

In 1992 Langenberg, Frommer and Tress presented a qualitative method for describing and interpreting musical works used in treatment, which originated in music therapy sessions. The method consists of a hermeneutic approach to individual case studies. Theories are formed inductively using the material available, a method associated with qualitative social research. Furthermore, the resonating function [German: Resonanzkörperfunktion] (Kenny, Jahn-Langenberg and Loewy 2005; Langenberg 1988) comes into play. This refers to a personal instrument of perception and model of comprehension put into use in clinical practice and as a research instrument. The resonating function, stemming from psychoanalytical concepts of transference and counter-transference, stands for the therapist's or researcher's attitude of perception and his personal resonance towards the object of treatment or study. This is similar to the attitude demanded of therapists by Freud: a form of continuous, unchanging attention to the patient.

In research, listeners unfamiliar with both case and context are requested to listen to a music therapeutic improvisation and write down their impressions according to the following instructions:

> Describe your impressions of the improvisation as freely as possible! Feelings, thoughts, pictures and stories – no matter how disordered they may seem – can be noted.

In clinical practice and research, patient and therapist draw up a protocol following the same instructions directly after the music therapy session. All texts are then qualitatively evaluated.

In order to obtain general categorical dimensions, the texts are reduced as a first step to keywords. They are then ordered according to Qualities 1, 2 and 2a (for a definition of the qualities, see the Method section). The resulting text passages are further reduced in a second step using the techniques of omission, generalisation, selection and bundling. In a discursive-dialogic process they are examined with emphasis on similar content. The method used is Open Coding from Grounded Theory (Glaser and Strauss 1967). The goal is to form thematic categories with titles similar to or taken directly from the texts. Group discussion of individual coding steps serves to minimise unavoidable subjective distortion (Dreher and Dreher 1995).[2] Finally, results gathered inductively from the material are supplemented by clinical data. Taken as a whole, a picture of the relationship figures between the players develops, providing a kind of set figure of the session (see also Sembdner, Wosch and Fromer 2004).

In 1994 Langenberg, Frommer, Seizinger and Ressel introduced a new methodical facet. Motifs from individual texts are noted chronologically. Notation of procedural dynamics is a first step towards microprocess analysis. Simultaneously it mirrors the experience process of the writer and shows how processes of meeting and relationship develop within changing conditions of experiencing (see also Langenberg, Frommer and Langenbach 1996).

In a 2001 study Brennscheidt tested and applied the method with three sessions from the beginning, middle and end of a course of therapy. The question of frequency of quality per motif is answered by the formation of preferences, which mirror the way the describer 'goes with' the improvisation. The formation of a meta-level, consisting of composite or meta categories for motifs taken from all analysed sessions, is a new facet of the method, and reveals themes to be worked through. Finally, synopses of individual, analysed sessions are put together in tables.

In a study conducted in 2002 Sembdner also included all direct, verbal, patient commentary during a treatment session. The reason given for enlarging the material included was that this 'allows current processes of experience to be viewed in an essentially unaltered manner. It appears to stay closer to fleeting, musical expression within improvisation than the written protocol of the session' (Sembdner 2002, p.35). In Sembdner's approach, inductive motifs from listeners' texts are applied deductively to direct verbal patient commentary. As a result, microprocess changes can be shown occurring in the course of a single therapy session in the three steps of preliminary conversation, improvisation, and concluding conversation.

In 2005 Doffek included all verbal patient responses in the design of her study and enlarged the area of the method dealing with quantification (see Method section and Case example). As a result, discrete differences between patient and therapist, as well as within the improvisation itself, could be registered. While a maximum of six independent listener texts

2 In the original method, a graphic notation of the improvisation followed this step.

were available to Langenberg *et al.* (1992), 41 listener texts[3] were processed by Sembdner (2002) and Doffek (2005).

Method

All types of tables of this method, which are very important for the process and results of this method, can be seen on the web-based resources. Please work in parallel, reading this Method section and viewing the mentioned files on the web-based resources.

In the section below, a longer version of the microanalysis method especially relevant for research will be described first. A shorter version for clinical use follows.

In order to examine a music therapy session using the method presented here, the session must exist in form of an audio or video recording.

Long version of the method

Step 1: The recording of the clinical improvisation is played to a number of objective listeners[4] not familiar with the conditions under which the recording was made (see Langenberg *et al.* 1992; Wosch 2002).

Step 2: Each listener records impressions of the music according to the directions given in the Theoretical basis. When the resonating-body function is utilised (see the Theoretical basis section; Langenberg *et al.* 1992), occurrences in the musical improvisation can be verbalised by means of neutral listener texts.

Step 3: When Sembdner's version of the method is used as described above, conversations between therapist and patient – before and after the improvisation – must also be recorded in writing. If a session encompasses several improvisations, and conversations take place between the improvisations, these must also be recorded in writing. All conversations are recorded word for word.[5] Now the conversations taken from the music therapy session and the listener descriptions exist in written form.

Step 4: All texts are then shortened in such a way that whole sentences become short state-ments. As little actual content is deleted as possible, as interest centres not only on motifs, but also on the number of times words are used within a certain motif. For example, in Listener Text 26 (Doffek 2005):

3 These texts stem from a study by Wosch (2002).

4 In our study the listeners were music therapy students. Music therapists would also be suitable.

5 The various semantic levels contained in the language are not focused in this microanalysis. However, in work by Sembdner (2002) and Doffek (2005), transcription rules by Mergenthaler (1992) were followed. Resulting texts could thus be included in the Ulm Text Bank [German: Ulmer Textbank] for purposes of further research.

The longer I listened to it, the friendlier the music became. It was very soft at the beginning as far as the volume was concerned, but the more I got used to it, the better I could perceive the music.

The resulting shortened form was: 'Music becomes friendlier; very soft at the beginning; getting used to; perceived music better.'

Step 5: The shortened text passages are then worked on further. Using the following 'quality criteria', passages from the texts are divided into varying qualities according to decisive definitions by Langenberg (Langenberg *et al.* 1992; see the Theoretical section). The definitions were, however, extended for the method presented here as patient responses not having to do with the music were also included in the study. All additions to the original definitions appear in italics. Tri-categorical dimensions exist for categorising the text passages:

Quality 1: 'What contextual structures did I perceive?' As non-verbal material is being dealt with, descriptions are not just concrete, but also metaphorical or fantastical. As a rule, a form or set of occurrences with a certain development and character emerges within an improvisation. Descriptions are made in story-form and attempt to do justice to the procedural character of the music. All descriptions dealing with content, pictures and scenes are understood as belonging to Quality 1. Examples for Quality 1 are: 'very soft at the beginning', 'A mule is walking on a sandy path'. *In the patient's description, Quality 1 also includes all neutral narrations of experiences not coloured by emotion, as well as 'technical' questions (for example, how an instrument is played) and descriptions of instruments having to do with appearance and the way they are played (for example, 'we once drove into the courtyard of a seminary', 'doesn't one knock there?').*

Quality 2: 'What feelings emerged?' These descriptions portray the experience of music in reference to emotional experiences evoked or expressed by the music. These are closely related to statements that align with that which is experienced according to the describer's system of norms and values. In addition, abstract-reflexive thoughts about what was heard belong to Quality 2. This quality thus includes all feelings, values and reflections emerging as a result of listening to the improvisation. Examples of this are 'the music becomes friendlier' or 'tense, aggressive atmosphere'. *In the patient's description, narrations, personal reflections and values etc., which are not merely descriptive memories, are included, for example 'I'm not used to singing' or 'I didn't think so at all'.*

Quality 2a: 'What feelings emerged within me as a result of what I perceived?' This refers especially to affects, emotions, moods, values and reflections used by the writer, not in describing the music, but as first person descriptions of personal reactions to the musical experience: 'I perceived the music better' or 'I had the feeling of having to move'.[6]

On the whole, the three qualities show gradual movement from distanced, objective commentary to subjective responses that immediately touch a particular individual.

6 This category is, of course, omitted when analysing patient texts.

Step 6: Following shortening and sorting text passages into three qualities, inductive catego-
ries[7] are formed from all shortened text passages. Thus, categories originate out of the text
material. All text passages from the texts studied are gone through in an iterative manner in
discourse and dialogue and sorted according to (mostly content-oriented) similarities. The
method used is open coding from Grounded Theory (Glaser and Strauss 1967). In this
manner, individual categories gradually crystallise. Two examples for excerpts from text
passages related to each other by means of content similarity are: 'tense, aggressive atmo-
sphere – discussing angrily and with irritation', 'The feeling of having to move – a mule
walking on a sandy path', 'I don't know if that is important – not being able to use that for
anything'.

Step 7: When all category responses are bundled, a motif-heading is chosen that resembles the
original text as closely as possible. For example, the heading 'Anger – Aggression' could be
chosen for 'tense, aggressive atmosphere – discussing angrily and with irritation – that
bothered me'.

Step 8: All commentary not corresponding to available categories is then listed in a final
category (Doffek 2005). Group discussion minimises unavoidable subjective distortion.
Individual coding steps in forming categories are also debated. Discussion of participant
responses and opinions add relative dimensions to personal and subjective perceptions and
difficulties in classifying certain text passages can be solved.

After the material has been processed using the steps above, it can be combined in various
ways, which correspond respectively to differing results and possibilities of interpretation.
For a comparative examination of microprocesses, four tables are used.[8] A so-called
'summary motif table' (Sembdner 2002; completion of the sum row, Doffek 2005) is put
together first (A21.1a; see also A21.4 and the case example below). In this table, all catego-
ries are listed alphabetically in descending order. Vertical columns contain the exact number
of individual category entries in the 'three sections' of the session (Preliminary Conversa-
tion/Pre-Text; Improvisation; Concluding Conversation/Post-Text). The quality to which
each entry belongs is differentiated within the respective sections. This enables statements to
be made concerning distance and closeness expressed by each statement. In addition, the
sum of individual category entries is listed in a separate section. The sum total of all entries
appears at the end of each column. Through quantitative listing of individual categories, cat-
egories can be ordered according to frequency of appearance. Thus a step is made from quali-

7 For general understanding of qualitative research, we use the term 'categories'. At this point
 it must, however, be called attention to that in the original method (Langenberg *et al.* 1992)
 these were called motifs, then understood solely in reference to thematic categories of
 listener associations.

8 Tables less relevant to the present evaluation but at the same time helpful and significant for
 further research in the method are mentioned briefly in the Summary and perspectives
 section'.

tative portrayal – that is, the type of category chosen by the listener during the session – to quantitative portrayal of all entries by listeners and by the patient in each category. Content that predominates quantitatively can be ascertained, and processes of development during the therapy session determined. In addition, a format for portraying results is developed, on the basis of which sessions can be compared, one with another.

Three further tables are developed from the first table, providing a better overview of material. Categories are ordered to the three sections respectively according to the frequency of occurrence:

- A21.1b: Categories are sorted according to the number of entries in the pre-text

- A21.1c: Categories are sorted according to the number of entries in the improvisation

- A21.1d: Categories are sorted according to the number of entries in the post-text.

When placed next to each other, the tables show processes of development and change within categories during the course of the session (A21.1b–A21.1d on the web-based resources).

Transformation of summarised category tables into ranking tables further assists a better grasp of the data. A separate table is drawn up for each section of the session being examined. Here, only categories found in the corresponding section are included. These are sorted according to frequency of appearance. The respective number of entries is replaced by a ranking number from 1 to 'x'. At the same time, ranking numbers of each category from the remaining sections are listed. In this manner, the order of motifs in individual sections as well as changes in frequency of appearance can be compared quickly and easily (A21.2a–A21.2c, A21.3a–b on the web-based resources).

If confusion is caused by the emergence of a large number of categories during the selection process, it can be helpful to reduce material and combine individual categories in composite or meta categories on a meta-level. Criteria must be decided on case by case. Again, material is handled inductively, without using pre-assumptions for composite or meta-categories. Thorough and conscientious work ensures that only 'meaningful' composite or meta categories emerge. These permit a better overview without falsifying results (A21.5a–c on the web-based resources).

In addition, it is interesting to attempt to order listener comments to specific instruments. This is usually only possible for a small number of entries. However, if instructions preceding listening are changed, it would be possible to obtain a significantly higher number of comments that refer directly to a specific instrument. This would allow (Emotion-) impulses during the improvisation to be more clearly assigned to individual players. A more differentiated view of the improvisation would be the result (see Wosch 2002) (A21.6a–b, A21.7a–b on the web-based resources).

In cooperation with Wosch in a study (2002), Doffek (2005) was able to divide the improvisation into several sections and thus indicate processes occurring within the improvisation.

Short versions of the method and visions

During the course of the research study, the idea emerged of shortening the method presented here for use by practising music therapists in clinical work and in academic education. A shortened version of the method would be especially helpful for examining therapy sessions with unclear processes of meaning, especially as the longer version described above is time consuming and requires a large number of personnel. Within a relatively short period of time, the shorter version provides the therapist with a different viewpoint regarding the session, and helps him to examine personal working hypotheses. New recognitions gleaned from up-to-date listener reports can be utilised quickly in working with the patient.

The very short version for clinical practice can include Steps 4 to 8 with analysing only the verbal feedbacks of a patient in a music therapy session. This can be realised by only one analyser: the music therapist. Important processes within these parts of special music therapy sessions become visible with this microanalysis. Moreover, the music therapist will enter strongly into the verbal expression of his or her patient in one selected detail of one music therapy session.

Another version presented below consists of recommendations for a shortened form of the method, stemming from Sembdner (2002) and Doffek (2005). This version requires cooperation with university students.[9] As in the method above, an audio or video recording of the session must be available. A separate audio recording of the improvisation is also made. University students are included as listeners, as this keeps the therapist's work and time expenditure to a minimum. Two groups of students are necessary for further work on a particular session. The first group listens to the improvisation without any prior information. The group members notate impressions of the music according to Langenberg's instructions (see the Theoretical basis section).[10] This group then transcribes conversations before and after the improvisation. In this case, a word-for-word transcription is sufficient.

At this point, all necessary material is available in writing. A second group of students then processes this material further.[11] First, texts are shortened using the method shown (see the long version). Then, all shortened text passages are ordered according to the three qualities. Finally, inductive categories are formed out of all responses, and given headings.

At this point, material from the therapy session is returned to the music therapist. This material consists of unshortened listener texts, conversation transcriptions, and a representa-

9 Such cooperation is ongoing in Germany together between the University of Applied Sciences, Magdeburg and Stendal, Otto-von-Guericke-University, Magdeburg, the University of Arts, Berlin, and the University of Applied Sciences, Wuerzberg-Schweinfurt.

10 Previous examinations show that at least 20 listeners are statistically necessary for this step. Tendencies or prevailing atmospheres of session sections can thus be proved (see Wosch 2002).

11 A prerequisite is that students are instructed in the use of the method using the long version described above. Cooperation with our research group is highly recommended (see contact details in list of contributors at the end of the book).

tion of material in the so-called 'Category Tables' (A21.4 on the web-based resources). One table is made for each category. The tables show listener responses and their respective categories. Responses are given in shortened form.

In the same way, patient responses in these categories are given in shortened form and separated according to pre-text and post-text. Through division of the table into three quality columns, qualities from each text passage are immediately visible.

In addition to the material from the therapy session, the music therapist is given a blank table, the 'Summarised Table of Categories' and the 'Ranking Table'. He can then fill in the results of the session being examined. In the Summarised Table of Categories, the category name is entered in the first space in each line. The number of responses per category in each section of the session (Pre-Text; Improvisation; Post-Text) can quickly be quantitatively determined. As text passages in category tables have already been ordered according to quality, the number of responses per quality is also shown. The result is a group of tables similar to those in the example in A21.1a–d on the web-based resources. This is sufficient for recognising a main motif for each section of the session. Changes in frequency of appearance of individual motifs can also be ascertained. For a better overview, these summarised motif tables can be broken down into several shorter tables, as in the long version. Motifs are then sorted respectively according to frequency of appearance in individual sections (for a more exact description, see the long version). It is advisable to develop three ranking tables from the first version of the summarised category table. Ranking tables enable a quick comparison of acquired data.

When two groups of students and music therapist work together efficiently, the results from a therapy session are available within two to three weeks. Close proximity between session and results is important, as the music therapist can then meaningfully integrate results in further therapy sessions. Results can be of especial interest to the clinician when dealing with sessions or improvisations that are difficult to understand.

Case example

An initial music therapy session with a client is now described, processed using the method described above.[12] The patient is a 32-year-old woman diagnosed with atypical bulimia nervosa. Differential diagnosis shows bulimia with depressive-hysterical personality components. The therapist's approach was psychoanalytically oriented. The therapy session was 30 minutes in length, and consisted of a preliminary conversation (pre-text), an improvisation, and a concluding conversation (post-text). An audio recording of the session was available. The therapist played the piano in every session. The patient was able to choose freely from all available instruments. In this first therapy session, she chose two congas. The 41 listener texts stem from a study by Wosch (2002).

12 This is a shortened presentation of Doffek's (2005) thesis.

The material was processed as described in the Method section above. Categories were decided on slightly differently. Based on Sembdner (2002), inductive categories were taken only from listener texts. Patient responses were assigned to these categories whenever possible. The impression was, however, of not having fully grasped the session in this research process by only using the categories of the clinical improvisation. This led to inductive formation of additional categories from remaining patient responses (A21.3a–b on the web-based resources), which were then used in the evaluation. Certain tensions in the preliminary conversation resulting from the dichotomy between 'ability' and 'inability', which first became visible by means of this modification, could be shown, and results included in the new description of the method, as mentioned above.

A summarised category table was drawn up using listener categories (A21.1a on the web-based resources). A similar table was then made for each section of the session, ordered according to frequency of appearance of individual categories in the section (A21.1b–d). The progression of the session was made easier to follow by transforming these tables into three ranking tables (see Method section; A21.2a–c on the web-based resources). In this example, 'unclearness – strangeness' and 'relaxation – well-being' dominate in the pre-text. During the improvisation, 'joy – freedom' and 'change – development' take centre stage. The concluding conversation is marked by 'strength' and 'relaxation – well-being'. The ranking tables, however, provide only a rough overview of the session's progress. No exact statements can be made regarding frequency of responses within categories. When viewed for the preliminary conversation, the transformed summarised category table, A21.1a, shows that the first two motifs, 'unclearness' and 'relaxation', stand out from all other motifs, and thus dominate quantitatively. If patient categories are included, however (A21.3a–b), the categories 'reports – descriptions' and 'ability' and 'disability' must be added to the list of dominating categories. The category table in A21.1c shows the first two motifs, 'joy' and 'change', standing out distinctly from the motifs that follow, 'relaxation' and 'insecurity'. The summarised category tables (A21.1a and A21.1d) make clear that few entries were made during the concluding conversation, and that the motifs 'strength' and 'relaxation' predominate only slightly. If patient categories are included, the motifs 'ability' and 'doing or making on one's own' also appear in the concluding conversation.

Taken as a whole, the tables show that during the preliminary conversation many unclear areas are verbalised by the patient. This is due to the fact that this is the first therapy session. The patient does not know exactly what to expect, and many things are still foreign to her. These are themes she introduces at the beginning of the session. At the same time, however, she appears to be carried by a certain feeling of well-being. A feeling of joy found neither in preliminary nor concluding conversations predominates during the improvisation. Possibly a positive basic feeling (well-being) during the preliminary conversation laid the path for the development to joy during the improvisation. This category appears in third place during the improvisation. Furthermore, change and development is possible during the improvisation. At the same time, however, a relatively high number of responses are made in

the categories 'insecurity' and 'unrest', and in the category 'intention – awareness'.[13] Looking back (post-text), the patient appears to have experienced the improvisation as strengthening, whereby a feeling of well-being remained.

The two table forms included in this interpretation are those worked with in the short version of the method (A21.1a–d and A21.2a–c). These tables are sufficient for obtaining a rough picture of a session and for preliminary interpretations.

Composite or meta-categories were used, as many individual categories came into being as a result of the high number of listener texts (N = 41) (on A21.5a–c).

During the pre-text 'strength – knowledge' dominate, strengthening the importance of patient categories 'knowing', 'ability' and 'doing oneself' and supporting the assertion that the inclusion of all patient responses is important. The motif 'confusion – unclearness' also appears frequently. 'Unclearness' also takes first place when individual motifs are considered. The motif 'relaxation – joy' loses importance, as the motif 'joy' is not found at all in the preliminary conversation. The categories 'joy' and 'change' predominate in the improvisation, further supporting the above-mentioned results.

During the concluding conversation 'strength – knowledge' takes first place, and is a combination of 'strength', 'ability' and 'doing oneself'. The composite or meta-categories, with 'relaxation' in second place, underline the results obtained from the individual categories.

In the composite or meta-categories it is interesting to observe that in both conversations 'strength – knowledge' dominates for the patient and appears to be an important theme for her. The category 'movement – change', predominant in the improvisation, hardly appears at all in the conversations. The category 'relaxation – joy', second most important in the improvisation, plays only a secondary role in the conversations.

At first glance, this fact appears to be contradictory. For better understanding, it helps to view the text evaluation of the piano and drum (A21.6a–b, 21.7a–b on the web-based resources). Responses associated with the piano are dominated by the categories 'joy' and 'change'. Drum responses are almost equally balanced between 'change' and 'no-change', whereas 'joy' and 'relaxation' are named less frequently. 'Joy' and 'change' appear to be associated more with the piano during the improvisation. It can be assumed that these elements were brought into the joint music-making by the therapist, who, of course, played the piano. This is also confirmed by the fact that these (emotional) tendencies were either little or not at all perceived by the patient during the session. This interpretation and realisation would not be possible without this individual test evaluation of piano and drum.

Division of the improvisation into three sections, made possible by reference to Wosch's study (2002), also opened up many interesting aspects. Development within the improvisation could be shown clearly (A21.8 on the web-based resources). At the beginning 'insecurity', 'disorder', 'sadness', 'separation' and 'unclearness' predominated. Through the

13 A further analysis using EQ 26.5 (Wosch 2002 and Chapter 17 in this book) shows that in the first section insecurity predominates. Joy is the ruling emotion in the last section.

categories 'approach' and 'turning towards', the improvisation developed from the middle onwards towards 'joy' and 'change'. This shows that both dominating categories in the summarised category tables of the improvisation first appear towards the end of the improvisation. Predominating categories at the beginning of the improvisation would be completely neglected if this procedure of timing were not used. This is one of the perspectives for the future of the method, as it shows even more strongly microprocess analysis within a clinical improvisation.

Summary and perspectives

Using the method of qualitative quantitative text analysis presented here, micro-processes in music therapy sessions can be recognised. The first methodological step is the formation of qualitative categories. These are quantified in a second step, and quantitative prevalence of categories, their origins, increase and decrease during the course of a music therapy session, can then be determined.[14] This method is not limited to music therapy, but can be used in examining all other artistic therapies as well as verbal psychotherapy. Inclusion of video recordings is also a consideration. Evaluation would then be carried out using both audio and visual material. Previously, this method was used on three therapy sessions from a 24-session course of music therapy. In the future, an analysis of an entire music therapeutic course of treatment, which would include exact determination of all processes, would be of great interest for music therapy as a whole. An interesting step would then be to evaluate several complete music therapy sessions using the method and compare them to each other (for example, a comparison between different therapy forms). This would make possible a systematic meta-analysis of fundamental music therapy microprocess procedures and factors. Using this form of analysis, music therapy sessions occurring 'naturally', outside the influence of a laboratory situation, could be examined. This would serve both research and teaching, and function as a starting point for fundamental research.[15] The authors would be pleased to obtain access to material submitted by readers of this chapter for use in such a multi-centre study. When qualitative and quantitative means are combined, qualitative quantitative text analysis can serve a wide variety of practical music therapy fields and patients as well as providing a basis for comparing differing therapy sessions and case examples.

14 In addition, the extent to which content appearing during the course of a therapy session touches an individual, whether increasingly or decreasingly (see qualities 1, 2 and 2a, above), can be determined for individual cases.

15 In illustrating this perspective, a variant of A.21a is shown in A21.9 on the web-based resources. This compares several different sessions and cases and portrays all categories proportionally.

References

Brennscheidt, R. (2001) '"Laufenlernen" Unbewusste Affekte, Konflikte und Phantasien bei psychosomatischen Erkrankungen – qualitative Analyse einer Musiktherapie bei einem Fall von Colitis ulcerosa.' Dissertation, University of Düsseldorf. Accessed on 13/03/07 at www.ulb.uni-duesseldorf.de/diss/med/2001/brennscheidt.html.

Doffek, K. (2005) 'Analyse eines musiktherapeutischen Erstkontaktes.' Final thesis, University of Applied Sciences, Magdeburg.

Dreher, M. and Dreher, E. (1995) 'Gruppendiskussionsverfahren.' In U. Flick, E. Kardoff, H. Keupp, L.V. Rosensiel and S. Wolff (eds) *Handbuch Qualitative Sozialforschung: Grundlagen, Konzepte, Methoden und Anwendungen*, 2nd edn. Weinheim: Psychologie Verlags-Union, pp.186–9.

Glaser, B.G. and Strauss, A.L. (1967) 'Discovery of Grounded Theory: Strategies for Qualitative Research.' In G. Jüttemann (ed.) (1990) *Komparative Kasuistik*. Heidelberg: Asanger.

Kenny, C., Jahn-Langenberg, M. and Loewy, J. (2005) 'Hermeneutic Inquiry.' In B. Wheeler (ed.) *Music Therapy Research*, 2nd edn. Gilsum, NH: Barcelona Publishers, pp.335–51.

Langenberg, M. (1988) *Vom Handeln zum Be-handeln*. Stuttgart: Fischer.

Langenberg, M., Fromer, J. and Langenbach, M. (1996) 'Fusion and Separation: Experiencing Opposites in Music, Music Therapy and Music Therapy Research.' In M. Langenberg, K. Aigen and J. Frommer (eds) *Qualitative Music Therapy Research: Beginning Dialogues*. Gilsum, NH: Barcelona Publishers, pp.131–60.

Langenberg, M., Frommer, J. and Tress, W. (1992) 'Qualitative Methodik zur Beschreibung und Interpretation musiktherapeutischer Behandlungswerke.' *Musiktherapeutische Umschau 13*, 258–78.

Langenberg, M., Frommer, J., Seizinger, F. and Ressel, T. (1994) 'Verschmelzung und Trennung.' In H. Faller and J. Frommer (eds) *Qualitative Psychotherapieforschung*. Heidelberg: Asanger, pp.108–127.

Langenberg, M., Frommer, J. and Tress, W. (1995) 'Musiktherapeutische Einzel-fallforschung – ein qualitativer Ansatz.' *Psychotherapie Psychosomatik und medizinische Psychologie 45*, pp.418–26.

Langenberg, M., Aigen, K. and Frommer, J. (eds) (1996) *Qualitative Music Therapy Research – Beginning Dialogues*. Gilsum, NH: Barcelona Publishers.

Mergenthaler, E. (1992) *Die Transkription von Gesprächen*. Ulm: Ulmer Textbank.

Sembdner, M. (2002) 'Sprachanalytische Prozessuntersuchung zu musikalischen und verbalen Patientenäußerungen. Entwicklung und Erprobung einer qualitativen Methode der Musiktherapieforschung.' Final thesis, University of Applied Sciences, Magdeburg.

Sembdner, M., Wosch, T. and Frommer, J. (2004) 'Musiktherapeutische Einzelfallforschung – Sprachanalytische Prozessuntersuchung zu einer musiktherapeutischen Improvisation.' *Musiktherapeutische Umschau 21*, pp.19–30.

Wosch, T. (2002) *Emotionale Mikroprozesse musikalischer Interaktionen. Eine Einzelfallanalyse zur Untersuchung musiktherapeutischer Improvisationen*. Berlin: Waxmann.

Microanalysis in Music Therapy: A Comparison of Different Models and Methods and their Application in Clinical Practice, Research and Teaching Music Therapy

Tony Wigram and Thomas Wosch

Introduction

Microanalysis in Music Therapy offers a modest contribution to the complex field of clinical and research evaluation. Containing 20 chapters predominately from the European and Australian geographical area, this book set out to invite contributors to document their method of microanalysis, with enough detail and procedure, as well as clinical examples set out within the text or in web-based resources, in order for anyone using the text to be able to apply the model. This may have been an ambitious aim, and the book has achieved some of these goals, but not all.

First of all, it became clear that the majority of contributors developed their models of microanalysis through the research they had undertaken, and the procedures that they had established within the research design were complex and detailed in order for the careful analysis of material to be undertaken for either a quantitative and/or qualitative study in music therapy. Nearly all the methods of microanalysis were developed very close to clinical material. However, this does not translate easily into a clinically applied model of all methods, but we are convinced that the authors have actually done their utmost to offer a procedural approach that can be applied in clinical work. In clinical practice, there is limited time to report the effects and micro processes or micro changes of therapy, and increasingly health care systems are requiring any reports of therapeutic interventions to be documented electronically. Tools for such standardized systems can be found in some methods of microanalysis.

The authors have attempted to establish some simple, step by step (or stage by stage) procedures to guide clinicians, students and researchers through the model that has been presented in order for it to become a functional, clinical model of analysis. In many cases this is well described and clinicians should be able to draw on these tools for clinical analysis. There are nevertheless some contributions which remain complex, true to the original research design, and these chapters will be of more use to researchers undertaking video, audio or textural analysis than to clinicians.

Clinical populations

Contributors have usually identified a clinical population with whom their particular model of microanalysis can be applied. It is evident to the editors that each particular model is not exclusive to a population, and could be applied in a variety of different clinical settings to a greater or lesser extent. Therefore it would be inappropriate in this final chapter to try and identify populations; in the most part, the analyses are specifically geared. However, there are some examples where the form of analysis has been developed to look particularly at the behaviour and at the responsivity or therapeutic process of a particular client group. Table 22.1 identifies the general clinical area each tool is directed towards on the basis of the clinical case example that was provided within each chapter. However, this does not mean that these tools cannot be adapted for microanalysis procedures with other clinical populations.

While acknowledging that many of the microanalysis methods can be applied to diagnoses other than those described by the contributors, the overview of the way these models are presented as chapters in this book demonstrates that a dominant number have been developed by contributors experienced in working within psychiatry, autism and developmental disability or social and behavioural disorders. Table 22.1 illustrates that a limited number are focused particularly on neurodisability (Ridder, Chapter 4; Baker, Chapter 8) and dementia (Ridder, Chapter 4). Many of the methods were developed to analyse nonverbal/musical behaviour in children and adults with autism and developmental disability (Holck, Chapter 2; Plahl, Chapter 3; Scholtz et al., Chapter 5; Wigram, Chapter 16). In psychiatry there is some differentiation between psychotic disorders and affective disorders. De Backer and Wigram (Chapter 9) designed a method that was focused on analysing improvisational material from psychotic patients, while Wosch (Chapters 17 and 18) and Ortlieb et al. (Chapter 21) were concerned with analysing affective disorders. Finally, in social and behavioural disorders, Scholtz et al. (Chapter 5) and Wigram (Chapter 16) have models that can be applied more broadly than just for the autism and developmental disability populations.

There are some models of microanalysis that are defined by the authors as relevant to a specific population. For example, Schumacher and Calvet (Chapter 6) have a model which is primarily designed to be used with nonverbal or preverbal children. Baker (Chapter 8) involves technological aspects of her microanalysis method that are specifically geared at analysing voice contours. While this could be applied to other populations, its original

Table 22.1: General clinical areas represented through the case examples in each chapter

Clinical area	Chapters	
Psychiatry: psychotic disorders	9	De Backer and Wigram
	13	Pavlicevic
	17	Wosch EQ
	18	Wosch IAP
	21	Ortlieb et al.
Psychiatry: affective disorders	9	De Backer and Wigram
	12	Inselmann
	17	Wosch EQ
	18	Wosch IAP
	21	Ortlieb et al.
Neurodisability	4	Ridder
	8	Baker
Autism and developmental disability	2	Holck
	3	Plahl
	5	Scholtz et al.
	6	Schumacher and Calvet
	10	Erkkilä
	16	Wigram
	17	Wosch EQ
	18	Wosch IAP
Dementia	4	Ridder
Social and behavioural disorders or problems, behavioural disorders with somatic manifestation	5	Scholtz et al.
	15	Trondalen
	16	Wigram
	17	Wosch EQ
	18	Wosch IAP
	21	Ortlieb et al.
Not developed to apply to a specific clinical population	7	Abrams
	10	Erkkilä
	11	Grocke
	14	Sutton
	17	Wosch EQ
	18	Wosch IAP
	19	Bonde
	20	McFerran and Grocke

intention was to look at voice contour in patients with traumatic brain injury. There are other examples, but generally one can see how the many different tools of analysis could be employed differentially, and perhaps with some modifications, with the many varieties of population in music therapists' work. Given that many of the chapters address the analysis of improvisational music making, either through video analysis, audio analysis or through some form of structural analysis, the majority of populations with whom therapists work are engaged (in Europe) with this form of activity. Perhaps another chapter where the form of analysis is specifically designed for a certain population is Ridder (Chapter 4) where active and passive responses of elderly dementing clients were monitored in response to the thera- pist's song. The last row of Table 22.1 is a list of non-specified tools. Here the authors have developed their models for quite general application. For example, Abrams (Chapter 7) describes a hypothetical case of a depressed person, but this tool was included specifically to illustrate a type of analysis involving repertory grids. McFerran and Grocke (Chapter 20) also applied this model, in GIM research, as well as in analysing interviews with bereaved teenagers. Equally, this tool can be widely applied, but it is primarily a research analysis model, as are the two methods outlined by Wosch (Chapter 17 and 18).

Therefore students, clinicians and researchers can look at each presented model, with its procedural steps, as potentially available to a variety of different situations and client groups and consider the adaptations they may need to make depending on the type of material that is produced. Perhaps one of the deciding factors as to which analysis model is most appropri- ate might be the complexity (or non-complexity) of the musical material.

Analysis methods

In the first chapter of this book the editors offered a table (Table 1.1) that explained the theo- retical and microanalysis-level differentiation of the methods of microanalysis in music therapy in the book. This chart was prepared in order to achieve an overview of the different types of approaches that were used, the types of data that was collected, what form of analysis was undertaken, and the degree or level of microanalysis. The chart offers a checklist differ- entiating authors' basic approach, data source, form of analysed material and level of microanalysis to provide an analysis of the landscape of methods, and to provide summary totals. Almost all of the models are concerned with analysing some form of musical activity (17 out of 20), and a majority of them were concerned with either analysing an episode of therapy (15 out of 20) or a therapy event (10 out of 20). Perhaps unexpectedly, what emerged was that the majority of the analysis models were concerned with collecting and reporting in a quantitative way (14 out of 20) compared with a qualitative way (7 out of 20). This is interesting given that the predominant direction of music therapy research in Europe over the last 15–20 years has been towards more qualitative models of analysis. This table nevertheless demonstrated the range and scope of methods that were used, as well as identi- fying those coming from a very specific theoretical background such as phenomenology, grounded theory or ethnography. Moreover, some of the microanalyses in this book are

mixed methods of qualitative and quantitative elements (e.g. Chapter 21, Ortlieb *et al.*), which was also more broadly discussed in the first chapter.

Comparisons and differentiations

The aim of this final chapter is to offer further comparisons and differentiations between the different methods and models in the book beyond Tables 1.1 and 22.1. The four criteria that might be most useful for clinicians, for student researchers and for researchers to compare are:

1. Method and function of the analysis – what types of analysis were involved, and for what purpose was the analysis undertaken? The function refers to the therapeutic issue that was in focus for which an analysis was indicated. It could be looking at preverbal communicative behaviour, body language, eye contact, or at responses to recorded music when agitated.

2. Dependent measures and clinical characteristics – what types of specific dependent variable were monitored within each of the analysis, or what types of clinical characteristics were reported during the process of the analysis? This section is much more concerned with defining the comparative types of behavioural parameters: musical, emotional, cognitive, perceptual or communicative.

3. Method of data collection – this is concerned with comparing the different technical tools that we used to actually collect, record and document data.

4. Clinical application versus research tool – this comparison of the different contributions is looking specifically at whether the tool is being proposed from a research perspective, or from a more applied, clinical usage.

Method and function of the analysis

Table 22.2 shows the method and function of each microanalysis method as reported by the contributors. There is a considerable level of detail in each chapter regarding the function of the analysis, and this section provides some main points that may be useful in identifying an appropriate model for use in a given situation. It is a starting point for making a decision regarding the purpose behind undertaking the analysis (function) and the relevant and appropriate method.

 As can be seen in Table 22.2, while there is a wide variety of models, there are some common characteristics. As might be expected, there are frequent references to an intention to interpret musical parameters for clinical purpose. In many of the models, the study of communication and interaction as found in improvisational exchange is a focus for the analysis. In fact, the reference to some form of exchange is clearly stated in 12 of the 20 chapters, demonstrating that analysis of interactional events is a primary objective of music therapy analysis.

Table 22.2: The function of the microanalysis in relation to clinical practice

Chapter	Analysis method	Function of analysis
2 Holck	Video analysis: Music analysis Behaviour	Interaction between therapist and client or client and client
		Communication behaviours
		Facial expression
		Identify interaction patterns and changes in patterns
3 Plahl	Video analysis: Behavioural analysis Music analysis	Pre-verbal musical communication abilities
		Pre-verbal communicative sounds
		Musical 'behaviour'
		Gesture
		All forms of reciprocal dialogue
4 Ridder	Video analysis: Music analysis Physical behaviour	Communicative response of clients to songs
		Effects of music on behaviour
		Non-contingent ambulant behaviour
5 Scholtz et al.	Video analysis: Behavioural analysis Music analysis	To analyse the interaction processes
		To analyse communicative behaviours – musical and non-musical
		Analyse autonomy in client–therapist relationship
6 Schumacher and Calvet	Video analysis: Music analysis Vocal/pre-speech analysis	Use of musical materials
		Vocal sounds in client
		Intra/interpersonal relationship
		Sense of body
		Eye contact and engagement
7 Abrams	Audio analysis	To analyse improvisations using IAPs and RepGrid
		To analyse separate musical parameters of a client's (and therapist's) improvisation music making according to the six profiles: Salience, Autonomy, Integration, Tension, Variability and Congruence
8 Baker	Audio analysis: Musical material Vocal material Verbal material	Production of vocal sounds
		Affect in voice (emotional content and dynamic)
		Range of voice
		Ability to copy song phrases
		Ability to develop vocal range
		Accuracy of reproduction

Continued on next page

Table 22.2 *cont.*

Chapter	Analysis method	Function of analysis
9 De Backer and Wigram	Video and music score analysis: Musical scores Body language Verbal language	To analyse interaction
		To analyse patient's way of playing
		To analyse change over time in patient's playing
		To analyse psychic aspects of a patient's experience
		To analyse therapist's experience – musical and psychic
10 Erkkilä	Audio analysis: Computer analysis	To analyse musical characteristics of improvised music using MIDI interface into a computer program.
		To provide a detailed musical description in order to interpret based on accuracy
11 Grocke	Audio analysis: Score analyses	To compare the structural qualities of music
		To assess the suitability of recorded music in receptive approaches
		To be used as a checklist when analysing the form, structure and musical characteristics of musical material, pre-composed or improvised
12 Inselmann	Audio analysis: Interpretation of emotion analysis	To analyse emotional experience
		To analyse and rate a person's musical playing
		To analyse interaction and interpersonal behaviour
		To interpret the meaning in a client's playing and record it verbally
13 Pavlicevic	Audio analysis: Analysis of improvisations of client/therapist	To analyse musical contact between client and therapist on a 9-level scale
		To quantify the degree of contact and establish an average rating for each analysed segment
		To identify exchange of musical ideas between client and therapist
14 Sutton	Audio analysis: Musical scoring	To analyse improvisations as conversations
		To analyse beginnings and endings of improvisations
		To analyse turn-taking and silence in improvisations
15 Trondalen	Audio analysis	To make a phenomenological analysis of an improvisation
		To make a structural analysis of the music
		To make an interpretation of the music

Chapter	Analysis method	Function of analysis
16 Wigram	Video analysis: Musical analysis	To quantify frequency and duration of events in improvisation experiences To record events in interaction To record variability and style of playing in client
17 Wosch EQ	Audio (experiential) analysis: Musical material Instruments	To identify and analyse emotional transitions
18 Wosch IAP	Audio analysis: Score analysis Musical material	To analyse musical interactional transitions
19 Bonde	Musical analysis	Overview of different methods of music analysis A decision tree for selection of appropriate method Main function is analysis of musical material
20 McFerran and Grocke	Text analysis: Analysis of interview data	To make a phenomenological analysis of interview data To identify key issues, and follow through the analysis process to achieve a distilled essence of the interview
21 Ortlieb et al.	Audio analysis: Verbal material Text analysis	Verbal communication within music therapy sessions To identify and analyse the process of verbally expressed meanings and transitions during the course of one music therapy session

Having reviewed the primary purpose of the analyses documented in this book, it seemed the next most useful overview might be to identify the specific dependent measures the contributors define as relevant to their analysis. Table 22.3 lists these, including all those that are specifically identified by contributors.

Table 22.3: Dependent measures or criteria used in microanalysis by chapter

Chapter	Dependent measures
2 Holck	Rhythmic patterns; vocal phrases; facial expressions; turn-taking and turn-giving patterns Tempo and dynamics
3 Plahl	Communication of child: gaze, vocalization, gesture, musical activity; musical behaviour of therapist – vocalizing, playing instruments; verbal output of therapist
4 Ridder	Physiological data – heart rate and respiration; client singing; client tapping beat, walking, sitting, crying, sleeping etc.; therapist behaviours – singing and not singing
5 Scholtz *et al.*	Musical sounds of client; vocal sounds of client; movement behaviour of client: gaze, eye contact and gesture
6 Schumacher and Calvet	Physical contact and eye contact Affect Sound, rhythm, melody, harmony, dynamic, musical form, expression
7 Abrams	Musical parameters: rhythmic figure ground, rhythmic part-whole, melodic figure ground, melodic part-whole, harmony, phrasing, volume, texture, timbre, body, program/lyrics, interpersonal
8 Baker	Fundamental frequency of voice Pitch height, pitch range, pitch variation, pitch slope Vocal contours in songs
9 De Backer and Wigram	Musical parameters: melody patterns, rhythmic patterns, phrases Choice of instruments Verbal material of client
10 Erkkilä	Note density; note duration; articulation; register-related features; mean pitch; standard deviation of pitch; dynamics-related features; mean velocity; tonal-related features; dissonance-related features; pulse-related features
11 Grocke	Musical features (SMMA): style and form; texture; time; rhythmic features; tempo; tonal features; melody; embellishments, ornamentation and articulation; harmony; timbre and quality of instrumentation; volume; intensity. Other characteristics: mood; symbolic/associational; performance
12 Inselmann	Mood and emotions – expression and communication through an adjective checklist and a rating scale Musical parameters (rhythm, dynamics, melody, range, tempo etc.)

Chapter	Dependent measures
13 Pavlicevic	Dynamic form; all musical parameters; timing, phrasing and intensity; interpersonal exchanges
14 Sutton	Musical parameters; musical cells that are repeated; silences and pauses in the musical improvisation; turn-taking events
15 Trondalen	Description of experience; intensity contour; musical features (SMMA): style and form; texture; time; rhythmic features; tempo; tonal features; melody; embellishments, ornamentation and articulation; harmony; timbre and quality of instrumentation; volume; intensity. Other characteristics: mood; symbolic/associational; performance
16 Wigram	Musical parameters: rhythmic ground, melody, harmony, phrasing, volume, texture, timbre
	Autonomy and variability gradient criteria in relation to these musical parameters
	Frequency of events
17 Wosch EQ	Five basic emotions: interest (motivation), anxiety, anger, sadness, joy
18 Wosch IAP	Musical parameters: rhythmic ground, melody (with and without harmony), timbre (incl. volume, texture)
19 Bonde	All musical parameters depending on the focus of the analysis
20 McFerran and Grocke	Audio recording of the interview
	Transcription of the interview material
21 Ortlieb et al.	Audio recording of all words/verbal expression of client and therapist
	Transcription of this material
	Frequency of qualitative categories or motifs of verbal expression of client

As expected, in the majority of cases, musical parameters are referred to as the dependent measures. However, it should not be assumed that this means musical data. In some cases, it is a verbal description of musical material that constitutes the measures, while in others the transcription and notation of the music through a musical score represents actual musical data. There are also examples of graphic notation to represent musical material. Some authors refer to body language and gesture as forms of data. And there are also occasional references to physiological measures, measures of self-reported and interpreted emotion, and verbal material as dependent measures.

For the clinician perhaps more than the researcher, the usefulness of the microanalysis tool is dependent on it collecting and analysing appropriate data for a relevant purpose (function of the analysis, dependent measures). But what is equally important is the method by which the data is recorded and documented. Table 22.4 provides the third of the overviews of the 20 models represented in this book, and shows briefly the forms of data collection, representation and documentation tools.

Table 22.4: Forms of data collection, representation and documentation tools by chapter

Chapter	Form of data collection, representation and documentation
2 Holck	Video – notation of music and comments into a score
3 Plahl	Video – coding system leading to graphic representation
4 Ridder	Video – Excel spreadsheet with descriptions
5 Scholtz *et al.*	Video – standard text/standard items for behavioural analysis
6 Schumacher and Calvet	Video – standard text
7 Abrams	Audio – standard text; RepGrid; two-dimensional, spatial diagram generated from PrinGrid
8 Baker	Digital recording saved as wave files; graphic representation
9 De Backer and Wigram	Notation onto a musical score (Sibelius Notation System)
10 Erkkilä	Precise graphic notation of musical material Digital MIDI interface to computer program Musical score
11 Grocke	Text descriptions
12 Inselmann	Adjective checklist and Likert rating scale Scale of musical parameters + 3-stepped scale Scale of musical communication + 6-stepped scale Short-form: condensed scales
13 Pavlicevic	9-level qualitative scale of client–therapist contact; text descriptions Tabulated format of segmented scores in equal time units
14 Sutton	Written description of musical characteristics Score of improvisation – western notation and graphical representation
15 Trondalen	Written description of analyser's experience and reflections of the improvisation, and the results of the SMMA analysis Intensity profile
16 Wigram	Video – event-based analysis form IAPs results sheet for quantitative analysis
17 Wosch EQ	Audio – standard text/computerized emotion questionnaire (incl. time data for SPSS cluster analysis) Results for quantitative emotion graph

Chapter	Form of data collection, representation and documentation
18 Wosch IAP	Audio – standard text and notated score Results for quantitative interaction graph
19 Bonde	Audio – variable depending on the musical parameters in focus and the model of musical analysis used
20 McFerran and Grocke	Audio recording Standard text
21 Ortlieb *et al.*	Audio – standard text Results for quantitative tables

This offers a rather abbreviated format to summarize these forms of data collection. Some involve the use of computer programs, while others require the completion of forms. There are examples of some developed scales that are applied to the collection and analysis of data.

Finally, the intention of this book was to develop some working tools for music therapy students, clinicians and researchers in order for the process of microanalysis to be demystified, simplified, understandable and usable. As the reader will have realized, the majority of chapters were developed as part of a research study at either master's or PhD level. Consequently they present as complex and in-depth methods of analysis. Table 22.5 attempts to reflect on the relationship between research and clinical practice by reviewing the potential utility of the 20 models.

Research, as stated above, was the primary foundation for the development of the great majority of these tools. But there is a relevance to clinical practice and evaluation for many of these methods of microanalysis, which take more or less time depending on how many stages are included. An important facility some authors have offered is a 'short-form' of their tool (i.e. Trondalen, Chapter 15), excluding some stages in the analysis. The clinical applicability is not yet validated in the majority of cases, as there have been no reported extensive or systematic trials of any one of these tools. Applying one of these analysis tools relies on understandable and effective procedural instructions. Generally, music therapists are not very good at developing such essential but systematic instructions – almost the opposite: music therapists like flexibility and adaptability to be the watchwords! But for any procedure to be reliable and trustworthy there has to be some consistency in the way it is applied. To learn and apply any new method requires time and the development of appropriate skills. It is a duty of researchers to develop and then provide training in the use of such tools. Some suggestions are given here to provide clinicians with help and instruments of evaluation. The editors have requested clear guidelines and instructions, and the contributors have tried to meet that demand. The old adage 'the proof of the pudding is in the eating' certainly applies here, as it does for all of the previous books in this series. Do these tools work? Their applied use will attest to that, but we can also say that regularly revising and redeveloping such applied tools will be necessary, and you, the reader (and therapist), are going to be the best person to offer commentary and critique as to the 'user friendliness' of the methods described in this book.

Table 22.5: Research versus clinical uses of the microanalysis tools by chapter

Chapter	Research application	Uses as an applied clinical tool
2 Holck	Developed from research. Provides detailed horizontal and vertical analysis	1. For specific analyses of interaction themes 2. For self-supervision and clinical supervision of students and qualified therapists
3 Plahl	Research tool for detailed analysis of client and music therapist to determine the effects of music therapy intervention	1. To focus on specifically chosen musical parameters 2. Applied in clinical practice
4 Ridder	Research tool for the collection of physiological and behavioural data	To analyse behavioural response to songs
5 Scholtz *et al.*	Developed as a clinical and educational rather than a research tool	1. Clinical tool to analyse interpersonal behaviour with developmental delayed children 2. Analysis of interaction qualities 3. Educational tool for checking student's therapeutic competencies
6 Schumacher and Calvet	Research-based method for analysing quality of relationship	1. Can be applied in clinical practice following appropriate training 2. One of the four scales can be selected and applied depending on clinical focus
7 Abrams	IAPs and RepGrids in this tool have been developed in research studies	Theoretical stage of development for clinical application
8 Baker	Research-based method to collect precise and detailed voice characteristics	1. Can be applied in clinical practice 2. More useful for periodic assessment (due to complexity) than for analysing regular session work
9 De Backer and Wigram	Research tool from which categories were developed defining the way clients improvised and engaged that can apply in clinical work	1. To analyse the musical playing of the client 2. To interpret the style of playing 3. To analyse clients' reflections

Chapter	Research application	Uses as an applied clinical tool
10 Erkkilä	Tool developed from a research project	Complex and time-consuming for clinical analysis. Applied only to short improvisational excerpts. Excellent level of detail in music description
11 Grocke	Research-based tool developed to analyse classical music in a systematic way	Applied in clinical practice to define and describe characteristics of musical material. Some or all of the 15-category checklist can be applied
12 Inselmann	Developed for training and supervision, and as a tool to analyse clinical improvisation	1. For supervision of self and others 2. For teaching students 3. For advancing self perception 4. For analysis of clinical material
13 Pavlicevic	Developed for a research study in psychiatry	1. Applicable to clinical practice, with variable degrees of depth 2. Micro or macro analysis usability 3. Can be applied to analyse improvisational samples alone, or with an independent rater
14 Sutton	Developed for the analysis of improvised contemporary music	1. Requires written description and transcription 2. Unique attention to the importance of silences and pauses. Clinically relevant
15 Trondalen	Developed as a research tool for phenomenological analysis	1. Applied in a short form for clinical practice 2. Analysis involves the context, open listening, structural and semantic analysis and reflection
16 Wigram	Developed for clinical practice	1. Can be applied as a diagnostic tool to describe musical characteristics linked to pathology 2. Used as a clinical tool for assessment and evaluation

Continued on next page

Table 22.5 *cont.*

Chapter	Research application	Uses as an applied clinical tool
17 Wosch EQ	Research-based method uses software developed questionnaire	1. Software for clinical application currently in development phase 2. Basic research tool for basic emotional transitions in active music therapy
18 Wosch IAP	Research-based method involving the use of IAPs in analysis of notated scores and micro transitions	1. This is an analysis tool, the application of which clinicians need the assistance of author's university department 2. Educational tool to students of music therapy to train their perception of interaction of client and their own musical interaction flexibility
19 Bonde	Music analysis methods described through a flowchart	Decision making tool to determine appropriate analysis for any type of musical analysis needed in clinical practice
20 McFerran and Grocke	Research-based tool for a comprehensive and in-depth phenomenological analysis	1. Applicable for post-graduate students using phenomenology 2. Clinicians need supervision, support and guidance to access this tool
21 Ortlieb *et al.*	Research-based method, uses Grounded Theory and quantification of categories	1. Developed for use in masters' theses 2. Application recommended for clinicians trained in this method

Figure 22.2 is a decision tree relating the methods of the book to different aims and interests of students and research projects. First of all, it will become clear that video, music and text analysis are able to identify and evaluate different selected items and moments of a music therapy session. The most comprehensive and powerful tool is video analysis. However, video analysis is not used in most of the methods in this book, and where it is it tends to be focused on interaction and communication. So perhaps video analyses can be developed for other purposes, and to a greater extent than represented here. Looking beyond the music in music therapy sessions is a very interesting element for future and comprehensive research within music therapy.

Music analysis seems to be the 'favourite child' in the nation of worldwide music thera-pists. The majority of methods of this book are tools for the microanalysis of musical material. Here a wide range of items can be identified.

The least reported type of microanalysis in this book (and also in music therapy) is text analysis of verbal expression of clients. Of course, music therapy can work perfectly with non-speaking clients. However, many of our clients speak in therapy, and use words as a very important tool of communication and element of relationship to therapist and other clients in groups. On the one hand verbal psychotherapy can offer a substantial number of analyses for this purpose.[1] However, we may ask if these methods really fit the special demands of music therapy clinical practice, education and research. At the end of the day this field has potential to further the development of methods. On the other hand, when educating music therapy students, there is often a demand to teach verbal therapy skills. Text analysis can offer very interesting tools for this purpose. Moreover, acknowledging music (music microanalysis) and other nonverbal behaviour (video microanalysis) and taking into consid-eration all spoken words (text microanalysis), one can finally see represented a comprehen-sive outcome of processes from one music therapy session.

Figure 22.1 illustrates the first-stage decision of selecting video, music or text microanalysis to apply to the elements or moments from one music therapy session.

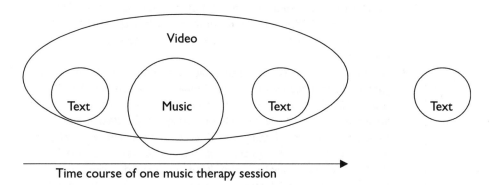

Figure 22.1: Differentiation of video, music and text microanalysis

Finally, in relation to Figure 22.1, Figure 22.2 gives a model of a decision tree for working with the microanalysis methods in this book.

1 It is interesting that one of the co-authors of Chapter 21 (Jörg Frommer) has developed and worked with text analyses in the field of verbal psychotherapy.

Microanalysis with/of

> Video microanalysis:
> 1. Interaction client–therapist/client, > 2 Holck (ethnographic), 5
> Scholtz et al. (standardized with 5 different roles of IAP-Autonomy)
> 2. Communication; > preverbal: 3 Plahl (standardized); > communicative
> behaviour: 2 Holck, 5 Scholtz (see also1); > communicative response:
> 4 Ridder (qualitative and quantification)
> 3. Intra- and interpersonal relationship, > 6 Schumacher and Calvet
> (standardized stages of relationship)

> Music microanalysis (see beyond this also 19 Bonde):
> 1. Voice; > 8 Baker (standardized, voice characteristics, emotional
> content, develop vocal range)
> 2. Interaction; > 7 Abrams (standardized with RepGrip and all IAPs), 9
> De Backer and Wigram (qualitative, score analysis of micro transi-
> tions), 10 Erkkilä (standardized, computer-analysis, synchronization),
> 12 Inselmann (interpersonal behaviour), 13 Pavlicevic (standardized,
> 9-level-scale, degree of contact, exchange of musical ideas), 14 Sutton
> (qualitative, score, musical conversation, turn-taking and silence), 16
> Wigram (standardized, IAP autonomy and variability, assessment), 18
> Wosch (standardized, score analysis with IAP autonomy, micro
> transitions)
> 3. Emotion; > 8 Baker (standardized, voice characteristics), 12 Inselmann
> (standardized, adjective lists for emotional experience), 17 Wosch
> (standardized, computerized emotion questionnaire, micro transitions)
> 4. Structural quality of client's style of playing; > 9 De Backer and
> Wigram (qualitative, 3 categories of psychotic play, change of play in
> micro process of one improvisation, score analysis), 10 Erkkilä (stan-
> dardized computer analysis with detailed musical description and
> items), 14 Sutton (qualitative, score analysis, meaning of pauses), 15
> Trondalen (phenomenological, comprehensive interpretation of music
> of a client), 16 Wigram (standardized, using IAP autonomy and vari-
> ability, quantification of frequency and duration of musical events)
> 5. Structural quality of composed music (Receptive Music Therapy); >
> 11 Grocke (standardized, complex 15 category checklist)

> Text microanalysis:
> 1. Course/transitions of different meanings of verbal expression of client
> > 21 Ortlieb et al. (grounded theory and quantification of categories)
> 2. Interview after music therapy for identifying key issues of each client
> (phenomenology) > 20 McFerran and Grocke

Figure 22.2: Simplified decision tree for using different microanalyses (in correspondence to Tables 1.1, 22.2 and 22.5

Conclusion

Microanalysis may sound very scientific, rather 'researchy', and rather too detailed for the average clinician and music therapy student. While there is a paucity of taught methods of clinical analysis, and history has shown us that the typical route down which music therapy practitioners go is to develop their own model, there is an urgent need for some professional agreement about models of assessment and evaluation. However, during our days in clinical practice there exists also the expectation of being provided with well developed and accepted models and methods for this purpose from the academic world of music therapy. A primary objective for music therapy in the coming years is to establish some reliable and valid tools for assessment and evaluation. This text offers an opportunity to make an informed choice about a relevant method for microanalysis. So choice and clinical appropriateness are also important factors. But, in the final analysis, this book will have proved useful if student clinicians and researchers find in here a tool that will serve their purpose rather than generating yet another similar but slightly different model. Moreover, many of the models can in total or in part be applied in music therapy education. Students will train in a very systematic *and* practice orientated way to develop professional perception and self-control when becoming music therapists. It offers a huge source for academic training of music therapy competencies and for starting practice oriented research with students' theses.

As with the previous books in this series – Improvisation, Songwriting and Receptive methods, the techniques and methods described here are neither for the amateur nor for the untrained. Some of the contributors have explained in their chapters that a degree of training needs to take place to use the method they are describing. This may well be the case, but should not put off the serious practitioner. Almost all therapeutic assessment tools need a form of skill acquisition for their applied use, and any that involve establishing reliable observations, scoring or collecting complex data will inevitably demand practice and experience in their use. So this book provides the information and the inspiration. The practitioners now have the opportunity to take this to academic study, clinical application and research investigation. As the medium of music is a medium governed by time, nearly all of these microanalyses require time-based analysis. They offer very well grounded, theoretical inspiration for searching and representing the smallest changes and transitions over time, which occur only in music therapy in a part or entire session of music therapy.

List of Contributors

Brian Abrams, PhD has served as Director of Music Therapy at Immaculata University in Pennsylvania since 2004. Prior to that, he served on the faculty of Utah State University from 2001–2004, after completing graduate studies at Temple University. Dr. Abrams has worked with various clinical populations, and has published and presented internationally on a wide range of topics such as music therapy in cancer care, music psychotherapy, and music therapy research. He can be contacted at babrams@immaculata.edu

Felicity Baker, PhD is Coordinator of Music Therapy Training at the University of Queensland, Brisbane, Australia. She completed her music therapy training at the University of Melbourne in 1992, her research masters degree in 1999 and completed her PhD in 2004 from Aalborg University in Denmark. Felicity is currently editor of the *Australian Journal of Music Therapy*. Her main area of research is in neurorehabilitation but she also has a strong interest in music therapy, emotion, and coping across the lifespan. Felicity is currently Chair of the Research Committee for the School of Music at the University of Queensland, is a member of the University's academic board and a member of the education committee for the Australian Music Therapy Association. Felicity has co-authored and co-edited two books and has published over 25 journal articles in music therapy and other interdisciplinary journals.

Lars Ole Bonde, PhD is Asssociate Professor of Music Therapy (MTL, FAMI) in the department of Communication and Psychology, Music Therapy at Aalborg University, Denmark. He is an educator, researcher and supervisor. His specialist areas are guided imagery and music, oncology and music analysis.

Claudine Calvet studied psychology at the University of Paris-Sorbonne. Since 1980 she has been working as a developmental psychologist in research projects about infancy at the Freie University, Berlin, Germany and at the High School of Arts of Berlin. Her main areas of interest are the development of interaccion, communication and attachment, and she developed an intervention concept to improve mother–child-interaction with children with disabilities. Since 1990, together with Karin Schumacher, she has been developing the "AQR" Analysis System. She is also a therapist for the mental health of infants and their families, a supervisor, and teaches developmental psychology at the University of Arts, Berlin, Germany.

Jos De Backer, PhD completed his doctoral studies in Music Therapy at the University of Aalborg, Denmark. He is Professor of Music Therapy at the College of Science and Art, Campus Lemmensinstituut, Leuven, Belgium, and head of the masters training course in Music Therapy. He is Head of the Music Therapy Department at the Psychiatric University Centre-K.U.L., campus Kortenberg where he works as a music therapist treating young psychotic patients. He specialises in psychoanalytic music therapy and is currently researching music therapy and psychiatric patients. He also has a private practice, and is President of the European Music Therapy Confederation (EMTC).

Jaakko Erkkilä has worked as a music therapist with several client groups in the field of psychiatry (both adolescents and adults), including children with neurological disorders and learning disabilities, as well as handicapped people from various subcategories. He has worked as the Head of Music Therapy master's program at the University of Jyräskylä since 1997, and he is the Head of Music Therapy Training at Eino Roiha Institute (Jyväskylä, Finland). He is also a PhD supervisor at the University of Jyräskylä. Professor Erkkilä is the Vice-President of the European Music Therapy Confederation (EMTC).

Jörg Frommer, MD, MA is a psychiatrist, psychoanalyst and Professor for Psychosomatic Medicine and Head of the Department of Psychosomatic Medicine and Psychotherapy, Medical Faculty and Clinic Centre, Otto-von-Guericke University, Magdeburg, Germany. Current research projects include methodolgy and methods of psychotherapy and counselling research, qualitative research, psycho-oncology, transplantation medicine and tinnitus. He is co-editor of *Qualitative Psychotherapy Research: Methods and Methodology*.

Denise Grocke is Associate Professor and Head of Music Therapy at the University of Melbourne, Victoria, Australia. She is Director of the National Music Therapy Research Unit (NaMTRU) and is currently Associate Dean (Research). She completed her music therapy qualifications at Michigan State University, and is a Registered Music Therapist (Board Certified) in the US. She holds a Masters degree in Music Therapy, and a PhD in Guided Imagery and Music (Bonny Method), both from the University of Melbourne. She served three terms as Chair of the Commission of Education, Training and Registration of the World Federation of Music Therapy and from 1999 to 2002 was President of the World Federation of Music Therapy. Denise has practiced as a music therapist with people who have mental illness, neurological disorders and dementia, and she has a private practice in the Bonny Method of Guided Imagery and Music. She is co-editor of two books, has authored 14 chapters in books and 50 articles on music therapy and Guided Imagery and Music.

Ulla Holck, PhD holds positions as Associate Professor at the Department of Communication and Psychology, Aalborg University, Denmark, and as a researcher at the Child and Adolescent Department at Aalborg Psychiatric Hospital. She is Head of Studies at the Music Therapy programme at Aalborg University, and teaches students at all levels. Ulla Holck has worked with adolescents with emotional and behavioural problems, as well as young adults with severe autism. Her doctoral study involved video microanalysis of clinical work.

Ute A.A. Inselmann, MD specializes in psychosomatic medicine and psychotherapy, psychoanalysis, music therapy and psychooncology (member of DKPM). She has worked at the Institute for Psychotherapy and Medical Psychology of the University of Würzburg, Germany since 1993, and her research interests include basic and clinical research in music therapy, psychooncology, psychotherapy with the elderly and teaching psychosomatic medicine and psychotherapy.

Katrina McFerran, PhD is a lecturer in music therapy in the Faculty of Music at the University of Melbourne, Australia. She specialises in clinical work and research with child clients, particularly those who are bereaved or have intellectual and learning disabilities, as well as chronic illness or eating disorders. Her research has investigated the musical processes that underpin adolescent group work, as well as outcome studies in special education and hospital settings.

Kerstin Ortlieb (née Doffek) was born in Nuremberg in 1981. After her practical training in an integrative kindergarten she began her studies in music therapy at the University of Applied Sciences at Magdeburg-Stendal, Germany in 2001. In her diploma thesis she focused on the microprocesses of a music therapy session. The usage and development of the methodologies of linguistic process analysis and of qualitative description and interpretation of music therapy treatments was the main point of her work. From April 2007 until January 2008 she is working on her practical training in psychiatry for children and young people in Nuremberg.

Mercédès Pavlicevic, PhD is co-head of research at Nordoff-Robbins Music Therapy (UK), and professor extraordinary at the University of Pretoria, South Africa, where she was Head of the Music Therapy master's programme for many years. Her primary research interests are in music therapy improvisation in various clinical settings, across a range of social and cultural contexts.

Christine Plahl, PhD is a psychologist, psychotherapist (approbation), and music therapist, and is Professor for Psychology at the University of Applied Sciences, Katholische Stiftungsfachhochschule Munich, Department Benediktbeuern, Germany. She researches and lectures on music therapy, evaluation, rehabilitation, developmental psychology and clinical psychology, and is a Lecturer on the training course for Orff Music Therapy at the Academy for Developmental Rehabilitation, Munich, Germany. She can be contacted at christine.plahl@ksfh.de

Hanne Mette Ridder, PhD is a postdoctoral researcher in the department of Communication and Psychology at Aalborg University in Denmark. Her research is focused on music therapy with persons with neurological degenerative diseases, as well as research designs and methodologies with this specific group of music therapy clients. She is the Danish EMTC delegate and president for the Danish music therapy association. She can be contacted at AAU, Kroghstr. 6, 9220 Aalborg Ø, Denmark or hanne@hum.aau.dk

Julia Scholtz studied music therapy at the college of Magdeburg-Stendal from 2001 until 2006 and finished with the 'Diplom in music therapy'. From October 2004 to February 2005, she worked at the social paediatric clinic 'Kinderzentrum'. There she found and studied the subject on which she wrote her thesis, which is discussed in her chapter of this book. Since July 2006 she has worked at 'Universitätsklinik' Dresden, Germany in paediatric care with children with oncological, neurological and other illness.

Karin Schumacher was born in Graz, Austria, and studied music therapy in Vienna and elementary music and dance pedagogy at the Orff-Institute in Salzburg. Between 1974 and 1982 she worked as a music therapist at a psychiatric clinic. Since 1984 she has worked at a school for children with autism and other developmental disorders in Berlin. Between 1984 and 1995 she established and supervised music therapy as an academic course at the University of Arts in Berlin, Germany, where she works today. Since 1995, she has held a lectureship at the University of Music and Arts in Vienna, Austria. In 1998, she graduated with her thesis on music therapy and infancy research from the University of Music and Theatre in Hamburg, Germany. Together with the developmental psychologist Claudine Calvet she developed an instrument which helps to assess the quality of the interpersonal relationship in music therapy work.

Maria Sembdner studied for her diploma in Music Therapy at the University of Applied Sciences, Germany. She is now a music therapist at the Clinic for Psychiatry, Psychotherapy and Psychosomatic Medicine, which is part of the Medical Faculty at Otto-von-Guericke University, Magdeburg, Germany, where she mentors and teaches music therapy students. Her specialist areas include a clinical focus on inpatients of psychosomatic medicine, qualitative language analysis and process research of musical and verbal expressions in a single case study.

Julie Sutton, PhD has worked for over 25 years as a music therapist, in Belfast, Dublin, London, Bosnia and Belarus, with both children and adults. She has research interests in a number of areas and is currently involved in projects concerned with trauma, the occurence of silence in the music therapy room, and musical processes within clinical improvisation. She has presented and taught in many countries and currently works in adult psychiatry at the Centre for Psychotherapy in Belfast, Northern Ireland, for John, Lord Alderdice and Professor Dr Paul Williams. She publishes regularly and is a past editor of the *British Journal of Music Therapy*. Her book *Music, Music Therapy and Trauma* was published in 2002 by Jessica Kingsley Publishers.

Gro Trondalen is Associate Professor in Music Therapy at the Norwegian Academy of Music in Oslo. She is a qualified music therapist and Special Education Teacher and holds a specialisation in BMGIM (FAMI). As a music therapist Trondalen has worked in the field of child welfare and adult mental health. Her research focus has been on clinical work linked to philosophical and theoretical perspectives. She can be contacted at gt@nmh.no

Melanie Voigt, PhD/Univ. Texas studied music education in the US and taught in the public schools there. She trained in music therapy with Gertrud Orff at the Kinderzentrum München in Munich, Germany. She has been Head of the Music Therapy Department at that institution since 1984. She is now Head of Training Courses in Orff Music Therapy at the Deutsche Akademie für Entwicklungs-Rehabilitation in Munich and lectures in Orff Music Therapy at the Hochschule Magdeburg-Stendal in Magdeburg, Germany. She also holds the qualification of 'Kinder- und Jugendlichenpsychotherapeutin'. She has published in both English and German.

Tony Wigram is Professor of Music Therapy and Head of PhD Studies in Music Therapy in the Institute for Communication and Psychology, Department of Humanities, University of Aalborg, Denmark. He is Head Music Therapist at the Harper House Children's Service, Hertfordshire Partnership N.H.S. Trust, Principal Research Fellow in the Faculty of Music, Melbourne University, and Reader in Music Therapy at Anglia Ruskin University, Cambridge. After reading music at Bristol University, he studied with Juliette Alvin at the Guildhall School of Music, and later qualified with a PhD in Psychology at St. George's Medical School, London University. He has written and edited 14 books on Music Therapy, authored more than 100 articles in peer reviewed journals and chapters in books. His research interests include the physiological effect of sound and music, assessment and diagnosis of Autism Spectrum Disorders and communication disorders, methods of training and advanced level training in music therapy, music therapy research and advanced improvisation skills. In 2004, he was the first recipient of the European Music Therapy Confederation Award for significant achievements in the development of music therapy in Europe. His principal publications include: Wigram, T. and Dileo-Maranto, C. (1997) *Music, Vibration and Health*. Pipersville, PA: Jeffrey Books; Wigram, T. (1999) 'Contact in Music: The analysis of musical behaviour in children with communication disorder and pervasive developmental disability for differential diagnosis.' In: T. Wigram and J.De Backer (eds) *Clinical Applications of Music Therapy in Developmental Disability, Paediatric and Neurology*. London: Jessica Kingsley Publishers; Wigram, T., Nygaard Pedersen, I.., and Bonde, L.O. (2002) *A Comprehensive Guide to Music Therapy. Theory, Clinical Practice, Research and Training*.

London: Jessica Kingsley Publishers; Wigram, T. (2004) *Improvisation: Methods and Techniques for Music Therapy Clinicians, Educators and Students*. London: Jessica Kingsley Publishers; Wigram, T. (2005) 'Songwriting Methods – Similarities and Differences: Developing a Working Model.' In F.Baker & T.Wigram (eds) *Songwriting: Methods, Techniques and clinical cases for Music Therapy Clinicians, Educators and Students*. London: Jessica Kingsley Publishers; Wigram, T. (2005) 'Survey Research.' In B. Wheeler and K. Bruscia (eds) *Music Therapy Research. Qualitative and Quantitative Methods* (2nd edn). Phoenixville: Barcelona Publishers; Wigram, T. and Gold, C. (2006) 'Research evidence and clinical applicability of Music Therapy for Autism Spectrum Disorder.' *Child Care: Health and Development 32*, 5, 535–542; Wigram, T. (2006) 'Musical Creativity in Children with Cognitive and Social Impairments.' In Deliege, I. and Wiggins, G. (eds) *Musical Creativity: Current Research in Theory and Practice*. London: Psychology Press; Wigram, T. (2007) *Receptive Methods in Music Therapy: Techniques and Clinical Applications for Music Therapy Clinicians, Educators and Students*. London: Jessica Kingsley Publishers.

Thomas Wosch read musicology, psychology and sociology at the three universities of Berlin, Germany, after which he studied with Christoph Schwabe at the Academy for Applied Music Therapy in Crossen, Germany, and later qualified with a PhD in humanities (on emotional transitions in music therapy) at Otto-von-Guericke University of Magdeburg, Germany. He was a clinician of music therapy in psychiatry in the federal states of Berlin and of Brandenburg for nine years. From 1998–2007 he was a lecturer of music therapy at the University of Applied Sciences of Magdeburg and Stendal, Germany. He is now Professor of Music Therapy in Social Work at the University of Applied Sciences of Wuerzburg and Schweinfurt, Germany. He is guest teacher, examiner, member and head of building up the MA program in music therapy at the National University of Saporoshje, Ukraine, the German Academy of Developmental Rehabilitation, Germany, Aalborg University, Denmark and the Centre of Excellence "Music and Cognition" of University of Jyväskylä, Finland. He is discussion editor of www.voices.no and board member of Grammophon – Mobile Musiktherapie, Germany. He has presented in Europe, the US and Australia. He has written or edited 2 books and 25 articles in peer reviewed journals and chapters in books. His research interests are microanalyses, emotional transitions, alexithymia and community work with music and intercultural studies. His principal publications include: Wosch, T. (2007a) 'Emotion Psychology and its Significance in Regulative Music Therapy (RMT) and the Bonny Method of Guided Imagery and Music (GIM).' In Frohne-Hagemann, I. (ed.) *Receptive Music Therapy*. Wiesbaden and Philadelphia: Reichert; Wosch, T. (2007b) 'Community Music Therapy.' In Decker-Voigt, H.-H., Knill, P.J. and Weymann, E. (eds.) *Lexikon Musiktherapie*. Göttingen: Hogrefe; Wosch, T. (2003) 'Der Weg zur Freude – Musikrezeption, Improvisation und Emotion im Kontext aktueller Musikvermittlung.' .['The Way to Joy – Music Reception, Improvisation and Emotion in Current Music Teaching.'] In: Kafurke, R., Petrat, N. and Schöne, K. (eds.) *Mit Spaß dabei bleiben – Musikästhetische Erfahrungen aus der Perspektive der Forschung. [Keeping Fun – Music Esthetical Experiences from the Point of View of Research.]* Essen: Die Blaue; Wosch, T. (2002) *Emotionale Mikroprozesse musikalischer Interaktionen. Eine Einzelfallanalyse zur Untersuchung musiktherapeutischer Improvisationen. [Emotional Micro Processes of Musical Interactions. A Single Case Analysis of Clinical Improvisations.]*Berlin: Waxmann; Wosch, T. and Frommer, J. (2002) 'Emotionsveränderungen in musiktherapeutischen Improvisationen.' ['Changes of emotion in clinical improvisations.'] *Musik-, Tanz- und Kunsttherapie 13*, 3, 107–114; Wosch, T. (2001) 'Psychiatrische Einzelmusiktherapie als Modifikation von Leipziger Schule und Verstehender Psychiatrie.' ['Psychiatric Individual Music Therapy as Modification of Leipzig Approach and Social Psychiatry.'] In: Decker-Voigt, H.-H. (ed.) *Schulen der Musiktherapie*. [Schools of music therapy.] München: Ernst-Reinhardt-Verlag; Wosch, T. (1997) 'Ursprünge und Symbolik des Xylophons.' ['Origin and symbolism of the xylophone.'] *Musik-, Tanz- und Kunsttherapie 8*, 165–168. He can be contacted at wosch@fh-wuerzburg.de

Subject Index

Page numbers in *italics* indicate tables
and figures; the letter 'n' after a page
number indicates a note.

Author Index